Visitor-Centered Exhibitions and Edu-Curation in Art Museums

Visitor-Centered Exhibitions and Edu-Curation in Art Museums

Edited by Pat Villeneuve
and Ann Rowson Love

ROWMAN & LITTLEFIELD
Lanham • Boulder • New York • London

Published by Rowman & Littlefield
A wholly owned subsidiary of The Rowman & Littlefield Publishing Group, Inc.
4501 Forbes Boulevard, Suite 200, Lanham, Maryland 20706
www.rowman.com

Unit A, Whitacre Mews, 26–34 Stannary Street, London SE11 4AB

British Library Cataloguing in Publication Information Available

Library of Congress Cataloging-in-Publication Data

Names: Villeneuve, Pat, 1955– editor. | Love, Ann Rowson, 1967– editor.
Title: Visitor-centered exhibitions and edu-curation in art museums / edited
 by Pat Villeneuve and Ann Rowson Love.
Description: Lanham, Maryland : Rowman & Littlefield, 2017. | Includes
 bibliographical references and index.
Identifiers: LCCN 2016052996 (print) | LCCN 2016053615 (ebook) | ISBN
 9781442278981 (cloth : alk. paper) | ISBN 9781442278998 (pbk. : alk. paper) |
 ISBN 9781442279001 (electronic)
Subjects: LCSH: Art museum visitors—Services for. | Art museums—Social aspects. |
 Art museums—Educational aspects. | Art—Exhibition techniques.
Classification: LCC N435 .V57 2017 (print) | LCC N435 (ebook) | DDC 708—dc23
LC record available at https://lccn.loc.gov/2016052996

Printed in the United States of America

Contents

Foreword

My museum career began with a rallying cry to rebel—unexpectedly in the education department at the British Museum. I was extremely fortunate to work with the director of education, John Reeve, an inspiring visionary from whom I learned an immense amount about museum practice and leadership. In my first meeting with John, I earnestly requested a textbook that would introduce me to museum education theory.

To this day I remain surprised that the one book that John gave me was a slim paperback, Ivan Illich's 1971 classic, *Deschooling Society*. I was shocked that a leader in one of the world's most formal institutions of learning would give me a radical text arguing *against* institutionalized learning. The book opened my eyes to the enormous potential of informal education and self-directed learning. But what really impacted me—then as well as today—was the idea of someone in a position of prestige and authority telling an idealistic intern that to question power and challenge assumptions was the path to a successful career in museums.

Around the same time, my museum world shifted again when I saw the exhibition *Visions of Japan*, curated by Arata Isozaki, at the Victoria and Albert Museum in London. The exhibition spanned just three rooms, and each space not only focused on a specific theme but also engendered different emotional and physical responses in the viewer. The first gallery serenely presented a minimalist sampling of the traditional arts of Japan, including the tea ceremony and tattoo arts. The second gallery assaulted the visitor with a cacophony of contemporary Tokyo, complete with vending machines, herds of Godzillas, and digital temple prayers. The small final room was unnervingly still, filled only with projected images of life dominated by technology. I left the exhibition in a daze, moved by intense sensory impact, surprising objects, and big ideas.

Like my reading of *Deschooling Society*, *Visions of Japan* memorably upended my understanding of museum work. The show challenged my assumptions about the role of exhibitions, demonstrating that the thoughtful engagement of emotion, the senses, and surprise could outweigh the importance of the objects on view. Visitor impact was the driving force of the exhibition, and it therefore packed a resounding punch.

Recently, I visited *Carambolages* (meaning "cannon," a ricochet shot in billiards) at the Grand Palais in Paris. Curated by Jean-Hubert Martin, the exhibition was like no other that I have experienced. Martin installed a series of geographically, chronologically, and culturally diverse objects in a linear fashion, without labels or didactic information. One object led to the next, like a ricochet shot in an intellectual and aesthetic game of billiards. Artworks were connected either by formal qualities, such as objects involving specific body parts, like the eyes, or by concepts, such as belief, death, magic, and good versus evil. It was a bit of an art historical inside joke, but I reveled in the focus on unknown works of art. Most of the works were not masterpieces, nor were they fully representative of a culture, time period, or artist. For the most part, the works on view were messy by-products of the human experience: quirky, intriguing, funny, and disturbing.

Carambolages contained the type of liminal works that humanity has produced prolifically throughout history, but remain largely unknown, sequestered in museum storage vaults. These marginal objects often express more about the lived human experience than the masterpieces that museums fetishize. Once again, I was engaged by the risky experimentation undertaken by the exhibition organizers to challenge curatorial practice and surprise visitors with a risky exhibition. While *Carambolages* was not without its problems, it was one of the most fearlessly speculative exhibitions that I have seen.

When discussing new initiatives with members of our innovative team at the Minneapolis Institute of Art (Mia), I often say, "Do something that makes me nervous." I want them to push my expectations and boundaries and those of our institution—and of our public. We must do work that surprises our audience and enables them to see the world a bit differently. *Deschooling Society*, *Visions of Japan*, and *Carambolages* all impacted my perception of museums because their creators boldly demonstrated that there could be another approach to our endeavors, even within the conservative and cautious self-constructed boundaries of museums.

The most significant change in the museum field over the last twenty years is the shift from museum work focused on our peers, colleagues, and ourselves to work focused on our audiences. Museums have spent the last fifty years building collections, donors, staffs, and buildings—but to what end? Our work is meaningless unless it is seen, experienced, and digested.

Museums used to delegate the responsibility for visitors to members of the education department ("They like children, don't they?"). In addition, since most education departments were historically overwhelmingly female, we assumed that the care of visitors was women's work. The men in curatorial departments could be left alone to think great thoughts about masterpieces, while the women in education nurtured visitors. Increasingly, as the entire museum profession has become largely female, this situation has changed significantly. At the same time, the barriers between curatorial and education are dissolving. In the current visitor-centered environment, all museum employees share responsibility for serving their audiences. At Mia, every employee's job description makes this position clear.

Our global world today is a converged world; many of the traditional distinctions and boundaries that have separated people, industries, products, technologies, participants, delivery channels, and so on have diminished or disappeared. In museums, our organizations have become flatter, and we collaborate more across departments and hierarchies. As exciting as these changes are, they also require that we develop new muscles and explore more ways to work together in service of the visitor. The integration of educational and curatorial practice is one of the most urgent and necessary opportunities resulting from the museum's destruction of silos. As edu-curation increases, we will see a greater number of visitor-centric exhibitions, many of which will stimulate young interns to pursue rebellious museum careers.

In *Deschooling Society*, Illich wrote that "the current search for new educational funnels must be reversed into the search for their institutional inverse: educational webs which heighten the opportunity for each one to transform each moment of his [*sic*] living into one of learning, sharing, and caring."[1] His rallying cry resonates in museums today as we move from the authoritarian funnel of knowledge to the participatory web of a shared learning journey.

Visitor-Centered Exhibitions and Edu-Curation in Art Museums argues that it is time for museums to conceive of exhibitions in a new way. A challenge to the idea of a solitary genius that toils in isolation for ten years and then allows the public in to behold the resulting brainchild, this book argues boldly for a much more collaborative, transparent, and audience-driven approach to museum work. In homage to Illich, we might call it *De-Siloeing Museums*.

Kaywin Feldman
Duncan and Nivin MacMillan Director and President
Minneapolis Institute of Art (Mia)

Preface

Practically, this book got its start at the 2015 American Alliance of Museums conference in Atlanta. Passing through the exhibition hall, I gave my business card to Charles Harmon at the Rowman & Littlefield booth; he showed great enthusiasm for my interest in visitor-centered exhibitions and welcomed a prompt proposal. In actuality, however, work on this book began a long time ago. Ann Rowson Love and I have more than sixty years of museum experience between us, and we've been collaborating since she entered the field some twenty-five years ago. We have dedicated our careers to making art museums visitor-friendly places, first in the field of art museum education and then with additional proficiencies in exhibition development and evaluation. For the past few years, we've been working together at Florida State University, establishing new graduate programs (MA and PhD) in museum education and visitor-centered exhibitions based on our conception of edu-curation, a balanced, collaborative approach to exhibition making. We see edu-curation and visitor-centered exhibitions as a way to complete a long-term shift that began in the 1990s from object-centered to visitor-centered practices.

In this book, which we've organized in five parts, we introduce edu-curation and provide a rationale for it. Additional content addresses changes in workplace culture and structure needed to support edu-curation and provides numerous examples of visitor-centered exhibition practices. A majority of the chapters are written by multiple authors, including educators, professors, curators, interpreters, evaluators, directors, students, and members of the general public—ensuring a diverse consideration of theory and practices. The authors represent US and international museums, large and smaller, established or experimenting, as well as alternate venues. What they have in common is a conviction for connecting audiences with art in meaningful

ways. The chapters demonstrate what is possible, and together they present a compelling case for visitor-centered exhibitions and edu-curation.

Part I, Foundations: The Need for Edu-Curation, includes three chapters. In chapter 1, I tell how I became a proponent of visitor-centered exhibitions and present the imperative for such exhibitions from my perspective. In chapter 2, Ann Rowson Love and I introduce edu-curation and the adapted feminist systems theory that informs our work. Chapter 3, written by Brian Hogarth, provides an extensive consideration of the training necessary for edu-curation.

Part II, Readiness: Structuring Your Approach, gives insights for museums ready to embrace visitor-centered practices. Chapter 4, by Judith Koke and Keri Ryan, includes a variety of mechanisms, ranging from low to high involvement, for integrating community voices into the exhibition development process. In chapter 5, Maia Werner-Avidon, Deborah Clearwaters, and Dany Chan reveal how they have prototyped and tested visitor-engagement experiences at the Asian Art Museum of San Francisco. In chapter 6, Ann Rowson Love introduces her Cu-Rate model and provides many practical suggestions for implementation. Chapter 7, by Kathryn E. Blake, Jerry N. Smith, and Christian Adame, looks at traditional museum power structures and discusses how museums can better align authority with responsibility for interpretation.

Part III, Collaboration in Action, features five examples of collaboration and visitor-centered exhibitions. Chapter 8, by Maureen Thomas-Zaremba and Matthew McLendon, discusses how The Ringling engaged audiences in contemporary art exhibitions by reaching out into its communities. In chapter 9, Rosie Riordan and Stephanie Fox Knappe describe how they worked with two area schools to generate interest in an exhibition through student-written labels. Chapter 10 details supported interpretation (SI), my model for visitor-centered exhibitions, and chapter 11, by Alicia Viera, Carla Ellard, and Kathy Vargas, uses SI to generate a community-based pop-up exhibition. In chapter 12, Monica O. Montgomery and Hannah Heller document the Museum of Impact's mobile social justice initiatives, also making best advantage of pop-up exhibitions.

Part IV, Seeing Inside the Process, includes four chapters that demonstrate how teams dialogue, negotiate, and develop outcomes. Chapter 13, by Marianna Pegno and Chelsea Farrar, reveals how two smaller- to mid-sized museums incorporated community groups in their curatorial activities. In chapter 14, Astrid Cats documents how the Van Abbemuseum in the Netherlands worked with Cuban artist Tania Bruguera to embrace the ideals of *Arte Útil*, a Spanish term for useful art that also suggests its function as a tool or device. Chapter 15 considers the role of philosophical inquiry in participatory curation; it is written by Trish Scott, Ayisha de Lanerolle, Karen Eslea, and participants from a philosophical inquiry at Turner Contemporary in the

United Kingdom. Chapter 16, by Ann Rowson Love and John Jay Boda, uses a screenplay format to present a professor–student duoethnography of a class on visitor-centered exhibitions.

Part V is Sustaining Engaged Organizational Learning. It features examples from museums that are known for their established visitor-centered exhibition practices. Chapter 17 by Stefania Van Dyke reflects on the curator–educator teamwork at the Denver Art Museum. In chapter 18, Jennifer Wild Czajkowski and Salvador Salort-Pons give their perspectives on building a workplace at the Detroit Institute of Art that supports educator–curator collaborations. And in chapter 19, Elizabeth K. Eder, Andrew Pekarik, and Zeynep Simavi share how their audience testing informs visitor-centered exhibition design within the Smithsonian's Freer | Sackler.

We prepared this book for art museum and higher education audiences. We hope a range of museum professionals will read it, including directors, curators, educators, collections, and installation staff. It's easier to change practice when we're all on the same page! We also plan to use the book in our teaching and would be pleased if other professors in art/museum education or museum studies programs would adopt it as well. Although our title clearly places the book in an art museum context, we think that colleagues in other types of museums will also find much to use here. The content in this book provides guidance advancing visitor-centered exhibition practices, which I have argued has the potential to move art museums to the hearts of their communities, transforming them into dynamic, sustainable organizations for the twenty-first century.[2]

Pat Villeneuve, editor
with Ann Rowson Love, co-editor

NOTES

1 Illich, Ivan. *Deschooling Society.* New York: Harper & Row, 1971, i.
2 Villeneuve, Pat. "Building Museum Sustainability through Visitor-Centered Exhibition Practices," *The International Journal of the Inclusive Museum* 5, no. 4, (2013): 37–50.

Acknowledgments

EDITORIAL TEAM

Pat Villeneuve and Ann Rowson Love wish to acknowledge:

Peter Weishar, dean of the Florida State University College of Fine Arts, and Dave Gussak, chair of the Department of Art Education, for supporting our new graduate programs in museum education and visitor-centered exhibitions, making our department the home of edu-curation.

The Ringling, our partner museum and home base for visitor studies and incredible internship opportunities for our MA and doctoral students. We especially thank executive director Steven High, curator of education Maureen Thomas-Zaremba, and curator of modern and contemporary art Matthew McLendon.

Editorial assistant Jay Boda for his capable assistance. We could not have done it without him.

The authors for completing the book with so many fine examples of visitor-centered exhibitions and edu-curation. We particularly appreciated their efforts and goodwill as we worked to meet all our deadlines.

Those who submitted proposals. The selection process was tremendously difficult, and we reluctantly had to pass on multiple viable proposals. We trust they will find other outlets for their excellent work.

Our first cohorts of edu-curators: John Jay Boda, Victoria Eudy, Sarah Gladwin Graves, Susan Mann, Aja Roache, Jessie Spraggins Rochford, Elizabeth F. Spraggins, Maghan Stone, Morgan Szymanski, and Anthony Woodruff. We appreciate their enthusiasm and willingness to try something new with us, and we rejoice in their passions and varied interests. We know they will do incredible things.

Our husbands, Tom Daly and Eric Love, who have always encouraged us to chase our dreams and have taken care of so much at home while we've been writing and traveling.

Ann would also like to thank her mom, Sandy Rowson, for understanding the busy schedule and treating lunches here and there. And to daughter, Abby, and granddaughter, Paisley, I hope you'll always enjoy art museums and visitor-centered exhibitions.

Jay Boda fondly thanks Pat Villeneuve and Ann Rowson Love for their scholarship, mentorship, and friendship and for embracing his multidisciplinary background and extending opportunities to succeed as he breaks ground in museum edu-curation. And to his husband, Pedro, cwm. Pupitza!

CHAPTER AUTHORS

Kathryn E. Blake, Jerry N. Smith, and Christian Adame wish to recognize the leadership of James K. Ballinger, director emeritus of Phoenix Art Museum, who has promoted equity and mutual respect among curators and educators.

Jennifer Wild Czajkowski and Salvador Salort-Pons thank all the Detroit Institute of Arts (DIA) educators and curators willing to embrace change and warmly acknowledge Nancy Jones, director of education at the DIA from 1996 to 2010, for building the foundation that made so much possible.

Elizabeth K. Eder, Andrew Pekarik, and Zeynep Simavi wish to thank other members of the Freer I Sackler IPOP Champions team—Nancy Eickel, Jan Stuart, Lee Glazer, Karen Sasaki, and Brooke Rosenblatt—for collaborating with us across departments to advance visitor engagement at the museum. Our special thanks to Nancy Eickel for her willingness to edit many drafts of this chapter. We'd also like to recognize Julian Raby, Dame Jillian Sackler director of the Arthur M. Sackler Gallery and the Freer Gallery of Art, for his support.

Monica O. Montgomery and Hannah Heller warmly acknowledge all the people and organizations that have supported our work and approach of radical museology and mobile social justice museum craft from the outset.

Marianna Pegno and Chelsea Farrar thank the staff at the University of Arizona Museum of Art and the Tucson Museum of Art for their support of educational programs like *Mapping Q* and *Museum as Sanctuary*. Special thanks to Sarah Bahnson, Jackson Wray, the Southern Arizona AIDS

Foundation, Marge Pellegrino, Abby Hungwe, and Owl & Panther for their trust and collaboration from the very beginning.

Rosie Riordan and Stephanie Fox Knappe gratefully acknowledge the support of the board of the Nelson-Atkins Museum of Art and its director, their many colleagues within the museum, and external partners who all recognized the value and meaning of bringing outside voices into the museum and on to its walls.

Maureen Thomas-Zaremba and Matthew McLendon would like to thank all The Ringling staff and volunteers whose support made these projects possible.

Stefania Van Dyke extends many thanks to colleagues Christoph Heinrich, Timothy J. Standring, Jodie Gorochow, Danielle St. Peter, Sarah Magnatta, and Melora McDermott-Lewis for their contributions and support.

Alicia Viera, Carla Ellard, and Kathy Vargas would like to thank Amanda Dominguez and the staff of Digital Pro Lab in San Antonio, Texas, for the opportunity to curate this SI exhibition at their venue.

Maia Werner-Avidon, Deborah Clearwaters, and Dany Chan thank the staff of the Asian Art Museum of San Francisco, Kathleen McLean, Maria Mortati, the Andrew W. Mellon Foundation, the Institute of Museum and Library Services, and our visitors who advised us every step of the way.

Part I

FOUNDATIONS: THE NEED FOR EDU-CURATION

Chapter 1

From There to Here

In Support of Visitor-Centered Exhibitions

Pat Villeneuve

Early in my career, I traveled to Paris for the New Year with a couple of my art museum education colleagues. After the jubilant celebrations on New Year's Eve, the city seemed deserted on January 1. We spent the chilly day roaming, trying to find any shops or restaurants that might be open. By early evening we were in the neighborhood of the Pompidou Center and were surprised to find it open. We rushed inside and were stunned at what we saw in the lobby: it seemed everyone left in the city was gathered there. We watched children playing, families enjoying picnics, people reading, a man doing tai chi. There were no guards in sight, and everyone seemed perfectly comfortable there. We recognized there were cultural differences but wondered aloud why US art museums weren't like this. As my friends and I talked, we used the term *museum as gathering center* to describe what we were observing. It stood in stark contrast to our experience of museums that functioned apart from their communities, content to serve select patrons rather than embracing the general public.

That fortuitous encounter, decades ago, sparked my quest to advance the field of art museum education and transform US art museums into visitor-friendly places that are integral parts of their communities. In this chapter, I document my transition from a proponent of art museum education to an advocate for visitor-centered exhibitions and introduce two pivotal publications that demonstrate for me the necessity for visitor-friendly practices.

FROM A SLOW START TO UNFULFILLED PROMISE

Despite my convictions, my initial progress was slow, given the priority many US art museums gave to curatorial issues over educational concerns—and

I still saw it very much as an either/or proposition. To enhance the level of professional practice in art museum education and increase regard for the field, I pursued a doctorate, disseminated my work in diverse scholarly and professional venues, and moved from museums to academe to establish graduate programs in the area.

I became more hopeful with the publications and opportunities I saw in the 1990s, beginning with Van Mensch's methodological museology that combined a museum's education and curatorial functions into a communications function.[1] The next two years saw the publication of *Excellence and Equity: Education and the Public Dimension of Museums*, the landmark policy piece issued by the American Association of Museums (AAM), and the museum experience model by Falk and Dierking.[2] The AAM publication called for education for diverse audiences to be placed at the center of museums' public-service roles, establishing much hope in art museum education circles.[3] The museum experience model took a broad look at the many factors impacting the visitor's experience, presenting the potential to expand the purview of art museum education.[4]

In the mid-1990s, museum education theorists like Hein and Hooper-Greenhill articulated the concept of the constructivist museum that shifted the responsibility for interpretation to individual visitors and called for a new approach to exhibitions to support individual meaning making.[5] Then, at the end of the decade, Weil famously declared that museum exhibitions must go from being *about* something (the object) to being *for* someone (the visitor), instilling hope once again for a paradigmatic shift toward education.[6] As I looked back at the 1990s, however, I felt a profound sense of frustration and disappointment and wondered how so much promise could remain largely unrealized for art museum education. Just what was it going to take? . . .

A BREAKTHROUGH AND NEW OPPORTUNITIES

Editing *From Periphery to Center: Art Museum Education in the 21st Century* set the stage for a personal breakthrough.[7] A chapter by Glenn Willumson, art historian, former curator, and then-head of museum studies at University of Florida, made me think in terms of *sharing* authority with objects curators—as Van Mensch had proposed years earlier—rather than prioritizing education.[8] When I stopped seeing education as vying with curatorial, I began to regard exhibitions as the most visible manifestation of a museum's work. In the spring of 2010, I welcomed an opportunity to curate a visitor-centered exhibition at the Arizona State University Hispanic Research Center, and that fall I went on sabbatical to Europe, where I was able to work on my developing ideas at the University of Leicester School of Museum

Studies and Reinwardt Academy where Van Mensch taught. The result was supported interpretation (SI), a new model for visitor-centered exhibitions.[9] Inspired by the ideas of Van Mensch and others, SI combines a museum's educational and exhibition functions into a communications function, with the exhibition serving as an interface, or point of interaction, between the museum and its visitors.[10] A few years later, I had the good fortune of being able to establish new graduate programs (MA and PhD) in the Florida State University Department of Art Education, where I am professor and director of arts administration. I chose museum education *and* visitor-centered exhibitions, which led to the articulation of edu-curation with Ann Rowson Love.

AS I SEE IT: THE IMPERATIVE FOR VISITOR-CENTERED EXHIBITIONS

Having spent my career as an arts administrator, museum educator, and professor, I've become accustomed to providing rationales for what we do, and this is something I've incorporated into my teaching. I think there are many arguments that could be made for visitor-centered exhibitions, but there are two readings I use in my classes that I find particularly compelling. Although the publications are dated and not likely to be on every museum professional's reading list, I think they indirectly attest to the need for visitor-centered exhibitions by exposing profound differences between general audiences and specialists, such as the curators who traditionally have produced art museum exhibitions.

The first is by Feldman, a cognitive psychologist, who reconceived human development and learning as extending along a continuum from universal (all people) to unique (the first one).[11] On the left end of the continuum (Figure 1.1), universal development achievements occur spontaneously to all worldwide, at approximately the same time frame. All healthy babies, for instance, learn to walk at around one year of age. Moving to the right along the continuum are cultural achievements, meaning the skills that a specific culture values and expects young people to gain through schooling, apprenticeship, or other means, to become fully functioning adults within that society. In the United States, reading and computer skills are prime examples, whereas sailing and navigational skills may be required in an island culture. Discipline-based and idiosyncratic achievements are attained by fewer and fewer people; they go beyond functional skills in any culture and demand increasing levels of commitment and education in one form or another. In Western cultures, these could be represented by higher education and then further specialization at the graduate level. Unique achievements at the right end of the continuum are the first of their kind, the breakthroughs, or the works of artist and

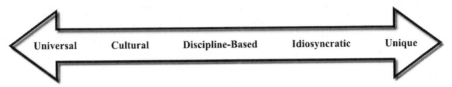

Figure 1.1. Feldman's universal-to-unique continuum.

genius. When these accomplishments are recognized and valued, they are supported and nurtured, enabling them to reoccur and move to the left along the continuum.[12]

A country's general public, a product of its compulsory education system, is represented by the cultural part of the continuum. In contrast, artists who have produced many of the artworks in museums and the curators who prepare exhibitions and catalogs generally endeavor to work as far toward the right end of the continuum as possible. At least in the United States, this leads to a sizable gulf between the knowledge and skills acquired in K–12 public education and the demands of the artworks, exhibitions, and other curator-prepared materials. (In class, I refer to it as the gulf of misunderstanding.)

The second reading is by Parsons.[13] His articulation of levels of aesthetic development—or how people respond to works of art—also illustrates a gap between the art understandings of the general public and those who are art-world insiders, such as traditional museum experts. Working from responses that study participants made about reproductions of artworks, Parsons described five developmental levels, from naïve to sophisticated. The stages, along with brief descriptions and sample statements, follow:

Stage	Brief Description of Viewer	Sample Statement
I. Favoritism	Responds with delight; strong attraction to preferred colors and subject matter	I just love the pink flowers and puppy!
II. Beauty and Realism	Prioritizes subject matter that is beautiful and/or representational	That's painted so good it looks like a photograph.
III. Expression	Recognizes that artworks can evoke feelings	I feel pain just looking at the woman's face.
IV. Style and Form	Sees artwork as part of an artworld context	It's a contemporary piece, but the artist has appropriated Cubist imagery.
V. Autonomy	Analyzes the artwork from various perspectives	A feminist lens renders a different interpretation of the work.

Members of the general public tend to be at Level II: Beauty and Realism, with fewer at Level III: Expression. Meanwhile, exhibitions and catalogs are usually presented at Level V: Autonomy or Level IV: Style and Form. In a related study using Viewpoints, Erickson and Villeneuve found that students studying to be art teachers responded primarily at the equivalent of Levels II and III—not unlike the general public—despite multiple courses in art history, studio, and education.[14] This raises the question of how much additional education is necessary before individuals adopt the mind-sets of art experts, such as curators.

If we refer back to the continuum, it suggests the answer: only people with the advanced training of curators can be expected to think like curators. However, it is inefficient and unrealistic for a society to demand that of its general population. This underscores the necessity of attending to visitor preparation and needs. I am concerned that without carefully considered exhibitions and educational and interpretive plans, museums risk turning off visitors who may lack adequate foundations to construe works of art to their satisfaction. Mediating the connection between art and our audiences is to our advantage and in no way undermines the importance of museum objects. What we must realize, in my view, is that people who are able to connect with works of art will feel comfortable in museums and use and support them. Visitor-centered exhibitions can help us achieve this worthwhile goal.[15]

NOTES

1 Van Mensch, Peter. "Methodological Museology, or towards a Theory of Museum Practice." In *Objects of Knowledge*, edited by Sue Pearce, 141–157. London: Athlone, 1990. See also chapter 10.

2 Hirzy, Ellen Cochran. (Ed.). *Excellence and Equity: Education and the Public Dimension of Museums*. Washington, DC: American Association of Museums, 1992; Falk, John H., and Lynn D. Dierking. *The Museum Experience*. Washington, DC: Whalesback Books, 1992.

3 Hirzy, *Excellence and Equity*. The original book sold for $2. I invested in ten and gave them to others at the museum where I worked: "Read this. It's really important."

4 Falk and Dierking, *Museum Experience*.

5 Hein, George E. "The Constructivist Museum." In *The Educational Role of the Art Museum*, edited by Eilean Hooper-Greenhill, 73–79. New York: Routledge, 1994; Hooper-Greenhill, Eilean. "Museum Learners as Active Postmodernists: Contextualizing Constructivism." In *The Educational Role of the Art Museum*, edited by Eilean Hooper Greenhill, 67–72. New York: Routledge, 1994.

6 Weil, Stephen. "From Being about Something to Being for Somebody: The Ongoing Transformation of the American Museum," *Daedelus* 128, no. 3 (1999): 229–258.

7 Villeneuve, Pat. (Ed.). *From Periphery to Center: Art Museum Education in the 21st Century.* Reston, VA: National Art Education Association, 2007.

8 Willumson, Glenn. "The Emerging Role of the Educator in the Art Museum." In *From Periphery to Center: Art Museum Education in the 21st Century*, edited by Pat Villeneuve, 89–94. Reston, VA: National Art Education Association, 2007.

9 See chapter 10.

10 Villeneuve, Pat. "Supported Interpretation: Museum Learning through Interactive Exhibitions." In *Intelligence Crossover*, edited by Qirui Yang, 58–72. Hangzhou, China: The Third World Chinese Art Education Association, 2012; Villeneuve, Pat, and Alicia Viera. "Supported Interpretation: Exhibiting for Audience Engagement," *The Exhibitionist Journal* 33, no. 1 (2014): 54–61.

11 Feldman, David. *Beyond Universals in Cognitive Development.* Norwood, NJ: Ablex, 1980.

12 For instance, the first heart transplant occurred in 1967. With support first from the medical community and then the general public, heart transplants became more common. Some fifty years later, over 5,000 such transplants are done worldwide each year, according to http://www.uptodate.com/contents/heart-transplantation-beyond-the-basics. This moves heart transplantation from its original position at the far end of the continuum to some place to the right of idiosyncratic because only specialized cardiothoracic surgeons—not all—currently perform the surgery.

13 Parsons, Michael. *How We Understand Art: A Cognitive Developmental Account for Experience.* Cambridge: Cambridge University Press, 1987.

14 Erickson, Mary, and Faith Clover. "Viewpoints for Art Understanding," *Translations* 12, no. 1 (2003): 1–5; Erickson, Mary, and Pat Villeneuve. "Bases of Preservice Art Teachers' Reflective Art Judgments," *Studies in Art Education* 50, no. 2 (2009): 184–200. Viewpoints offers a nonstagist revision to the work of Parsons that moves beyond his Modernist conception of Levels IV and V and looks at a possible repertoire of viewer response, including plural artworlds.

15 Villeneuve, Pat. "Building Museum Sustainability through Visitor-Centered Exhibition Practices," *The International Journal of the Inclusive Museum* 5, no. 4 (2013): 37–50.

BIBLIOGRAPHY

Erickson, Mary, and Faith Clover. "Viewpoints for Art Understanding," *Translations* 12, no. 1 (2003): 1–5.

Erickson, Mary, and Pat Villeneuve. "Bases of Preservice Art Teachers' Reflective Art Judgments," *Studies in Art Education* 50, no. 2 (2009): 184–200.

Falk, John H., and Lynn D. Dierking. *The Museum Experience.* Washington, DC: Whalesback Books, 1992.

Feldman, David. *Beyond Universals in Cognitive Development.* Norwood, NJ: Ablex, 1980.

Hein, George E. "The Constructivist Museum." In *The Educational Role of the Art Museum*, edited by Eilean Hooper-Greenhill, 73–79. New York, Routledge, 1994.

Hirzy, Ellen Cochran. (Ed.). *Excellence and Equity: Education and the Public Dimension of Museums.* Washington, DC: American Association of Museums, 1992.

Hooper-Greenhill, Eilean. "Museum Learners as Active Postmodernists: Contextualizing Constructivism." In *The Educational Role of the Art Museum*, edited by Eilean Hooper Greenhill, 67–72. New York: Routledge, 1994.

Parsons, Michael. *How We Understand Art: A Cognitive Developmental Account for Experience.* Cambridge: Cambridge University Press, 1987.

Van Mensch, Peter. "Methodological Museology, or Towards a Theory of Museum Practice." In Objects of Knowledge, edited by Sue Pearce, 141–157. London: Athlone, 1990.

Villeneuve, Pat. "Building Museum Sustainability through Visitor-Centered Exhibition Practices," *The International Journal of the Inclusive Museum* 5, no. 4, (2013): 37–50.

Villeneuve, Pat. (Ed.). *From Periphery to Center: Art Museum Education in the 21st Century.* Reston VA: National Art Education Association, 2007.

Villeneuve, Pat. "Supported Interpretation: Museum Learning through Interactive Exhibitions." In *Intelligence Crossover*, edited by Qirui Yang, 58–72. Hangzhou, China: The Third World Chinese Art Education Association, 2012.

Villeneuve, Pat, and Alicia Viera. "Supported Interpretation: Exhibiting for Audience Engagement," *The Exhibitionist Journal* 33, no. 1 (2014): 54–61.

Weil, Stephen. "From Being about Something to Being for Somebody: The Ongoing Transformation of the American Museum," *Daedelus* 128, no. 3, (1999): 229–258.

Willumson, Glenn. "The Emerging Role of the Educator in the Art Museum." In *From Periphery to Center: Art Museum Education in the 21st Century*, edited by Pat Villeneuve, 89–94. Reston, VA: National Art Education Association, 2007.

Chapter 2

Edu-Curation and the Edu-Curator

Ann Rowson Love and Pat Villeneuve

We begin this chapter by exploring the traditional view of the exhibition curator as a lone creative. Using ecofeminist systems thinking, a systems thinking lens, we reenvision the exhibition curatorial model and introduce edu-curation as a more appropriate alternative for collaborative and visitor-centered museum professionals in the twenty-first century.[1]

THE LONE CREATIVE

For much of the twentieth century, the lone creative as curator addressed the exhibition development process as a singular endeavor until design, installation, and programming necessitated working with others. Often, collaboration with a museum educator came at the end of the process in order to program events for audiences—families, teachers, pre-K–12 school groups, college students, and adults. The steps of the process may have looked similar to Figure 2.1.

In this widely accepted model, understanding and preparing for visitor interests, needs, and learning preferences came at the end, rather than being integrated into the process, preferring objects and ideas over museum visitor preferences.[2] Questioning where education will fit into this traditional model first appeared with publications like *The Uncertain Profession* by Dobbs and Eisner.[3]

TRADITIONAL TRAINING FOR ART MUSEUM PROFESSIONALS

In one chapter of a historic text on art museum education, El-Omami reported on two surveys, one sent to the membership of the Association of

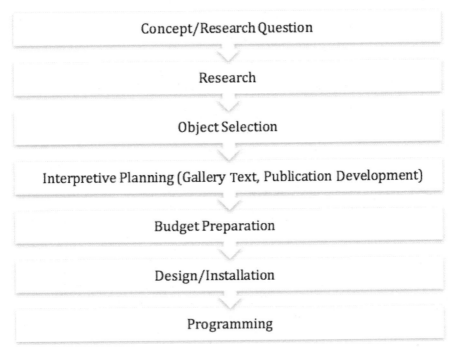

Figure 2.1. Traditional exhibition development process with the lone creative curator.

Art Museum Directors and the other to the members of CurCom, the curators standing committee of the American Association of Museums (AAM; now the American Alliance of Museums).[4] Both surveys asked directors and curators to consider the skills they valued in museum educators. Findings indicated continued strong favoring of art historical training, the traditional training trajectory for both curators and educators. However, curators and directors seemed aligned in augmenting art historical preparation with additional training in evaluation, audience research, art education, and education pedagogy and theory for art museum educators (Figure 2.2). This suggested that although specialized training in art history, culminating with doctoral degrees, was appropriate for curators and directors, museum educators should have broad training not only in art history but also in these additional areas. In response, El-Omami prescribed a graduate program incorporating skills in all the desired areas, but the resulting sixty-credit-hour course of studies was too long and impractical for graduate schools to implement at the master's level.

The preference for art historical training for art museum educators lingered into the new millennium. Cooper and Ebitz independently explored requested academic qualifications in monthly job postings for art museum educators

Figure 2.2. Traditional training for curators and museum educators.

in *Aviso*.[5] Ebitz concluded that art history remained the preferred degree for art museum educators, similar to a 1980s study that found that 42 percent of *Aviso* announcements for art museum education positions either required or preferred degrees in art history.[6] Cooper also identified a preference for advanced degrees, especially a master's degree in art history.[7] However, their studies also noted the growing consideration of other majors, including museum education, museum studies, art education, and fine arts. Ebitz posited that this change was due to "increased support and understanding of the role of museums, the growing professionalism of museum educators, and new course content and degree offerings in art and museum education to provide an alternative to art history for students seeking a career in art museum education."[8] Both authors also looked at required skills for art museum educators. The Ebitz study revealed a priority on written and verbal communication; interpersonal skills; and leadership, management, and supervision, all appearing in at least half of the listings.[9] Cooper's findings included communication, computer skills, organizational skills, and writing in at least one-third of the postings.[10]

1990s PARADIGM SHIFTERS

New perspectives throughout the 1990s set the stage for an expanded role for art museum education. This challenged museums to rethink exhibition development as a lone activity and consider when in the process collaboration with educators should start.

At the beginning of the decade, Van Mensch reconfigured the standard model of museum functions from the traditional five—collect, conserve,

research, exhibit, educate—to three.[11] His model included preserve (which presumed collecting), study, and communicate. The communication function conflated the previously separate exhibition and education functions, requiring collaboration in exhibition production, favoring the museum visitor.

In 1992, the AAM issued a landmark policy publication, *Excellence and Equity: Education and the Public Dimension of Museums.*[12] It featured ten principles advancing education, the first of which was: "Assert that museums place education—in the broadest sense of the word—at the center of their public service role."[13] Accompanying recommendations moved practice toward a more collaborative and community-oriented approach: "Ensure that all staff members and volunteers understand the implications of their decisions and actions for the educational and public service dimension of the museum's work."[14]

The same year, Falk and Dierking[15] introduced their interactive experience model, describing how personal, sociocultural, and physical contexts impacted the museum visit. The range of factors they offered, from personal agenda to interaction with others to the function of gallery spaces, suggested the opportunity for an expanded purview for the museum educator. At the close of the decade, Weil, then the foremost US museum theorist, asserted that museums must go from being *about* something (the object) to being *for* someone (the visitor).[16]

EMERGING MODELS OF INCLUSIVE CURATION: VISITOR-CENTERED APPROACHES

Over the past decade, new curatorial models have considered visitor input and required collaboration during the exhibition development process. Two examples of collaborative, visitor-centered and interactive models for exhibition planning include the interpretive planning outcomes hierarchy and the Selinda Model.[17] Wells, Butler, and Koke articulated the outcomes hierarchy as a means to embed visitor input and evaluation into interpretation planning, museum-wide as well as for exhibition development.[18] They used the language of evaluation to underscore the importance of outcomes, or what visitors will gain from their interactions in changing exhibition and permanent collection galleries. Their model also functions as a museum-wide interpretive planning process. Likewise, Perry's Selinda Model relies on outcomes.[19] Additionally, it focuses on what motivates visitors to interact in exhibitions and explores varying the types of engagement. In both models, educators play a central role on an exhibition team. Although both consider input from visitors to be important, neither requires visitor participation on the exhibition team itself.

REENVISIONING THE THEORETICAL LENS: APPLYING FEMINIST SYSTEMS THEORY TO CURATION

Stephens studied the intersections of critical systems thinking and cultural ecofeminism in order to articulate principles of a feminist systems theory.[20] Feminist systems theory, or ecofeminist systems theory, focuses on making social change, empowering the oppressed, and employing research to take action. "Critical systems thinkers apply methods of boundary analysis to obtain as comprehensive an understanding of a phenomenon as possible. They take a holistic perspective and look for emergent properties between and among the whole system. This is particularly true for the onset of undesirable and/or unexpected outcomes. Problem-solving methods are frequently applied to 'messy' problems."[21] Critical systems thinkers and cultural ecofeminists alike underscore the necessity for collaborative, participatory methods.

Stephens articulated a framework with five components.[22] The first component is to *be gender sensitive*. Gender sensitivity is not just about women; it is an awareness of genders and a commitment to build trust and empower authority. Collaborators are co-participants, in our case co-curators, throughout the process. Facilitation of the process is an important skill in order to help all participants engage in all elements of collaboration. The second component, *value voices from the margins*, includes the disenfranchised. In our work, this includes museum educators engaging in curatorial collaborative work. It may also include community knowledge bearers who are new to exhibition development and, perhaps, may be new to art museum culture itself—which is often perceived as a highly privileged culture. The third component, *center nature*, is a reminder that humans are connected to nature and place. Although we may not consider art museums a natural environment, identity and place-making figure strongly into the culture of the museum and its relationship within the community. The fourth component, *select appropriate methodologies*, focuses on research methods that are pluralist in orientation. Likewise, in museums, pluralist orientations include multiple interpretive perspectives. The fifth component, *bring about social change*, underscores an end goal. In museums, we can impact change as a call for social action through exhibitions, but we can also impact change during exhibition development through the other four components.

We have selected this framework because it necessitates collaboration throughout the research process, which we liken to the curatorial process of exhibition development. The approach and its five guidelines made sense to us as an appropriate and distinct way to examine the evolving role of art museum educators, who were once marginalized during the exhibition development process and whom we now view as empowered collaborators. Here we pair feminist systems theory components with our adaptation, which is

appropriate for considering the art museum as both institution and organizational culture:

Feminist Systems Theory	Adapted Model for Collaborative Visitor-Centered Exhibition Development
Be gender sensitive	Be inclusive and pluralistic
Value voices from the margin	Include voices of the disenfranchised
Center nature	Enhance organizational culture
Select appropriate methodologies	Advance appropriate methodologies
Bring about social change	Bring about social and systemic change

Stephens offered a diagram that may be useful during exhibition planning.[23] We adapted the language for visitor-centered exhibitions in Figure 2.3.

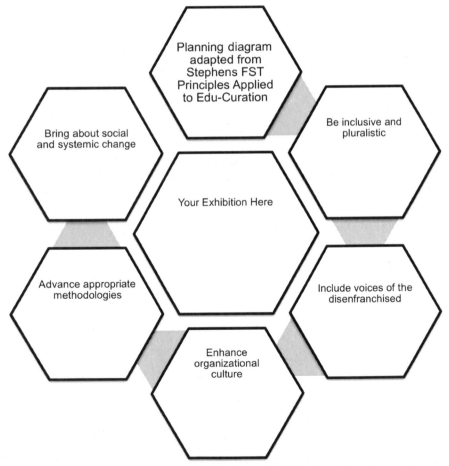

Figure 2.3. Stephens' feminist systems thinking principles adapted to edu-curation.

COLLABORATIVE CURATION AND THE EDU-CURATOR

Feminist systems theory aligns with our practices as researchers, art museum educators, and university professors who train emerging museum practitioners and scholars. Institutionalizing new models of collaboration in art museum exhibition development requires both an understanding of such models and a reconsideration of training approaches to include appropriate content, methods, and leadership skills for collaborative art museum cultures. We share two of our research efforts related to collaborative exhibition development here and introduce our conception for a new, hybrid leader in the field.

Love examined a collaborative exhibition team where the educator and evaluator facilitated collaboration among an art museum's interdepartmental staff and community members.[24] Aligning with a feminist systems thinking orientation, this study included formerly disenfranchised voices (such as the educator, community members, and a noncuratorial staff member) to influence organizational learning through exhibition development. To facilitate teamwork, a collaborative evaluation framework called *evaluative inquiry for learning in organizations* was used.[25] The exhibition development process was organic rather than hierarchical, moving from phase to phase and back again as team members raised questions, explored curatorial identities, and ultimately made collective decisions. Using grounded theory methods, Love articulated an inclusive curatorial model.

Villeneuve's supported interpretation (SI) is another example of collaborative, visitor-centered curation.[26] SI uses a curatorial team comprising representatives from curatorial, education, installation, and other relevant departments along with knowledge-bearing members of the community, valuing disenfranchised perspectives. SI views the exhibition as an interface, or point of interaction between the museum and its visitors. The curatorial team anticipates viewers' needs to know and imbeds diverse learning resources—mostly nontextual and non-authoritarian—in the interface that free-choice visitors may choose from to support their individualized meaning making, facilitating and dignifying inclusive and pluralistic responses.

These collaborative exhibition models, which serve as examples of our adapted feminist systems theory, benefit from a re-envisioned and expanded role for the museum educator. We call the new hybrid process *edu-curation* and its practitioners *edu-curators*. We see edu-curation as a viable alternative to earlier training models that either demanded high degrees of specialization (for the curator) or expected an extensive scope of knowledge (for the educator). Embracing a collaborative approach to curation plays to individual skill sets, relieving team members of the privilege or burden of functioning as sole authority.

Adapted Feminist Systems	The Edu-Curator
Be inclusive and pluralistic	Envisions exhibitions as a nonhierarchical, collaborative process
Include the voices of the disenfranchised	Includes underrepresented voices in exhibition development
Enhance organizational culture	Facilitates collaborative practices and reflection
Advance appropriate methodologies	Conducts visitor-centered research
Bring about social and systemic change	Seek social justice through museum practices

Next, we use the adapted planning guide diagram (Figure 2.4) to provide an example of an exhibition prepared using an edu-curation approach. We

Figure 2.4. Feminist systems thinking planning guide applied to *Waxing Poetic* . . . exhibition at the Figge Art Museum.

analyze *Waxing Poetic: Exploring Expression in Art and Poetry*, focused on permanent collection objects at the Figge Art Museum in Davenport, Iowa.[27] The Figge is the home base of the Western Illinois University-Quad Cities graduate museum studies program. We, the authors of this chapter, participated on one of the first cross-departmental exhibition development teams that also included graduate students and community members. Many art museums, like the Figge, experiment with new approaches to interpreting permanent collections to provide fresh experiences for visitors. A focus on permanent collections also offers an enticing opportunity to invite community partners and exhibition visitors into the process.[28] The outcomes listed in our example show that there may be overlapping outcomes throughout the process.

ESTABLISHING EDU-CURATION

In annual reports from the AAM, such as *TrendsWatch*, published by the Center for the Future of Museums, new ways of working together within both our museums and communities are championed through fresh approaches to defining work, identity, and technology.[29] Edu-curation will require changes to both museum culture and professional preparation. To present collaborative, visitor-centered exhibitions as envisioned by edu-curation, museums will need to transform their organizational structures, breaking down a traditional hierarchy of curatorial prestige and moving functions out of discrete silos. Training future edu-curators and encouraging current museum professionals to work collaboratively will also be an essential part of the culture shift. As we work with our early cohorts of edu-curators at Florida State University, we have found that we need to prepare students for the disconnect they may encounter in the field until the paradigm changes and help them develop skills to act as politicians, mediators, and agents of change.

NOTES

1 Stephens, Anne. *Ecofeminism and Systems Thinking*. New York: Routledge, 2013.

2 Weil, Stephen E. "From Being about Something to Being for Somebody: The Ongoing Transformation of the American Museum," *Daedalus* 128, no. 3 (1999): 229–258.

3 Dobbs, Stephen M., and Elliott W. Eisner. "The Uncertain Profession: Educators in American Art Museums," *Journal of Aesthetic Education* 21, no. 4 (1987): 77–86.

4 El-Omami, Ann. "Educating the Art Museum Educator." In *Museum Education: History, Theory, and Practice*, edited by Nancy Berry and Susan Mayer, 122–134. Reston, VA: National Art Education Association, 1989.

5 Cooper, Yi-Chien Chen. "A Day in the Life: The Qualifications and Responsibilities of an Art Museum Educator." In *From Periphery to Center: Art Museum Education in the 21st Century*, edited by Pat Villeneuve, 68–73. Reston, VA: National Art Education Association, 2007; Ebitz, David. "Qualifications and the Professional Preparation and Development of Art Museum Educators," *Studies in Art Education* 46, no. 2 (2005): 150–169. *Aviso* is a publication of the AAM that contains job postings.

6 Ebitz, "Qualifications," 160. Ebitz later observed that such findings were to be expected, given the training of the curators and directors; Zeller, Terry. "Art Museum Educators: Who Are They?" *Museum News* 63, no. 5 (1985): 53–59.

7 Cooper, "A Day in the Life," 68.

8 Ebitz, "Qualifications," 162.

9 Ibid., 162.

10 Cooper, "A Day in the Life," 68.

11 Van Mensch, Peter. "Methodological Museology, or towards a Theory of Museum Practice." In *Objects of Knowledge*, edited by Sue Pearce, 141–157. London: Athlone, 1990. For a traditional articulation of museum roles and functions, see Alexander, Edward P. *Museums in Motion.* Nashville, TN: American Association for State and Local History, 1979.

12 Hirzy, Ellen Cochran (Ed.). *Excellence and Equity: Education and the Public Dimension of Museums.* Washington, DC: American Association of Museums, 1992.

13 Ibid., 14.

14 Ibid., 15.

15 Falk, J.H., and Lynn D. Dierking. *The Museum Experience.* Washington, DC: Whalesback Books, 1992.

16 Weil, "From Being about Something to Being for Somebody."

17 Wells, Marcella, Barbara Butler, and Judith Koke. *Interpretive Planning for Museums: Integrating Visitor Perspectives in Decision-Making.* New York: Routledge, 2013; Perry, Deborah L. *What Makes Learning Fun? Principles for the Design of Intrinsically Motivating Museum Exhibits.* Walnut Creek, CA: Altamira, 2012.

18 Wells, Butler, and Koke, *Interpretive Planning for Museums.*

19 Perry, *What Makes Learning Fun?*

20 Stephens, *Ecofeminism and Systems Thinking.*

21 Ibid., 8.

22 Ibid., 8.

23 Ibid., 44.

24 Love, Ann R. "Inclusive Curatorial Practices: Facilitating Team Exhibition Planning in the Art Museum Using Evaluative Inquiry for Learning in Organizations." PhD diss., Florida State University, 2013. ProQuest (3596578).

25 Preskill, Hallie, and Rosalie T. Torres. *Evaluative Inquiry for Learning in Organizations.* Thousand Oaks, CA: Sage, 1998.

26 Villeneuve, Pat, and Alicia Viera. "Supported Interpretation: Exhibiting for Audience Engagement," *The Exhibitionist Journal* 33, no. 1 (2014): 54–61. See also chapter 10.

27 Figge Art Museum, http://figgeartmuseum.org/Figge-Art-Museum-(1)/February-2012/Waxing-Poetic--Exploring-Expression-in-Art.aspx.
28 See also Villeneuve, Pat. "Building Museum Sustainability through Visitor-Centered Exhibition Practices," *The International Journal of the Inclusive Museum* 5, no. 4 (2013): 37–50.
29 Center for the Future of Museums. *TrendsWatch*. Washington, DC: American Alliance of Museums, 2016.

BIBLIOGRAPHY

Alexander, Edward P. *Museums in Motion.* Nashville, TN: American Association for State and Local History, 1979.

Center for the Future of Museums. *TrendsWatch.* Washington, DC: American Alliance of Museums, 2016.

Cooper, Yi-Chien Chen. "A Day in the Life: The Qualifications and Responsibilities of an Art Museum Educator." In *From Periphery to Center: Art Museum Education in the 21st Century*, edited by Pat Villeneuve, 68–73. Reston, VA: National Art Education Association, 2007.

Dobbs, Stephen M., and Elliott W. Eisner. "The Uncertain Profession: Educators in American Art Museums," *Journal of Aesthetic Education* 21, no. 4 (1987): 77–86.

Ebitz, David. "Qualifications and the Professional Preparation and Development of Art Museum Educators," *Studies in Art Education* 46, no. 2 (2005): 150–169.

El-Omami, Ann. "Educating the Art Museum Educator." In *Museum Education: History, Theory, and Practice*, edited by Nancy Berry and Susan Mayer, 122–134. Reston, VA: National Art Education Association, 1989.

Falk, J.H., and Lynn D. Dierking. *The Museum Experience.* Washington, DC: Whalesback Books, 1992.

Figge Art Museum. http://figgeartmuseum.org/Figge-Art-Museum-(1)/February-2012/Waxing-Poetic--Exploring-Expression-in-Art.aspx.

Hirzy, Ellen Cochran. (Ed.). *Excellence and Equity: Education and the Public Dimension of Museums.* Washington, DC: American Association of Museums, 1992.

Love, Ann R. "Inclusive Curatorial Practices: Facilitating Team Exhibition Planning in the Art Museum Using Evaluative Inquiry for Learning in Organizations." PhD diss., Florida State University, 2013. ProQuest (3596578).

Perry, Deborah L. *What Makes Learning Fun? Principles for the Design of Intrinsically Motivating Museum Exhibits.* Walnut Creek, CA: AltaMira, 2012.

Preskill, Hallie, and Rosalie T. Torres. *Evaluative Inquiry for Learning in Organizations.* Thousand Oaks, CA: Sage, 1998.

Stephens, Anne. *Ecofeminism and Systems Thinking.* New York: Routledge, 2013.

Van Mensch, Peter. "Methodological Museology, or towards a Theory of Museum Practice." In *Objects of Knowledge*, edited by Sue Pearce, 141–157. London: Athlone, 1990.

Villeneuve, Pat. "Building Museum Sustainability through Visitor-Centered Exhibition Practices," *The International Journal of the Inclusive Museum* 5, no. 4 (2013): 37–50.

Villeneuve, Pat, and Alicia Viera. "Supported Interpretation: Exhibiting for Audience Engagement," *The Exhibitionist Journal* 33, no. 1 (2014): 54–61.

Weil, Stephen. "From Being about Something to Being for Somebody: The Ongoing Transformation of the American Museum," *Daedelus* 128, no. 3 (1999): 229–258.

Wells, Marcella, Barbara Butler, and Judith Koke. *Interpretive Planning for Museums: Integrating Visitor Perspectives in Decision-Making*. New York: Routledge, 2013.

Zeller, Terry. "Art Museum Educators: Who Are They?" *Museum News* 63, no. 5 (1985): 53–59.

Chapter 3

Rethinking Curator/Educator Training and Interaction in the Co-Production of Art Museum Exhibitions

Brian Hogarth

Exhibitions are the primary vehicle through which museums enact their public mission, using space, time, objects or specimens, text, and, increasingly, experiences. If education is at the core of the public mission of museums, then it's reasonable to say that exhibitions are the primary education program that a museum offers. Why then are educators not more directly involved in the conception and planning of exhibitions along with curators? In this chapter, I argue that the problem stems from traditional, discipline-based practices that educators and curators uphold, leading to a division of responsibilities where curators produce exhibitions and educators provide supportive programming. After reviewing the typical backgrounds and training that curators and educators receive, I consider external pressures affecting both professions, such as the call for museums to be more socially inclusive, participatory, and relevant. Increased attention to visitor experience implies a new convergence of curatorial and educational aims and helps to articulate new kinds of skills and training that would support the goals of edu-curation and the co-construction of art exhibitions.

BACKGROUND

How are art museum curators and educators typically generating exhibition content? Traditionally, most art exhibitions were about something first and for somebody second. Curators did research, selected objects, and proposed themes, while educators designed various public services that enhanced those themes, enlivening the exhibition through programs, resources, and tours. Discussions around content might arise, for example, in the development of key messages for the public or when reviewing label copy, but educators were rarely involved in the conception of exhibition content in terms of articulating

likely visitor outcomes. In the traditional exhibition planning model, visitors to art museums were still mostly *recipients* rather than active participants in the exhibition development process.

The curator-driven exhibition model, as it is still practiced in many institutions, reinforces traditional hierarchies, making true collaboration hard to enact. Curatorial work is seen as operating at the level of specialized expertise, whereas education work is envisioned to be a more generalized function associated with schools and focused on broad understanding. Director-level positions are usually filled by former curators, who tend to be male, and not by educators, who tend to be female. This is not to demean the role of education. Rather, any attempt to refashion how exhibitions are developed will have to take present structures and leadership models into account.[1]

Art museums, unlike museums from other disciplines, follow a particular mode of display that isolates and sanctifies the art object, highlighting its aesthetic qualities in largely decontextualized spaces. The visitor experience consists mainly of looking and reading. In such environmental constructs, education acts as a support service, rather than an essential ingredient in the conception of the art experience. As Murphy and Smyth described it, "The museum curatorially constructs the mystery that its education function must then solve for the audience."[2]

Edu-curation offers a compelling vision for a more unified conception of exhibition making, grounded in the assumption that curators and educators *both* generate content and have interests, practices, and standards that are mutually supportive. It assumes that exhibition work is more than the physical manifestation of a single perspective. Pairing curators and educators as equal partners will ensure that the visitor experience plays a more central role in the conception of exhibitions. Enacting such a vision will not be easy, however. It will require both parties to adopt a more iterative, experimental form of exhibition development that will at times be contested, difficult, and challenging.

Two early experiences working on exhibitions of African art impressed on me the importance of bringing together curatorial and educational perspectives along with audience engagement. The first experience consisted of creating a series of public programs for an exhibition called *Into the Heart of Africa*.[3] The programs—lectures, performances, and films—were drawn from local communities and artists of African descent in Toronto and were successfully received. But the exhibition concept, formulated by a singular curator, was misinterpreted by the public and stirred protests and riots. About two years later, I was fortunate to become part of a team that developed a similar exhibit, with a very different message, at the Glenbow Museum in Calgary. The fundamentally different planning processes in each institution yielded substantially different results. The Glenbow team, for example, developed a three-tiered consultation process comprising subject experts, community representatives, and the general public.[4] The absence of one single expert

Figure 3.1. At Glenbow (Calgary, Alberta), West-African community consultants view objects in storage as part of the exhibition development process. *Source:* ©Brian Hogarth, 1992.

Figure 3.2. At Glenbow (Calgary, Alberta), West-African community consultants view objects in storage as part of the exhibition development process. *Source:* ©Brian Hogarth, 1992.

provided the opportunity for a more iterative and layered process of development. Multiple perspectives emerged from a team dynamic of shared ownership and discovery (Figures 3.1 and 3.2).

Simona Bodo called these two modes *essentialist* and *dialogical*.[5] The former is static, consolidated, and transmitted from a primary source. The latter is negotiated, is reconstructed, and shares a common space. The essentialist mode relies on mechanical processes. Specialized departments check in at meetings to ensure that each member of the team is fulfilling specific roles. The dialogical mode encourages team members to share ownership of meaning and co-construct as plans develop. The dialogical team essentially learns together, and the exhibition is the result of that exploration.

UNPACKING THE HISTORY OF CURATOR–EDUCATOR INTERACTIONS

Intrigued by the educator–curator dynamics I had experienced to date, I chaired a panel on educators and exhibition development at the American Association of Museums'(AAM) 1993 conference.[6] The panel focused on ways educators could contribute to the process. Patterson Williams of the Denver Art Museum discussed her concept of the master teacher as a way to build closer ties with curators. Master teachers are senior educators who develop in-depth knowledge in a collecting area and oversee all programming related to that area. The British Museum had a similar structure at that time, with education specialists focused around collection areas.

The question of curator–educator relations, although much discussed, has not been extensively written about. Toohey and Wolins[7] created a list of guiding principles for productive working relationships between curators and educators. Lisa Roberts identified what she called the "murky" areas of educational involvement in exhibitions, for example, what roles educators play in conducting visitor research and who communicates and interprets subject matter. In *From Knowledge to Narrative*, Roberts linked the involvement of educators in exhibition planning with the move away from information toward more visitor-centered learning.[8] A panel of academics discussed curator–educator dynamics in *Issues in Cultural Theory*.[9] They acknowledged the very different agendas of educators and curators but saw no way out of the impasse. Other publications have documented the process by which new galleries were created, in the hopes that something could be learned from the exercise. A good example of this is the Victoria and Albert museum's *The Making of the Jameel Gallery of Islamic Art*.[10]

In nonart museums, for example, at the Academy of Sciences in San Francisco or the American Museum of Natural History in New York, it's

not unusual to find exhibition developer positions whose job is to operate in the space between specialized content and public understanding. The making of science and natural history exhibitions does not always require the direct participation of scientists. Some scientists may choose to focus entirely on research or fieldwork. Others may take an active role, but not necessarily the leading role that curators in art museums usually take.

Art museums have begun to embrace the concept of interpretive planning.[11] Interpretive planning is a holistic approach to thinking about museum reception from the visitors' perspective, resulting in an overall communications strategy to meet those needs. Interpretive planning uses outcomes-based models to clarify what visitors can expect to experience at the museum. Interpretive planning also draws on the long-standing field of interpretation in the parks and heritage sector. Freeman Tilden's six principles of interpretation are still widely adopted in that sector and easily applied to interpretation in the art museum.[12]

Books on exhibition planning and design tend to be either philosophical or more technical ("how-to") in their approaches. The exception is Polly McKenna-Cress and Janet Kamien's *Creating Exhibitions*[13] that outlines exhibition development from the perspective of advocacy (e.g., advocating for the visitor, advocating for the subject, advocating for the design). Each chapter offers examples of successful exhibitions, and there are lengthy quotations from practitioners in each area about their work experiences.

A reasonable assumption today is that some art museum educators are actively involved in exhibition planning teams and others are not. There are educators leading exhibition initiatives. At the same time, there are curators who actively seek advice about responses to exhibition ideas or what questions visitors might have about aspects of an exhibition. Unfortunately, preparation for exhibition work happens mostly on the job, unless one has been trained in an exhibition design program or a curatorial training program. More efforts could be made to study the history and production of exhibitions in the disciplines of art education and art history, as exhibitions are the primary vehicle through which art is publicly presented.

WHAT THE VARIOUS DISCIPLINES PREPARE CURATORS AND EDUCATORS TO DO

A discipline is a unified field of study with its own interests, literature, critical terms, and ways of conducting itself. Few disciplines outside exhibition design adequately prepare students for collaborative work on exhibitions.

Without better preparation, participants in exhibition development teams cling to their disciplinary boundaries and carve out areas of the planning process where they can exert some control. It is natural that conflicts should arise given the added scarcity of resources, space, and time.

The College Art Association's standards and guidelines indicate that aspiring curators should not consider museum studies and curatorial training programs as substitutes for the PhD in art history. Doctoral candidates in art history spend about eight to ten years mastering the content of a specific area, progressively narrowing the field of inquiry until they arrive at a research question that forms the basis for a dissertation. Often, more time is spent pouring over the literature than looking at works of art. Doctorial programs are designed to create further professors, add to the literature, and advance the field. Graduates leave with skills in conducting original research, foreign language, giving lectures, and writing papers. As incoming curators, they must learn additional skills on the job.

Peter Schertz, a curator of ancient art at the Virginia Museum of Fine Arts, provided an overview of curatorial work.[14] He referenced the AAM curator's definition that includes not only caring for collections and forming exhibitions but also fostering community support and generating revenue. While he enjoys working at the intersection between academe and the public, he admits that public work can take time away from conducting original research. His work is distinguished from that of scholars in the university by its emphasis on objects: their acquisition, care, and exhibition.

Robert Storr offered a more contentious view of curatorial work.[15] He vigorously defended the exhibition maker's vision, claiming that nothing should tamper with the integrity of it. Storr abhors design by committee, likening instead the maker's role to a film director who commands respect. Tampering with the maker's reading of the art will lead to incoherence, in his view. The work will speak for itself if properly shown. Storr admitted that meaning cannot be imposed on the visitor, but visitors can become more discerning through exposure to more art.

CURATORIAL TRAINING PROGRAMS

If art and education online notices are any indication, there has been a surge of curatorial studies programs at the graduate level. Many are housed alongside studio production programs and therefore focused more on contemporary art. All tend to emphasize "radical" and "critical" approaches that will be transformative for the student. A long list of faculty and invited speakers, including artists and theorists, ensures a global perspective.

The Bard Center for Curatorial Studies in upstate New York is one such program. Its goal is to "provide a sustained platform for dialogues around curatorial practice as it relates to art and cultural histories and as it attends to and configures possible future endeavors."[16] By contrast, the exhibition studies course at Liverpool John Moores University in the United Kingdom seeks to understand and engage with "worldwide exhibition cultures."[17] The curriculum includes research in contemporary art, design practice, international art, sound and the visual arts, art history, exhibition studies, art and creative technologies, environmental art, and urban architecture. The program claims to prepare graduates for work in design, art, and fashion as well as museums, galleries, and biennials.

The Center for Curatorial Leadership (CCL) program in New York[18] was launched in response to a perceived turning away from curatorial art expertise in favor of business skills when selecting director-level positions. The CCL program is designed to provide advanced training for existing curators and is mostly taught by business school professors from Columbia University. Curriculum includes change management, decision making, managing up, financial management, strategy, negotiation, organizational alignment, leading teams, and governance. There does not appear to be much emphasis on creative and adaptive forms of leadership, co-creation, or planning for greater inclusion, however. Nor are there educational and visitor perspectives. What it does is ensure that curators can claim to be better prepared for director-level positions, at least in their present conception.

EDUCATOR TRAINING

What disciplines do museum educators come from? My own observation, having directed five different museum education departments, leads me to conclude that educators typically come from a mix of art history, art education, teaching in schools, or museum studies. All aspiring educators need to be organized; have an interest in how people learn (formally, informally, and through digital media); be comfortable studying and interacting with visitors of all ages; and be resourceful in terms of institutional dynamics, community collaboration, and funding opportunities.

The scope of museum education work is changing, evolving from a major emphasis on school-related programs to include after-school work with teens, young professionals, families, visitors with special needs, underserved communities, tourists, and the elderly. In terms of on-the-job training for art museum educators and docents, there is a great deal of focus on pedagogical techniques. For example, Visual Thinking Strategies is the current preferred

method among many educators; however, new forms of gallery teaching are actively being pursued, and these practices are being shared through online communities.[19]

Museum education work is typically consumed by the year-round staging of events. Left with little time to rethink exhibition conception, art museum educators tend to reinforce current exhibition models by adapting programs to existing modes of presentation. Alternative models do exist—the galleries at the Denver Art Museum, the Oakland Museum, or the Detroit Institute of Arts are well known. But curators and even directors are known to be dismissive of such efforts. Or they are willing to contain education within defined spaces, such as Gallery One at the Cleveland Museum of Art, which, in this writer's opinion, leaves the permanent galleries in the curatorial mode, unencumbered by educational distractions.

CHANGES TO BOTH PROFESSIONS

Rethinking training for both curators and educators is made even more pressing when we consider a number of external forces impacting the creation of content in museums. For instance, museums are being asked to address issues in broader society and not limit themselves to narrow issues arising from specialized interests. Funders are asking for evidence of greater impact and value to communities. At this time of writing, issues such as Black Lives Matter and the immigration crisis in Europe call out for attention. Can museums act as platforms, as public spaces in which to engage in these matters? Can art museums impact social change? David Fleming, director, National Museums of Liverpool, is adamant that museums attend to the needs of the general public and not just critics, academics, politicians, and vested interests.[20] He faults museum organizations for continuing to be caught up in processes rather than outcomes. The Museum of Liverpool, recently opened on the banks of the river Mersey, does not tell a single narrative, but a kaleidoscope of stories told by many individuals. The public is welcome to propose mini-exhibits through a program called "community curators" with dedicated cases in each of the major galleries. Children's activities are embedded in the galleries, and collections are displayed at lower levels as well as at the more conventional adult level (Figure 3.3). Some of the education staff works in the collections area to encourage cross-disciplinary perspectives.

The digital world has dislodged the authority of any single institution to "own" a subject, given that a vast world of information is now available in the palm of one's hand. New media disrupts the orderly, detached, rational model of the museum in favor of a more transparent, relational model that

Brian Hogarth

Figure 3.3. Case from the "History Detectives" section of the Museum of Liverpool (UK) showing objects displayed for children at lower levels. *Source:* ©Brian Hogarth, 2016.

invites multiple voices and perspectives. Younger generations practice and expect peer-to-peer, open-source ways of communicating and sharing. Amelia Wong[21] says that the implications for museums are that knowledge will be seen as collective and shared. Visitors will expect a more informal, conversational tone. There will be a "commingling of curatorial and audience voices" and less authoritative stances. She adds that dangers also attend these changes, such as misinformation, bias and distortion, the "echo-chamber effect," and a bias toward immediate response rather than deeper contemplation.

The relentless production and consumption of digital information means that future audiences are easily distracted and need help focusing. People look to a new breed of popular "curators" to help them sort and select things from the deluge of information online.[22] Hans Ulrich Obrist, one of the most famous of a new international breed of contemporary art curators, feels that there is now "a fashion for applying the word 'curating' to everything that involves simply making a choice" and that "risks producing a kind of bubble in the value attached to the idea of curating."[23] Obrist recognizes that information and technology are growing and changing at a rate faster than our ability to comprehend it. He feels that artists are in the best position to help us understand what it means to be human in light of such momentous change.

Education as a field is also changing. Popular scholars like Ken Robinson and Tony Wagner[24] envision new models that will replace the current industrial mode of education with its emphasis on universal curricula and frequent testing rather than fostering unique talents of individual learners. Eilean Hooper-Greenhill believes that education still operates under three pervasive myths: that the self is a fixed entity, that explanations have universal significance, and that knowledge stems from established disciplines with predetermined parameters and standards. "Knowledge," she says "is now understood as perspectival rather than universal."[25] Just as education can no longer be fixed to a single agenda, information can no longer be assumed to dwell only in the institution. Identities are "multiple and open to change."[26] The role of the museum educator is therefore to open multiple pathways to self-discovery that include embodied approaches to learning by doing, making, and interacting with others.

The response, in most museum organizations, is to address these developments through "engagement." But despite its growing use in museums, the meaning of *engagement* is not always clear. How is engagement different from interactive or participatory or immersive? Is engagement associated with learning or something different? Who is responsible for engagement? Sorting through these newly assigned terms will be critical for exhibition development as team members will want to know where professional identity, expertise, and responsibility lie, even as work takes on a more interdependent and multiauthored character.

CONTEMPORARY ART CURATION AND THE DISCURSIVE/EDUCATION "TURN"

The art museum world has been steadily shifting in the direction of contemporary art. At the same time, the curator of contemporary art has been moving from organizer to auteur to new discursive or pedagogical models. Such changes signal a growing interest in the intersection between contemporary art and the role of public participation and whether that constitutes a new form of knowledge production. These new modes offer tantalizing ways for curators and educators to work together toward common goals in exhibition development.

One place where this convergence is emerging is in the area of artists working in socially engaged practice. The infusion of social values into art exhibition making can be traced (in part) to Nicholas Bourriaud's concept of "relational aesthetics" (or relational art) that he described as "a set of artistic practices which take as their theoretical and practical point of departure the whole of human relations and their social context, rather than an independent

and private space."[27] Socially engaged artistic practice needn't be confined to the institution or white cube. It can inhabit unexpected locations and act more like events than object-based installations. The spectator can become part of the art work, as in Abramovic's *The Artist Is Present* (2010) where visitors sat and silently communed with the artist at appointed times. A quick glance at recent contemporary art exhibitions in New York City reveals a number of instances where visitor involvement is embedded in the exhibition itself.[28]

Socially engaged practice is also at the heart of New Institutionalism,[29] an attempt to rethink art institutional frameworks and how art is produced. One of its leaders, Charles Esche, wanted to instill questions such as "can art be a useful democratic device."[30] He imagined a place of "knowledge production" that was "part community center, part laboratory, part school and not so much the (traditional) show room."[31] As a movement, New Institutionalism failed to dislodge the established model, but it drew attention to institutional ties to the art market and the relentless "economization of creativity."[32] Esche has maintained an emphasis on rethinking institutional practices in his current position as director at the Van Abbemuseum in the Netherlands. The museum has committed itself to the principle of "usership," offering a "genuine platform for exchange and inspiration."[33] Calling its work "reflexive recuration," the Van Abbemuseum prioritizes viewer engagement and avoids market-driven, linear, art historical frameworks for staging exhibitions.

A recent book edited by O'Neill and Wilson called *Curating and the Educational Turn*[34] identified a curatorial turning toward the use of pedagogical tools as a way to enhance public participation and develop new forms of engagement. How would these ideas be manifested in the making of exhibitions? One example is offered by The Fatima Groups United, a community development organization focused on housing issues in the Rialto area of Dublin. The group imagined a "cultural archaeology" project comprising narratives about the district and its regeneration. At Studio 468 and later at the National College of Art and Design, the collective generated an open space for gathering and collecting stories, media, and imagery in an open, modular studio where content could be "rearranged, contested and edited, thus breaking the idea of the fixed 'do not touch' element of representation" or "the fixed sanctuary of stable content."[35] A further offshoot of the project envisioned the project as an inquiry space, where all the walls were covered with paper, so that its surfaces could be written on, allowing "visual representation and knowledge production (to) come together with modes of conversational inquiry."[36]

A symposium held recently in Denmark proposed that art museums were poised between discursive and immersive modes of presentation.[37] It asked participants to share brief presentations on the potential of art museums as research institutions. If exhibitions were a medium of research, what sort

of knowledge is produced, and by whom? Could research on visitors be embedded within artistic production? Could exhibitions unfold as a series of discursive events rather than a finished product? Could they make better use of sensorial or narrative approaches over the prevalent "visually induced cognitive model"?[38]

WHAT EDUCATORS AND CURATORS CAN DO

While it's helpful to consider new paradigms of exhibition making within certain fields, it is even more critical that new training skills and training opportunities are developed if edu-curation is to take hold.

First, curators and educators must establish an understanding about the broader context for exhibition making—why does the museum present exhibitions and for whom? Put another way, "What, how, and in whose interests will knowledge be produced and disseminated?"[39] Has the museum moved beyond what Tony Bennett aptly described as an "exhibitionary complex" of "show and tell"?[40] Has it embraced a postcolonial mind-set, one that includes perspectives other than that of Western, white, highly educated, urban professionals with an ironic understanding of the world? Have educators and curators (and directors) had a conversation about authority, that no single authority owns (colonizes) the message? Such reframing will be a crucial first step.

How will exhibitions embody the museum's larger social purpose? Does the current mode of exhibition making create barriers to greater public engagement? How does this look from outside the organization? Does the museum welcome diversity by offering a range of modes of interaction, or does it cling to the didactic mode of presentation? Is education offering only "learning" programs? Are educators talking with visitors about their own lived perspectives around art and culture or just from the privileged view of the art museum with its assumptions about art background and appreciation? The point of diversity is not to train visitors around a dominant mode of behavior but to welcome many perspectives and modes of participation. As Tom Freudenheim has said, museums must be sure not to "assert one set of values and operate on another."[41]

New possibilities arising from contemporary curatorial practices could guide our thinking about future training opportunities to support edu-curation. One implication is that reframing exhibitions around the production of visitor experiences effectively unites the functions of curatorial and educational work. How might that work? Socially engaged artistic practice is one possibility. The staging of exhibition work could become more transient and nomadic, moving to the community so that participants can become agents

of co-production and then taking what has developed back into the museum. Education could tone down its eagerness to instruct and work instead on the provision of space, what Mary Jane Jacobs describes as open-minded experiences, giving permission to the visitor to "not know."[42] This would mean placing less emphasis on learning outcomes and goals and leaving more room for discovery and reflection. Andrea Witcomb, speaking at a recent conference at the University of Leicester, spoke of the need for exhibitions that prepare visitors to become strangers, to become someone new. She envisioned exhibitions not where we experience the other, or something different, but where the exhibit gazes on us, so that we (the viewer) become the subject of the display.[43]

What else can educators do? Educators could dial down the machinery of event production to attend to the demands of exhibition making. They could make time to learn more about collections and exhibitions content so they can have productive conversations with curators. As Wendy Woon, director of education at the Museum of Modern Art, has noted, educators are good at synthesizing information.[44] They have to know the whole museum as a subject, whereas curators are trained to zoom in on a particular subject. Edu-curation has to include a conversation about the different ways that each player approaches subject matter.

Curators could spend more time observing how visitors are actually responding to art in the galleries. This means walking through galleries at times other than exhibition openings or when an important funder has requested a tour. Curators need to practice listening to other voices that may seem less important because of a perceived lack of expertise. In addition to curatorial perspectives, more stories about the life histories of objects could be included. Curators need to recognize that most visitors are not conditioned to see objects with the eye of a connoisseur. They are more likely to respond if there are multiple approaches to engaging with works of art. Having more opportunities to do something in galleries—rather than simply reading a label and looking—will actually increase the amount of time visitors spend in galleries. Curators could take a cue from their counterparts in science centers and natural history museums, where in a variety of settings and in different media, experts directly explain to the public what interests them about their work, how science is done, and why it matters in the world today (Figure 3.4).[45]

Another step would be for both parties to review some of the studies that have been done to determine the kinds of values people ascribe to museum visits. One study on *Cultural Value* in the United Kingdom gathered visitor comments into three broad categories.[46] "Active engagement" included such things as evaluating, questioning, comparing, focusing, confronting, changing. "Well-being" included such things as positive and pleasurable feelings, calm, inspiration, feeling alive, uplifted, healed, confident, and energized.

Figure 3.4. In the "Cocoon" at the Darwin Center (Natural History Museum, London) scientists on staff guide the visitor by explaining their interests in exploring, studying, and preserving the natural world. *Source:* ©Brian Hogarth, 2016.

"Connection" included feeling connected to place, other cultures, the personal to the universal, community, difference, national identity, and values. Factors such as these could be used to rework the goals of exhibitions so that they are less about museum outcomes and more about visitor benefits.

Training for teamwork is an issue needing attention in almost any organization. The collective intelligence of teams can be enhanced through greater self-awareness. Teams need to be well put together, with a mix of intelligences, with some who are task oriented and others who excel at relationship building. There should be a mixture of extroverts and introverts. Recent studies suggest that good teams will be skilled at reading nonverbal cues, cultivating an atmosphere of psychological safety where trust and empathy can develop.[47] Another study concluded that the most important team skills were "appreciating others, being able to engage in purposeful conversations, productively and creatively resolving conflicts and program management."[48] Lauri Halderman, senior director of exhibitions at the American Museum of Natural History in New York, deems that team players need more training in emotional intelligence and listening. "When a team works well, there's a lot of mutual respect. Everyone understands the other person's skills are just as essential as your own."[49]

Polly McKenna-Cress, who directs the exhibition design program at the University of the Arts in Philadelphia, recommends training in design thinking.[50] Design thinking is a process that emphasizes empathy and ideation (including brainstorming and prototyping) in addition to implementation. In contrast to how most people think about design—as a later stage in product development—design thinking begins with a people-first approach, seeing how users go about their daily routines, what problems they encounter or challenges they have that a product might address. The crucial next step is to test a concept out in the community, among users, not within an institution. Observe, find out what people think, see how they react to your idea, and then reiterate the plan. The point, according to McKenna-Cress, is for curators and educators to spend more time practicing these techniques in public, outside of the museum.[51]

The problem of disciplinary boundaries could be addressed by designing common working spaces that are conducive to experimentation and interdisciplinary work. Exhibition prototypes could be staged in workshops or laboratory areas open to the public. Education could play a lead role in facilitating the generation of public input in these spaces.

Ultimately it would help if more institutions of higher education embraced interdisciplinary work, to prepare students for team-based projects involving multiple perspectives that they will encounter after graduation. Practitioners already in the workplace would do well to contact the schools where they obtained graduate degrees and indicate what aspects of the training served them well, what did not, and what else is needed now. For example, future iterations of curatorial and educational training programs could include such topics as digital storytelling, conducting oral history, arts and community development work, and co-creation. Continuing education programs could be offered to alumni on topics such as design thinking, collective impact, and project management. There could be sessions on cognitive research, embodied experiences, the use of public space, and gerontology. Curators and educators could visit non-art museums and consider what elements could be borrowed from other disciplines. In general, all academic programs would serve the industry better if there was more assessment based on group work, rather than individual assignments.

CONCLUSION

In this chapter, I have cast a wide net to think about the many factors that can limit and provide opportunities for collaborative work between educators and curators. Rigid adherence to discipline-based thinking will, in the future, only serve to make change that much more difficult. Several examples have been

drawn from outside the field of art museums. My goal has not been to produce a template or specific process or to highlight an individual project but to consider the roles that background training, disciplinary work, and the external environment play when articulating new models of exhibition development. Edu-curation will need to be aligned with the deeper values and goals of the museum and its value to the community if it is to succeed. Exhibition work needs to be seen as a process of construction, not just production. There will be less transmission and more sharing of knowledge. In this way, curators and educators entering the space for exhibition development will approach their work in a spirit of collaboration, experimentation, and inclusiveness and not with trepidation or a fear of crossing borders.

NOTES

1 Shapiro, Michael. *Eleven Museums, Eleven Directors: Conversations on Art and Leadership*. Atlanta, GA: High Museum of Art, 2015. The curator–director model is reinforced in this recent book. Each director talked about important mentors and about his or her grounding in art history and working closely with objects. Only one director—Kaywin Feldman from the Minneapolis Institute of Art—mentioned it will be important for future graduates of art history programs to study not only art but also the impact it has on audiences.

2 Murphy, Ailbhe, and Ciaran Smyth (Vagabond Reviews). "More Bite in the Real World: Usership in Art-Based Research Practice," *ONCurating, After the Turn: Art Education beyond the Museum*, no. 24 (December 2014): 8.

3 *Into the Heart of Africa* was staged at the Royal Ontario Museum, Toronto, in 1989–1990.

4 Hogarth, Brian. "Community Partners," *Glenbow* 14, no. 1 (Spring 1994): 14–15. The Glenbow exhibition was entitled *Where Symbols Meet: A Celebration of West African Achievement*.

5 Bodo, Simona. "Museums as Intercultural Spaces." In *Museums, Equality and Social Justice*, edited by Richard Sandell and Eithne Nightingale, 181–191. London and New York: Routledge Press, 2012, 182.

6 Hogarth, Brian. "External Advocates/Internal Partners: Educators and Exhibit Development." *AAM Sourcebook* Conference Proceedings for the American Association of Museums National Conference, Fort Worth, Texas, 1993. The panelists were Brian Hogarth, Glenbow Museum; John Reeve, the British Museum; Joanne Sparks, Canadian Museum of Nature; and Patterson Williams, Denver Art Museum.

7 Toohey, Jeannette M., and Inez Wolins. "Beyond the Turf Battles: Creating Effective Curator–Educator Partnerships," *Journal of Museum Education* 19, no. 3 (1994): 4–6.

8 Roberts, Lisa C. "Educators on Exhibit Teams: A New Role, A New Era," *Journal of Museum Education* 19, no. 3 (1994): 6–9; Roberts, Lisa C. *From Knowledge to Narrative: Educators and the Changing Museum*. Washington, DC: Smithsonian Institution, 1997.

9 Berger, Maurice. *Issues in Cultural Theory 8*. Santa Fe, NM: Georgia O'Keefe Museum Research Center and University of Maryland Baltimore County Center for Art and Visual Culture, 2004, 156–183.

10 Stanley, Tim, and Rosemary Crill. *The Making of the Jameel Gallery of Islamic Art*. London: Victoria and Albert Museum, 2006.

11 Wells, Marcella, Barbara Butler, and Judith Koke. *Interpretive Planning for Museums: Integrating Visitor Perspectives in Decision Making*. Walnut Creek, CA: Left Coast Press, Inc., 2013.

12 Tilden, Freeman. *Interpreting Our Heritage*. Chapel Hill, NC: University of North Carolina Press, 2008.

13 McKenna-Cress, Polly, and Janet Kamien. *Creating Exhibitions: Collaboration in the Planning, Development and Design of Innovative Experiences*. Hoboken, NJ: John Wiley & Sons, Inc., 2013.

14 Schertz, Peter J. "The Curator as Scholar and Public Spokesperson," *Journal of Eastern Mediterranean Archaeology & Heritage Studies* 3, no 3 (2015): 277–282.

15 Storr, Robert. "Show and Tell." In *What Makes a Great Exhibition?* edited by Paula Marincola, 14–31. Philadelphia, PA: Exhibitions Initiative, 2006.

16 Bard College Graduate Program Online Catalogue, Fall 2013. http://www.bard.edu/ccs/wp-content/uploads/The-Graduate-CatalogueFall2013.pdf.

17 Liverpool John Moores University Exhibition Studies Online Course description. https://www.ljmu.ac.uk/study/courses/postgraduates/exhibition-studies-ma.

18 Center for Curatorial Leadership (CCL) Online Program Description. https://www.curatorialleadership.org/programs/ccl-program/.

19 See, for example, entries concerning new pedagogical practices in the online community of practice site https://artmuseumteaching.com/.

20 Fleming, David. "Museums for Social Justice: Managing Organizational Change." In *Museums, Equality and Social Justice*, edited by Richard Sandell and Eithne Nightingale, 72–83. London and New York: Routledge Press, 2012.

21 Wong, Amelia. "Social Media towards Social Change." In *Museums, Equality and Social Justice*, edited by Richard Sandell and Eithne Nightingale, 281–293. London and New York: Routledge Press, 2012.

22 Balzer, David. *Curationism. How Curating Took Over the Art World and Everything Else*. Toronto: Coach House Books, 2014.

23 Obrist, Hans Ulrich. *Ways of Curating*. New York: Faber and Faber, Inc., 2014, 24.

24 Robinson, Ken, and Lou Aronica. *Creative Schools: Revolutionizing Schools from the Ground Up*. New York: Penguin Books, 2015; Wagner, Tony, and Ted Dintersmith. *Most Likely to Succeed. Preparing Our Kids for the Innovation Era*. New York: Scribner, 2015.

25 Hooper-Greenhill, Eilean. "Education, Postmodernity and the Museum." In *Museum Revolutions: How Museums Change and Are Changed*, edited by Simon Knell, Suzanne McLeod, and Sheila Watson, 367–377. London and New York: Routledge, 2007, 370.

26 Hooper-Greenhill, "Education, Postmodernity and the Museum," 371.

27 Bourriaud, Nicholas. *Relational Aesthetics*. Dijon: Les Presses du Reel, 2002.

28 A recent exhibition to employ viewer participation was Pia Camil's *A Pot for a Latch* in which the artist invited the public to exchange objects hung in the gallery for an object that had personal value and history. See http://www.newmuseum.org/exhibitions/view/pia-camil.

29 See *ONCurating, (New) Institution(alism)*, no. 21 (December 2013) freely available online at http://www.on-curating.org/index.php/issue-21.html#.Vyj2rHDw3fc.

30 Kolb, Lucie, and Gabriel Fluckiger. "We Were Learning by Doing: An Interview with Charles Esche," *ONCurating, (New) Institution(alism)*, no. 21 (December 2013): 24–28. http://www.on-curating.org/index.php/issue-21.html#.Vytj0nDw3fc.

31 Kolb, Lucie, and Gabriel Fluckiger. "New Institutionalism Revisited," *ONCurating, (New) Institution(alism)*, no. 21 (December 2013): 6–15. http://www.on-curating.org/index.php/issue-21.html#.Vytj0nDw3fc.

32 Mader, Rachel. "How to Move in/an Institution," *ONCurating, (New) Institution(alism)*, no. 21 (December 2013): 35–45. http://www.on-curating.org/index.php/issue-21.html#.Vytj0nDw3fc.

33 Smith, Terry. *Thinking Contemporary Curating*. New York: Independent Curators International, 2012, 217.

34 O'Neill, Paul, and Mick Wilson. *Curating and the Educational Turn*. London: Open Editions/Amsterdam: De Appel, 2010.

35 Murphy and Smyth, "More Bite in the Real World," 13.

36 Ibid., 15.

37 "Between the Discursive and the Immersive." A symposium on "Research in 21st Century Art Museums" held December 3–4, 2015, at the Louisiana Museum of Modern Art, Humlebaek, Denmark. Videos from the symposium can be found at http://research.louisiana.dk/.

38 Byvanck, Valenttijn. "Reading the Senses." Speaker abstract for the conference, "Between the Discursive and the Immersive." A symposium on "Research in 21st Century Art Museums" held December 3–4, 2015, at the Louisiana Museum of Modern Art, Humlebaek, Denmark.

39 Lindauer, Margaret, A. "Critical Museum Pedagogy and Exhibition Development." In *Museum Revolutions: How Museums Change and Are Changed*, edited by Simon Knell, Suzanne McLeod, and Sheila Watson, 303–314. London and New York: Routledge Press, 2007, 307.

40 Bennett, Tony. *The Birth of the Museum: History, Theory, Politics*. London: Routledge Press, 1995.

41 Freudenheim, Tom L. "Museum Collecting, Clear Title and the Ethics of Power." In *Ethics and the Visual Arts*, edited by Elaine A. King and Gail Levin, 49–63. New York: Allworth Press, 2006, 59.

42 Jacob, Mary Jane. "Making Space for Art." In *What Makes a Great Exhibition?* edited by Paula Marincola, 134–141. Philadelphia, PA: Exhibitions Initiative, 2006, 140.

43 Witcomb, Andrea. "Responding to the Global Contemporary—Learning to Live with Difference," lecture at the conference titled "Museums in the Global Contemporary: Debating the Museum of Now." University of Leicester, UK, April 20, 2016.

44 Wendy Woon, interview with author, February 24, 2016.

45 One example of this can be seen at the *Q?rius* exhibition at the National Museum of Natural History (Smithsonian) in Washington, DC, designed for all ages to explore how science is conducted, including an open-storage collection area. Another example is the Darwin Center at the Natural History Museum in London, UK. The Darwin Center includes an eight-story cocoon-shaped building that explains what scientists do and the importance of collections to research going on in science today. In addition, there is a small lecture hall where discussions are held about scientific research, and visitors can bring in specimens for identification, which builds interest in local ecological issues. The idea transplanted to art museums would be to showcase more about curatorial, collections, and conservation work and the "people" side of the operation and to talk more about how art museum work is conducted and what motivates interest in art, implying that work in art museums is not secretive or mystifying but is interesting and engaging.

46 The report "Cultural Value. User Value of Museums and Galleries: A Critical View of the Literature" produced by the Arts and Humanities Research Council and the Research Center for Museums and Galleries at the School of Museum Studies, University of Leicester, is available for downloading here: http://www2.le.ac.uk/departments/museumstudies/rcmg/publications/cultural-value-of-museums.

47 Duhigg, Charles. "Group Study." *New York Times Magazine. The Work Issue.* February 28 (2016): 21–26, 72, 75.

48 Gratton, Lynda, and Tamara J. Erikson. "8 Ways to Build Collaborative Teams," *Harvard Business Review* 85, no. 11 (2007): 101–109.

49 Lauri Halderman, interview with author, April 7, 2016.

50 Brown, Tim. *Change by Design. How Design Thinking Transforms Organizations and Inspires Innovation.* New York: HarperCollins Publishers, 2009.

51 Polly McKenna-Cress, interview with author, February 29, 2016.

BIBLIOGRAPHY

Balzer, David. *Curationism: How Curating Took Over the Art World and Everything Else.* Toronto: Coach House Books, 2014.

Bennett, Tony. *The Birth of the Museum: History, Theory, Politics.* London: Routledge Press, 1995.

Berger, Maurice. *Issues in Cultural Theory 8.* Santa Fe, NM: Georgia O'Keefe Museum Research Center and University of Maryland Baltimore County Center for Art and Visual Culture, 2004.

Bodo, Simona. "Museums as Intercultural Spaces." In *Museums, Equality and Social Justice*, edited by Richard Sandell and Eithne Nightingale, 181–191. London and New York: Routledge Press, 2012.

Bourriaud, Nicholas. *Relational Aesthetics.* Dijon: Les Presses du Reel, 2002.

Brown, Tim. *Change by Design. How Design Thinking Transforms Organizations and Inspires Innovation.* New York: HarperCollins Publishers, 2009.

Duhigg, Charles. "Group Study." *New York Times Magazine. The Work Issue.* February 28 (2016): 21–26, 72, 75.

Fleming, David. "Museums for Social Justice. Managing Organizational Change." In *Museums, Equality and Social Justice*, edited by Richard Sandell and Eithne Nightingale, 72–83. London and New York: Routledge Press, 2012.

Freudenheim, Tom L. "Museum Collecting, Clear Title and the Ethics of Power." In *Ethics and the Visual Arts*, edited by Elaine A. King and Gail Levin, 49–63. New York: Allworth Press, 2006.

Gratton, Lynda, and Tamara J. Erikson. "8 Ways to Build Collaborative Teams," *Harvard Business Review* 85, no. 11 (2007): 101–109.

Hogarth, Brian. "Community Partners," *Glenbow* 14, no. 1 (Spring 1994): 14–15.

Hogarth, Brian. "External Advocates/Internal Partners: Educators and Exhibit Development." *AAM Sourcebook* Conference Proceedings for the American Association of Museums National Conference, Fort Worth, Texas, 1993 (no pages).

Hooper-Greenhill, Eilean. "Education, Postmodernity and the Museum." In *Museum Revolutions: How Museums Change and Are Changed*, edited by Simon Knell, Suzanne McLeod, and Sheila Watson, 367–377. London and New York: Routledge, 2007.

Jacob, Mary Jane. "Making Space for Art." In *What Makes a Great Exhibition?* edited by Paula Marincola, 134–141. Philadelphia, PA: Exhibitions Initiative, 2006.

Kolb, Lucie, and Gabriel Fluckiger. "New Institutionalism Revisited." *ONCurating, (New) Institution(alism)*, no. 21 (December 2013): 6–15. http://www.on-curating.org/index.php/issue-21.html#.Vytj0nDw3fc.

Kolb, Lucie, and Gabriel Fluckiger. "We Were Learning by Doing. An Interview with Charles Esche," *ONCurating, (New) Institution(alism)*, no. 21 (December 2013): 24–28. http://www.on-curating.org/index.php/issue-21.html#.Vytj0nDw3fc.

Lindauer, Margaret, A. "Critical Museum Pedagogy and Exhibition Development." In *Museum Revolutions: How Museums Change and Are Changed*, edited by Simon Knell, Suzanne McLeod, and Sheila Watson, 303–314. London and New York: Routledge Press, 2007.

Louisiana Museum of Modern Art, Copenhagen, Stedelijk Museum, Amsterdam, and Aarhus University. "Between the Discursive and the Immersive." Symposium on "Research in 21st Century Art Museums," held December 3–4, 2015. http://research.louisiana.dk/.

Mader, Rachel. "How to Move in/an Institution," *ONCurating, (New) Institution(alism)*, no. 21 (December 2013): 35–45. http://www.on-curating.org/index.php/issue-21.html#.Vytj0nDw3fc.

McKenna-Cress, Polly, and Janet Kamien. *Creating Exhibitions: Collaboration in the Planning, Development and Design of Innovative Experiences*. Hoboken, NJ: John Wiley & Sons, Inc., 2013.

Murphy, Ailbhe, and Ciaran Smyth (Vagabond Reviews). "More Bite in the Real World: Usership in Art-Based Research Practice," *ONCurating, After the Turn: Art Education beyond the Museum*, no. 24 (December 2014): 8–21. http://www.on-curating.org/index.php/issue-24.html#.VytV7nDw3fc.

Obrist, Hans Ulrich. *Ways of Curating*. New York: Faber and Faber, Inc., 2014.

O'Neill, Paul, and Mick Wilson. *Curating and the Educational Turn*. London: Open Editions/Amsterdam: De Appel, 2010.

Roberts, Lisa C. "Educators on Exhibit Teams: A New Role, A New Era," *Journal of Museum Education* 19, no. 3 (1994): 6–9.

Roberts, Lisa C. *From Knowledge to Narrative: Educators and the Changing Museum*. Washington, DC: Smithsonian Institution, 1997.

Robinson, Ken, and Lou Aronica. *Creative Schools: Revolutionizing Schools from the Ground Up*. New York: Penguin Books, 2015.

Schertz, Peter J. "The Curator as Scholar and Public Spokesperson," *Journal of Eastern Mediterranean Archaeology & Heritage Studies* 3, no 3 (2015): 277–282.

Shapiro, Michael E. *Eleven Museums, Eleven Directors: Conversations on Art & Leadership*. Atlanta: High Museum of Art, 2015.

Smith, Terry. *Thinking Contemporary Curating*. New York: Independent Curators International, 2012.

Stanley, Tim, and Rosemary Crill. *The Making of the Jameel Gallery of Islamic Art*. London: Victoria and Albert Museum, 2006.

Storr, Robert. "Show and Tell." *In What Makes a Great Exhibition? edited by Paula Marincola*, 14-31. Philadelphia, PA: Exhibitions Initiative, 2006.

Tilden, Freeman. *Interpreting Our Heritage*. Chapel Hill, NC: University of North Carolina Press, 2008.

Wagner, Tony, and Ted Dintersmith. *Most Likely to Succeed. Preparing our Kids for the Innovation Era*. New York: Scribner, 2015.

Wells, Marcella, Barbara Butler, and Judith Koke. *Interpretive Planning for Museums. Integrating Visitor Perspectives in Decision Making*. Walnut Creek, CA: Left Coast Press, Inc., 2013.

Witcomb, Andrea. "Responding to the Global Contemporary—Learning to Live with Difference," Museums in the Global Contemporary: Debating the Museum of Now. University of Leicester, UK April 20, 2016.

Wong, Amelia. "Social Media towards Social Change." In *Museums, Equality and Social Justice* edited by Richard Sandell and Eithne Nightingale, 281-293. London and New York: Routledge Press, 2012.

Part II

READINESS: STRUCTURING YOUR APPROACH

Chapter 4

From Consultation to Collaboration

Mechanisms for Integrating Community Voices into Exhibition Development

Judith Koke and Keri Ryan

As art museums strive for financial sustainability, they work to build attendance from two pools—new, more diverse audiences and increasing repeat visits from their existing audiences. The New Media Consortium's 2015 *Horizon Report* for museums defined audience building as requiring "both a philosophy and strategy that . . . leverages new modes of communication to make cultural institutions more relevant."[1] Both your new and repeat visitors share a need for relevance. Neither group is likely to attend our museums in significant numbers if the collections and temporary exhibitions are presented in a manner that does not seem connected to ideas and issues they are already considering and leisure needs they have already identified. Museums, having developed largely in a positivist era, continue to seem certain that they know what visitors want to see (or even what visitors *should* see) and how they would choose to experience the art. Gathering public input is often perceived as catering to the lowest common denominator. Yet what other industry develops a product without consulting its target market to inform both the final use and the shape of that product and how it is positioned for maximum appeal? Engaging active and potential audience members in conversations about concepts, exhibitions, and programs does not dilute our expertise—it enhances it. Audiences are the experts in their own interests, their preferences, and their values. Better aligning the themes and ideas that art museums prioritize with what our constituents value can only increase our long-term financial stability and public value.

In entering into different kinds of partnerships with audiences, most museums find themselves considering their position along a continuum of shared authority. On one end are institutions, or staff members, who hold on to a traditional approach where they are certain that they are expert in understanding visitors. At the far end is the position where the institution gives up its role in

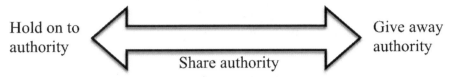

Figure 4.1. A continuum of shared authority.

framing the experience and provides a platform for the community to speak. Currently, most museums are working to find the right location for their institutions or exhibitions along this continuum knowing that to be relevant means there will need to be some degree of authority sharing (Figure 4.1).

This chapter sets out different methods that help to locate an organization on this continuum. The mechanism chosen should respond to the level and kind of input desired and how comfortable an institution feels in sharing authority with its audiences. Whichever form is chosen, the degree of decision-making power offered—from consultation to collaboration—should be clearly articulated at the onset, or participants may be disappointed. The following discussion outlines some frequently used methods and the benefits and challenges they offer. The most important element in doing this work, however, is a true desire and respect for community wisdom.

VISITOR INPUT

One of the most cost-effective and practical ways of engaging visitors in the process of making an exhibition is to invite them to provide input on how your organization will deliver your content. In some cases, this can be formalized in your exhibition development process as part of a formative evaluation, and in other cases, it might be something that you decide to do in response to an issue or challenge you are trying to solve. What both of these approaches have in common is that they are designed to engage visitors at a stage when their voices, opinions, and reactions can still be incorporated into the execution of the project. In any type of consultation, it is fundamental that you engage with participants because you genuinely believe that input will support better decision making—it is not about ticking a box. There are several exhibition elements that can benefit from this type of formative evaluation—exhibition text and prompting questions for visitor engagement, label positioning, and, of course, low-tech and digital interactives.

No matter what you are inviting visitors or users to respond to, there are some common steps to take. Decide if you are doing your research ad hoc—that is, recruiting visitors who are in your museum on the day of the research

to respond to your questions—or by planning to invite your subjects to participate at a designated time. In both ways, it is important to first define the target audience of your exhibition or installation: Is it families with children, young adults, or senior citizens? Recruit participants that represent a range of people in that target segment and bring a multiplicity of perspectives into the conversation about how your content is working in order to manage your own assumptions and cultural baggage. How do you know when you have spoken to enough people? The rule of thumb is that once you reach a saturation level (i.e., you are not hearing any new types of responses), you can feel pretty confident that what you are noticing are not anomalies but patterns.

At the Art Gallery of Ontario (AGO), one of the most common ways that visitors are engaged in the exhibition development process is in the development of exhibition texts. Not only is this a great way to see how well your texts work but it also helps to manage any conflicts that arise within an exhibition team. Typically, the AGO interpretive planner asks anywhere from ten to twenty people to read aloud texts to answer the following questions: "When did they want to stop reading? What most piqued their attention in the text? Were there any words or sentences that a teenager wouldn't understand?" This research takes no more than a couple of hours and has helped in the development of smart and accessible texts.

VISITOR PANELS

A visitor panel is a group of ten to twenty individuals invited to participate in a consultative capacity for an extended period of time. Meeting several times a year, the group comes to know the institution and its programs well and is thus in a strong position to offer input on marketing and program choices, exhibition titles or concepts, and institutional shifts such as hours or membership structure. Although visitor panels tend to work at a high level to cover a broad number of topics, they can work with deeper focus on a specific exhibition and act much like a focus group to test key themes, design choices, and community engagement strategies. The individuals are usually awarded a membership to make frequent visits attractive and to keep abreast of all marketing and PR materials. The benefits of such a group are that its input is based on a deeper understanding of the institution, rather than a newcomer's view. This ensures there are well-informed conversations, fewer suggestions for things you are already doing, and a good sense of the current and nonattending audiences. As this represents a significant commitment on the part of the participant, individuals often receive some sort of remuneration for their time at each meeting. If members are chosen carefully to represent diverse audiences (rather than appointed for development or political reasons), the

group can offer useful and important intelligence on a wide range of topics. However, the institution must be careful not to overgeneralize about single opinions, as individuals are not broadly representative of the diverse communities they embody. Again, aligning planning and scheduling between meetings, department functions, and significant decision moments is key, as the panel's function is to provide input when it can shape decisions, not affirm decisions already made.

LAYERING COMMUNITY VOICES

Even while a museum retains complete authority to define an exhibition's main thesis and direction, it can offer an opportunity for multiple perspectives or voices to be layered into the conversation. Individuals who offer an alternative or additional perspective can be invited to add a label or audiovisual track that is personal, acknowledged, and edited but substantively unaltered by the institution. This might include the addition of student labels in an exhibition designed to attract new audiences, an alternative expert perspective (i.e., theologian or environmentalist), or a member of the general public with a specific personal connection to the show's thesis. Whereas this approach does not share power, it does share space or a platform, and offers the visitor an opportunity to observe that multiple perspectives are welcome, and preexisting knowledge about art history is not essential to building a personal connection with art. This strategy offers an opportunity to connect an exhibition to issues and conversations already at play in the museum's community and supports the audience in understanding how art is relevant and connected to their everyday lives. Aside from the additional time investment required to work with outside contributors, the challenge of this approach can be the reception of this type of knowledge by a traditional audience. The AGO invited members of its exhibition advisory group for *Basquiat: Now's the Time* to write labels as a means to make connections between the themes of Basquiat's work and the experiences of racialized communities today. Although the response to this addition was largely positive, some visitors found these labels superfluous. Indeed, for some, the disruption of the traditional singular voice of authority was hard to take as this shift complicates traditional museum hierarchies and interrupts the authority of institutional narratives.[2]

EXHIBITION ADVISORY GROUPS

According to Nina Simon, one of the reasons that museums might undertake a collaborative project with communities is to engage with experts or

community representatives as a means of ensuring accurate and authentic content in their exhibitions and programs.[3] In this type of approach, it is typical to identify ten to twelve individuals who reflect your target audience or have knowledge of the time period, subject matter, or medium expertise that makes up your exhibition. The group is invited to participate in shaping an exhibition or program. This approach still positions the institution as an authority but opens itself to external perspectives and additional areas of expertise. One of the mistakes that can be made when taking this step is not providing clear goals for the advisory group at the outset of your planning. Getting your invitation and participant list right and knowing why you are inviting these people to the table are critical to the success of an exhibition or program advisory. It is important not to conflate audience development with content development when forming exhibition advisories. This challenge is particularly apparent when planning an exhibition with a goal to reach a new community. The work of audience development is a thoughtful and well-developed strategy for thinking about how to build and grow a museum's audience. In contrast, an exhibition advisory group's purpose is to debate and discuss ideas and themes about an exhibition. Museum leadership will often assume that by inviting representatives from other communities to talk about an exhibition, the advisory group members will also function as ambassadors and bring in new audiences. The process of relationship and community building is very different than exhibition development, underscoring the importance of knowing the original purpose of the group. Although the exhibition development process may naturally contribute to relationships with new audiences, it is important to value the expertise of the advisory group members first and foremost.

In the case of the AGO's advisory group for *Outsiders: American Film and Photography, 1950–1980*, a cross section of diverse film, photography, subject, and audience experts participated in a series of exhibition content development meetings. The AGO engaged the advisory group over the course of the exhibition development process and tested some of the planned interpretive strategies. One of the most important moments for the advisory group came six weeks before the opening of the exhibition, when the team was faced with an unforeseen challenge. In this instance, it was important that the exhibition team already shared the ownership of the exhibition with the advisory group. A solution was identified by bringing the issue, and the institution's vulnerability in that moment, to the advisory group. The AGO benefited from the commitment, knowledge, and thoughtfulness of the group members and ultimately opened a stronger exhibition because of the direction taken after this conversation.

The question of compensation often arises in discussions about advisory groups. Although most people join advisory groups because they respect the organization and are interested in participating in the creative process for

making an exhibition, respect for the participants' time and expertise should be explicit. At the AGO, the museum will provide recognition in the exhibition and dual or family memberships to participants. The museum will also look for opportunities to involve advisory group members in other ways in the exhibition that do offer financial compensation such as, exhibition catalogues, audio tour participants, panelists or moderators in public programs, or even, as mentioned earlier, exhibition label writers.

COMMUNITY MEMBERS AS OFFICIAL MEMBERS OF EXHIBITION TEAMS

The Detroit Institute of Art (DIA) is a leader in the development of visitor-centered exhibition design. Leading up to its collection reinstallation in 2007, it adopted a team-based approach to exhibition making that used cross-disciplinary teams to inform their collection installation projects. The DIA has, for the last several years, worked with advisory groups on its temporary exhibitions, and it wanted to ensure that the permanent galleries benefited from the same approach. The DIA also wanted to create greater connection to, and investment in, these galleries from members of its diverse communities. In order to achieve this, the DIA is inviting community members to apply for, and earn places on, exhibition development teams. The institute is currently piloting this process as it works to reinstall its Japanese galleries. As paid consultants, the selected members join the curator, interpretive planner, research assistant, and exhibitions staff as full-fledged members of the team. The team's charge is to learn the objects, talk together, and let their imaginations fuel as many ideas and stories as they can generate. At the end of the ten-week early-concept phase, the team will produce a list of potential big ideas that will move into the next phases of concept development by the staff team. The DIA's director of interpretation, Swarupa Anila, explained: "If we think about expertise more broadly and inclusively and shift processes so that team members—experts and non-experts, museum staff and museum goers— think about relationships between people, art, and the museum together, perhaps we will find new ways the museum can highlight its collections to serve its visitors and communities in richer, unexpected ways."[4]

EXHIBITIONS AS COMMUNITY PLATFORM

As the demand for more dynamic participation increases, activating traditional exhibition spaces is becoming more frequent, and museums are experimenting with designing exhibition spaces with performance or community

space in mind. Such an invitation provides for the marriage of art forms, supporting music and dance in visual art spaces, or even a more interdisciplinary approach. The Nelson-Atkins Museum of Art invited related community groups to host interactive stations in *Heartland: The Photographs of Terry Evans*, a 2012 photography exhibition that focused on environmental issues. These stations consisted of tables staffed by representatives of those community groups who engaged with the exhibition audience in conversation about environmental issues, distributed their organization's literature, and offered related hands-on activities and opportunities to participate in pro-environmental behaviors and organizations. An additional strategy for community inclusion in the *Heartland* exhibition offered elementary students photography training and an assignment to photograph a specific environmental element over the period of weeks. The exhibition showcased the students' photographs on a large screen at the exhibition entrance when they arrived for their field trip.

For a recent exhibition at the AGO, *Song Dong's Communal Courtyard*, the artist was approached at the inception of the exhibition conversations and asked to consider if the AGO might use the courtyard as a space to invite local artists to take up residence during the run of the exhibition. Song agreed, and local artists and performers were invited to propose residency projects that connected to the theme of the installation, which explored how communal spaces are changed and shaped with the arrival and departure of people over time. Over the five-month-long exhibition, each subsequent artist residency deepened the engagement for visitors to the exhibition and how they looked at and engaged with the installation.

PARTICIPATORY EXHIBITIONS

At the furthest end of the continuum are exhibitions and programming that completely support the visitors' authority. In some ways, this is both the easiest and the hardest place to be on the continuum. For many museums, it is hard to imagine putting the collection, or a gallery, into the hands of non-experts and giving up control. Opportunity often creates the space for these types of projects to emerge, and at the AGO in 2006, it was a building under construction that provided the catalyst to *In Your Face: The People's Portrait Project*. Needing to fill a gallery that couldn't be climate controlled provided an opportunity to invite the public to fill the gallery with their self-portraits. The AGO placed two ads in the national newspaper for the public to submit self-portraits. The only restrictions were that they had to be handmade and be 4 by 6 inches. Over 20,000 portraits arrived and filled the original gallery and spread into a second and then a third. This exhibition enabled visitors to see

themselves in the museum in a way that they had yet to experience with more traditional art gallery exhibitions. The project also injected fun and creativity into the AGO, which was perceived by many as a staid and boring space.

Click!, an exhibition at the Brooklyn Museum of Art, took inspiration from *New Yorker* business and financial columnist James Surowiecki's book, *The Wisdom of Crowds*, in which he asserted that a diverse crowd is often wiser at making decisions than expert individuals.[5] *Click!* began with an open call for artists to submit photographs that responded to the theme "Changing Faces of Brooklyn." The public were invited to assess the photographs online, using a sliding scale from most to least effective, taking into consideration aesthetics, techniques, and relevancy to the theme. Participants were also asked to disclose their knowledge of art and expertise. The top seventy-nine works were installed in the museum's gallery and were printed to a scale that reflected how well they were ranked by the public evaluators as a means to clearly show how the crowd responded.[6]

At the Nelson-Atkins Museum of Art, community members who had been active in civil rights in Kansas City in the 1960s were invited to explore works from across the collection that had been created during that time. In partnership with the Black Archives of Mid-America, individuals recorded their memories of the time (for the archives) and spoke to an artwork that connected them to their experiences. Their spoken responses to the art were transcribed as labels for the exhibition entitled *History and Hope: Celebrating the Civil Rights Movement*, which opened in November 2013. The small exhibition was important to the community as it signified that their experiences, memories, and opinions mattered to the museum.

Working this collaboratively has its challenges. Engaging outsiders in internal processes requires more time and, hence, longer deadlines, and possibly, more funding. Art museums, committed to extremely high production values, are uncomfortable sharing materials when they are still under design, incomplete, or not perfect, in their view. Although invited audiences can be uncomfortably frank with their criticisms and observations, relationships must be sustained, or they will be perceived as tokenism. While shifting the balance might make an institution more relevant to some, it can also disappoint traditional audiences who've come to the museum expecting to learn from "experts."

SHARING POWER

In a swiftly changing society, art museums are eager to build relationships with nontraditional and younger audiences. However, they tend to make these efforts within the framework of working "for visitors"—museum

professionals are experimenting with alternative types of exhibitions, marketing messages, and visitor welcomes. The key to success in diversifying and growing our audiences may in fact be much simpler. These audiences are themselves expert in what they find interesting, relevant, and engaging. Only our commitment to our own professional expertise and authority, combined with long-held definitions of "best practices" in how this work is completed, keeps us from accessing and integrating community wisdom and moving to a framework of working *with* audiences.

In each of the previous examples, the museum had to surrender some level of authority and put some degree of decision-making power into the hands of the visitors. This sharing of power represents a significant shift in how our institutions frame their relationship with their audiences. As well, in each of these approaches, visitors moved into a new relationship with the museum. Their tastes, opinions, and creativity were valued alongside those of in-house expertise. In an age when the selfie is becoming core to the way visitors make meaning, leveraging this desire to see oneself in the museum in the very literal ways described can only lead to deeper relationships and, indeed, a sustainable future for art museums.

NOTES

1 The New Media Consortium. *NMC Horizon Report: 2015 Museum Edition.* http://www.nmc.org/publication/nmc-horizon-report-2015-museum-edition/2015.

2 Quinn, Traci, and Mariana Pegno. "Collaborating with Communities: New Conceptualizations of Hybridized Museum Practice." In *Multiculturalism in Art Museums Today*, edited by Joni Boyd Acuff and Laura Evans, 67–80. London: Rowan & Littlefield, 2014.

3 Simon, Nina. *The Participatory Museum.* Santa Cruz, CA: Museum 2.0, 2010.

4 Swarupa Anila (DIA director of interpretation), in discussion with the authors, June 2016.

5 Surowiecki, James. *The Wisdom of Crowds: Why the Many Are Smarter Than the Few and How Collective Wisdom Shapes Business, Economies, Societies, and Nations.* New York: Doubleday, 2004.

6 "Click! A Crowd-Curated Exhibition," Brooklyn Museum. Accessed April 21, 2016. http://www.brooklynmuseum.org/exhibitions/click/.

BIBLIOGRAPHY

The New Media Consortium. 2015. *NMC Horizon Report: 2015 Museum Edition.* http://www.nmc.org/publication/nmc-horizon-report-2015-museum-edition/2015.

Quinn, Traci, and Mariana Pegno. "Collaborating with Communities: New Concep-
tualizations of Hybridized Museum Practice." In *Multiculturalism in Art Museums
Today*, edited by Joni Boyd Acuff and Laura Evans, 67–80. London: Rowan &
Littlefield, 2014.
Simon, Nina. *The Participatory Museum.* Santa Cruz, CA: Museum 2.0, 2010.
Surowiecki, James. *The Wisdom of Crowds: Why the Many Are Smarter Than the
Few and How Collective Wisdom Shapes Business, Economies, Societies, and Na-
tions.* New York: Doubleday, 2004.

Chapter 5

Dynamic Moments

Testing High-Engagement Visitor Experiences at the Asian Art Museum of San Francisco

Maia Werner-Avidon, Deborah Clearwaters, and Dany Chan

Traditionally, art museum visits have been largely introspective experiences—looking, thinking, listening, reading, and maybe talking quietly. Visitor-centered art experiences aim to add variety and relax the mood in the galleries by activating other senses, providing choices, and offering analog and digital tools that allow visitors to follow their curiosity and share their experiences. At the Asian Art Museum of San Francisco, we value both kinds of experience. To address the latter, we are currently developing new high-engagement exhibits we call "Dynamic Moments" through a collaborative process of prototyping and visitor testing that has transformed our interpretive planning.[1] In this chapter, we share the key findings from this project and offer a glimpse behind the scenes to share our evolving thinking and learning.

THE NEED FOR A NEW APPROACH

Major demographic shifts nationwide are resulting in the growth of populations for whom traditional museums may be unfamiliar. Additionally, societal changes in the way individuals interact and learn mean that many potential arts audiences desire new ways of engaging with artwork. These changes have resulted in a growing "relevance gap" for traditional arts organizations—"a growing divide between their traditional program offerings and the expectations, inclinations, and behaviors of their audiences."[2] Related, the percentage of US adults who visit art museums has been on the decline, from 26.5 percent in 2002 to 21 percent in 2012.[3]

At the Asian Art Museum, we became acutely aware of these challenges during the financial crisis in 2008. But, the crisis had a silver lining. We realized

that in order to continue to grow and thrive, we would need to find a way to bridge this "relevance gap" and bring in new audiences that had not previously been part of our core visitorship. The then-new director, Jay Xu, drafted a new vision for the museum—to spark connections and ignite curiosity, conversation, and creativity. We developed a business plan that documented the need to transform the visitor experience by expanding the building to enhance special exhibitions and reimagining the visitor experience in the collections galleries.

In 2013, to prepare for the reinstallation project, two staff members participated in Stanford University's online Design Action Lab to learn how design thinking, centered on empathy for our customers, could inform our interpretive planning. This online course outlined the five stages of the design thinking process: "empathize: understanding the needs of those you are designing for; define: framing problems as opportunities for creative solutions; ideate: generating a range of possible solutions; prototype: communicating the core elements of solutions to others; and test: learning what works and doesn't work to improve solutions."[4] Around the same time, Xu called for new investments in interpretation and evaluation; he asked educators to collaborate with curators and designers to facilitate interpretive planning and hired our first in-house evaluator.

Two key grants allowed us to step out of our silos and modes of working to grow as an institution and as a cohort of collaborators. A grant from the Andrew W. Mellon Foundation enabled curators, educators, and our exhibition designer to travel together to inspiring museums in Europe and the United States. This short burst of travel bridged the oft-bemoaned curator–educator divide as we discussed what we liked and didn't like at the other museums, over coffee or wine, often surprising each other with our shared values and expansive thinking, while seeing firsthand new interpretive methods that worked and developing a shared vocabulary to talk about them. The strength of the bonds formed outside our museum was directly proportional to the effectiveness of the teams about to dive into the interpretive planning work.

A Museums for America Grant from the Institute of Museum and Library Services (IMLS) is currently supporting this same team of educators, curators, and exhibition designers to work (often in smaller cohorts) with consultants in developing visitor-centered experiences for our soon-to-be-transformed galleries. With these grants secured, we had all the key elements in place to begin to engage in change: leadership from the top, a clear vision of the museum's overall and project-specific goals, funding, and dedicated hours from the team.

A COLLABORATIVE DESIGN PROCESS

At the beginning of our project, we formed an interdepartmental interpretive planning team that was tasked with reimagining the interpretation of the collections. Made up of core curators, three educators, our in-house evaluator, an

exhibition designer, and a registrar, and with guest appearances by conservators and other staff, the group first read background material and defined the scope, goals, and approach of its work. As our museum had little experience with prototyping in our galleries, some members of the team were skeptical about the value of the process and our ability to do it within temporal and financial constraints. This process challenged staff as we struggled with finding the bandwidth to work on these projects, opening ourselves up to a higher degree of ambiguity and accepting the messy creativity of team-developed content. Top-down leadership and committed funding were essential to move through this early phase; doubters had to get on board because the prototyping project had the director's support, and we had an IMLS grant that kept us moving forward.

To get started, the team brainstormed ideas we wanted to try and pared them down based on popularity and feasibility. The leadership was committed to testing exhibition experiences with visitors, but staff had little experience. To help us initiate this work, we hired exhibition development consultant Kathleen McLean to lead us in a workshop on prototyping in our galleries (Figure 5.1). McLean introduced the prototyping concept to our staff, which she defined as "a mock-up or a quick and dirty version of an idea; something

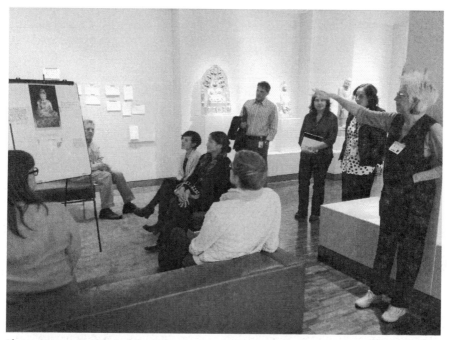

Figure 5.1. Members of the Asian Art Museum's interpretive planning team engage in a prototyping workshop with Kathleen McLean. *Source:* ©Deborah Clearwaters.

flexible and changeable; a tool for learning something about the effects of an idea or object on the end-user (and in the case of museums, the relevance of an exhibit or experience on a museum visitor)."[5] After an intensive day in the galleries with butcher paper and sticky notes, some robust concepts jelled, and we were ready to move forward with developing and testing a slate of new interpretive experiences.

PROTOTYPES

Our goal was to create museum experiences, or Dynamic Moments, that built on current research suggesting that museums can better engage visitors by providing opportunities for active learning and personal agency, rather than through traditional didactic approaches.[6] Our team sought to design experiences that accomplish several goals: are accessible to a range of ages and learning styles, are visually impactful, share and invite multiple perspectives, situate art and ideas into a global context, provide a multisensory or participatory experience, inspire new ways of seeing and thinking, or encourage close looking.

In 2015 and 2016, we engaged in two rounds of Dynamic Moments prototype design and testing (Figure 5.2). We developed and installed the first

Figure 5.2. Installation view of *Prototyping Gallery*, 2016, Asian Art Museum of San Francisco. *Source:* ©Asian Art Museum of San Francisco.

round of prototypes throughout the museum's collections galleries. In the second round, we dedicated an entire gallery space as a prototyping lab for a five-month period.

Through these two phases, we tested a range of types of interpretive experiences

Immersive Experience/Physical Engagement with a Work of Art

We sought to offer ways for visitors to engage with artworks in a physical or kinesthetic way. In one prototype experience, visitors were invited to enter the museum's tearoom and to act as a participant in a tea ceremony, crawling into the space, learning how to sit properly, and handling tea implements. In another experience, visitors were invited to take the position of the Buddha and, by looking at an anamorphic (distorted) photo of the Wheel of Life and Death in a mirror, see how the chaos of the world come into focus for the Buddha at the moment of enlightenment.

Tools and Prompts for Looking Closely

We tested several approaches for helping visitors look closely at works of art (Figure 5.3). Tools and prompts included "deep seeing prompts" (cards or

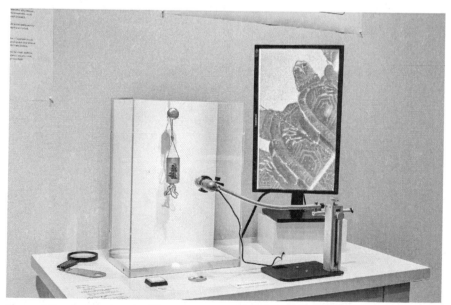

Figure 5.3. In the close-looking prototype, visitors tested different techniques to take a close look at an artwork. *Source:* ©Asian Art Museum of San Francisco.

placards encouraging visitors to find details on specific artworks, such as on the foot of a ceramic bowl); physical tools such as magnifying glasses, digital microscopes, and strategically placed mirrors to look inside or at the bottom of an object; pictorial labels (labels featuring a reproduction of the artwork with arrows calling out specific things to notice); and guided viewing audio stations where visitors listened to a museum curator or educator describe details in a work of art.

Multisensory Experiences Integrating Sound, Smell, and Touch

Some experiences allowed visitors to engage with senses other than sight (Figure 5.4). Experiences included looking at and smelling different types of tea; listening to the raga (a traditional musical mode) depicted in an Indian painting; listening to Buddhist chants associated with different Buddhas depicted on a Himalayan stupa; touching various materials (stone, silk, gold leaf, copper, wood, lacquer, etc.) as part of an experience showing how art objects can be damaged through touch; and handling different types of ceramics (earthenware, stoneware, and porcelain).

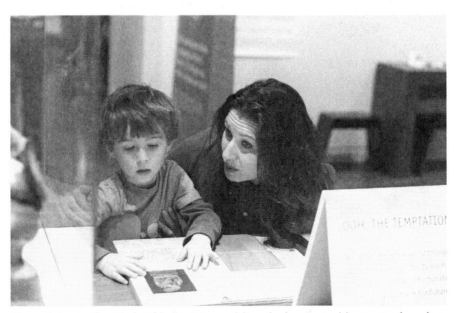

Figure 5.4. In the touch table prototype, visitors had opportunities to touch various materials to learn how art objects can be damaged through touch. *Source:* ©Quincy Stamper.

Contextual Information via Videos and Slideshows

Several experiences provided deeper contextual understanding of an art object by telling a story depicted through an artwork, showing similar objects in context, or simply providing deeper information about the artwork and its importance. Examples included a slideshow of contemporary teahouses and a video showing a traditional Thai dance depicting the story shown on an artwork.

Offering New Perspectives on Artworks

We also designed experiences to provide visitors with opportunities to think about the art from a new and different frame of reference. We experimented with videos, labels, and interactive apps. In one case, a video featured a curator, conservator, and historian talking about the same object. Other prototypes included rotating labels with different perspectives on each side, handwritten labels signed by a conservator, and an interactive iPad app that allowed visitors to learn more about the conservation process by looking at an object in X-ray or UV light and adding layers that highlighted key features of the object that could be seen only in these wavelengths (Figure 5.5).

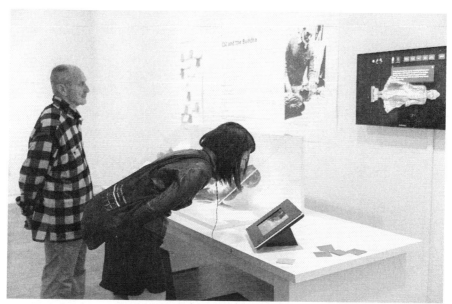

Figure 5.5 The CSI and the Buddha prototype included an iPad interactive to explore techniques used by conservators to study artworks. *Source:* ©Quincy Stamper.

Visitor Response Opportunities via Creative Expression and Feedback Journals

Finally, some of the prototype experiences offered visitors opportunities to share their own ideas and make their own art. We experimented with journals inviting responses to the artwork, as well as more structured opportunities for creative expression (e.g., write a haiku, make a flower arrangement).

EVALUATION METHODS

We used four different methods to gather feedback on the prototypes:

Focus Groups

We recruited specific target audiences to participate in focus groups to give feedback on the prototype experiences. These audiences represented groups that the museum saw as potential growth areas and included families with children aged eight to twelve, young adults (aged twenty-five to forty-four), and school teachers.

Observations

We conducted observations of visitors as they interacted with the prototypes, followed by short interviews about the experience.

Sticky-Note Feedback System

Within the prototyping gallery, there was an unfacilitated feedback system, where visitors could use sticky notes to provide comments on each prototype experience. Near each was a sheet asking visitors to comment on what worked, what didn't, and anything else they wanted to share.

Community Feedback Sessions

We hosted two informal events where representatives from community organizations and other local museums were invited to provide feedback on the prototypes.

EVALUATION FINDINGS

In addition to providing data on the functionality of each individual prototype, the evaluation process resulted in broader understandings of the impact of these types of experiences and the types of interpretive approaches that

visitors found most appealing and effective. Here, we document some of the more broadly applicable findings that resulted from the evaluation.

Finding #1: Visitors Reported That the Prototypes Had Positive Impacts on Their Experience of Looking at Artwork in Several Ways

When asked how the prototypes impacted their experience of looking at the artwork, one of the most frequent comments from visitors was that the experiences slowed them down, allowing them to spend more time and have a deeper engagement with a single work of art. Visitors described the experiences as making them "slow down and think," "go deep," and "be in the moment more." The following statement, made by a participant in a teacher focus group, exemplifies this impact: "To come away with all these different angles and modalities, you really go deep and you really get so much out of it. As opposed to going fast through. . . . So it is powerful. To slow it way down and go deep." Visitors also commented that they looked more closely at the artworks because of the interpretive elements, and this made them appreciate the objects more. In particular, visitors said they noticed details about the objects that they would not have seen on their own or that they looked at the objects from a different perspective that gave them new insights. Visitors also noted that they learned new things or thought about the artworks in new ways. For the team, this finding reinforced the value of these types of experiences and gave us motivation to continue to pursue the goal of offering this type of experience in the museum's galleries.

Finding #2: Not All Interpretive Experiences and Not All Artworks Appeal to All Visitors

Visitors were selective when choosing which activities to engage with, rather than engaging with all the available experiences, and emphasized a desire to have choices about which artworks they wanted to engage with more deeply. They also had clear preferences for how they wanted to engage. Some saw themselves as visual or tactile, rather than auditory, learners; some were not interested in having their experience mediated by technology; some perceived certain activities as being more appropriate for children; and some said the experiences took them too far out of their comfort zones. In general, the idea of being able to choose which activities they wanted to engage with and decide which artworks they wanted to have a deeper experience with was appealing to visitors. One participant in our young adult focus group commented, "It depends if I liked the artwork. I would look at the artwork and then, if that interested me, I would definitely look at everything else around it." This finding emphasized the need to offer a range of types of experiences

and consider how these experiences may be able to be rotated to ensure a fresh visitor experience for repeat visitors.

Finding #3: Visitors Want a Balance of Interactive Experiences with Opportunities to Engage with the Artwork in an Unmediated Way

Visitors generally valued the Dynamic Moments experiences, but they also emphasized that they did not want these types of experiences to overtake the museum. They appreciated the calm and quiet of the museum and didn't want such experiences to take away from that. One participant in our young adult focus group commented,

> I think it's a very different experience when something is showcased as a prize in this box, and everyone looks at it and thinks it's really spectacular, versus this very interactive experiential type of thing. I like both of them, but I think they're very different experiences, and if everything had an interactive aspect, there's a positive to it, but it's also taking away a different type of experience.

In designing new experiences, we must create a balance of these types of interactive experiences with opportunities to engage with the artwork in an unmediated way. We must carefully consider how these experiences integrate and fit with the rest of the museum experience.

Finding #4: Context Is Very Important to Visitors

One of the clearest messages that emerged from the Dynamic Moments protototyping is that we cannot separate objects from their context. Visitors like having different ways to engage with an object, but they also want to know what it was used for, how it was made, and why it is important. Looking closely at an object simply for the sake of looking closely is not enough. We must provide visitors with contextual information about the artwork. As one participant in a young adult focus group eloquently put it, "What does that mean? . . . What does it really tell us about the people who made it or the people who loved it or the people who let it deteriorate?" We must find ways to incorporate this information into the interpretive experiences that we offer to visitors.

Finding #5: Experiences That Explicitly Engaged Visitors in Looking at the Artwork Were More Impactful Than Those That Were More Tangentially Related to the Artworks

Interpretive experiences that directly engaged the visitor in looking at the artwork (what we call "look-up" experiences) were particularly valued. Some visitors felt turned off by experiences that involved looking at photographs

of an object instead of the real object. Similarly, videos were underutilized and generally lower rated, with visitors saying that they felt that they would take them away from looking at the art. As one observed visitor stated, "It's not part of my culture to have videos in museums. I like the object." Engaging visitors with looking closely at the art is a goal that seems to fit with the visitors' own desires and goals for their experiences. This finding has been embraced by our team, as we have made creating "look-up" experiences a core value for our Dynamic Moments experiences.

CONCLUSION

The Dynamic Moments experiments will have lasting impact on the way staff at the Asian Art Museum conducts interpretive planning. The process of prototyping and iterating based on visitor feedback is becoming institutionalized and has become a powerful tool for the museum's transformational goals. In conclusion, we explore the impact of this project on the museum from the perspectives of an educator and a curator.

Prototyping Culture: Impact on the Museum from the Perspective of an Educator

Deborah Clearwaters, Director of Education and Interpretation, Asian Art Museum

Educators pride themselves on speaking for our diverse public audiences, but what makes us so much abler to represent the average visitor than anyone else working at a museum? Sure, we know about educational theory. We've talked to scores of teachers and community leaders about the exhibitions and experiences they want. But we are still insiders, many of us art lovers with art history degrees trying to serve the curious museum goer wandering around the museum, often without much prior knowledge of art. Design thinking, with its grounding in empathy for future users, and practices of prototyping and iteration have become essential tools enabling us to walk a bit in the shoes of our wildly diverse visitors.

These practices, long used in many science museums but not so much in art museums, have brought curators and educators closer together at the Asian Art Museum. Once it is the visitor (rather than the educator) saying, "I'd rather not read all that text right now" or "please explain how this relates to life today," then educators become partners working together with curators on a shared problem, rather than being merely the redundant nags calling attention to the problem.

The changes we are seeing in our museum represent a twenty-first-century museum phenomenon, where content experts from all fields collaborate and

experiment, and multiple perspectives are now considered the norm. The visitor-centered museum can happen if we let it. But it takes time and space and requires a higher tolerance for informality, noise, and mess than we would normally allow in our traditional shrines to art. We are not out of the white box yet, but the walls are getting thinner and a little more transparent.

Prototyping Culture: Impact on the Museum from the Perspective of a Curator

Dany Chan, Assistant Curator for Exhibition Projects, Asian Art Museum

Prototyping has become a valuable forum for communication between curators and visitors. Since it is not possible to speak with each and every visitor to get individual feedback, prototyping provides a structure for presenting an idea and soliciting feedback. Yet, what sets it apart from traditional methods are the iterations: every iteration represents the next part of the conversation. In a way, prototyping has allowed us to open wider the doors of communication with our visitors. As a curator, I find these conversations are indeed helpful in offering some insight into the visitors' experiences and perspectives. Furthermore, these conversations, theoretically, can continue without end—an ideal scenario for the chatty curator. Of course, there are challenges that we are still overcoming: accepting a certain degree of flux ever present in the galleries and prioritizing the commitment of time and resources needed to sustain a thriving prototyping culture in the museum.

The impact of prototyping on curatorial practice and interpretative process is twofold. Curators are encouraged to be more creative and innovative in the ways we tell stories about artworks. Creativity is not only encouraged in curators but also museum-wide, engaging educators, designers, and conservators, allowing for a multiplicity of perspectives through dynamic collaborations between departments. One can say that the possibilities for engaging the visitor have become limitless.

Yet, amid all the excitement to innovate and engage visitors creatively, we have been compelled to articulate a core value—that of ensuring a "look-up" experience for any and all of our Dynamic Moments, so that art comes first. This value was always present but has been brought to the fore to become the foundation upon which all visitor-centered experiences should be built.

NOTES

1 The Dynamic Moments project was made possible in part by the Institute of Museum and Library Services Grant #MA-10–14–0497–14. The views, findings,

conclusions, or recommendations expressed in this chapter do not necessarily represent those of the Institute of Museum and Library Services.

2 Rabkin, Nick, Peter Linett, and Sarah Lee. *A Laboratory for Relevance: Findings and Recommendations from the Arts Innovation Fund.* San Francisco, CA: The James Irvine Foundation, 2012, 27–28. Accessed April 29, 2016, http://interactives.irvine.org/aiflearning/docs/AIF-report-2012DEC3.pdf.

3 Silber, Bonnie, and Tim Triplett. *A Decade of Arts Engagement: Findings from the Survey of Public Participation in the Arts, 2002–2012, NEA Research Report #58.* Washington, DC: National Endowment for the Arts, Office of Research & Analysis, 2015, 17. Accessed April 29, 2016. https://www.arts.gov/sites/default/files/2012-sppa-feb2015.pdf.

4 "Stanford Online Design Thinking Action Lab." Accessed May 19, 2016, http://online.stanford.edu/course/design-thinking-action-lab.

5 McLean, Kathleen. *Museum Exhibit Prototyping as a Method of Community Conversation and Participation.* Report of the Consultancy and Professional Development Program of the American Folklore Society, 2013, 2. Accessed April 29, 2016. http://c.ymcdn.com/sites/www.afsnet.org/resource/resmgr/Best_Practices_Reports/McLean_and_Seriff_Museum_Exh.pdf.

6 Tishman, Shari. "From Edification to Engagement: Learning Designs in Museums," *College Art Association News* 30, no. 5 (2005): 12.

BIBLIOGRAPHY

McLean, Kathleen. *Museum Exhibit Prototyping as a Method of Community Conversation and Participation.* Report of the Consultancy and Professional Development Program of the American Folklore Society, 2013. Accessed April 29, 2016. http://c.ymcdn.com/sites/www.afsnet.org/resource/resmgr/Best_Practices_Reports/McLean_and_Seriff_Museum_Exh.pdf.

Rabkin, Nick, Peter Linett, and Sarah Lee. *A Laboratory for Relevance: Findings and Recommendations from the Arts Innovation Fund.* San Francisco, CA: The James Irvine Foundation, 2012. Accessed April 29, 2016. http://interactives.irvine.org/aiflearning/docs/AIF-report-2012DEC3.pdf.

Silber, Bonnie, and Tim Triplett. *A Decade of Arts Engagement: Findings from the Survey of Public Participation in the Arts, 2002–2012. NEA Research Report #58.* Washington, DC: National Endowment for the Arts, Office of Research & Analysis, 2015. Accessed April 29, 2016. https://www.arts.gov/sites/default/files/2012-sppa-feb2015.pdf.

Stanford. "Stanford Online Design Thinking Action Lab." Accessed May 19, 2016. http://online.stanford.edu/course/design-thinking-action-lab.

Tishman, Shari. "From Edification to Engagement: Learning Designs in Museums," *College Art Association News* 30, no. 5 (2005): 12–13, 41.

Chapter 6

Cu-Rate

Starting Curatorial Collaboration with Evaluation

Ann Rowson Love

As a curator, are you ready for collaboration? Is your museum ready to engage in visitor-centered exhibition making? This chapter is about readiness and preparedness. It is about where and how to start collaborative exhibition teamwork by incorporating evaluation strategies. Cu-Rate is a model, or a tool, that may help you and your co-curators identify assumptions about teamwork, assess strengths, prepare for potential challenges, and rate current practices—all in an effort to build an effective visitor-centered exhibition development team. Cu-Rate helps team members get on the same page, so to speak, to build a comfortable, trusting environment for collaboration. Cu-Rate takes you through components that I have found helpful over numerous years of participating on and facilitating curatorial exhibition teams in art museums. Through conducting exhibition evaluations and research and teaching visitor studies, I articulated this model with input from many team members and by addressing issues that arose during exhibition development with teams made up of interdepartmental museum staff members, community members, and graduate students. This model is based on my own experiences as an exhibition team member and facilitator—there is room for adaptation and refinement based on your exhibition team's experience. Specifically, I hope this model will be helpful for curators and team members based in small- to mid-size museums, where hiring internal or external evaluators is often impractical.

There is some precedence for museum educators to help implement evaluation strategies during the initial stages of planning for visitor-centered exhibitions.[1] But I propose that curators step into an educational evaluative mind-set in order to better prepare for collaborative curatorial

teamwork for exhibition development. Although there are relatively few studies that empirically examine exhibition development teamwork, those that have indicate a need for leveling the playing field toward shared authority.[2] Without intention, shared authority can be undermined when team members, such as interdepartmental museum members or external community members, defer to the expertise of curators on the team.[3] Likewise, a number of studies and evaluations cited that museums new to visitor-centered exhibitions and collaborative exhibition development incorporate evaluators onto teams in order to assist with visitor studies training, help define outcomes for visitor experience in exhibitions, and provide resources for teamwork.[4] Without this assistance, where do you start?

I propose beginning with an evaluative inquiry mind-set.[5] The mind-set for the model Cu-Rate is that of a co-learner. Imagine yourself as a co-learner on a team of co-learners and that your work together is an inquiry. Your team will ask questions, develop overarching themes and outcomes, select objects, and generate interpretive materials for a visitor-centered exhibition, while at the same time reflecting, talking, debating, and dealing with conflict. Curating visitor-centered exhibitions is a co-learning process for the development team. Cu-Rate helps prepare for teamwork anticipating needs and preferences of team members, while also learning about needs and preferences of visitors in your museum. Because Cu-Rate relies on an evaluative inquiry mind-set, the model complements all five tenets of edu-curation as described in chapter 2 of this book: be inclusive and pluralistic, include voices of the disenfranchised, enhance organizational culture, advance appropriate methodologies, and bring about social and systemic change.

READINESS FOR CO-LEARNING: YOUR MUSEUM AS A LEARNING ORGANIZATION

Evaluation reporting from a number of art museums indicated that a commitment to curating visitor-centered exhibitions is more than project-based; it requires support from museum leadership and a rethinking of organizational structure.[6] Before you worry about this being a bigger topic than you and your museum can handle, start rethinking how you develop visitor-centered approaches to exhibition development. This is a good entry point for later thinking about overall museum organization. When you begin by reframing your role as a co-learner, no one individual is responsible for holding or offering sole knowledge in the manner of a traditional, or lone creative, view of curatorial exhibition development. In that model, the ideas

come from one source, the curator, who becomes the teacher to all who visit the exhibition. In fact, if all team members consider themselves co-learners, the burden of a teacher role is diminished and the potential for dialogue with visitors opens.

The following is a compressed version of Preskill and Torres's evaluative inquiry for learning in organizations adapted for visitor-centered exhibition development teamwork (see Figure 6.1). As a curator considers the bigger picture of the museum as a learning organization,[7] the co-learning components—individual and team-based—move cyclically toward applying this learning to your museum organization. You will be on an inquiry journey. In a way, each exhibition team project may inform the museum's overall goal of becoming more participatory and visitor-centered as an

Figure 6.1. Preskill & Torres's evaluative inquiry for learning in organizations condensed/adapted for visitor-centered exhibition development teams.

organization. A learning organization is less hierarchical and more cyclical and inclusive.

In their introduction, Preskill and Torres stated:

> The traditional structures that have given us a feeling of solidity and predictability have vanished. This shift has placed a greater emphasis on the need for fluid processes that can change as an organization and its members' needs change. Instead of the traditional rational, linear, hierarchical approach to managing jobs, which focused on breaking down job tasks and isolating job functions, tomorrow's jobs will be built on establishing networks of relationships. Workers will require listening, communicating, and group facilitation skills to get their work done.[8]

The authors emphasize that organizational structure will be more infused with interdisciplinary teamwork, less boundaries or silos, more innovation and relationship building, and commitment to diversity.

Using Evaluative Inquiry as a Conceptual Frame for Exhibition Development Teams

Stein, Adams, and Luke refer to readiness and preparedness for advancing an evaluation mind-set in the museum as *thinking evaluatively*.[9] Korn stated, "The museum, however, must relinquish some of its power and share it with visitors if visitors are to have significant and memorable experiences."[10] She asserted that using front-end evaluation during exhibition development is a strong starting point for doing this work—power sharing. Similarly, evaluative inquiry advances evaluative thinking. Evaluative inquiry is informed by social constructivist theory that inherently necessitates individual learning in addition to team and organizational learning.[11] There is focus on teamwork during collaborative exhibition development, but there must also be a commitment to individual learning, whereby each team member has the opportunity to study, to share her or his own experience and preferences, and to complete individual tasks. As applied to visitors, a social constructivist approach takes into account that visitors have different preferences for engaging with art and exhibitions. Likewise, evaluative inquiry includes individual learning during preparation for teamwork and throughout the process.

Regarding teamwork facilitation, Preskill and Torres stated, "Although one person may take the initial role of facilitation, it is possible that different team members would also facilitate at various times. Having different people facilitate meetings often strengthens the team's functioning because

no one person is expected to have all the necessary skills."[12] When there are opportunities for different team members to facilitate, usually based on a particular skill like negotiating conflict or making sure all members have the opportunity to contribute to discussion and tasks, team members learn from each other. This takes pressure off of any one individual and helps establish a culture of collaboration—a supportive, safe space for teamwork.

Preskill and Torres also share qualities present in effective and ineffective teams.[13] Effective team members share enthusiasm, creativity, flexibility, accountability, and transparency, among other traits. They are focused in purpose; they trust each other. Ineffective teams, on the other hand, may be unfocused, shirk conflict, lack defined roles for team members, and misuse time and power, among other traits. Ultimately, ineffective teams can lead to ineffective exhibitions.

Applying Evaluative Inquiry to Your Exhibition Team

No one wants to participate in an ineffective exhibition team or produce an ineffective exhibition, particularly when the ultimate goal is a visitor-centered one. Thinking about these ideas before your team comes together may prevent some of the problems faced when developing visitor-centered exhibitions. Based on their findings from analyzing several exhibition team research projects, Mygind, Hällman, and Bentsen found a disconnect between museum organizational culture and invited community members on exhibition teams. Community participants on a team may defer to curatorial voice if they lack the vocabulary of the museum culture or the necessary skills for decision making. The authors asserted, "Proactivity with regard to these matters may evade some challenges in participatory practices and help reach a level of participation intended. A tool such as offering courses in professional terminology and culture appears to be valuable in leveling authority and providing mutual understanding."[14] McCall and Gray, who studied the application of *new museology*, or the reinterpretation of museum functions toward visitor-oriented, participatory practices, in thirty-nine museums in the United Kingdom, likewise found persistence of hierarchy within museums.[15] In addition, they found perceptions among curators that their formerly defined roles were either expanding or getting muddied during the paradigm shift. These findings suggest that an evaluative inquiry model can provide an opportunity for curators to anticipate and address needs and skills prior to teamwork. That is the goal of Cu-Rate.

Cu-Rate Guiding Principles

Catherine Evans, a curator whose museum moved toward team-based exhibition and collection planning using evaluation during that process, stated, "I have come to believe and more fully understand that bringing cross-departmental knowledge, strengths, and questions to the table results in more robust, thoughtful, and dynamic experiences for our visitors."[16] The museum redefined its organizational culture through its teamwork. The curator is not alone in rethinking teamwork and the power of evaluation to inform exhibitions. Pekarik and Mogel also reported that curatorial and interdepartmental team members found observation and other forms of visitor study data collection important to exhibition development.[17] They asserted that the impact on team members when they conducted visitor studies themselves was much stronger than sharing published reports. These are just two museum examples. Additional models that incorporate evaluation throughout the exhibition development process are presented in other chapters of this book.

Cu-Rate is a process for exhibition teamwork framed by evaluative inquiry and incorporates evaluation methods. There are several guiding principles that can be viewed as components. These components do not necessarily need to be sequential; they may be cyclical, adapted, and applied according to your team's needs and preferences throughout the process. Revisiting components aligns with evaluative inquiry for learning in organizations. The following guidelines inform Cu-Rate:

- Understanding that the curatorial process during exhibition development is a creative and collaborative process
- Determining multiple perspectives/voices to include on the team
- Developing a common language or vocabulary
- Examining team roles to empower equal authority
- Assessing individual and team assumptions/assertions about the exhibition ideas and visitor experience
- Applying evaluation tools with visitors
- Analyzing data that influence team-based decision making
- Reexamining team goals based on findings and realigning with visitor perspectives/preferences
- Including opportunities for individual, team, and organizational learning

Cu-Rate takes its name from *curate*, but by rephrasing slightly with the addition of the hyphen, the model's name suggests an evaluative structure. Although these components will more than likely be revisited more than once, I will address them in order in the following section to introduce

guiding questions and example evaluation strategies. I also suggest where in the evaluative inquiry framework each component may be helpful in addressing individual, team, and organizational learning.

TRY IT! CU-RATE MODEL: AN EVALUATIVE TOOL FOR COLLABORATIVE CURATION

Each section that follows introduces one component of the Cu-Rate model. Each is framed by a guiding question, or set of questions, and followed by a potential evaluation activity to assist with teamwork during the development of a visitor-centered exhibition. I suggest how each component may fit into the cycle of organizational learning levels—individual, team, and organization. *Try This! Activities* provide examples of possible cu-rating questions for individual team members.

Understanding That the Curatorial Process during Exhibition Development Is a Creative and Collaborative Process

Before you establish your team for a co-curated and visitor-centered exhibition, spend time doing a little self-reflection. You may want to start an exhibition journal. I often give each team member a journal for self-reflection activities. Later, the journals are potential artifacts that show the process of individual and team learning during exhibition development, if team members consent. Think about these guiding questions:

- In what ways is exhibition development a creative process? On a scale of one to five, how much creativity do I use when I develop exhibitions? Consider one the lowest part of the scale and five the highest. Devise your own descriptors for each level, one through five.
- What are the skills that I can bring to collaborating on a visitor-centered exhibition? What skills do I need to develop? What are the benefits of collaboration?
- What will my team need to get started on this project?

Spending time self-reflecting about creativity and collaboration provides an example of individual learning time (Figure 6.2). These same questions may be useful for your team members when they come together, or perhaps these questions can be asked prior to meeting for the first time. In the past, I created a private blog site or discussion board, where team members could introduce themselves and reflect on these kinds of questions prior to the first team meeting.

Try This! Cu-Rate Your Assumptions about Curatorial Collaboration

How would you rate the level of creativity you'll use in the following exhibition development activities? Click and drag each stem to one of the following categories.

Items	High Level of Creativity
Defining overall exhibition goals	
Gaining visitor input during exhibition development and installation	
Developing outcomes for visitor experience	**Medium Level of Creativity**
Developing a storyline, or narrative, for the exhibition	
Creating a schedule for visitor input	
Selecting objects	
Writing wall text and labels	
Creating interactive interpretation resources	**Low Level of Creativity**
Dealing with disagreements on the team	
Communicating with collectors or other art world representatives	
Installing the exhibition	
Generating checklists, timelines, budgets	

Figure 6.2. Example Cu-Rating form developed in FSU Qualtrics System, individual learning.

Determining Multiple Perspectives/Voices to Include on the Team

If the makeup of the team is up to you to decide, who should participate? Consider diverse perspectives and voices.

• Which museum-based colleagues and/or skill sets across museum departments would be strong team contributors? Begin with those who you know have enthusiasm for this work—visitor-centered exhibitions.
• Are there community members who hold special expertise? How will you gain access to those individuals?

This presents a good opportunity to talk with colleagues to discern their interest in the project and also to consider community member participation. Community members may be knowledge bearers related to the potential content of the exhibition. They may represent community organizations or teach at a local university. They may be a regular visitor to your museum or a nonvisitor, someone who has yet to visit your museum. Team learning may begin as you consider and invite team members.

Developing Common Language or Vocabulary

Before you examine potential team roles, it may be helpful to build a common vocabulary and to develop a set of experiences that will start establishing a team identity and a warm environment with a common understanding of goals. The following questions may assist this team learning component:

• Return to your individual self-reflection. What activities will help the team have a common language?
• Ask all team members to define a visitor-centered exhibition. How will those definitions influence team goals?

This is a good time to ask team members what kinds of training or experiences they might benefit from early in the teamwork (Figure 6.3). Activities may include behind-the-scenes visits to museum collections storage, tours of exhibition-related artist studios and interviews with collectors or other key contributors to the exhibition. They may also include initial training sessions on visitor studies or conducting curatorial research. During past teamwork, I've developed a curatorial file for each team member with common exhibition-related readings and visitor studies methods used for initial discussions.

Try This! Cu-Rate Activities for Team Learning—Select All That Apply

What learning activities will be helpful to our curatorial team?

Overview of exhibition proposal

Introduction to visitor studies methods

Overview of museum visitor learning preferences/identities

Introduction to archival research

[] Other

Figure 6.3. Example Cu-Rating form developed in FSU Qualtrics System, individual learning.

Examining Team Roles to Empower Equal Authority

Developing a common vocabulary may assist with establishing equal authority across the team, but I often also introduce a personality-type activity to examine working style preferences. It is also a good icebreaker for new teams. For many years, I've used *Compass Points*, an activity published by the National School Reform Faculty,[18] which is a short group activity based loosely on the Myers-Briggs test, with only four working preference styles. Each compass point embodies essential roles and skills needed for teamwork including individuals who prefer jumping into work and meeting deadlines; conceptualizing big ideas; attending to fine details; and making sure all group members' voices are heard.

Early on, it may be helpful to brainstorm roles individual team members might prefer fulfilling. Roles may change or evolve throughout the process, but starting where team members are comfortable may be helpful. Other helpful questions to ask team members:

- How comfortable do you feel asserting your voice on the team so far? How can we help each other feel more comfortable?
- What role or roles would you feel most comfortable taking on?

Assessing Individual and Team Assumptions/Assertions about the Exhibition Ideas and Visitor Experience

A team discussion or an individual learning opportunity may include addressing the following:

- What would the ideal visitor experience be like in the exhibition? Does that ideal match what the museum has done before, or is it different?
- How would you rate the museum experience based on your own experience in the museum?

If team members have not had the opportunity to experience permanent collection or special exhibitions in your museum before, an individual learning experience could include Beverly Serrell's judging exhibitions framework.[19] The detailed criteria may assist in common vocabulary development and give team members solitary time in the museum as a visitor. Following this, a team discussion will complete the activity. Even if team members are museum staff members, the activity may offer new insights into the visitor experience in exhibitions (Figure 6.4).

Try This! Cu-Rate Visitor-Centered Practice in Our Museum

How visitor-centered is our museum? (10 = We are hot—at the top of our field; 9 = We are almost there; 8 = We can still work a little; 7 = We're getting there; 6 = We can work more; 5 = We are in the middle, not great, not terrible; 4 = We need to improve; 3 = We have a long way to go; 2 = We need to make changes; 1 = We're just getting started; and 0 = We have no where to go but up)

Figure 6.4. Example Cu-Rating Form developed in FSU Qualtrics System.

Applying Evaluation Tools with Visitors

Once team members have had the opportunity to experience museum galleries or a specific exhibition on their own, it is time to refocus on the museum visitors. A team-learning activity may include addressing questions such as:

- What do we most want to know about our visitors' experience? What method(s) will we use to find out?
- How will we use this information to refine our exhibition goals and visitor outcomes?

Applying evaluation tools in the galleries can be as formal or informal a process as needed or desired by team members. The important thing is to move into the galleries and observe how visitors are engaging with objects, with each other, with spaces, and with additional resources. A formal collection activity could be using a timing and tracking map that follows movements of a visitor around a gallery, where she or he stops, and for how long. An informal activity may just include a few minutes in the galleries when time allows and writing down what's happening there at that particular time. Typical formal evaluation tools include observation, interviews, surveys, and visitor artifacts (such as artwork, written comments, or other visitor-generated materials). All three forms potentially provide insight into visitor preferences. Any one or all of these strategies may be useful to your team. There are many resources to assist the team in deciding upon and implementing strategies.[20]

I've also asked exhibition co-curators to think about creative ways to collect data about museum visitors. Recently, graduate students used social media apps like *1 Second Everyday* to record one gallery space every day at the same time for a month—at the end a 30-second video provides a brief overview of what happened in the space. Identifying popular hashtags for your museum may also give you a glimpse into what visitors are posting on Instagram, Facebook, Twitter, or other platforms. What is or is not posted about your museum exhibitions may be important information for the team.

Later, in your exhibition development, prototype testing of the interpretives you develop will also give you feedback on visitor preferences for labels, wall text, interactives, e-books, among other exhibition resources.

Analyzing Data That Influence Team-Based Decision Making

Whether you or your team members have formal training in data analysis or not, each team member can review what she or he collected and summarize

findings to share during a team meeting. Guiding questions for thinking about individual data may include:

- What, if any, are the overall patterns in the data set? What key words would you use to describe the patterns?
- What did you find or not find that was insightful . . . discouraging . . . exciting?
- What words did you hear most from visitors you interviewed? What were the strongest preferences for _____ (team chooses parameter)?
- What was the most common pattern through the gallery space you observed? Which works of art were most viewed? What was the average amount of time a visitor spent in the exhibition? What kinds of resources were used most (labels, wall texts, handouts, interactive resources, etc.)?

Reexamining Team Goals Based on Findings and Realigning with Visitor Perspectives/Preferences

As in the literature reviewed in the first part of the chapter, incorporating visitor studies or evaluation methods into your exhibition teamwork should provide insightful information about your visitors that you can return to again and again during co-curation. As you develop goals and outcomes for the exhibition, return to findings and/or continue to seek visitor input. Guiding questions for team learning may include:

- What does the team most want visitors to be able to do in and take away from the exhibition (based on what was learned from visitors)?
- What activities will most help visitors experience those goals and outcomes?
- How will visitor preferences help shape the overall theme, narrative, and experiences in the exhibition?
- How will visitors continue to provide input to the team during the entire exhibition development process?

Including Opportunities for Individual, Team, and Organizational Learning

At all moments of individual and team learning through the components discussed earlier, there is also opportunity for organizational learning. Although each exhibition team and resulting exhibition is unique, the process and

artifacts from your team's work will continue to give back to your organization. Take photos, assemble journals or discussion boards, and provide individual and team reflections of the entire process. These are data that you or team members can review and present to the organization. Guiding questions for organizational learning may include:

- What were the key findings we learned about our museum's visitors?
- How did we incorporate visitor preferences into the exhibition? What new or different approaches were used?
- How did these approaches strengthen the exhibition? What were the biggest challenges?
- How can the organization best support this work?
- What impact can this kind of work have on the organization as a whole?

This provides an opportunity for meta-reflection about the process from individual learning, team learning, and directions for organizational learning. Cu-Rate it!

CU-RATING AND CURATING

Does including evaluative inquiry during collaborative and visitor-centered exhibition development sound like a lot of work? Yes. Does this take more time than a traditional model of curation? Yes. Will there be messy problems or conflict during teamwork? Yes. This is not work for the faint-hearted or for the museum with a strong hierarchical organizational structure. This may not be the choice for every exhibition, but the more you collaborate and focus on visitors during exhibition development, the easier the process will become. Cu-Rating will become infused with curating (Figure 6.5).

Now Try This! Cu-Rate This Chapter

How would you rate the effectiveness of this chapter?

Categories	☹	☹	☺	☺	☺	Tell Us Why
Evaluative inquiry makes sense for my museum	○	○	○	○	○	Why
I feel confident that I can co-curate	○	○	○	○	○	Why
I feel confident I can help facilitate collaboration	○	○	○	○	○	Why

Figure 6.5. Survey question developed in FSU Qualtrics System.

NOTES

1 Evans, Catherine. "The Impact of the Participatory Visitor-Centered Model on Curatorial Practice," *Journal of Museum Education* 39, no. 2 (2014): 152–161.

2 Mygind, Larke, Anne Kahr Hällman, and Peter Bentsen. "Bridging Gaps between Intentions and Realities: A Review of Participatory Exhibition Development Teams in Museums," *Museum Management and Curatorship* 30, no. 2 (2015): 117–137.

3 Ibid., 129.

4 Luke, Jessica J., and Jeanine Ancelet. "The Role of Evaluation in Reimagining the Art Museum," *Journal of Museum Education* 39, no. 2 (2014): 197–206; Pekarik, Andrew J., and Barbara Mogel. "Ideas, Objects, or People: A Smithsonian Exhibition Team Views Visitors Anew," *Curator* 53, no. 4 (2010): 465–482; Sikora, Matt, Daryl Fisher, Beverly Serrell, Deborah Perry, and Ken Morris. "New Roles for Evaluation at the Detroit Institute of Arts," *Curator* 52, no. 1 (2009): 45–65.

5 Preskill, Hallie, and Rosalie Torres. *Evaluative Inquiry for Learning in Organizations.* Thousand Oaks, CA: Sage, 1999. An evaluative inquiry mind-set considers each member of a team as a co-learner and the museum or institution as a learning organization overall.

6 Evans, "Impact of Participatory Visitor-Centered Model"; Sikora, et al., "New Roles for Evaluation at DIA."

7 Senge, Peter M. *The Fifth Discipline: The Art and Practice of the Learning Organization.* New York: Doubleday, 2006. Senge, a business management theorist, defined a learning organization. He encouraged organizational leaders to think like learners, designers, and teachers and to think about their organizations as a system. Using teams and design processes, organizations can become stronger, collaborative cultures using systems thinking strategies.

8 Preskill and Torres, *Evaluative Inquiry*, xvii.

9 Stein, Jill, Marianna Adams, and Jessica Luke. "Thinking Evaluatively: A Practical Guide to Integrating the Visitor Voice," *American Association of State and Local History Technical Leaflet*, no. 38 (2007).

10 Korn, Randi. "Studying Your Visitors: Where to Begin," *History News* 49, no. 2 (1994), 24.

11 Preskill and Torres, *Evaluative Inquiry*, 49.

12 Ibid., 31.

13 Ibid., 30, 33.

14 Mygind, Hällman, and Bentsen, "Bridging the Gaps," 129.

15 McCall, Vikki, and Clive Gray. "Museums and the New Museology: Theory, Practice, and Organizational Change," *Museum Management and Curatorship* 29, no. 1 (2014): 19–35.

16 Catherine, "Impact of the Participatory Visitor-Centered Model," 153.

17 Pekarik and Mogel, "Ideas, Objects, or People."

18 "Compass Points." Accessed October 24, 2016. http://www.nsrfharmony.org/system/files/protocols/north_south_0.pdf.

19 Serrell, Beverly. *Judging Exhibitions: A Framework for Assessing Excellence.* Walnut Creek, CA: Left Coast Press, 2006.
20 Diamond, Judy, Michael Horn, and David H. Uttal. *Practical Evaluation Guide: Tools for Museums and Other Informal Education Settings.* Lanham, MD: Rowman & Littlefield, 2016. This is an introduction to museum evaluation methods.

BIBLIOGRAPHY

Diamond, Judy, Michael Horn, and David Uttal. *Practical Evaluation Guide: Tools for Museums and Other Informal Educational Settings.* Lanham, MD: Rowman & Littlefield, 2016.

Evans, Catherine. "The Impact of the Participatory Visitor-Centered Model on Curatorial Practice," *Journal of Museum Education* 39, no. 2 (2014): 152–161.

Korn, Randi. "Studying Your Visitors: Where to Begin," *History News* 49, no. 2 (1994): 23–26.

Love, Ann Rowson. "Inclusive Curatorial Practices: Facilitating Team Exhibition Planning in the Art Museum Using Evaluative Inquiry for Learning in Organizations." PhD diss., Florida State University, 2013. ProQuest (3596578).

Luke, Jessica J., and Jeanine Ancelet. "The Role of Evaluation in Reimagining the Art Museum," *Journal of Museum Education* 39, no. 2 (2014): 197–206.

McCall, Vikki, and Clive Gray. "Museums and the New Museology: Theory, Practice, and Organizational Change," *Museum Management and Curatorship* 29, no. 1 (2014): 19–35.

Mygind, Larke, Anne Kahr Hällman, and Peter Bentsen. "Bridging Gaps between Intentions and Realities: A Review of Participatory Exhibition Development Teams in Museums," *Museum Management and Curatorship* 30, no. 2 (2015): 117–137.

National School Reform Faculty. "Compass Points." Accessed October 24, 2016. http://www.nsrfharmony.org/system/files/protocols/north_south_0.pdf.

Pekarik, Andrew J., and Barbara Mogel. "Ideas, Objects, or People: A Smithsonian Exhibition Team Views Visitors Anew," *Curator* 53, no. 4 (2010): 465–482.

Preskill, Hallie, and Rosalie Torres. *Evaluative Inquiry for Learning in Organizations.* Thousand Oaks, CA: Sage, 1999.

Senge, Peter M. *The Fifth Discipline: The Art and Practice of the Learning Organization.* New York: Doubleday, 2006.

Serrell, Beverly. *Judging Exhibitions: A Framework for Assessing Excellence.* Walnut Creek, CA: Left Coast Press, 2006.

Sikora, Matt, Daryl Fisher, Beverly Serrell, Deborah Perry, and Ken Morris. "New Roles for Evaluation at the Detroit Institute of Arts," *Curator* 52, no. 1 (2009): 45–65.

Stein, Jill, Marianna Adams, and Jessica Luke. "Thinking Evaluatively: A Practical Guide to Integrating the Visitor Voice," *American Association of State and Local History Technical Leaflet*, no. 38 (2007).

Chapter 7

Aligning Authority with Responsibility for Interpretation

Kathryn E. Blake, Jerry N. Smith, and Christian Adame

Representatives from each museum department gather to prepare for an upcoming exhibition. To all appearances, this creates a cross-functional team that will collaborate toward reaching a unified goal. But is this a true sharing of expertise or simply a meeting of discrete functions to make sure everyone is hitting deadlines? Who makes what decisions and how? The answers to those questions have a direct impact on the outcomes of museum work. In turn, those outcomes should support the stated mission. Art museum mission statements have evolved away from an emphasis on "preserve and present" to an emphasis on "educate and engage," yet the organizational structures that determine responsibilities and authorities have done little to eradicate tension between audience-centric and object-centric practices and practitioners.[1] In our experience, factors that influence the definitions of these roles include tradition, inherent bias, training, leadership, and the personal traits of those entrusted with decision making. To become audience-centric in a sustainable way, organizations must reconsider how authority aligns with responsibility, particularly as it affects the roles and relationships of museum educators and curators.

Despite the evolving and deepening emphasis on education, engagement, and experience over the past twenty-five years, few art museums have, by policy or practice, allowed museum educators authority equal to that of curators for the creation of interpretive material in the galleries.[2] When missions emphasized object collection, preservation, and presentation, authority for object choices and arrangement fell to the curator, a content specialist. Now, most art museums include variants and expansions on the term *education* in their mission: engagement, enlightenment, understanding, learning, or experience.[3] Each of these terms focuses on people and their relationship to content, be it object or information. Consequently, most art museums have

some form of an education department that is largely focused on people. However, most education departments are limited in implementing holistic interpretive plans, particularly where it involves written material about objects. Whereas a curator may have been (and may still be) accorded final authority over text, layout, titles, design, and even marketing decisions to achieve an object-centered mission, an educator rarely has similar authority to influence decisions that directly impact an audience-centered mission in these arenas.

This chapter explores the circumstances that subvert equal partnership between educators and curators and the keys to true collaboration. The authors worked together at Phoenix Art Museum, an institution that, as early as 1990, endeavored to strike a balance between curatorial and education in assigning authority over the interpretive process.[4] The senior educator was hired in 1991 into a structure that acknowledged both parity and differentiation of dispositions, skills, and sensitivities between curators and educators. Lead education department staff were "curators"—a deliberate title choice to signal equivalent rank. Education staff held advanced degrees in art history (though not PhDs). Educators were charged with recommending, editing, and sometimes generating interpretive material throughout the museum. They were assigned to exhibition teams and took the lead in conceptualizing interpretive content and programming. Acknowledged as rare, it was based on an oft-stated belief by the then-director that the institution could gain a reputation for innovation in education, even while it might be challenged in collecting. The structure persisted, but its success wavered and was highly dependent on individual personalities. Some curators expressed frustration at perceived slights by educators who wanted to "dumb down" content, while educators struggled to be accepted as equals by "privileged" curators. There was sometimes open, but more often subtle, contention between the two departments. If a curator should seek involvement with educators on anything beyond basic label writing, he or she might be questioned by fellow curators as to allegiance: with "us" or "them." Why has this tension between education and curatorial persisted?

DEFINING EDUCATION AND EXPERTISE

Practically, an organizational chart (and its associated job descriptions) represents authority grounded in expertise and aligned with responsibility. When there is a gap between responsibility and authority, tension often results. Most importantly, definitions of what constitutes education/engagement and what qualifies as expertise—and whether those definitions are shared across the institution and the industry—impact working relationships.

Phoenix Art Museum educators felt fortunate to have responsibility for the gamut of interpretation, including in-gallery written formats, since this function is typically considered the right and responsibility of curatorial staff.[5] Education in art museums remains overwhelmingly equated with facilitated, timed-and-dated programs and youth or school initiatives. But are programs where most museum learning occurs? For eight years the lead educator calculated statistics on program participation against annual attendance. Even assuming that program numbers equaled unique participants, the percentage of those impacted by timed-and-dated programs represented less than 20 percent of visitation. The robust program schedules art museums promote—weekly talks, monthly lectures, films, music, family days, art classes, access programs—require a significant investment of time and resources. This emphasis on programming and exclusion from direct participation in generating written interpretation can mean that the education department is constrained in reaching 80 percent of its potential audience where they are: in the galleries, wandering freely. *Where do most visitors spend the most time? What interpretive method most frequently impacts visitor learning and experience of objects? Who has authority over that process?*

Education is not only the content but also the *process* of facilitating learning, of acquiring or imparting knowledge. Engagement suggests application, personal relevance, and usefulness of information. Facilitated programs can make this process explicit and visible, though it is a misapprehension that the presence of a facilitator (presenter, performer) guarantees engagement and learning. Timed-and-dated programs are attractive not insignificantly because there is something to *count*. How many people attended? How many programs did the museum offer? True or not, high numbers are often considered equivalent to broad impact. However, facilitated programs are not inherently more responsive to audience, more likely to encourage construction or application of knowledge, or more successful in establishing relevance than written interpretation that pays equal attention to process and is always available. Unfacilitated strategies consistently serve visitors where they are. Educators should play a key role in devising methods for utilizing curatorial expertise in ways that provoke direct interaction between viewer and object. Successful interpretive strategies should combine facilitated and unfacilitated methods appropriate to the target audience and desired outcomes, which may viably include acquisition (not only delivery) of factual information as well as content such as skill building or comfort in the museum environment. This is the primary work of museum educators, who have the responsibility for such outcomes. *Why would authority over this work be divided across departments?*

Expertise in teaching, informal learning methods, and environments might logically place educators in a position to define the strategy for all educational

endeavors. Our experience and observation, however, indicates this is not a widely accepted museum practice. The problem may lie in differing (and perhaps changing) value systems for how expertise is acquired and documented, as well as resistance to distributed authority. Over the last thirty years, the museum field has generated a significant body of research and theory about how visitors navigate the museum physically, intellectually, and emotionally. Site-specific evaluation is considered the industry best practice (if not always undertaken) for exhibitions and collection galleries. But atypical is the curator who has investigated or integrated these findings into personal practice. Educators, by training or experience, tend to be more conversant in this body of research. *Who holds knowledge of audience, and does this research, experience, and expertise reach and prevail at the decision-making table?*

Education and curatorial staffs are frequently perceived in ways that parallel perceptions of K–12 teachers and higher education faculty in the public sector. In the K–12 context, teachers are trained, evaluated, and promoted for their skills in the *practice* of teaching, with the assumption that excellent practice increases acquisition of content in students. Museum educators align with K–12 educators; they are content generalists whose specialty is teaching. In art museums, many educators focus their efforts, by choice or policy, in the K–12 realm. When it comes to in-gallery museum teaching targeted to adults, the model shifts. Adult teaching is more aligned with the academic model, where content often supersedes method. James Durston questioned this split between innovative education targeted to children and its dearth aimed to adults in his online article "Why I Hate Museums": "One area in which museums have struck some form of success seems to be with children. . . . But where's the equivalent for adults? Why should over 16 year olds, who still make up the significant majority of museum goers, be subjected to stiff, dry, academia-laced presentations as if fun were a dirty word?"[6] Durston is intentionally provocative, but his observation is largely on target.

Curatorial staff, on the other hand, is the equivalent of faculty in a university context, primarily hired and valued for their content knowledge; most professors have no formal (or even informal) training in the practice of education. In *Excellent Sheep*, William Deresiewicz noted, "The unspoken premise among institutions . . . is that the best scholars make the best instructors. But there is little reason to believe as much, and a lot of reason to believe the opposite."[7] Similarly, few curators are actually trained to be curators, much less educators; the bulk of their education focuses instead on training to be art historians.

When it comes to assigning authority over interpretation in an art museum context, the academic bias most often prevails. Luciano Floridi wrote in *The Fourth Revolution*, "Our Western culture is based on a deeply ingrained Greek divide between *episteme* (science and 'knowledge that'), which is

highly valued and respected, and *techne* (technology and 'knowledge how'), which is seen as secondary."[8] The American Alliance of Museums' document outlining curator core competencies, which attempts to promote collaboration and sensitivity to audience, perpetuates some of these traditional alignments. The section on education that appears at the end of the document largely positions it as programmatic, not interpretive. Museum educators are grouped with "tour leaders and docents," an association that many educators would resist, as those positions are often nonprofessional.[9] The document encourages a collaborative mind-set, but does not suggest curators might accord authority for interpretive strategies to educators in the same way educators grant authority for the object checklist to curators.

In the past, when art museums were object-centered, object-centered competency and authority was fitting. With the switch to missions focused on audience and the visitor experience, however, misunderstanding and undervaluing of skill sets are detrimental. Without a holistic and scaffolded approach to visitor learning in every nook and cranny of the building, the museum loses opportunities to reinforce and build both skills and content knowledge. Without a shared belief that an organization chart represents distributed authority for responsibilities based on *equally valued expertise*, there will always be greater potential for conflict than for collaboration.

TRAINING FOR DISTRIBUTED AUTHORITY

There is an egocentric practice among curators in describing exhibitions as "my exhibition." It is true that a curator may work for years on planning and researching an exhibition, but the enterprise requires the whole of the museum staff to make an exhibition possible. Rarer among curators is the use of the more accurate "our exhibition" that acknowledges distributed authority and expertise. The notion of equally valued expertise is key to supporting edu-curation. So how are curators and educators valued within the museum? It is important to consider both external markers and internal perceptions in understanding relative value. The 2014 American Alliance of Museums (AAM) National Comparative Museum Salary Survey emphasized the perceived value of curators over educators based on degrees acquired through formal education. The survey indicated that 52.7 percent of senior curators have a master's degree and 27.5 percent a doctorate. A higher percentage of education directors have a master's degree (63.9 percent), but only 5.2 percent have doctorates. Seen through the traditional lens of educators as programmers, the chasm widens. Only 35.5 percent of public programs managers have master's degrees, and only 1.4 percent have doctorates. [10] In the United States, a senior curator's median annual salary in 2016 is $27,094 higher

than an education director's.[11] Academic training remains the benchmark and accepted method for acquiring expertise and therefore compensation and authority. While possession of an advanced degree may reasonably impact salary, do experience and value to core mission have an equal impact? *How does training for curators and educators contribute to their perceived value? Does their training support their actual responsibilities and authority?*

FROM FORMAL TO INFORMAL

Curators acquire expertise through academic qualifications and experience of the *object*. Educators acquire expertise through academic qualifications and experience of *audience*. Curators delve deeply into specific areas of art history; they advance scholarship and awareness in the museum field and throughout the art world. While some undergraduate programs may encourage gallery management and practice courses, few art history graduate programs include the everyday nuances of the display of art as part of the curriculum. Practical aspects of spatial relations between objects, for example, or how to lay out and design exhibitions, secure loans, or organize and oversee an exhibition budget are learned on the job, not at the university. Likewise, students of art history and potential curators are trained in scholarly writing, not label copy. Students of art history may be taught how to identify the signs of a "hegemonic discourse" and how to "problematize" various aspects of the visual arts, but are rarely, if ever, asked to consider the visitor experience. The classroom experience is largely removed from direct interaction with the general public.

In the academic environment, lectures and readings of scholarly texts are the most common methods of content delivery. This format can reinforce passivity and authoritative voice, thus it should be no surprise when these academic experiences carry over into the museum context.[12] Curator-generated texts often reflect in tone academic art-historical training. Even the term *didactic* denotes an idea to be taught and to be received. A museum is not a classroom, however, nor are visitors students in an academic context. "Much contemporary art-writing remains barely comprehensible," according to Gilda Williams. However, she posits: "The cause of much bad art-writing is not so much pretentiousness, as is commonly suspected, but a lack of training."[13] *When academic environments foster deep research and expertise, where are they assisting curators with effective communication to the target audiences their institutions hire them to serve?*

Similar inconsistencies exist in museum education. The academic track into museum education often happens via the K–12 classroom (many art history undergraduates are not introduced to museum education as a field

of practice). Art education programs also focus deeply within the formal learning environment. While these educators receive meaningful training in academic standards, teaching methodologies, education theory, and learning styles, they gain the majority of their experience in mediated settings, not in the free-choice spaces of museums. Formal programming (lectures, panel discussions, performances, films, etc.) has driven hiring and job responsibilities. This pattern has limited "bridge-building" positions that apply educational theory and audience knowledge to curatorial content within galleries.

Museums are places of leisure and largely unmediated inquiry. Educators acquire expertise through watching, interacting with visitors, studying evaluations, and experimenting. Every interaction is unique, even if it falls within an understood framework, because it involves individuals. It is difficult for educators to demonstrate deep audience knowledge in a definable way. Documenting impact or learning in an informal context is almost prohibitively challenging for resource-strained institutions unable to regularly afford professional evaluation staff. Educators may have personal portfolios of work—gallery guides, program listings, interpretive strategies—but these don't capture the essence of their work in a permanent way, nor do they distribute it widely as an exhibition catalogue or review can. It may be that there is a systemic bias against experience and expertise that seems so ephemeral and poorly documented. Bias of this sort on the part of supervisors or peers can undermine the best organizational chart.

Content knowledge is crucial for learning, but *how* the learning happens and *how* knowledge is applied often prove more meaningful for visitors long term. Yet museum structures still position content over interpretive strategy. Where museum educator roles are skewed to live programs, the educator skill set can be perceived as a logistics-driven event organizer, not a purveyor of original content. Original content is still equated with the art object itself, not the social experience of it. The interpretation of art, as well as creating the conditions for self-directed learning, is, in fact, its own layer of content, one anchored in the object but made visible through audience. In a sense, educators view all interpretation as relational aesthetics, to borrow a curatorial term.

HIRING THE EDU-CURATION MIND-SET

Curators and educators gain their true training within the museum environment, and the practical aspects of day-to-day museum work remain largely unknown until actually hired.[14] The opportunities to learn collaboratively are present. The core competencies for curators acknowledge this on-the-job necessity. Educators, accorded the appropriate value of their expertise, can

serve as mentors for curators, just as curators deepen educators' understanding of the potential of objects. As Rika Burnham and Elliott Kai-Kee stated, "Curatorial research remains the critical foundation of museum education. But in the museum of the future, educators move from the periphery to the center. . . . They lead the department, define its philosophy and mission, and overturn the historical definition of teaching as a peripheral, volunteer, or entry-level activity."[15] In the edu-curation model, educators gain parity with curators, hybrid positions blend the skill sets of both tracks, authority is distributed, and the professional development of staff happens on the job. Foremost, the edu-curation relationship is marked by mutual respect and trust. Kaywin Feldman, the Duncan and Nivin MacMillan director and president of the Minneapolis Institute of Art (Mia), described a personal experience in hiring those interested in working collaboratively. In a search for a new curator, Feldman recounted walking through galleries with a candidate at their home institution. "I noticed that this person ignored every security guard. The guards were used to being ignored by this person, and they made no contact. I decided not to hire the person because I don't want people like that working at our museum."[16] Feldman's decision was not based on ability or achievements, but on interpersonal skills, which are vital for collaborative practices. *Does the museum hire people willing to learn and to share authority?*

IN PRACTICE

What does it look like when education and curatorial are balanced in the organizational chart, and authority aligns with responsibility? Phoenix Art Museum staff experienced an unusual confluence of exhibitions in spring 2015 that exemplified respect, as well as shared understanding of terms, responsibilities, and authorities. A single curator—and specialist in American Modernism—was assigned to both *Leonardo da Vinci's Codex Leicester and the Power of Observation* and *Andy Warhol: Portraits* that ran simultaneously. Both were traveling exhibitions of significant size, and both included a bulk of material from outside the curator's expertise. The resulting collaboration with the educators (the authors involved in this chapter) proved exemplars of edu-curated exhibitions. Research and label writing was *shared* between departments. There was honest discussion, even impassioned debate, about approaches to information. There was give-and-take on all aspects of the exhibitions that ranged from didactic material, to exhibition layout and wall-color choices, to selective rather than prolific programming. Interpretation was conceived holistically: label content influenced label format influenced in-gallery activities influenced timed-and-dated programs. Close to deadline, discussing educator-written and designed labels, the curator said, "I don't like the approach myself, but I trust your reasoning." While collaboration is key,

ultimately someone has to make a decision. The curator accorded authority for the educational strategy to the educator; the educator relied on the knowledge of the curator to vet for accuracy and context. The mutual respect for professional expertise generated work that was well received by visitors and was highly rewarding personally, professionally, and institutionally.

The key to success for edu-curation must begin with the organizational structure of the museum. The organizational structure establishes responsibilities in the collaborative process but is supported by professional value for proficiency that legitimizes authority assigned to those responsibilities and rewards it comparably. A museum's success in achieving an audience-centric mission then will be appropriately perceived as the product of many skills, developed differently but valued equally.

NOTES

1 American Alliance of Museums. "Developing a Mission Statement." Accessed June 1, 2016, http://aam-us.org/docs/continuum/developing-a-mission-statement-final.pdf?sfvrsn=2. Regarding continued tension, the session "Insiders and Outsiders" at the AAM Annual Meeting, May 28, 2016, began with a skit presenting the disjunction between staff's "meeting behavior" and private opinion about roles in a team.

2 Schaffner, Ingrid. "Wall Text." In *What Makes a Great Exhibition*, edited by Paula Marincola Paula, 154–167. Philadelphia, PA: Philadelphia Exhibition Initiative, 2006. http://ingridschaffner.com/2013/06/wall-text-what-makes-a-great-exhibition/. Schaffner's essay on label writing notes that she never spoke to a museum where educators wrote wall text, "but there were rumors."

3 Fischer, Daryl, and Lisa Levinson. "Redefining Successful Interpretation in Art Museums," *Curator* 53, no. 3 (2010): 299–323. Patterson Williams describes the changing meanings of the word *learning*.

4 Other institutions have explored unique organizational structures to assign authorities and eliminate silos. For instance, see the Oakland Museum of California's Organizational chart at http://museumca.org/sites/default/files/OMCA%20Org%20Chart%20072016.pdf.

5 Some museums have "content strategists." See Minneapolis Institute of Art website http://collections.artsmia.org/curators.

6 Durston, James. "Opinion: Why I Hate Museums,"CNN. August 22, 2013. Accessed April 15, 2016. http://www.cnn.com/2013/08/22/travel/opinion-why-i-hate-museums/.

7 Deresiewicz, William. *Excellent Sheep: The Miseducation of the American Elite.* New York: Free Press, 2014, 183–184.

8 Floridi, Luciano. *The Fourth Revolution: How the Infosphere Is Reshaping Human Reality.* Oxford: Oxford University Press, 2014, chapter 3, Kindle edition. Floridi argues for balance between types of knowledge.

9 American Alliance of Museums Curators Committee. "Curator Core Competencies," *American Alliance of Museums*, 2015. Accessed April 15, 2016. http://www.

aam-us.org/docs/default-source/professional-networks/curator-core-competencies. pdf?sfvrsn=2.

10 American Alliance of Museums and New Knowledge Organization, Ltd. *2014 National Comparative Museum Salary Survey.* Washington, DC: American Alliance of Museums, 2014.

11 Association of Art Museum Directors. *2016 Salary Survey.* New York: Association of Art Museum Directors, 2016.

12 The disconnect between training and job responsibilities was raised during an AAM Annual Meeting session *Fail Early, Often and Off-Broadway* on May 20, 2014, presented by Kaywin Feldman, Brian Kennedy, and John Wetenhall.

13 Williams, Gilda. *How to Write about Contemporary Art.* London: Thames & Hudson, Ltd., 2014, 10.

14 The curatorial partner in this chapter, Jerry N. Smith, looked at involvement with educators and the exhibition designer, David Restad, as a survival tactic. He stated, "Were it not for my time working with Kathryn, Christian, and others in the education department, as well as with David, I would not have the curatorial skills I have today. Collaboration proved the most practical and enjoyable choice I could make."

15 Burnham, Rika, and Elliott Kai-Kee. *Teaching in the Art Museum: Interpretation as Experience.* Los Angeles, CA: The J. Paul Getty Museum, 2011, 152.

16 Kaywin Feldman, quoted in Shapiro, Michael E. (Ed.) *Eleven Museums, Eleven Directors: Conversations on Art and Leadership.* Atlanta, GA: High Museum of Art, 2015, 42.

BIBLIOGRAPHY

American Alliance of Museums. "Developing a Mission Statement: Reference Guide." *American Alliance of Museums.* 2012. http://aam-us.org/docs/continuum/developing-a-mission-statement-final.pdf?sfvrsn=2.

American Alliance of Museums and New Knowledge Organization, Ltd. *2014 National Comparative Museum Salary Survey.* Washington, DC: American Alliance of Museums, 2014.

American Alliance of Museums Curators Committee. "Curator Core Competencies." *American Alliance of Museums.* 2015. http://www.aam-us.org/docs/default-source/professional-networks/curator-core-competencies.pdf?sfvrsn=2.

Association of Art Museum Directors. *2016 Salary Survey.* New York: Association of Art Museum Directors, 2016.

Burnham, Rika, and Elliott Kai-Kee. *Teaching in the Art Museum: Interpretation as Experience.* Los Angeles, CA: The J. Paul Getty Museum, 2011.

Deresiewicz, William. *Excellent Sheep: The Miseducation of the American Elite.* New York: Free Press, 2014.

Durston, James. "Opinion: Why I Hate Museums." August 22, 2013. http://www.cnn.com/2013/08/22/travel/opinion-why-i-hate-museums/.

Fischer, Daryl, and Lisa Levinson. "Redefining Successful Interpretation in Museums," *Curator* 53, no. 3 (2010): 299–323.

Floridi, Luciano. *The Fourth Revolution: How the Infosphere Is Reshaping Human Reality.* Oxford: Oxford University Press, 2014.

Schaffner, Ingrid. "Wall Text." In *What Makes a Great Exhibition*, edited by Paula Marincola, 154–167. Philadelphia, PA: Philadelphia Exhibition Initiative, 2006.

Shapiro, Michael E. (Ed.). *Eleven Museums, Eleven Directors: Conversations on Art and Leadership.* Atlanta, GA: High Museum of Art, 2015.

Williams, Gilda. *How to Write about Contemporary Art.* London: Thames & Hudson, Ltd., 2014.

Part III

COLLABORATION IN ACTION

Chapter 8

Beyond the Gate

Collaborating with Living Artists to Bring Communities into the Museum and the Museum into Communities

Maureen Thomas-Zaremba and
Matthew McLendon

John and Mable Ringling founded their museum in Sarasota, Florida, with the intention that it would provide educational experiences to all museum visitors and be a resource for the community.[1] Coming from economically modest backgrounds, both of The Ringlings remained mindful of the privileges that were available to them given their wealth and status. The creation of a public museum gave them the ability to offer the benefits of a broader education to a large population. Today's education and curatorial departments at The Ringling continue to build on this tradition. As The Ringling has grown, these departments have embraced the opportunities that new venues and collections have provided: an historic home, acres of grounds and gardens, the history of the circus arts, modern and contemporary performance art and architecture, and, most recently, the art of Asia.

While education and curatorial have built on the past, we have looked to the present and the future and have embraced the evolving nature of museum interpretation. Programming is viewed at The Ringling as the seamless integration of interpretive strategies designed to educate, engage, and delight. This means paying attention to best practices, new research, and most importantly to the changing role of the museum within the community. Given the diverse nature of collections at The Ringling, it is critical that education and curatorial forge a strong relationship. We depend on the curators of this vast and diverse set of collections to bring their research and ideas to the table. It is only through such a dialogue that we are able as a team to identify which projects to focus on, which are attainable in terms of staff and financial resources, and, most importantly, which fulfill The Ringling's mission. Due to the constraints of finance and personnel that all museums face, we are strategic

in selecting which exhibitions and permanent installations will benefit most from this integrative approach.

In 2010 the John and Mable Ringling Museum of Art renewed its commitment to engaging with contemporary art and, more specifically, living artists. While this was a significant shift in programmatic mission at the time, it was not without precedent. One year earlier the first Ringling International Arts Festival, a celebration of international performing arts, had opened to great success signaling a change in focus at The Ringling. Yet, long before that, the first director of The Ringling, A. Everett "Chick" Austin, Jr., who had been director of the Wadsworth Athenaeum in Hartford, Connecticut, before coming south, was a champion not only of contemporary visual artists but also of an expanded idea of the museum in which the visual, performing, and literary arts all found a home.[2] Chick's model of the museum was more in keeping with its etymological roots—the house of the muses, *all* of the muses. In coming to The Ringling in 1946, Chick Austin brought with him this belief in the importance of dialogue between the past and the present within the walls of the museum. It is on the foundation of Chick Austin's museum practice—one that it seems US museums are only now catching up to more than half a century later—that The Ringling's Art of Our Time initiative is based.

At the outset, the Art of Our Time initiative, which encompasses the visual and the performative, has as its mission a direct engagement with the living artist that catalyzes engagement beyond the museum with new and diverse audiences. Thus, the mission statement includes the active language of "building, developing, and sustaining":

> Mission: To play a vital role in an emerging community and international network of living artists whose work moves beyond traditional practices in the conceptualization, creation, and exhibition of visual and performative art. To that end, we are committed to:
>
> - *building* a creative environment for artistic inquiry, experimentation, and collaboration;
> - *developing* a public platform upon which new works, with an emphasis on emerging and underrepresented artists, can be presented to an informed and engaged audience; and
> - *sustaining* relationships between artists, audiences, and The Ringling so that ongoing programming can be fostered in meaningful and mutually rewarding ways.

With both of the exhibitions discussed in this chapter, *Beyond Bling* and *Re:Purposed*, we will explore our strategies for increased community engagement in both the galleries and outside the walls of the museum. In these examples, education and curatorial had the luxury to begin the discussion about the exhibition content and related programming very early in the

projects. Brainstorming sessions involving both departments assisted curatorial with refining and articulating exhibition goals while both departments were able to dream big in terms of programming, knowing that the realities of time, money, and staff would modify some of these hopes and dreams. Being on the same page from the earliest discussions created a clear vision that was supported by all materials and programming and kept staff focused on supporting the stated goals.

BEYOND BLING: VOICES OF HIP-HOP IN ART

The first full-scale programming under the aegis of the Art of Our Time initiative opened in spring 2011. *Beyond Bling: Voices of Hip-Hop in Art* consisted of an exhibition of the work of ten artists, all of whom were influenced by the pancultural movement of hip-hop.[3]

The exhibition housed in the museum of art provided an axis around which satellite programming revolved for the duration of the exhibition (Figure 8.1). *Beyond Bling* was chosen as the first project to be publicized as part of the Art of Our Time initiative because of the interdisciplinary nature of hip-hop in its embrace of the visual, verbal, and performative. To reflect the nature of the hip-hop movement, a season of events complemented the exhibition.

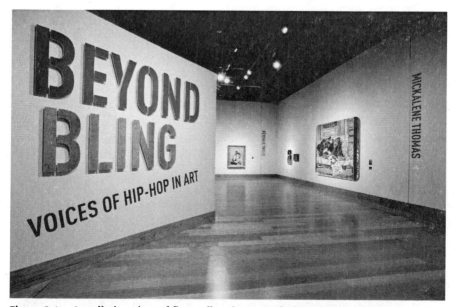

Figure 8.1. Installation view of first gallery in *Beyond Bling: Voices of Hip-Hop in Art.*
Source: Giovanni Lunardi.

The Rennie Harris Dance Company opened the season in the Historic Asolo Theater and was followed by the spoken word performance, *The Word Begins*, presented by the Hip-Hop Theater Festival. The timing of the exhibition roughly coincided with what was deemed in the popular press as the thirtieth anniversary of the "birth" of hip-hop, marked by the release of the 1980 single, *Rapper's Delight*, by the Sugar Hill Gang. The ten artists and their exhibited works also aligned perfectly with the mission statement of the initiative. In particular, it was felt that the subject matter of the exhibition, the first contemporary exhibition curated "in-house" in over a decade, would provide an ideal bridge between the museum and historically underserved communities, namely, minority communities and the sixteen-to-thirty-five-year demographic.

Education was enthusiastic about an exhibition that explored the social and artistic contributions of hip-hop. This show and accompanying programming provided the means to break down many of the perceived barriers within the immediate as well as larger regional community. Without programming that engaged with contemporary art and issues, The Ringling's role in the community was relegated to school field trips and the place to take out-of-town visitors. As one member phrased it, "It's like The Ringling is a sleeping giant coming to life again."

Engagement in the Galleries

Ringling museum professionals have worked over the years to break down the public image of museums as being elitist and unfriendly. Staff recognized that a crucial key to the success of upending this perception would be to ensure that the demographics interested in the exhibition would find The Ringling to be a welcoming place. Once we got them here, we wanted them to come back. To this end, we worked with the museum's frontline staff, visitor services, admissions, and security, as well as volunteers, to address preconceived and stereotypical ideas about the artists, the artwork, the music, and the visitors to mitigate microaggressions. We also spent time coaching staff and volunteers who were not comfortable with iPods and QR codes, both of which were featured in the in-gallery activities. We provided simple operating instructions for each iPod that featured a playlist selected by a local radio station (Tampa 101.5) to encourage technologically challenged visitors to use them. By including colleagues and volunteers in the process, we were able to substantially move the benchmark on being a user-friendly museum. This approach has paid dividends and has been adopted for almost all subsequent Ringling exhibitions.

One of the first questions to be posed at the beginning of exhibition planning at The Ringling is whether there will be room for an education space in the exhibition itself. This is determined by the exhibition designer who has

to consider the requirements of the art and the logistics of the layout, in dialogue with education and curatorial. For our audiences, many of whom are first-time museum visitors, providing a separate space where they can read, reflect, and discuss their reactions to the art is reassuring. The staff was able to carve out a space in the exhibition where visitors could read about the artists, watch the pioneering documentary *Style Wars*, and respond to a prompt "Bling is . . ." by writing or drawing on a form available in the gallery. These were displayed in the education space over the course of the exhibition to facilitate continued dialogue. This gallery activity also operated as an informal visitor engagement survey allowing the staff to track visitor reactions and depth of engagement. While anecdotal, many of the responses provided constructive feedback on the reception of contemporary art by our audiences who may not have a familiarity with discourses surrounding contemporary art. Perhaps the most surprising, and satisfying, outcome of this activity was the amount of audience-generated art that then became a de facto part of the exhibition. For the final gallery-based activity, education created *Continuing the Conversation*, a gallery activity that encouraged visitors to make the connection between contemporary works in the exhibition and those in the permanent collection from the sixteenth to the twentieth centuries. Activities like this enabled visitors to see the broader continuum of art, history, and social change and to understand the relationships between the past and the present situating the contemporary work within the broader context of The Ringling collections.

The Ringling has developed a menu of public programs that can be tailored to each exhibition, designed to offer visitors a variety of learning formats. Programming for *Beyond Bling* included ViewPoints, a formal lecture series where the museum can serve a large audience. The speaker was James Prigoff, artist and author, who has been a longtime advocate of street art. Walk and Talks are informal tours and discussions in the galleries. Building on the ideas articulated in the gallery activity "Continuing the Conversation," we chose to pair works from the permanent collection with objects from *Beyond Bling*. The talks developed into lively discussions between staff and the visitors who were notably intergenerational. Art and a Movie paired films with themes represented in traveling exhibitions or the permanent collection. Curatorial and education conducted tours through *Beyond Bling* before the film *Exit through the Gift Shop*, directed by the street artist Banksy.

Targeted Engagement Outside the Museum

The Ringling is surrounded by a pink, stucco wall about five feet tall, with an ornate iron gate directly in front of the main entrance into the museum of art (Figure 8.2).[4]

Figure 8.2. Front gate and façade of the John and Mable Ringling Museum of Art.
Source: ©John Jay Boda.

Over time, the wall and locked gate had become a literal as well as psychological barrier to many members of the Sarasota community. A key goal of both the curatorial and education departments was to use the newly invigorated contemporary programming at The Ringling to invite communities who perceived the museum as "not for them" or not relevant to their lives back to the museum. To accomplish this, it became clear early in the process that the museum would need to extend into these communities before it could expect these communities to come into the museum.

The first strategy was to find a community partner within the communities with which we wanted to engage for both guidance and assistance. Newton, the historically African American neighborhood of Sarasota, is fewer than two miles from the imposing iron gate of the museum, but it could just as well have been 200 miles, such was the distance that had grown between the community and the museum over the years. The community partner that proved ideal for engagement was the North Sarasota branch of the Sarasota Public Library, located in the heart of Newtown. Through a series of meetings between the library and museum staff, it was decided that a dialogue session reintroducing the museum to the community would be most effective. At this event, the curator of the exhibition, Matthew McLendon, and the curator of performance, Dwight Currie, presented the artists and performances that would make up the *Beyond Bling* season of events. This dialogue achieved

two goals. The first was informing a community who had felt long-overlooked by the museum about programming that would enable them to see themselves reflected in both the artists and the work that was programmed. The second goal was opening up a safe dialogue between the community and the museum for an exchange of ideas as to how the museum could better serve the community and to demonstrate that we were open to this conversation.

This dialogue has had lasting effects at The Ringling. Through the first talks with library staff, as well as the dialogue session with the community, it became clear that transportation, especially to nighttime events, was a major impediment. When the next opportunity arose, in 2013, for engagement specifically with the African American youth community through the presentation of Mark Bamuthi Joseph's dynamic dance-poetry work, *Word Becomes Flesh*, we were able to work quickly with our partners at the North Sarasota Library and with the development team at The Ringling to put together a plan of action to raise the funds necessary to purchase tickets that could then be offered free of charge to the youth community. Through an established endowment in the education department, funds were set aside to hire an off-duty public school bus and driver who would pick up members of the Newtown community from the North Sarasota Library (a far more accessible location for most) and transport them to and from the performance. A special information session specific to the performance was held at the library before the audience came to the museum to provide a wider context for why the work had been programmed and to answer any questions the audience might have.

While both efforts of targeted engagement with the Newtown community may seem simple at best, or even obvious, that is the point. Oftentimes, in searching for new approaches to community engagement, we miss the forest for the trees. These two approaches were as remarkably simple as they were effective. By engaging with the community *within* the community and with a trusted partner, an immediate bond of trust was formed. What this experience reminded us is that the museum is not a neutral space, and, while intentions for engagement may be honorable, engagement is often best begun within the community. Further, something as basic as transportation—more easily negotiated by an institution like The Ringling with substantial ties to donors and with a dedicated fund-raising team—can mean the difference between engagement and seeming as though you are many miles, and a wall, away.

Artist–Community Engagement

The second form of community engagement was born directly out of the community work of one artist featured in the exhibition. Sofia Maldonado, a

Puerto Rican artist based in New York City at that time, had already engaged in a number of public art projects with the international skating community. Concurrently with the planning of *Beyond Bling*, the local skate park in Sarasota was in the news. Hours were being cut, and funding was falling short. It was possible that the important after-school activities taking place in the skating community would end. Skaters and communities have long been at odds with one another, with skateboarding often being perceived of as disruptive behavior. Payne Skate Park provided a vital space for youth-based skating activities and culture. With Sofia's background, it seemed that it would be an ideal partnership between the museum and another community organization. We approached the leaders of the skate program with the idea of a public art project, designed and led by Sofia, at the skate park in which the skaters would work with Sofia in creating a mural on the skate bowl. Students in a charter school physical education program who used the skate park as part of their PE during the day, AP art students from a local high school, and skaters from the wider community all came together with Sofia the week leading up to the opening of *Beyond Bling* at The Ringling to create the mural (Figure 8.3). The project was supervised by Mery-et Lescher, a doctoral student at Florida State University (the parent university of The Ringling) who was serving as the curatorial intern at the museum. Thus, in this one project, the museum, another community organization, two schools, and the university came together to bring the exhibition beyond the walls of the museum while simultaneously promoting the exhibition and the needs of the community. This initial mural project has generated further art at the skate park.

Lessons Learned

We learned important lessons from this first major project under the mantle of the Art of Our Time at The Ringling, and they have informed our subsequent programming. The first was the need for early involvement with frontline staff. The contemporary programming at The Ringling is, by design, "out of the ordinary." It brings with it complex issues and new audiences. To ensure those audiences feel welcome, the frontline staff need to feel comfortable with the content, purpose, and messaging of the programming. The second major lesson was the need for direct engagement with targeted communities in *their* communities, not ours. Before new audiences can feel comfortable or engaged with the museum, they must feel that they are a part of an active dialogue, that they are being heard. The simple acts of conducting conversations in the community rather than the museum continue to pay dividends five years later. Finally, there is no substitute for direct engagement between artist and community. Working with living artists provides the ideal and most rewarding opportunity for communities to come together, through art, in service to common goals.

Figure 8.3. The artist Sofia Maldonado and curator Matthew McLendon surveying part of the skate park mural. *Source:* Peter Acker.

FOUR YEARS LATER, *RE:PURPOSED*

In 2015, the exhibition *Re:Purposed* opened at The Ringling. Made up of the work of ten widely diverse international artists, the unifying concept was that each artist employed "garbage," that is, materials that had been disposed of, to create their works.[5] The idea for the exhibition grew out of an interest in conversing with the permanent collection, in particular the small collection of Readymades by Marcel Duchamp. The work of the ten artists in *Re:Purposed* was explored in the lineage of the Readymades and of Assemblage with particular attention paid to the varied methodologies and theoretical positions employed by the artists.

In keeping with the mission of the Art of Our time to [build] "a creative environment for artistic inquiry, experimentation, and collaboration," the artist Jill Sigman was invited to create the site-specific *Hut #10*, the tenth in a series of huts she had created around the world in widely varied contexts. Made of discarded materials scavenged by Sigman, the huts are meant as sites of contemplation and conversation where visitors are invited to reassess their complex relationships with the objects they consume. Jill was invited to be an artist in residence at The Ringling and spent two and a half weeks collecting garbage from the museum, the estate, and the wider community. She then spent another two weeks building the *Hut #10* as the exhibition opened to the public (Figure 8.4).

Jill's practice is community based: it takes more than just the artist to accumulate the amount of material needed for a hut on the scale proposed for The Ringling. Therefore it was essential to work with her to identify the communities that should be involved in the project.

Targeted Engagement with the Artist

When the exhibition *Re:Purposed* was proposed for The Ringling, education could not have been more excited. The possibilities for engaging community through an exhibition about trash and garbage were endless! Everyone has it and needs to deal with. Reaching out and engaging the external community could be accomplished with programming and media. But we also recognized an opportunity to achieve a long-standing goal and connect with our own museum community, both staff and volunteers, who are also part of the external community. Welcoming thousands of visitors a day in admissions or making sure the bills are paid in accounting can distance staff from the museum mission. The Ringling's volunteers number over 500 and represent a good sampling of the external community. We challenged our colleagues to be a part of the art by contributing their own trash to the *Hut #10* installation created by Jill Sigman. Collection bins were placed throughout the

Figure 8.4. Artist Jill Sigman placing final elements on *Hut #10*. *Source:* Daniel Perales.

museum, and the challenge went out. Gardeners brought in dried plant material, some brought in clothing and household goods that were destined for Goodwill, and others contributed Florida or family memorabilia that needed to be repurposed. Under the direction of the artist, an art space was created from these donations. Staff and volunteers came by to watch the construction process and to locate their contributions. The outcomes were a renewed camaraderie between different parts of the organization and a sense of being important to the mission. Intersectional relationships were formed as the project crossed all genders, ages, and cultures. A new comfort level

with contemporary art was created as everyone's "stuff" was part of the art. The internal community became our greatest resource for marketing to the external community.

Education also reached out to the museum community to help collect materials for art activities. In an education space within the exhibition, visitors were invited to create their own repurposed art using clean, recycled materials. Family workshops, held weekly on Saturdays, encouraged families to work together to compose inventions using recyclables.

Lessons Learned

While it had been a long-standing goal to better engage with the internal community, oftentimes we overlook how representative of the external community the museum family actually is. We in programming can also overlook that our colleagues in other departments might feel removed from the museum's mission. Engaging with the internal community through an artist-led project seamlessly offered an opportunity to be directly engaged with a mission-based activity. The result was a fostering of camaraderie and ongoing dialogue about the mission that then evolved into powerful testimony in the larger community. Specifically to the contemporary programming, there was skepticism when *Re:Purposed* was initially announced to the museum staff. The concept of an exhibition about art made from garbage seemed beyond the scope of a museum renowned for its Rubens paintings. The long-lasting effects of including the museum community in this project are still visible. The wider museum is much more comfortable with the contemporary program and its importance to the overall museum mission. Staff and volunteers also have a better understanding of how contemporary work can engage audiences in different ways than the Old Master Collection as well as bring in new audiences. In short, the museum community has "buy-in" now for the contemporary program.

CONCLUSION

As with all museums, The Ringling's resources of staff, funding, and time are limited. To maximize impact, we focus on projects with sustainable outcomes. Both *Beyond Bling* and *Re:Purposed* still pay dividends in meaningful engagement with new and diverse audiences as well as renewed interest in contemporary programming across the internal museum community. These reenergized external and internal dialogues provide additional support for our efforts to move the museum beyond the wall.

NOTES

1 For more information on The Ringling story, see: Weeks, David C. *Ringling: The Florida Years 1911–1936*. Gainesville, FL: The University Press of Florida, 1993.

2 For more information on Chick Austin, see: Gaddis, Eugene R. *Magician of the Modern: Chick Austin and the Transformation of the Arts in America*. New York: Alfred A. Knopff, 2000.

3 McLendon, Matthew. *Beyond Bling: Voices of Hip-Hop in Art*. London and New York: Scala Publishers Ltd., 2011.

4 The ornamental iron gate marks the original entrance into the museum of art. In 2006, the John McKay Visitors Pavilion was opened to the north of the museum. The Visitors Pavilion now serves as the main entrance onto the estate where the museum of art and the Circus Museum, Tibbals Learning Center, Ca' d'Zan, Historic Asolo Theater, and gardens are also found.

5 McLendon, Matthew. *Re:Purposed*. London and New York: Scala Art Publishers Inc., 2015.

BIBLIOGRAPHY

Gaddis, Eugene R. *Magician of the Modern: Chick Austin and the Transformation of the Arts in America*. New York: Alfred A. Knopff, 2000.

McLendon, Matthew. *Beyond Bling: Voices of Hip-Hop in Art*. London and New York: Scala Publishers Ltd., 2011.

McLendon, Matthew. *Re:Purposed*. London and New York: Scala Art Publishers Inc., 2015.

Weeks, David C. *Ringling: The Florida Years 1911–1936*. Gainesville, FL: The University Press of Florida, 1993.

Chapter 9

Collaboration within and outside the Museum

Student-Written Labels in a Featured Exhibition at the Nelson-Atkins Museum of Art

Rosie Riordan and Stephanie Fox Knappe

At a time when many art museums are recrafting their mission statements to reflect the types of institutions they must strive to be to ensure their ongoing relevancy, there is a tandem effort to more deliberately and deeply engage their myriad communities. Critical among the outcomes resulting from these exercises is a fresh focus on the creation of meaningful visitor-centric experiences inspired by and facilitated through significant encounters with art. Often, this dedication is realized through retooled or newly imagined programs that are actively shaped by public involvement or that evince true inception-to-execution collaboration between institutions and the multifaceted communities they serve. Likewise, an emphasis on more vigorous and consequential partnerships with current and potential audiences is frequently motivated by a distinct, yet related, desire fueled by critical necessity—the aspiration to make greater space for a range of experiences, attitudes, and identities. Increasingly acknowledged as essential to the act of compelling meaning making, multivalent interpretation is more and more evident today in permanent collection installations as well as special exhibitions.[1] With ever-expanding prevalence and growing impact, outside voices influence what occurs within a museum's walls. Augmenting those more commonly heard voices that belong to curators and educators and expanding the variety and content of the messages presented, voices of community members are also increasingly expressing themselves directly from art museum walls. The inclusion of these voices in didactic panels and labels has the potential to amplify engagement and enhance visitors' experiences while fostering and deepening relationships between museums and the many publics they serve.

In 2012, the Nelson-Atkins Museum of Art in Kansas City, Missouri, embarked on such an endeavor. A soon-to-be-unveiled strategic plan dedicated to engaging a wider constituency by becoming a catalyst for more profound and dynamic relationships with the educational, social, civic, and cultural life of our community, as well as our increasingly expanding range of visitors, provided part of the impetus for this project. The occasion to invite a chorus of outside voices into the museum and onto its wall was also spurred by the development of a highly anticipated exhibition.[2] Four years later, this chapter revisits that opportunity as a case study in visitor-centered collaboration within and outside the museum and details the process and outcomes of the integration of student-written labels within a featured exhibition.

THE PROCESS

Coinciding with efforts to refine its forthcoming strategic plan, the Nelson-Atkins's preparations for its then-upcoming exhibition *Frida Kahlo, Diego Rivera and Masterpieces of Modern Mexico from the Jacques and Natasha Gelman Collection* were in high gear.[3] From June 1 through August 18, 2013, the museum would highlight more than 100 historic and contemporary examples of Mexican art in a variety of styles representing an array of subject matter drawn from the exceptional Gelman collection. These paintings, sculptures, photographs, prints, and conceptual pieces were selected for inclusion in the exhibition to showcase the rich artistic traditions of Mexico's past and to celebrate the vitality of Mexican art today. Stimulated by discussions centered on the intrinsic role that community was playing in the shaping of the museum's strategic plan, the museum recognized a synergy between the goals enumerated by that document and the potential inherent in the interpretation of the Gelman collection for the Nelson-Atkins to realize its aims in an immediate and public way. This synergy inspired the Nelson-Atkins to implement community partnerships that gave rise to a new in-gallery interpretive strategy conceived to enhance visitor experience. The collaboration and its outcome allowed the museum to clearly demonstrate that its declaration to be a site "where the power of art engages the spirit of community" was much more than simply a catch phrase.[4]

This new in-gallery interpretive strategy—unprecedented at the Nelson-Atkins—involved the use of student-authored labels in tandem with curator-written didactics on the walls of the featured exhibition. The opportunity necessitated a high level of trust, commitment, and collaboration both within the museum itself and with its outside community partners.[5] However, before the Nelson-Atkins could engage in a meaningful partnership

with any external entity, an internal alliance between museum departments was necessary. With the enthusiastic endorsement of Julián Zugazagoitia, Menefee D. and Mary Louise Blackwell director and CEO of the Nelson-Atkins, and tactical guidance from Judy Koke, then-director of education and interpretive programs, members of the exhibition's core team united in an effort to devise and support a collaboration between two local schools and the museum that would not only be mutually beneficial but also valuable to museum visitors who would ultimately be the audience for results of the partnership.[6] The team's shared goals were naturally reflective of those that had become part of the common parlance and culture of the Nelson-Atkins through the strategic planning process: to help students deeply connect with art; to create an opportunity for students (and by extension, their families and caregivers) to feel a part of the museum community; to foster a long-term relationship between students, the important people in their lives, and the Nelson-Atkins; and to engage diverse and multigenerational audiences in meaningful ways.

Moving beyond the museum's own staff, the project afforded the Nelson-Atkins the privilege of collaborating with students, teachers, and principals from a pair of schools thoughtfully identified by retired Shawnee Mission, Kansas, art teacher Rosie Riordan. Riordan, who had recently joined the Nelson-Atkins staff as its head, school and educator services, brought to this position a network of contacts from the greater Kansas City education community.

Riordan targeted University Academy, a charter school in Kansas City, Missouri, and Shawanoe Elementary School in nearby Shawnee, Kansas, as ideal partners. These schools were deliberately chosen for their potential for strong administrative commitment and a solid match between the opportunities presented by this partnership and the existing curriculum. Eager teachers and willing students likewise made these two schools especially viable candidates with which to enter a collaboration of this nature. Both institutions also represented a diverse student body as well as demographics that were different from those reflected in the museum's current core audience.[7] Careful school selection, followed by unwavering investment from administrators and teachers, was critical to the success of the project as it unfolded over the course of the next several months. The Nelson-Atkins pledged its professional resources and staff time to work directly with teachers and students at University Academy and Shawanoe Elementary. All parties were dedicated to a meaningful exchange among students, teachers, and Nelson-Atkins staff that had art from the Gelman collection as its core.

Beginning in the fall of 2012 and throughout the many months leading up to opening of the featured exhibition in June 2013, members of

the museum's curatorial, interpretation, and school and educator services departments, in addition to retired teachers with ties to the museum, repeatedly met with juniors and seniors in Advanced Placement art courses at University Academy as well as third- and fifth-grade students enrolled in Shawanoe Elementary. At the inaugural visit to each school, exhibition curator Stephanie Fox Knappe provided a tailored overview of the Gelman collection and highlights from the exhibition in the context of a larger discussion with the students about the act of collecting. Accompanying Knappe on these first visits were Rosie May, head, interpretation, and Riordan who each led students through a Visual Thinking Strategies (VTS) exercise.[8] The students' experience with VTS simultaneously served as an icebreaker while it introduced key art-viewing and critical-thinking skills. Engagement with a single painting over a period of twenty to thirty minutes fostered "the permission to wonder," free thinking, and an appreciation for the array of experiences one brings to art that influences how one sees and understands it, while underscoring the validity of opinions other than one's own. In future meetings with museum staff, students drew on these experiences that would significantly inform the label-writing process and, eventually, affect the experience of those visitors who encountered the student-authored labels in the featured exhibition.[9]

The partnership subsequently involved eight working sessions both on-campus and on-site at the Nelson-Atkins. These meetings consisted of museum staff and liaisons facilitating VTS activities, encouraging students to look beyond what might be obvious in order to consider an artist's message or underlying intent, and discussions on curatorial choices and the purposes of object labels. Throughout this process, the students progressively became more comfortable expressing their own views, opinions, and interpretations about art while showing more respect for those offered by others. Paula Ferlo, Shawanoe Elementary fifth-grade teacher, recognized this shift as it occurred in her classroom: "It was amazing to listen to my students talk with each other about what they thought and how they would agree to disagree. Some kids just gave you an answer they think you want to hear, [but] they would get so involved, they would forget they were learning."[10] Gradually, the newly enlisted members of the Nelson-Atkins' project team also grew familiar with the exhibition's key ideas, its checklist, and the powerful, storytelling role that the labels they would contribute would play in visitors' experiences while engaged with the exhibition.

The students then began to write. Working from images of art in the Gelman collection, the students first drafted a descriptive paragraph. They then pared down those paragraphs through a variety of writing exercises. All the while, they were asked to consider whether what they wrote conveyed the

essence of the pieces they were assigned. Would their words direct readers to what was most vital for them to see or appreciate? In order to avoid any extra burden on the dedicated teachers who generously offered up hours of time in their classrooms to realize this partnership, there was never an expectation that their students would write labels that were steeped in the biography of the artists, that revealed deep contextual knowledge, or that provided incontrovertible facts related to content. Rather, as the University Academy and Shawanoe Elementary students wrote their labels, what was expected from them was simple—thoughtful responses based on visual evidence gleaned from close looking. After months of coaching by museum staff and teachers, lively conversation in the classroom and at the museum, and rounds of peer and professional editing, forty-five student-written labels were presented on the gallery walls in conjunction with labels authored by Knappe and the renowned scholar of Mexican art Edward Sullivan.[11]

THE RESULTS

When the exhibition opened, visitors encountered a text panel in its first gallery that foregrounded the collaboration inspired by the museum's mission to be a site "where the power of art engages the spirit of community." The panel explained the intended function of the partnership and concluded with an invitation for other outside voices to join the conversation initiated by the dual sets of object labels throughout the exhibition:

Multiple Voices—Many Responses

The Nelson-Atkins was privileged to have many partners help shape the presentation of this exhibition. Our collaborators include the Vergel Foundation that oversees the Gelman collection, distinguished scholar of Mexican art Edward Sullivan, as well as third- and fifth-grade students at Shawanoe Elementary School in Kansas and high school juniors and seniors from University Academy in Missouri. The labels found throughout the exhibition offer a range of responses inspired by the art in the Gelman collection. The first set of labels reflects our institutional voice. A second set of labels records students' thoughts on selected works. We hope that you will be encouraged to join the conversation. Add your voice and share your responses in the final gallery of the exhibition. #fridadiego[12]

The following is a representative sampling of the labels the students contributed to the exhibition that demonstrates the range of responses inspired by

the Gelman collection with the curator-written labels preceding the student-written contributions, as they appeared on the gallery walls:

Diego Rivera

Mexican, 1886–1957
Girasoles (*Sunflowers*), 1943
Oil on canvas on Masonite

Although best known for his large murals, Rivera also painted smaller easel pictures like *Sunflowers* for private collectors such as Jacques and Natasha Gelman. Like *Modesta* that hangs nearby, *Sunflowers* belongs to a series of paintings that feature Mexican children as their subject. Although not a direct quotation from one of his murals, it resembles the scenes of everyday life in Mexico that Rivera painted on a much grander and more public scale.

> *I see children playing in a sunflower garden on a warm fall day. They stopped in the garden because the large sunflowers gave them a shady place to play with their masks and dolls.*
> —Third-grade student, Shawanoe Elementary

Ángel Zárraga

Mexican, 1886–1946
Retrato de Natasha Gelman (*Portrait of Natasha Gelman*), 1946
Oil on canvas

Jacques Gelman commissioned many artists to paint Natasha, his partner in life and art collecting. This unfinished portrait by Ángel Zárraga and others in the Gelman collection expressed Jacques' love and devotion to his wife through a form they both treasured—art.

> *On this hot, summer day Natasha sits under a shade tree in her backyard. She looks dressed up ready to go to a party, but her expression says to me, "what's next?"*
> —Fifth-grade student, Shawanoe Elementary

Carlos Orozco Romero

Mexican, 1898–1984
Protesta (*Protest*), 1939
Oil, gouache, and pencil on canvas

Combined with the painting's title, the startling, puppet-like figure that dangles in an awkward position may refer to World War II. This conflict that left the world upside down began around the time that Carlos Orozco Romero made this painting. Its enigmatic, dream-like quality also suggests Romero's engagement with the Surrealist movement, an interest he shared with Juan Soriano, Agustín Lazo and Lola Álvarez Bravo, among other artists in the Gelman collection.

The woman's face has a dark side and a light side. The background has a stormy sky—is the artist painting a metaphor? There is always a good side and a bad side of a person's life. To me, it looks like she is all tangled up in it and trying to get out.

—Junior, University Academy

Frida Kahlo

Mexican, 1907–1954
Autorretrato con trenza (*Self-Portrait with Braid*), 1941
Oil on canvas

"Through her paintings, [Kahlo] breaks all the taboos of the woman's body and of female sexuality."

—Diego Rivera

Frida Kahlo painted this image of herself in 1941, shortly after she reconciled with Diego Rivera following their divorce. In a reaction to the emotional pain caused by the separation, Kahlo cropped her long hair into a man's style, symbolically relinquishing this aspect of her femininity. Now reunited with Rivera, Kahlo here ostentatiously displays her long hair, wrapped in red ribbon and twisted into a flamboyant braid. She accents her femininity and sexuality by portraying herself nude, emerging from lush foliage like a burlesque dancer peeking through feathered fans.

I see a face of a strange beauty. She catches your eye with her daring stare. I wonder—Is she looking at me or at something else? Her tribal necklace and headpiece tell a bit of where she's been and who she belongs with. Leaves clothe her naked body, fierce and exhilarating. The question is—Where does Frida belong?

—Senior, University Academy

EVALUATION

The Nelson-Atkins viewed the collaboration with University Academy and Shawanoe Elementary not only as aligned with its mission and as a chance to experiment with new interpretive strategies but also as an opportunity to evaluate the impact of outside voices on the experiences of visitors within a featured exhibition.[13] Exit interviews revealed that 64 percent of the 151 visitors surveyed felt that the student labels added value to their experience. Although the project team conceived of the student-authored labels with a novice museum visitor in mind, the exit survey indicated that visitors who frequented art museums (not just the Nelson-Atkins specifically) more than once a year appreciated the student labels the most. Seventy-one percent of these at-least-annual art museum attendees expressed that the students' participation added value to their experience. Responses that addressed the means by which the student-written labels added value fell into three categories (listed here in order of prominence): a perceived benefit in exposure to different perspectives, general positive comments (including that the labels were worthwhile because the effort benefited the students), and a belief that the labels encouraged deeper engagement with the art and closer looking, which takes time. A sweep-rate study conducted as part of the evaluation revealed that visitors covered an average of 239 square feet per minute and spent an average of 44 minutes in the exhibition—two statistics indicative of a high level of visitor engagement.[14]

Twenty-three percent of the 151 visitors polled upon exiting the exhibition reported that the student-authored labels did not positively or negatively affect them. Again, these indifferent responses broke down into three categories: interesting, but did not add to the experience; did not particularly like the labels, but did not feel as though they detracted from the experience; and a sense that although they might be good for others, the labels did not enhance their own experience. Eight percent of the visitors polled did not notice the students' labels, while 1 percent was undecided regarding their impact. The remaining 4 percent of respondents (only 6 of the total 151 visitors surveyed) suggested that the labels detracted from their experience in the featured exhibition. Their reasons varied from feeling as though these labels were a distraction, intrusive, or that they "dumbed down" the exhibition; to a preference for an expert opinion; or simply not wanting any interpretation of any sort to interfere with the experience of directly engaging with art.

CONCLUSION

The partnership with University Academy and Shawanoe Elementary School that brought new voices into the Nelson-Atkins Museum of Art

and afforded them an opportunity to speak from its walls marked the first of its kind for the museum. In addition to contributing an integral element to a featured exhibition that enhanced the experience of the majority of visitors who attended *Frida Kahlo, Diego Rivera and Masterpieces from Modern Mexico from the Jacques and Natasha Gelman Collection*, this collective effort promoted and strengthened relationships both within and outside the museum. It allowed the Nelson-Atkins to be a site "where the power of art engages the spirit of community" before that mission was publicly announced. Concomitantly, the process and result of presenting student-written labels in a featured exhibition reflected goals outlined in the Nelson-Atkins's impending strategic plan: to break down barriers, to grow new audiences, to become more deeply invested in the communities the museum serves, and to foster powerful and ongoing connections with art. A mother of an eight-year-old student who together attended a celebration in honor of the partnership expressed what the opportunity meant to her son, "He had so much fun. He loves art, especially when it comes to our culture. To him, it's very special."[15] In the article published in the *Kansas City Star* that detailed the alliance between the schools and the museum, Dr. Gene Johnson, superintendent of Shawnee Mission schools, added, "It's really important to give these students experiences they wouldn't be able to do on their own."[16]

The legacy of this collaborative endeavor is the value of an expanded project team that welcomes contributions from outside the Nelson-Atkins. This collaborative mode of working with our communities is now routinely applied to many of the museum's undertakings. Outside voices and perspectives are incorporated into front-end evaluation of didactics and the development of in-gallery interactive elements. They shape and enhance our public programs, permanent collection installations, and featured exhibitions. This collaborative practice not only yields richer and more relevant outcomes but also honors multiple perspectives, significantly enhancing meaning making for all who come through its doors.

NOTES

1 Henry, Carole. *The Museum Experience: The Discovery of Meaning*. Reston, VA: National Art Education Association, 2010, 23–31.

2 The Nelson-Atkins Museum of Art, "Strategic Plan."

3 *Frida Kahlo, Diego Rivera and Masterpieces of Modern Mexico from the Jacques and Natasha Gelman Collection* was organized by the Nelson-Atkins Museum of Art with the Vergel Foundation, through support of the Donald J. Hall Initiative. Generous funding has been received from the Keith and Margie Weber Foundation, Belger Cartage Service, Inc., the Campbell-Calvin Fund and Elizabeth C. Bonner Charitable Trust for exhibitions, and donors to the museum's Annual Fund.

With special thanks to Instituto Nacional de Bellas Artes, Conaculta, and Consulado de México en Kansas City.

4 "Where the power of art engages the spirit of community" is the first line in the Nelson-Atkins' full mission statement that is part of the museum's strategic plan, which was adopted in April 2013.

5 Although new for the Nelson-Atkins, labels written by students receiving pride of place in an exhibition were not novel. The Nelson-Atkins' lead interpretive planner, Rosie May (now associate director of public programs and interpretive practices at the Museum of Contemporary Art Chicago), cited inspiration from a London museum at which students were responsible for an entire exhibition, from object selection to interpretation. See Lipoff, Beth. "For Shawanoe Students, Art Is What They Make of It." *Kansas City Star* (MO), June 11, 2013.

6 Judy Koke is now the chief of public programming and learning at the Art Gallery of Ontario. The exhibition's core team was composed of curator Stephanie Fox Knappe, curatorial project assistant Brittany Lockard (now assistant professor of art history and creative industries at Wichita State University), school and educator services head Rosie Riordan May, exhibition designer Amanda Ramirez (now senior designer at the J. Paul Getty Museums), graphic designer Susan Patterson, and evaluator Jennifer Holland (now certified brand strategist with the Boy Scouts of America).

7 At the time of the collaboration in 2012, University Academy had a student body that was 93 percent African American, while 66 percent of Shawanoe Elementary students were of Hispanic background. University Academy is approximately three miles from the Nelson-Atkins—well within in the five-mile radius from which the museum sees a surprisingly low number of visitors (less than one-third of overall attendees), despite the proximity to the museum. The vast majority of Shawanoe Elementary students had never been to a museum. Conversely, more than half of visitors to the Nelson-Atkins report that they make more than one visit to an art museum each year.

8 Visual Thinking Strategies (or VTS) is a decades-old art education and critical thinking tool developed by Philip Yenawine and Abigail Housen that is widely used in museums as well as educational institutions. VTS relies on a facilitator delivering a set of three prompts about a piece of art to a group: "What is going on in this picture/ sculpture/work of art?" "What do you see that makes you say that?" "What more can we find?" See Yenawine, Philip. *Visual Thinking Strategies: Using Art to Deepen Learning across School Districts.* Cambridge, MA: Harvard Educational Press, 2013.

9 The phrase, "permission to wonder" is frequently invoked by Yenawine.

10 Lipoff, "For Shawanoe Students, Art Is What They Make of It," 8.

11 The students' labels were identified as such through a "signature line" that indicated the author's grade level and school affiliation. Additionally, the students' texts were italicized.

12 The final gallery of the exhibition included both a board to which visitors could add their handwritten comments and a flat screen on which social media posts tagged with #friedadigeo appeared as they were uploaded in real time. More than 2,000 response cards (in multiple languages) were collected during the exhibition's

run, while 854 exhibition-related tweets and more than 600 Instagram posts were registered.

13 The summative evaluation, led by Holland, consisted of the results of three exit interviews, two of which were conducted with randomly selected visitors, while the third involved only visitors who indicated that they visited art museums no more than once every five years in an effort to increase the number of responses from this group of visitors. In addition to asking two open-ended questions about the student-written labels, the interviews addressed the efficacy with which the exhibition's key messages were communicated, the success of the exhibition design, and issues related to marketing.

14 Sweep rate indicates the average speed visitors move through a space with a successful rate identified as 300 square feet per minute or less. As of this writing, the sweep rate of visitors to the Gelman collection exhibition remains the lowest, and therefore best, of any featured exhibition at the Nelson-Atkins.

15 Lipoff, "For Shawanoe Students, Art Is What They Make of It," 8.

16 Ibid.

BIBLIOGRAPHY

Henry, Carole. *The Museum Experience: The Discovery of Meaning*. Reston, VA: National Art Education Association, 2010.

Lipoff, Beth. "For Shawanoe Students, Art Is What They Make of It." *Kansas City Star* (MO), June 11, 2013.

The Nelson-Atkins Museum of Art. "Strategic Plan," 2013. Accessed April 27, 2016. http://www.nelson-atkins.org/strategic-plan.

Yenawine, Philip. *Visual Thinking Strategies: Using Art to Deepen Learning across School Districts*. Cambridge, MA: Harvard Educational Press, 2013.

Chapter 10

Supported Interpretation

Building a Visitor-Centered Exhibition Model

Pat Villeneuve

Supported interpretation, or SI, is a model for visitor-centered exhibitions. I developed it through an iterative process informed by decades of professional experience, the literature in a number of fields, collaboration and opportunistic experimentation, and a deep conviction that museum exhibitions should be for everyone. SI reconsiders an exhibition as an interface, or point of interaction between the museum and the visitor. A curatorial team comprising education, curatorial, and installation staff, as well as appropriate representatives of the museum audience, embeds the interface with mostly nontextual and nonauthoritarian resources that free-choice visitors may choose from to support their individual meaning making. In this chapter, I reveal the origin and development of the model and discuss the first SI exhibitions that helped refine SI guidelines.

KEY INFLUENCES

In my view, SI extends beyond the ideas and ideals of the constructivist museum, as most prominently articulated by Hein and Hooper-Greenhill.[1] Their work was informed by constructivist epistemologies that describe learning as a subjective, individual process of knowledge construction based on experiences, beliefs, and prior knowledge, rather than an objective process of accumulation of established knowledge. When applied to museum exhibitions, the constructivist museum shifts the responsibility for interpretation from the curatorial expert to the individual visitor.

Hein described how a constructivist practice in a museum would differ from a traditional one:

> The systematic [traditional] museum . . . is one based on the belief that: 1) the content of the museum should be exhibited so that it reflects the "true" structure of the subject-matter, and 2) the content should be presented to the visitor in the manner that makes it easiest to comprehend. . . . In contrast, proponents of the constructivist museum would argue that: 1) the viewer constructs personal knowledge from the exhibit, and 2) the process of gaining knowledge is itself a constructive act.[2]

Hein further detailed that a constructivist exhibition:

- will have many entry points, no specific path and no beginning and end;
- will provide a wide range of active learning modes;
- will present a range of points of view;
- will enable visitors to connect with objects (and ideas) through a range of activities and experiences that utilize their life experiences; and
- will provide experiences and materials that allow students in school programs to experiment, conjecture, and draw conclusions.[3]

I have expressed concerns that US general education has not systematically included content about art in the curriculum.[4] Consequently, many adults in this country may lack an adequate foundation to construct personally satisfying meanings about works they may encounter in an art museum. (How, for instance, can we expect visitors to construe the meaning of a postmodernist piece that makes oblique references to art historical iconography if they don't know the referents? And how likely are they to return to the museum if they feel confused or belittled there?) This establishes the need for some type of appropriate educational assistance or support, as provided in an SI interface.

Other key influences for my development of SI were methodological museology, as articulated by Van Mensch, and guided interaction, as described by Knowles.[5] Van Mensch reconceived a museum's functions from the traditional five—collect, preserve, exhibit, education, and study— to three, research, preserve, and educate. The critical difference in the new model is that it conflates the exhibition and education functions into a communication function to the advantage of museum visitors. This reconceptualization informed my use of a collaborative curatorial team. Knowles worked in *andragogy*, his term for adult education. He viewed adults as capable and responsible learners and advocated placing them in a content-rich environment to support their self-directed learning. He called this *guided interaction*. These ideas inspired my conception of the exhibition as an interface.

GETTING STARTED: A GOLDEN OPPORTUNITY

A rare opportunity in 2010 set the scene for the development of SI. I received a call from Arizona State University (ASU) asking if I would like to work on a curatorial project. The Hispanic Research Center (HRC) had received a small grant to mount a demonstration project, encouraging participants to try out something new that then might be parlayed into bigger grant funding or a larger project. From previous work with the HRC, I knew the unit had a substantial collection of modernist works on paper by Mexican American artists. I jumped at the opportunity and arranged a trip to Tempe. As ASU colleagues Mary Erickson and Melanie Magisos and I stood around the HRC conference table sifting through the collection, we recognized that many of the artworks referred to complex issues of identity and determined to make that the subject of a pilot exhibition. At the same time, we realized that visitors who did not recognize the iconography would not understand what the artists were expressing. What to do? The traditional response would be to include explanatory labels in the exhibition—"the geometric eagle graphic is the logo of the United Farm Workers of America"—but we were unwilling to add more words, knowing that visitors who opted not to read the labels could lack information necessary to interpret the objects.

I suggested instead that we could insert labeled, thumbnail images of all the symbols within the exhibition (Figure 10.1) so that visitors could use the

Figure 10.1. Installation view with thumbnails. *Source:* Homenaje 'a Cesar Chavez, ©1993 Ester Hernandez. Photo by Mary Erickson.

cues to construct their own meanings from the works of art (guideline 5).[6] To convey the topic of the exhibition and our expectations to visitors, we placed a short sign at the entrance to the exhibition, which we named *Mixing It Up: Building a Mexican American Identity in Art*:

> This exhibition explores how seven Mexican American artists have expressed ideas about who they are using symbols and images from both the Mexican and US cultures that impact their lives. Use the smaller images as clues to see what is important to these artists. What are they telling us about themselves?

We did not attempt to define "identity," thinking it would require too many words. Instead, we presumed visitors would be familiar with the idea or understand it from the context of the exhibition. Nonetheless, we were cautious of unintended takeaways and did not want visitors to leave thinking that identity was exclusively a Mexican American concern. To help them

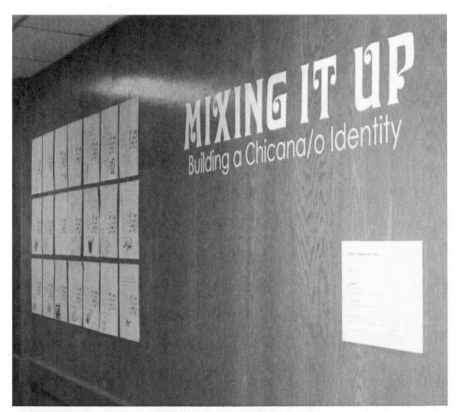

Figure 10.2. Visitor-participation wall. *Source:* ©Mary Erickson.

transfer the concept to themselves and make meaningful connections, we added a visitor participation wall at the exit (Figure 10.2). There visitors could complete and share open-ended worksheets that asked them to reflect on their identities and draw symbols representing themselves. The wall quickly filled, and an informal evaluation of the posted sheets suggested that visitors had indeed understood the concept of identity and could apply it to their lives.

I saw potential in the demonstration project and decided to pursue the approach for visitor-centered exhibitions. I initially referred to it as *guided interaction*, the term Knowles had used to describe an ideal learning situation for independent adult learners.[7] I later changed the term to *supported interpretation* out of concerns that *guided interaction* might convey a sense of an educator-controlled situation ("First look at this and then that and then that") rather than the supportive, self-directed environment I envisioned.

THEN A FULL-SCALE SI EXHIBITION

The demonstration project at the HRC led to another exhibition at the Tempe Center for the Arts in metropolitan Phoenix, Arizona.[8] I again joined my ASU colleagues in the curatorial process, with the following guidelines for SI gelling:

1. An SI exhibition is produced by a team of curatorial, education, and installation staff, along with appropriate representatives of the museum audience. The curatorial team works together from exhibition conception through evaluation and closing.
2. Anticipating visitors' needs to know, the curatorial team considers and develops plans for visitor engagement throughout the curatorial process, informing important decisions such as object selection and installation.
3. The exhibition is presented as an interface rich in challenges and educational resources visitors may choose from to support their individualized meaning making.
4. To determine the content of the interface, the curatorial team considers exhibition objectives and includes art and other pertinent content (historical, political, cultural, etc.).
5. Decisions about interface content and label copy assume diverse audiences but presume no specialized knowledge.
6. The resources embedded in the interface do not rely primarily on authoritarian didactics and encourage individualized and active learning.
7. The interface includes explicit directions to cue visitors on how they might participate.

8. Visitor contributions or other types of feedback are shared within the exhibition.
9. Evaluation is required and informs current and future exhibitions.[9]

The expanded curatorial team—including the gallery coordinator and pre-parator (a local Mexican American artist), among others—opted to continue exploring Mexican American art and the topic of identity (guideline 1). We wanted to be more ambitious with the interface, however, seeing if we could find ways to imbed learning resources about three themes in art and three artistic styles (guidelines 3 and 4). Remaining committed to our ideal of fewer words, we crafted one-sentence definitions of each:

Themes

National Identity—Artists explore connections with their US and/or Mexican heritages.
Labor—Artists comment on issues about workers.
Family and Community—Artists celebrate connections with others.

Styles

Traditional—Artists use old-world knowledge and techniques like anatomy, perspective, and shading to make their artworks look real.
Folk—Artists inspired by affordable art of the people often use lots of details, bright colors, and simplified, even cartoon-like shapes.

Figure 10.3. Exhibition entry with style and theme icons to the right. *Source:* ©Pat Villeneuve.

Graphic—Artists use affordable processes for wide distribution of dramatic, attention-grabbing designs.

The themes and styles, along with their definitions, appeared at the exhibition entry (Figure 10.3), accompanied by dedicated graphic icons inspired by the ubiquitous Mexican lotto game, *la lotería* (guideline 6). To reinforce learning of the themes and styles, we flagged strong examples of each with the appropriate icons within the exhibition.

Interactive Elements

To give visitors an opportunity to practice their learning and express their opinions, we built a tagging activity into the interface (guideline 2). Magnetic strips and a supply of icon magnets, along with a card with reminder definitions, were installed adjacent to select artworks (Figure 10.4) with an invitation to "pick which themes and styles fit this artwork." This enabled visitors to see the assessments of earlier visitors while also inviting them to leave their own opinions of style or theme for others to consider.[10]

Another interactive element appeared in an adjacent alcove where we recreated a traditional Mexican kitchen depicted in one of the artworks. We included an adapted *lotería* game board on a tabletop (Figure 10.5). Visitors could gather around the table and play our variation of the game by placing reproductions of exhibition artworks on appropriate theme or style icons. For example, a player might place a card of a print depicting work on the lower left icon representing Mexican labor. Other players might discuss placements, encouraging social interaction and learning:

> Looking for artworks that share similar themes engages visitors through attention to subject matter, while looking for artworks that share similar styles focuses their attention more on form and technique. The purpose of [an] interface is not only to stimulate careful viewing of individual artworks but also to guide visitors to make comparisons they might otherwise not consider.[11]

The *lotería* icons appeared again in an oversized visitor comment book at the exit. To encourage visitors to connect exhibition content with their lives, we matched each icon with a prompt, such as this for the family and community theme: "What family traditions are important to you?" Visitors shared many responses, particularly about food, and were observed reading the comments left by others. This activity dignified the experiences of all visitors, effectively making them an integral part of the exhibition (guideline 8).

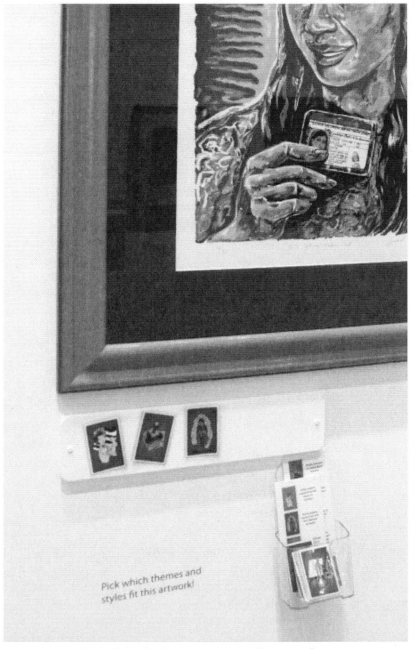

Pick which themes and
styles fit this artwork!

Figure 10.4. Tagging activity detail. *Source:* ©Pat Villeneuve.

Figure 10.5. Game adapted for exhibition. *Source:* ©Pat Villeneuve.

LESSONS LEARNED/MOVING FORWARD

As we prepared for the installation of the larger *Mixing It Up* exhibition, I drafted a short label telling visitors how they could interact within the exhibition. I intended it to be placed near the entrance, but the gallery coordinator thought it was unnecessary as the gallery had constant docent presence. Exhibition evaluation, however, revealed that many visitors were unsure about their participation, particularly in the alcove with the *lotería* game, which was located far from the docent desk (guideline 9).[12] Evaluator Alicia Viera also observed a disconnect between the individualized learning atmosphere we desired for the gallery and the traditional didactic approach of the docents. These shortcomings reinforced for me the importance of one of the original guidelines: 7. The interface includes explicit directions to cue visitors on how they might participate. I also established a new guideline based on evaluation findings: 10. Docents, if used, must be retrained as facilitators of personal meaning making, rather than conveyors of authoritarian knowledge.

The following SI exhibition I participated in was *Waxing Poetic: Exploring Expression in Art and Poetry*, held at the Figge Art Museum in 2012.[13] Labels introduced the exhibition and clearly welcomed various forms of participation (guideline 7):[14]

> Have you ever been puzzled by an artwork or confused by a poem? Some people expect that art should be beautiful or realistic and that poetry should rhyme. When they don't match our expectations, we might have a harder time figuring them out—or be tempted not to bother at all. In this exhibition, we use poetry to help interpret artworks that aren't traditionally beautiful or representational. We hope that this approach will encourage viewers to stop and think about the meanings and expression in the works of art.
>
> Start with an artwork that intrigues you. It doesn't have to be something you like. Take a good look. Read the poetry. Open yourself to the possibilities. Consider what the artist is expressing. This is a collaborative process, and we invite you to join in. There are lots of ways to participate:
>
> - **List** words that describe the feelings in an artwork
> - **Write** a poem to hang next to a work of art
> - **Tweet** a poem about something in the exhibition
> - **Share** your thoughts in the visitor comment book
> - **Create** your own response to the exhibition, such as an artwork
>
> Together we can build meanings exploring expression in art.

As the exhibition continued, staff noticed people sketching in the exhibition and added drawing media to the work tables in the gallery.

The day after the opening, I conducted a session with museum docents, explaining the intentions of SI exhibitions and asking them to work with me to create a role for docents in *Waxing Poetic*. They reimagined themselves as hosts in the gallery, facilitating visitors' participation and individual meaning making (guideline 10).

TO BE CONTINUED

The evolution of SI will continue as more exhibition venues curate SI exhibitions and audiences respond. I look forward to seeing more visitor-centered exhibitions in museums, as well as variations and adaptions, such as in the *Absolute Resolution* photography exhibition discussed in chapter 11. Forms may vary, but the intention remains to engage people with art in meaningful ways.

NOTES

1 Hein, George E. *Learning in the Museum*. New York: Routledge, 1998. Hein, George E. "The Constructivist Museum." In *The Educational Role of the Art Museum*, edited by Eilean Hooper-Greenhill, 73–79. New York: Routledge, 1994; Hooper-Greenhill, Eilean. "Museum Learners as Active Postmodernists: Contextualizing Constructivism." In *The Educational Role of the Art Museum*, edited by Eilean Hooper Greenhill, 67–72. New York: Routledge, 1994.

2 Hein, "The Constructivist Museum," 76.

3 Hein, *Learning in the Museum*, 35.

4 Villeneuve, Pat. "Supported Interpretation: Museum Learning through Interactive Exhibitions." In *Intelligence Crossover*, edited by Qirui Yang, 58–72. Hangzhou, China: The Third World Chinese Art Education Association, 2012, 65.

5 Van Mensch, Peter. "Methodological Museology, or towards a Theory of Museum Practice." In *Objects of Knowledge*, edited by Sue Pearce, 141–157. London: Athlone, 1990; Knowles, Malcolm S. *Andragogy in Action*. San Francisco: Jossey-Bass, 1984; Knowles, Malcolm S. *Informal Adult Education: A Guide for Administrators, Leaders, and Teachers*. New York: Association Press, 1955; Knowles, Malcolm S. *The Modern Practice of Adult Education: From Pedagogy to Andragogy*. Englewood Cliffs, NJ: Cambridge Book Company, 1988.

6 This refers to the SI guidelines presented in the next section.

7 Knowles, *Andragogy in Action*.

8 "Mixing It Up: Building an Identity," https://www.tempe.gov/home/showdocument?id=3528.

9 Throughout the chapter, see parenthetic references to the guidelines, by number, following clear-cut examples.

10 Villeneuve, Pat, and Mary Erickson. "Beyond the Constructivist Museum: Guided Interaction through an Exhibition Interface," *The International Journal of the Inclusive Museum* 4, no. 2 (2012): 49–64.

11 Villeneuve, Pat, and Mary Erickson. "La Lotería: Guided Interaction through a Visitor–Exhibition Interface." In *Museums at Play: Games, Interaction and Learning*, edited by Katy Beale, 358–371. Edinburgh: Museums, Etc, 2011, 368.

12 Villeneuve, Pat, and Alicia Viera. "Supported Interpretation: Exhibiting for Audience Engagement," *The Exhibitionist Journal* 33, no. 1 (2014): 57.

13 Figge Art Museum. http://figgeartmuseum.org/Figge-Art-Museum-(1)/February-2012/Waxing-Poetic--Exploring-Expression-in-Art.aspx.

14 Villeneuve, "Supported Interpretation."

BIBLIOGRAPHY

Figge Art Museum. http://figgeartmuseum.org/Figge-Art-Museum-(1)/February-2012/Waxing-Poetic--Exploring-Expression-in-Art.aspx.

Hein, George E. "The Constructivist Museum." In *The Educational Role of the Art Museum*, edited by Eilean Hooper-Greenhill, 73–79. New York: Routledge, 1994.

Hein, George E. *Learning in the Museum.* New York: Routledge, 1998.

Hooper-Greenhill, Eilean. "Museum Learners as Active Postmodernists: Contextualizing Constructivism." In *The Educational Role of the Art Museum*, edited by Eilean Hooper Greenhill, 67–72. New York: Routledge, 1994.

Knowles, Malcolm S. *Andragogy in Action.* San Francisco, CA: Jossey-Bass, 1984.

Knowles, Malcolm S. *Informal Adult Education: A Guide for Administrators, Leaders, and Teachers.* New York: Association Press, 1955.

Knowles, Malcolm S. *The Modern Practice of Adult Education: From Pedagogy to Andragogy.* Englewood Cliffs, NJ: Cambridge Book Company, 1988.

Mixing It Up: Building an Identity, https://www.tempe.gov/home/showdocument?id=3528.

Van Mensch, Peter. "Methodological Museology, or towards a Theory of Museum Practice." In *Objects of Knowledge*, edited by Sue Pearce, 141–157. London: Athlone, 1990.

Villeneuve, Pat. "Supported Interpretation: Museum Learning through Interactive Exhibitions." In *Intelligence Crossover*, edited by Qirui Yang, 58–72. Hangzhou, China: The Third World Chinese Art Education Association, 2012.

Villeneuve, Pat, and Mary Erickson. "Beyond the Constructivist Museum: Guided Interaction through an Exhibition Interface," *The International Journal of the Inclusive Museum* 4, no. 2 (2012): 49–64.

Villeneuve, Pat, and Mary Erickson. "La Lotería: Guided Interaction through a Visitor-Exhibition Interface." In *Museums at Play: Games, Interaction and Learning*, edited by Katy Beale, 358–371. Edinburgh: Museums, Etc, 2011.

Villeneuve, Pat, and Alicia Viera. "Supported Interpretation: Exhibiting for Audience engagement," *The Exhibitionist Journal* 33, no. 1 (2014): 54–61.

The *Absolute Resolution* Photography Exhibition

Facilitating Visitor Engagement with Supported Interpretation (SI)

Alicia Viera, Carla Ellard, and Kathy Vargas

It was August 28, 2015, minutes after 6:00 pm. Typically, Digital Pro Lab (DPL), a photo lab located in San Antonio, Texas, would be closed by now, but not that day. The DPL staff was finalizing the setup of cocktail tables outside the front entrance. Inside, a temporary intro wall was ready to welcome visitors by showcasing the title of a special pop-up exhibition curated for the space, a description of its themes, and instructions for visitor participation. Temporary walls gave the space the appearance of an art gallery while they hid the computer stations and desks usually displaying an assortment of marketing products.

There were photographs on display on every wall. Colorful round stickers with the exhibition icons were on the walls next to some of the photos. A participation wall set up in a corner of the room showcased 4 by 6 inch photos submitted by DPL Facebook followers in response to the exhibition themes. Even the TV screen that normally advertised DPL services and products was instead displaying a slideshow with the exhibition icons and guidelines for participation. On the other side of the room, the front desk had been set up to work as a bar and was ready to serve guests. *Absolute Resolution: A Participatory Photography Exhibition* was ready to open to the public. Throughout this chapter, we share details of the development of this visitor-centered exhibition, which was curated using the supported interpretation (SI) model.

GENESIS OF THE EXHIBITION

The planning of *Absolute Resolution* had started in March of 2015, when Amanda Dominguez, marketing manager at DPL, invited the lead author of this chapter to curate a photography exhibition that would convert the lobby

of their facility into an art gallery. DPL's primary goal was to participate in the 2015 FotoSeptiembre USA International Photography Festival, a local, month-long event that has celebrated photography in San Antonio for over twenty years.[1] The plan was to curate a group show that would engage the diverse photography community with whom DPL has been working for years, as well as new, up-and-coming photographers. DPL was open to accepting entries from amateurs, photography students, and professional photographers and did not wish to restrict the selection to only local photographers, although that represents most of their clientele and social media fan base.

Dominguez's plan was to create an online platform for the submission of photographs, to provide printing and mounting services at no cost to the selected photographers, and to generate revenue for the artists by selling their photographs and giving them 50 percent of the profit. However, as she put it, "it was the very first time we had attempted an event of this kind and magnitude."[2] The lab needed help, and Viera was motivated to get involved. She thought it was wonderful that a for-profit business such as DPL wanted to create a more meaningful relationship with the community it serves and suggested the use of supported interpretation, an inclusive, visitor-centered model for curating participatory exhibitions created by Pat Villeneuve.[3]

EXHIBITION DEVELOPMENT

Viera had already used SI in the past and started the exhibition development process by following the guidelines for its implementation.[4]

The Curatorial Team

SI calls for the use of a curatorial team whose members include experts from the community as well as representatives of different museum departments/ divisions. The curatorial team for *Absolute Resolution* included:

- Amanda Dominguez, marketing manager, DPL. Dominguez has thorough knowledge of the community the lab serves and of photography and photographic processes in general.
- Carla Ellard, curator/photography archivist at the Southwestern & Mexican Photography Collection, Texas State University's Wittliff Collections. Ellard has organized and served as juror for a number of photography exhibitions.
- Ray Seabaugh, large-format print and restoration manager, DPL. Seabaugh is responsible for printing, mounting, scanning, restoring, and retouching photographs at DPL.

- Kathy Vargas, artist/photographer and professor of photography and history of photography, University of the Incarnate Word. Vargas has served as juror for art exhibitions, has been visual arts program director/curator at a local arts organization, and also gallery director at her current university. Additionally, she was part of the curatorial team at a previous SI exhibition spearheaded by Viera.[5]
- Alicia Viera, director of cultural programs/curator, Texas A&M University-San Antonio's Educational and Cultural Arts Center (ECAC).[6] Viera has training and experience in museum education, visitor-centered exhibition curation, and program evaluation. She previously organized and co-curated an SI exhibition at the ECAC[7] and was the evaluator of another exhibition elsewhere.[8]

The three authors of this chapter happily volunteered their time to work on *Absolute Resolution* as a side project. We were passionate about joining forces with Dominguez and Seabaugh to strengthen the sense of community among photographers and involve the community at large through an SI exhibition. Throughout the exhibition development process, each of us took the lead, as needed, based on our areas of expertise.

Selecting the Works

Having experienced SI exhibitions in the past, either as curators or museum visitors, we were all fully on board with SI's visitor-centered approach to exhibition development and already had an idea of what to expect from the process. Nonetheless, Viera gave the group an introduction to SI, sharing the most relevant literature on the topic, guidelines, and details of previous implementations. Next, she helped Dominguez create the online submission platform. After the online form was tested and ready to receive submissions, a call for entries was distributed. Although the selection of works is a typical part of the curatorial process, this time we knew we were going to be selecting from a pool of digital photographs that could be printed to any size and on a variety of surfaces.

For our first meeting, Seabaugh and Dominguez provided the group with 4" 6" prints of all of the photographs submitted to facilitate their review and selection. In one marathon, four-hour session, we reviewed over 200 photographs from seventy photographers and started to group them intuitively into categories such as portraits, travel, documentary, nature, fashion, and fine art since the commonality of subject matter was noticeable. Multiple rounds of review allowed us to identify our top choices by selecting and discarding photographs as well as discussing the rationale behind each choice. The process culminated with a final selection of fifty photographs by thirty-one

photographers from San Antonio and elsewhere. Next, we needed to define the focus of the exhibition.

The Big Idea

Beverly Serrell advised that an exhibition team should begin by establishing a big idea, a statement that describes what the exhibition is about.[9] Although it wasn't necessarily a priority for us to come up with such a statement, given the time constraints, conversations at the first curatorial meeting eventually lead to one. Two main discussions occurred as we reviewed the submitted photographs: the technical side of what makes a good photograph and the impact or overall experience of taking and looking at a good photograph.

At this point, we engaged in a philosophical discussion about photography and the binding forces that unite being behind a camera to standing in front of a photograph. Vargas and Ellard motivated the group by talking about the foundations of photography, engaging everyone in conversations about the principles of design, the unique characteristics of the medium, and instinct, as something intrinsic to photography and as the initial factor that makes viewers respond to a photograph. As the first audience to view these photographs, we had the instinctive response of expressing what we thought made a photograph great and worthy to be part of the show. On the technical side, terms such as *light, color,* and *composition* were discussed, which made us realize they could become conversation starters among visitors. Additionally, the discussion of what makes a good photograph included the impact of the moment, the mood created, and meaning, as instilled by the photographer and interpreted by the audience.

We then wrote a statement that wouldn't necessarily meet Serrell's description of a big idea but would act as one. Our statement highlighted that impact and technique are both important in photography. Under the two major themes we included in it (impact and technique), we also identified six categories that could tie the exhibition together and stimulate visitor participation. They were *moment, mood,* and *meaning* (under *impact*) and *color, light,* and *composition* (under *technique*), which would lead to a discussion about the interactive components and the overall exhibition design. It was also around then that the title *Absolute Resolution: A Participatory Photography Exhibition* was born. The first part of it was agreed upon after trying different terms related to photography, and the second part was added to describe the end product.

Interactive Components and Interpretation

The conversation, both in subsequent online and face-to-face meetings and discussions, naturally transitioned to what could be done with the six

categories selected to engage the audience in a more meaningful exhibition experience. Led by Viera, the team came up with three opportunities for interaction with three different engagement levels, addressing visitors' variety of learning and interactivity preferences. One of the activities was to take place in the exhibition space, but the other two relied on social media. Overall, the three interactive opportunities that we selected intended to bridge the gap between physical visitors and online followers, bringing the latter into the exhibition space and extending the exhibition experience of the former outside the setting.

The first activity invited visitors to use stickers with the icons of the exhibition categories in order to tag their preferred photographs, labeling them as representative examples of said categories. The second activity was to be conducted via Twitter, and it invited visitors to use the aforementioned categories to respond to one or more of the photographs using the hashtag #dplAbsoluteResolution. The third and last activity invited DPL Facebook followers to share personal photographs matching the selected categories, which would be printed and posted to the participation wall that was part of the exhibition.

The DPL designer created icons to represent the six chosen categories. We then wrote brief descriptions of each and instructions on how to participate in the exhibition, which were later incorporated in the flier, the flat screen TV slideshow, and the introductory wall (Figure 11.1).

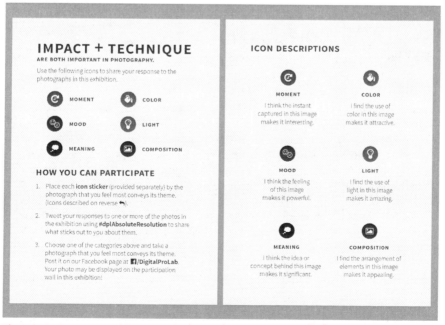

Figure 11.1. Front and back of flyer. *Source:* **Courtesy of Digital Pro Lab.**

When it came to label content, Viera selected short quotes from the artists' statements, addressing the selected categories to make visitors reflect on them and stimulate conversations in the exhibition space while highlighting the voices of the artists. For example, the following label content by three participating photographers highlighted the meaning, moment, and light categories:

Within 3 years I've lost seven members of my closest family. Self-Portrait without Face is about loneliness. After all I've been through I became a completely different person. My face no longer fits me.

Karolina Jonderko (Poland)

In between rounds at the Boys and Girls Clubs of San Antonio Golden Gloves Tournament, this fighter was almost out of energy. I found him focusing, just before the bell.

Robert Córdova (San Antonio, TX)

I'm intrigued by light and how its quality can change the emotions evoked by the image.

Jon Johnston (Schertz, TX)

Viera also wrote content for small text panels that would be applicable to more than one photograph in the exhibition. These panels were meant to encourage visitors to construct personal meanings and reflect on their own photography practices and to stimulate experimentation with new photography techniques and approaches. They had a different background color and were much larger than the regular labels. They also had a camera icon to the left of the text to draw attention. Some of the prompts in those text panels included:

Communicating a message with a photograph takes skill. Do you have a concept or idea that you think would make a great photograph?

An asymmetric composition (one in which there are no mirror images) can make your photographs more dynamic. Try experimenting with different viewpoints just by moving (right, left, up or down) right before taking your photographs. How different would this photo look if the moment had been captured from a balcony?

Telling the story of an event through photographs is not an easy task. What important event have you documented or would like to document with your camera?

At this point, we also finalized the wording for a revised curatorial statement:

A mere moment captured can give an image impact. The mood or meaning of a photograph can be affected by color. Effective use of light and composition can

demonstrate an artist's understanding of technique. Yet, from photographers to viewers, all of those qualities are defined, perceived, and interpreted differently. In this exhibition, we invite you to share what matters most when you are in front of a photograph or behind the camera.

Designing the Exhibition Interface

Designing the layout of the exhibition was a significant part of the space transformation. Early in the process, Viera met with Dominguez to come up with an exhibition layout suitable for their space. The DPL store has display areas with an assortment of products, computer stations for customers, and a long conference table. There is also a front desk area that had to remain in operation during the course of the show. The idea was to buy temporary wall panels that could be installed to hide the desks as much as possible, giving the space the appearance of a gallery. In alignment with the ideas of the constructivist museum,[10] Viera suggested a layout that wasn't linear and that was flexible enough to provide visitors with multiple ways of experiencing the exhibition. This layout also allowed for the venue to maintain most of the existing furniture in place. Temporary walls were going to be placed behind their floor-to-ceiling windows as well, to block the view

Figure 11.2. Intro wall. *Source:* **Courtesy of Digital Pro Lab.**

from outside and to provide more room for displaying photographs. In addition, an introductory wall with the title of the exhibition, category icons, and instructions on how to participate was going to be placed in front of the front doors (Figure 11.2).

As explained by Villeneuve, with SI "exhibitions become interfaces, or points of interaction between museum visitors and related content,"[11] which was fundamental to keep in mind when the time came to place the photographs and interactive components in the space. We grouped the photographs and considered the dimensions to which they could be printed and mounted, based on the specific walls where we wanted to install them. We also decided on the best location for the participation wall and the fliers and stickers that visitors were going to use to participate. We determined that the fliers and stickers would be held in a pocket that was part of the intro wall, allowing visitors to take them on their way in, and that the participation wall was going to be located at the back of the space (Figure 11.3).

During this stage, Dominguez and Seabaugh's expertise were central to the process. Seabaugh made suggestions on the best ways to present the

Figure 11.3. TV with slideshow and participation wall at the back. *Source:* **Courtesy of Digital Pro Lab.**

photographs as we discussed the impact each image needed to make in the show. Aesthetic decisions were made based on Seabaugh's recommendations, but he and Dominguez still had to make final decisions on print size based on image sharpness and pixelation. They would also choose paper and mounting styles since they were the ones in a position to showcase DPL products to best advantage. Once all of the photographs were printed and mounted, the team worked together to install them and their labels. The last part of the process was deciding the best locations for the text panels featuring questions and statements, which we ended up distributing throughout the exhibition interface.

The show was almost ready. Just final lighting adjustments were required at this point. As the exhibition opening day approached, Dominguez encouraged DPL Facebook followers to submit their own photographs explaining what category they best represented. She printed the submissions at 4" 6" as they were received, and the participation wall started to populate. By the time the exhibition opened (Figures 11.4 and 11.5), the wall was almost full. The only piece of the puzzle that was pending was the Twitter component, which was to be initiated after the exhibition opened. Unfortunately, given the time constraints, this component could not be executed as planned.

Figure 11.4. Gallery wall. *Source:* **Courtesy of Digital Pro Lab.**

Figure 11.5. Gallery layout shot. *Source:* **Courtesy of Digital Pro Lab.**

OPENING NIGHT

DPL staff had already made use of the stickers prior to the opening of the exhibition to provide a cue for visitors to follow their lead. The participating artists had been invited to experience the exhibition an hour before the official opening, and some of them were starting to arrive. Up to that point, they had been informed of the choices made by the curatorial team, but none of them had seen how their photographs had been presented. This was their opportunity to become familiar with the different printing and mounting processes that had been selected, as well as to engage in informal conversations with the curators and DPL staff. Very soon the public began to arrive, and the place started to fill up. The owner of the business welcomed visitors by the entrance handing out fliers and sticker sheets for them to participate in the exhibition.

The director of the FotoSeptiembre USA festival was in attendance, and a number of local photographers were seen walking around the exhibition space. There were also photography students and photo aficionados since the exhibition marked the beginning of the annual festival. The exhibition space remained crowded for the rest of the night. Attendees were spotted having conversations about the work and getting their pictures taken in front of the photographs. They were also seen looking at photographs on the participation

wall, reading the labels that showcased quotes by the artists as well as the text panels that stimulated reflections on photography techniques and processes. They seemed to be reflecting on the exhibition themes described on the fliers before carefully placing their stickers next to their favorite photographs. Overall, it was a well-attended and enjoyable night, and an experience the DPL staff was never going to forget: their first FotoSeptiembre and SI exhibition.[12]

LOOKING BACK

The curatorial process for *Absolute Resolution* was exhilarating for all of us. We were inspired by each other's ideas and suggestions and enjoyed putting the visitors first. We certainly appreciated the collegial exchange of ideas taking place in our meetings, the opportunity of seeing and discussing works by a variety of photographers, and SI's visitor-centered approach to exhibition development. Viera is grateful that DPL approached her to work on this show and that the business was on board with the idea of using the model. SI provided an opportunity for taking a collaborative approach to exhibition curation, including local professionals in the exhibition development process and engaging the broader community on-site and online. The show prompted reflection while stimulating photography practices.

Dominguez shared what *Absolute Resolution* meant for their business:

> For us, the exhibition allowed us the opportunity to show that we are supporters of the arts and of creative expression through photography. . . . Through an exhibition like this, you are inviting people out to your business, not to sell them something, but to show them that you are interested and care about the things they care about. It makes your business more approachable. . . . and then after the exhibition, they remember your business. . . . The other great thing about an exhibition like *Absolute Resolution* is the artists become advocates for your business, which is a powerful thing.[13]

Vargas has already become an advocate for DPL herself, recommending it to her students and colleagues. She saw the show as an opportunity for photographers to have their work seen in a different way, one that compelled the audience to respond actively. She argues that all artists, photographers included, love audience feedback and feels that this exhibition, because of its accessibility and inclusiveness, guaranteed that the feedback was going to be far-reaching. Vargas was also happy to help Viera implement SI again at this exhibition. The unconventional experience we were providing for visitors with the help of the SI model was also important for Ellard, not only because the show was taking place at an alternative exhibition space but also because

of its interactive nature. As she puts it, watching both photographers and visitors interact and select themes from their favorite images was inspiring. Dominguez shared a similar sentiment when she said:

> The Absolute Resolution photography exhibition far exceeded our expectations. . . . Not only did the exhibition open a dialogue about photography as an art form, but it also brought artists, photographers, and photo enthusiasts to our business that had never been before. Not only were they met with an exhibition that was unique in that it invited active participation with the works on display, but also our products and our company's appreciation and encouragement of printing photos, which is happening less these days. . . . From a marketing and business standpoint, the participatory nature of the exhibition online, via social media outlets, helped to invite interaction with our social media pages, increasing our brand's reach.[14]

She also shared some of what she thinks made the exhibition successful:

> I think the participatory aspect of the exhibition set us apart from other Foto-Septiembre exhibitions and other exhibitions in general. The use of stickers to encourage audience participation was a big hit! Moreover, the curatorial team took great care to ensure that all peoples were able to participate, regardless of age, intellect, interest, language, or background. . . . Another aspect of Absolute Resolution that set it apart, in my opinion, was the educational component. Through the exhibition, we openly invited attendees to acknowledge and question the key components that make great imagery. It introduced individuals to these different terms and brought them to the forefront of the overall discussion that was the theme of the exhibition.[15]

After curating *Absolute Resolution*, we argue that SI can facilitate two-way museum–audience communication and bring collaboration and participation to the center of both the curatorial process and the visitor experience. Facilitating the construction of meanings and meaningful connections with art is what makes an experience visitor-centered, and it is with inclusive, visitor-centered exhibition development practices/models, such as SI, that museums, galleries, and alternative exhibition spaces can truly make a significant impact in the communities they serve and become part of the everyday lives of their community members.

NOTES

1 FotoSeptiembre USA. *About.* http://fotoseptiembreusa.com/fotoseptiembre/about/.

2 Amanda Dominguez, e-mail message to author, June 12, 2016.

3 Villeneuve, P. "Building Museum Sustainability through Visitor-Centered Exhibition Practices," *The International Journal of the Inclusive Museum* 5, no. 4 (2013): 37–50; Villeneuve, Pat, and Mary Erickson. "La Lotería: Guided Interaction through a Visitor-Exhibition Interface." In *Museums at Play: Games, Interaction and Learning*, edited by Katy Beale, 358–371. Edinburgh: Museums, Etc, 2011; Villeneuve, Pat, and Alicia Viera. "Multiculturalism and the Supported Interpretation (SI) Model: Embracing Cultural Diversity through Inclusive Art Exhibitions." In *Multiculturalism in Art Museums Today*, edited by Joni Boyd Acuff and Laura Evans, 81–94. Lanham, MD: Rowman & Littlefield, 2014.

4 Villeneuve, Pat, and Alicia Viera. "Supported Interpretation: Exhibiting for Audience Engagement," *The Exhibitionist Journal* 33, no. 1 (2014): 54–61.

5 The previous SI exhibition was entitled *Contemporary Latino Art: El Corazón de San Antonio* and was on display from May to September 2014 at the Texas A&M University-San Antonio's Educational & Cultural Arts Center (ECAC).

6 Viera is currently an interpretive planner at the Detroit Institute of Arts, but she was working at the ECAC at the time of this exhibition.

7 For *Contemporary Latino Art: El Corazón de San Antonio*, the inaugural exhibition of the ECAC, Viera invited Vargas and Villeneuve, among others, to join the curatorial team.

8 Villeneuve and Viera, "Multiculturalism and the Supported Interpretation (SI) Model," 81–94; Villeneuve and Viera, "Supported Interpretation," 54–60.

9 Serrell, Beverly. *Museum Labels: An Interpretive Approach.* Lanham, MD: Roman and Littlefield, 2015.

10 Hein, George E. *Learning in the Museum.* New York: Routledge, 1998.

11 Villeneuve and Viera, "Supported Interpretation," 58.

12 To see more pictures of the *Absolute Resolution* exhibition, visit: http://fotose ptiembreusa.com/fotoseptiembre-usa-2015-digital-pro-lab/.

13 Amanda Dominguez, e-mail message to author, June 12, 2016.

14 Ibid.

15 Ibid.

BIBLIOGRAPHY

FotoSeptiembre USA. *About.* http://fotoseptiembreusa.com/fotoseptiembre/about/.

Hein, George E. *Learning in the Museum.* New York: Routledge, 1998.

Serrell, Beverly. *Museum Labels: An Interpretive Approach.* Lanham, MD: Roman and Littlefield, 2015.

Villeneuve, Pat. "Building Museum Sustainability through Visitor-Centered Exhibition Practices," *The International Journal of the Inclusive Museum* 4, no. 4 (2013): 37–50.

Villeneuve, Pat. "Supported Interpretation: Museum Learning through Interactive Exhibitions." In *Intelligence Crossover*, edited by Q. Yang, 58–72. Hangzhou, China: World Chinese Art Education Association, 2012.

Villeneuve, Pat, and Mary Erickson. "La Lotería: Guided Interaction through a Visitor-Exhibition Interface." In *Museums at Play: Games, Interaction and Learning*, edited by Katy Beale, 358–371. Edinburgh: Museums, Etc, 2011.

Villeneuve, Pat, and Alicia Viera. "Multiculturalism and the Supported Interpretation (SI) Model: Embracing Cultural Diversity through Inclusive Art Exhibitions." In *Multiculturalism in Art Museums Today*, edited by Joni Boyd Acuff and Laura Evans, 81–94. Lanham, MD: Rowman & Littlefield, 2014.

Villeneuve, Pat, and Alicia Viera. "Supported Interpretation: Exhibiting for Audience Engagement." *The Exhibitionist Journal* 33, no. 1 (2014): 54–61.

Chapter 12

Visitor as Activist

A Mobile Social Justice Museum's Call for Critical Visitor Engagement

Monica O. Montgomery and Hannah Heller

> I feel Black Lives Matter is propelled by young people, but it has an access point for old people like myself, so it gives me a space to delve into their efforts and spreading information. I don't feel like this is just some crazy young people being radical and young. These are young people, and they're concerned about their future, and they are allowing me to help them in their efforts so that the world can be a better place. That's cool.[1]

Museum of Impact (MOI) is a mobile social justice museum. Our exhibitions engage and inspire our diverse audiences to use our institution as a vehicle of social change, to make community real and relatable with the unapologetic presence of its members from all backgrounds. Many of our exhibitions speak to the diversity of the African, Latino, Asian, Indian, and First Nations diaspora in the United States and abroad and relate to issues communities of color face. Our goal is to create emotionally resonant spaces that empower people to become "solutionaries" and be agents of change for themselves and their surroundings.[2]

Our practice dwells in radical investigation, provocation, and co-creation, using environmental soundscapes, multimedia compilations, memorials and reflection space, question prompts, didactics, live performance, and visual art. We encourage visitors to think critically and find connection and outlets for creative expression as we share the good news of movement building. By default, our exhibits celebrate changemakers' spirit—especially innovators who outwit societal oppression. In our selection of artists, activists, and partners, we honor everyday people who are making a difference in our world, as we strive to inspire visitors to see their role as those who will improve our collective future.

We aim in this chapter to describe MOI, our inaugural exhibition named *Movement Is Rising* and its main objectives, as well as the various ways the

exhibition utilized different approaches to curation that not only put the visitor first but also prioritized their response as a means for channeling emotion into inspired action. Guided by an abiding belief in the need for collective catharsis and in particular by a critical learning approach, MOI, and in turn its revolving schedule of exhibitions, allows for multiple opportunities for participation and meaning making.

ABOUT MOI AND *MOVEMENT IS RISING*

MOI crafts temporary exhibitions around pressing social justice issues, encouraging visitors to take action where and when they can. With its focus on "archiving the now," and nimble traveling model, MOI offers a faster response time to contemporary issues than traditional museums.[3] MOI doesn't offer canned responses, dominant cultural narratives, or predetermined experiences. The visitor's experience is paramount, and we thrive off resonant moments of cause and effect that create ripples and shifts in our society's memory and consciousness. We counteract patriarchal messages and hidden agendas and curriculum of traditional art museums by grounding our approach in multidisciplinary, free-choice learning, and progressive, critical pedagogies. We aim to be a model for traditional museums interested in reaching visitors where they are, with the explicit goal of achieving societal change.

MOI's inaugural exhibition, *Movement Is Rising*, connected visitors to the human rights injustices perpetrated against people of color around the nation. The exhibition raised awareness about racialized violence; martyrs like Eric Garner, Trayvon Martin, Sandra Bland, and Mike Brown; and contemporary social movements such as #BlackLivesMatter, #HandsUpDontShoot, and #SayHerName. The exhibition emerged in solidarity and resonance with international calls for reform, harm reduction, deconstruction of systemic oppression, prejudicial treatment, police brutality, and racial bias in an effort to inspire change and creative expression in communities affected by extrajudicial injustice and inequality. Featuring both established and emerging *artivists* (artist + activist),[4] as well as dynamic opportunities for response and reflection, *Movement Is Rising* channeled the bravery and brilliance of new artists and leaders in the movement into a dialogue on everyday interventions and action steps that people can tackle. The exhibition first popped up in Harlem in September 2015, and the Brooklyn Museum in February 2016, and will travel to several other mid-Atlantic cities by year-end 2016. This chapter will focus on initial efforts that took place in Harlem and Brooklyn.

A CRITICAL APPROACH TO CURATION—WHAT DOES IT MEAN, AND WHAT DOES IT LOOK LIKE?

MOI takes a critical approach to curating, couching our efforts in an explicitly educational context. Critical learning, or pedagogy, is derived from the field of critical theory, which upholds critical thinking as its mainstay. Critical thinking has been described as "the longing to know—to understand how life works."[5] But critical thinking is not just about raising questions. Paulo Freire, one of the most well-known critical pedagogues, argued that criticality is a form of becoming more fully human. [6] Critical thinking strives toward a goal of humanization and empowerment for all. Critical thinking allows space for critique of the institutions we are familiar with and take for granted, recalling educator John Dewey's words that, "democracy has to be born anew in each generation, and education is its midwife."[7] Democracy is not, and has not always been, a given in this country, and requires constant work and vigilance.[8] Critical thinking engages with the notion of knowledge—what do we know, how do we know it, who tells us this is so? The next section will explore several important tenets of critical pedagogy and how these elements have informed our own practices as social justice museum workers.

Major Tenets of Critical Pedagogy

Freire was one of the first critics to apply notions of critical thinking to schools and education. He decried the "culture of silence" that he saw in schools in his native Brazil.[9] He found that schools suffered from a "narration sickness" whereby the object (teacher) is tasked with filling the subjects (students) with narratives the teacher deems important. This is his "banking" theory of education, where teachers do the thinking, speaking, teaching, choosing, acting, all in an effort to "deposit" information into the students, who passively accept.[10] These "deposits" are often contradictions to the reality of the students. This system serves the oppressor, as they dictate what narratives get told and how. School curricula are an additional site of contestation, one of the "fronts" on the battle for the democratization of knowledge.[11] The challenge of schooling is not to find the most efficient ways to transmitting knowledge, but rather how content can be based on exploring questions of "whose knowledge" is being taught and why. One way of doing this is deprivileging more accepted ways of knowing and shifting discourse to having multiple "centers"—gendered, racial, and class-based readings of the world.[12] To subvert the banking system of education is to acknowledge that we all are not only in this world but we also act upon it.[13]

Thus, any attempt to radicalize requires a shift in teaching—a critical pedagogy. This shift may be characterized as one from a language of critique toward a language of possibility.[14] Power must be used for social betterment, not to reinforce the status quo. In other words, a revolutionary educational system that just resorts to the banking system by depositing different information is simply perpetuating a new form of oppression. Countering this, though, requires a radical shift in what information is taught, as well as how. Of course, many traditional museums are just as guilty as schools for assuming a banking theory of knowledge, relegating to exhibition margins works by non-white cultures and assuming a Western, patriarchal voice of representation.[15] Some major guiding elements for how this might be undone follow.

Learning from the Oppressed

One of the most important elements of critical pedagogy is the charge to learn anti-oppression from those who are oppressed themselves. Freire wrote: "No pedagogy which is truly liberating can remain distant from the oppressed by treating them as unfortunates and by presenting for their emulation models from among the oppressors."[16] Audre Lorde further discussed the responsibility we have to seek out these lessons so that "we not hide behind the mockeries of separations that have been imposed upon us and which so often we accept as our own."[17] One example she gave is of a white person suggesting that he or she cannot teach black women's writing because their experience is so different from his or her own, and yet teachers of all races and genders teach Plato, Shakespeare, and Proust. This represents one of the ways we continually reflect and perpetuate traditional hierarchies of knowledge. In opposition to this, *Movement Is Rising* was inspired by and sought out artivists of color puzzling through oppression through their art. We additionally hope to learn as much from our visitors' responses to the art and interactive content as they do by participating in it.

Interactivity

Following from the guiding element "learning from the oppressed," we respond to the need for participation in a democratic society to be just that— participatory.[18] People who are oppressed can learn social responsibility only by "experiencing that responsibility," through intervening in the "destiny" of public settings such as schools, unions, churches, and the like.[19] Democracy can be learned only through exercising it; democratic knowledge can only be "assimilated experientially."[20] Indeed, given our interest in our visitors coming away with concrete learning tools for impacting the world, we would be remiss if we did also provide interactive learning tools toward this end.

Dialogic Process

What does interactive learning look like? bell hooks described critical thinking as "an interactive process, one that demands participation on the part of the teacher and student alike."[21] The process of dialogue enables several key elements of critical thought. First, it "imposes itself as the way by which they [the oppressed] achieve significance as human beings," establishing itself as an "existential necessity."[22] Second, the process of dialogue allows participants to engage in their "naming of the world, which is an act of creation and re-creation."[23] However, it is not an imposition of truth, where those in power name on behalf of those less powerful. Freire maintained that true dialogue that serves the purpose of criticality cannot exist without humility, faith, and trust in one's co-participants. Without faith in those you are speaking with, "dialogue is a farce which inevitably degenerates into paternalistic manipulation."[24] There are many lessons here for our work, in particular the goal of establishing a dialogue through our exhibitions that not only raises an issue but also proposes multiple avenues for visitors' response, for them in effect to "name" their own next steps toward social justice.

Museums and Criticality

In many ways, these very questions around how we name our own world and how we know what we know are embedded in museum work, given their historical and traditional roots. What knowledge are museums representing? How? What stories are worth telling? Whose perspective is being represented? Museums may be considered sites of "critical public pedagogy," where "practicing critical pedagogy" may occur.[25] The very nature of museum curation—who chooses what to show or which cultures to represent—inspires important questions that recall a critical pedagogical approach. Like schools, museums may be considered "sites of contestation and reconstruction."[26] Indeed, museums must capitalize on the "counterdiscursive space" they provide.[27] This notion echoes the need for the aforementioned questions, adding too a need to consider, through object exhibition, whether a museum truly encourages cultural autonomy and embraces opportunities to authentically collaborate with communities that represent traditionally marginalized groups.[28] Only when museums commit to these modes of introspection can they truly call themselves sites that foster critical thinking.

We believe there is possibly room for alternative modes of criticality that emanate not only from the art works but also from associated interactive elements. This is where MOI locates its "sweet spot" of potential impact, implementing specific arts-based opportunities for engagement with the issue at hand within the exhibition design.

CRITICAL ENGAGEMENT IN *MOVEMENT IS RISING*

Aiming to provide an interactive "discursive space" referred to previously, *Movement Is Rising* incorporated several different "stations," in addition to the visual artworks themselves that bridge the concepts of installation, visitor participation, and performance art. Some examples of these that particularly involve critical engagement follow.

Every Mother's Son is a poster image of a mural featuring mothers of the martyrs. Visitors used markers and Post-its to express their feelings and ideas on how we can keep any more parents, guardians, friends, and loved ones from being heartbroken over extrajudicial killings (Figure 12.1). Our critical-ity in this instance envisioned artwork as a provocation to be reacted to. This piece draws out the pathos of black mothers across the country and diaspora, mothers who have endured the unimaginable horror of losing their children to police violence, an all-too-common grievance in communities of color that adds insult to injury. This work stands out as a large-scale interactive where art must play healer, bridge builder, repairer, and educator to help us move forward as a society, transfixing the visitor to respond. No matter what hap-pened in the cases of the mothers and sons, the blood debt of their crimes becomes part of our civic responsibility. The work challenges the visitors to not just memorialize the piece as a shrine for the dead, and not only react emotionally, but channel those emotions into a personal and critical reflec-tion, answering the call: what will *you* do?

The Unindicted is an audience performance piece offering visitors a chance to have visceral reactions and unapologetic emotional responses to the images of unindicted police officers and vigilantes. The images bear resemblance to a "wanted" picture with the name and person they killed. Visitors in the space are invited to react to the images—simply read them, draw over, or destroy images as they see fit to grieve and express disdain for the heinous, violent, and racist acts they represent (Figure 12.2). Visitors are given space not only to emote likely internalized frustrations, anger, and sadness but also to con-sider a flipped reality in which perpetrators of state-sanctioned violence are held accountable for their actions. In this case, criticality involves a kind of one-sided dialogue with the oppressor where finally the oppressed have the microphone and the power to call out injustice.

Activist Love Letters (ALL) is a transmedia project amplifying activism as a public benefit and participatory action.[29] ALL hosts a community archive encouraging participants to write and share their support and admiration for past, present, and future activists (Figure 12.3). Additionally, through using dialogue, art making, and envisioning, participants speak in small groups as activists-in-training and record their own oral histories. Among many things, these histories and interviews articulate shared hopes and dreams for

Figure 12.1. "Not One More!" Detail of responses to *Every Mothers Son*, the exhibition's copy of a mural by Sophia Dawson, 2016. Participants were instructed to place sticky notes on the piece with their thoughts, ideas, and feelings. *Source:* ©Adia Harris, Artwork by Sophia Dawson.

community uplift and intersectional understanding of social action movements and processes for engaging in organizing work. ALL provides an opportunity for visitors to engage critically with the real-life responsibilities around activism and their own potential for taking on this role. Writing a letter to an activist demands a degree of empathy, of learning from the "oppressed," who in this case learned the impact and benefit of critically looking at the world and now provide an example for us. One participant remarked that she appreciated writing a letter, as "it can feel very exhausting and very lonely being an activist"—the knowledge of knowing there are others like her, fighting the same fight in their own ways can be an incredibly gratifying moment and provide the energy to keep going.[30]

Upstanders pledge is a pledge to take action and not be a bystander to societal problems. Visitors learn about resources and organizations doing movement work and brainstorming with MOI staff and other like-minded visitors on actions they can take. They then have the option to read an oath and take a bracelet memento reminding them that fighting for justice takes some combination of fists, heart, or feet. This pledge to uplift our

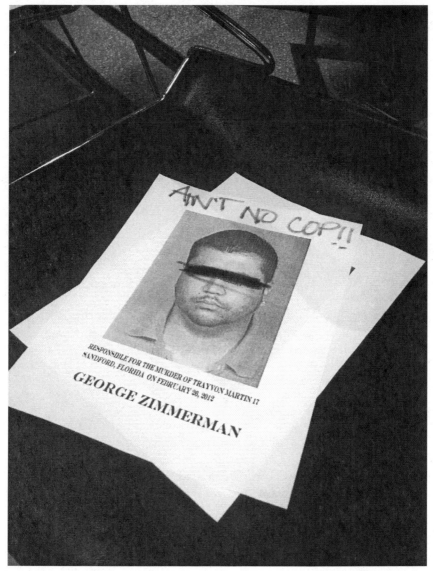

Figure 12.2. Example of response to *The Unindicted,* a collective performance piece.
Source: ©Adia Harris.

communities one person at a time inspires everyone to see themselves as
part of the change; it provides an entry-level access point to interacting
with social justice. Although many of our visitors are well versed in the
different movements and their concerns, we hope to also provide support
to those less aware but eager to take part. The pledge meets these visitors
where they are, allowing them—not us—to engage in the internal dialogic

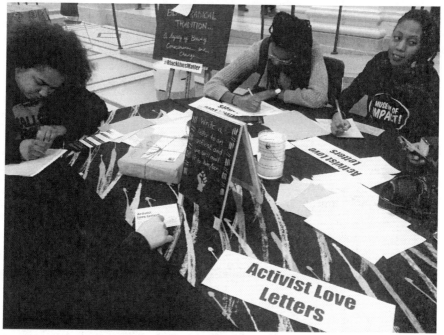

Figure 12.3. Visitors writing their own "Activist Love Letters" at the pop-up event at the Brooklyn Museum, February 2016. *Source:* ©Adia Harris.

process that enables them to authentically name their own steps toward social justice action.

In curating, we highlight the importance of culture, community, charity, creativity, and change, offering thoughtful exhibit work that is democratic in its forms, aims, and outcomes and focused on the interrelationships among people, power, and society. It is our aim to consistently open dialogue that adds vibrancy and embraces the cornerstone of communities. We encourage and support our upstanders to create and debate at MOI pop-ups, as a way to advance culture and democracy, and open commentary around our themes and beyond.

CONCLUSION: IMPLICATIONS AND LESSONS FOR TRADITIONAL MUSEUM MODELS

According to a report conducted by the American Alliance of Museums and the Center for the Future of Museum in 2010, only 9 percent of museum visitors are people of color.[31] These paltry numbers reflect an overall reality in our society that keeps people of color in the margins. We see the rippling

impact of these intentional and unintentional barriers to cultural offerings affecting people of color in communities large and small across the United States and abroad and have focused our potential for impact in the form of a mobile social justice museum.

Museums can and should adopt a nimbler approach to curation. We are activating creative placemaking in urban communities, searching for areas where there exists a critical mass of people desirous for more relevant cultural offerings. We pop up with art and activism in the streets, in disenfranchised communities, in areas where art, culture, and creativity are lacking.

We believe curating has a power to shape conversations and perspectives. It's already been tried and tested that public programs are a mainstream mechanism museums use to respond to social issues. However, museum educators, programmers, and curators alike need to push past the standard and draw upon new ways of knowing, utilizing curation as a radical transformative act that echoes story, meaning, and intention, beyond art for art's sake, or history for history's sake. Intentional, participatory, and evocative exhibition design is a bold way for museums to openly engage with the ebb and flow of humanity, its imperfect cultures and customs, and issues around the world.

Visitors are more likely to critically engage with topics that are pressing and relevant to their current lives. Each visitor has the potential to personally connect to activism, but that connection needs to be authentic and grow from a source of personal meaning, intention, and urgency. This is why we encourage our visitors to develop the look and feel of the exhibition with us, in the form of telling their individual stories verbally and artistically in the context of the landscape of social movements. In this way, they are imprinting their organic, critically aware reactions onto the exhibition, which keeps reflection continual, honest, and transparent as the shape of the exhibit organically changes from day to day.

"Archiving the now" is tantamount to appreciating the gravity, history, and importance of what's happening in our world and coming up with ways for people to interact with current events and notable issues. We are "archiving the now" because we realize what most institutions don't want to admit: politically charged views and contemporary issues take up more of our collective attention as a society and weigh heavily on our psyche and perceptions. If museums are to become dynamic, critical, responsive institutions, evolving past collections, repositories, and archival usages, we have to embrace the present and the unpredictability of humanity in all of its glory, story, error, and chaos. Other humanities industries, including news media, theater, cinema, dance, opera, poetry, music, and more, are embracing current events and using social justice issues as a muse and a catalyst for creating new works. We believe institutions with large endowments as well as small volunteer-run museums (much like ours!) have the potential to transform their spaces into

hubs for critical thinking around social justice contemporary curations. If museums embrace this ideology and apply it to the "ivory tower" of curation, our exhibits can allow the tenor of what is happening in the world to shift the focus of the institution toward reflecting its visitors, its community, and their values.

NOTES

1 Anonymous visitor, exit interview with Hannah Heller, Brooklyn Museum, February 6, 2016.

2 For more information on Museum of Impact, see our website: www.museum ofimpact.org.

3 "Our Mission," Museum of Impact. Accessed June 21, 2016. http://www. museumofimpact.org/#!about-us/y2do8.

4 Asante, Molefi K. *It's Bigger Than Hip-Hop: The Rise of the Post-Hip-Hop Generation.* New York: St. Martin's Press, 2008.

5 hooks, bell. *Teaching Critical Thinking: Practical Wisdom.* New York: Routledge, 2010, 7.

6 Freire, Paulo. *Pedagogy of the Oppressed.* New York: Continuum, 1970, 44.

7 Dewey, John. *The Middle Works, 1899–1924.* Carbondale, IL: SIU Press, 1980, 139.

8 Dewey, *Middle Works*, 139.

9 Freire, *Pedagogy*, 71.

10 Ibid., 73.

11 Apple, Michael W. *Official Knowledge: Democratic Education in a Conservative Age.* New York: Routledge, 2014.

12 Apple, *Official Knowledge*, 137–138.

13 Freire, *Pedagogy*, 75.

14 Giroux, Henry. *Border Crossings: Cultural Workers and the Politics of Education.* New York: Routledge, 2005.

15 Alexander, Edward P., and Mary Alexander. *Museums in Motion: An Introduction to the History and Functions of Museums.* Lanham, MD: AltaMira Press, 2008; Golding, Vivien. *Learning at the Museum Frontiers: Identity, Race, and Power.* Farnham, Surrey, England: Ashgate Publishing Company, 2009; Lynch, Bernadette T., and Samuel J.M.M. Alberti. "Legacies of Prejudice: Racism, Co-Production and Radical Trust in the Museum," *Museum Management and Curatorship* 25, no. 1 (2010): 13–35; Weil, Stephen E. *Making Museums Matter.* Washington, DC: Smithsonian Institution Press, 2002.

16 Freire, *Pedagogy*, 54.

17 Lorde, Audre. "The Transformation of Silence." Paper delivered at the Modern Language Association's "Lesbians and Literature" panel. Chicago, IL, December, 1977.

18 Freire, Paulo. *Education for Critical Consciousness.* London: Bloomsbury Academic, 1973/2014.

19 Freire, *Education*, 32.
20 Ibid.
21 hooks, *Teaching Critical Thinking*, 9.
22 Freire, *Pedagogy*, 88–91.
23 Ibid.
24 Ibid.
25 Mayo, Peter. "Museums as Sites of Critical Pedagogical Practice," *Review of Education, Pedagogy & Cultural Studies* 35, no. 2 (2013): 144–153.
26 Mayo, "Museum as Sites," 147.
27 Acuff Boyd, Joanie, and Laura Evans. "Introduction and Context." In *Multiculturalism in Art Museums Today*, edited by Joanie Acuff Boyd and Laura Evans, xiii–xxxiv. Lanham, MD: Rowman & Littlefield, 2014, xxviii.
28 Acuff Boyd and Evans, *Multiculturalism*, xxviii.
29 While we are aware that another project by the same name exists (see: https://syrusmarcusware.com/past-projects-exhibitions/activist-love-letters/) MOI is and always has been completely unaffiliated.
30 Anonymous visitor, interview by Hannah Heller, Brooklyn Museum, February 6, 2016.
31 Farrell, Betty, and Maria Medvedeva. *Demographic Transformation and the Future of Museums*. Washington, DC: AAM Press, 2010.

BIBLIOGRAPHY

Acuff Boyd, Joanie, and Laura Evans. "Introduction and Context." In *Multiculturalism in Art Museums Today*, edited by Joanie Acuff Boyd and Laura Evans, xiii–xxxiv. Lanham, MD: Rowman & Littlefield, 2014.

Alexander, Edward P., and Mary Alexander. *Museums in Motion: An Introduction to the History and Functions of Museums*. Lanham, MD: AltaMira Press, 2008.

Apple, Michael W. *Official Knowledge: Democratic Education in a Conservative Age*. New York: Routledge, 2014.

Asante, Molefi K. *It's Bigger Than Hip-Hop: The Rise of the Post-Hip-Hop Generation*. New York: St. Martin's Press, 2008.

Dewey, John. *The Middle Works, 1899–1924*. Carbondale, IL: SIU Press, 1980.

Farrell, Betty, and Maria Medvedeva. *Demographic Transformation and the Future of Museums*. Washington, DC: AAM Press, 2010.

Freire, Paulo. *Education for Critical Consciousness*. London: Bloomsbury Academic, 1973/2014.

Freire, Paulo. *Pedagogy of the Oppressed*. New York: Continuum, 1970.

Giroux, Henry. *Border Crossings: Cultural Workers and the Politics of Education*. New York: Routledge, 2005.

Golding, Vivien. *Learning at the Museum Frontiers: Identity, Race, and Power*. Farnham, Surrey, England: Ashgate Publishing Company, 2009.

hooks, bell. *Teaching Critical Thinking: Practical Wisdom*. New York: Routledge, 2010.

Karp, Ivan, and Steven D. Lavine. "Introduction: Museums and Multiculturalism." In *Exhibiting Cultures: The Poetics and Politics of Museum Display*, edited by Ivan Karp and Steven D. Lavine, 1–10. Washington, DC: Smithsonian Institution Press, 1991.

Lorde, Audre. "The Transformation of Silence." Paper delivered at the Modern Language Association's "Lesbians and Literature" panel. Chicago, IL, December, 1977.

Lynch, Bernadette T., and Samuel J.M.M. Alberti. "Legacies of Prejudice: Racism, Co-Production and Radical Trust in the Museum," *Museum Management and Curatorship* 25, no. 1 (2010), 13–35.

Mayo, Peter. "Museums as Sites of Critical Pedagogical Practice." *Review of Education, Pedagogy & Cultural Studies* 35, no. 2 (2013), 144–153.

Weil, Stephen E. *Making Museums Matter*. Washington, DC: Smithsonian Institution Press, 2002.

Part IV

SEEING INSIDE THE PROCESS

Chapter 13

Multivocal, Collaborative Practices in Community-Based Art Museum Exhibitions

Marianna Pegno and Chelsea Farrar

In this chapter we explore how multivocal practice is foundational for equitable, collaborative, and nonhierarchical community–museum collaborations and edu-curatorial endeavors. Challenging monocultural and heteronormative narratives, the exhibitions explored in this chapter, *Museum as Sanctuary* and *Mapping Q*, depend on community partnerships in order to work *with* audiences to level out top-down hierarchies in museums. Multivocality, the process of sharing authority and expertise, is the way in which these exhibitions work to challenge traditional structures of power in museums. Furthermore, through this process where unique perspectives are respected and honored, the presence of multiple voices highlights the ways in which community-based curation is neither easy nor scripted.

Museum as Sanctuary, a collaborative arts program, provides safe spaces for refugee families to share stories and create artwork. Within this chapter, refugees are defined as individuals fleeing persecution due to their race, affiliation with a certain social group or political party, religion, or nationality. *Mapping Q*, a community arts education program, invites LGBTQ (Lesbian, Gay, Bisexual, Transgender, and Queer) youth to critically analyze representations of identities within museums. In writing about the LGBTQ community, we acknowledge the always-evolving identities that can be associated with this shorthand of "LGBTQ," and for consistency here, we use the acronym LGBTQ.

A THEORY OF MULTIVOCALITY

Our definition of multivocality is informed by Freire's theory of dialogue and Minh-ha's ideas of ambiguity.[1] These theories call for a shift from

singular perspectives to more complex exchanges while warning against privileged groups speaking *for* another, a common practice in traditional museum curation. Instead, community-based curatorial practices are participant directed, offering multiple points of view and involve shifting/evolving boundaries.

We approach community–museum exhibitions by embracing a space that is not always known. Minh-ha described this as a space by saying, "ambiguity offers a site where nature continues to resist hierarchized and linear categories" and "it is a place of decentralization that gives in to neither side, takes into its realm the vibrations of both."[2] When planning for multivocal exhibitions and working with community partners, we aim to situate ourselves within a space of ambiguity and decentralization in order to foster exhibitions that are based in true collaborative dialogue. These exhibitions assert that visitors and participants are active and essential in their creation, echoing Freire's declaration that "no one can say a true word alone—nor can she say it *for* another."[3]

These community-based exhibitions use a theory of multivocality to combat traditional museum perspectives that often privilege highly refined and professionalized interpretative language. Within this context, exhibitions are seen as an evolution rather than a finite end point because they shift based on context and collaborator. For this reason, it is difficult to pinpoint one single model—in this framework the term *un-model* is more appropriate—for situating the art museum as a place for dialogue where multiple voices share knowledge and ambiguity is embraced. Instead, we offer guiding principles that curators and educators can use to produce equitable and effective collaborative exhibitions. For us, these principles can be summarized in two succinct points: "shut up and listen" and "move at the speed of trust."

Museum as Sanctuary

At the Tucson Museum of Art (TMA), *Museum as Sanctuary* is an ongoing collaboration with Owl & Panther, a program of the Hopi Foundation, which is a local expressive arts program serving refugee families affected by traumatic dislocation. These organizations have created interpretative materials for works on view and two exhibitions (2013 and 2015) featuring participant artwork and descriptive labels. As a direct result of these hybrid educational–curatorial endeavors, the TMA has implemented community-written labels in other exhibitions to extend community-based collaborative interpretation beyond a single program.

Museum as Sanctuary uses Freire's "action-reflection" paradigm, known as praxis, to propel community-based practice into an ongoing edu-curatorial

project.[4] Through this process, "dialogue is thus an existential necessity" where content, themes, works of art, and wall labels are created through conversation with multiple parties: museum, partner organization, and participant.[5] These exhibitions require "constant acknowledgement of and transformation in shifting condition," and thus each emerges from a place of dialogue and multiplicity.[6]

In 2013, *Museum as Sanctuary* had its first exhibition, and works on view were the result of in-depth, creative explorations of community, identity, place, and culture. During the planning stages, we discussed that when working in collaboration, the act of writing or curating in isolation could be seen as authoritative; it can allow a single voice to speak for a group of people. As a result, participants wrote individual object descriptions and biographies to accompany their artworks. Nigerian author Chimamanda Adichie warned that there is danger in a single story because it "creates stereotypes and the problem with stereotypes is not that they are untrue, but that they are incomplete, they make one story become the only story."[7]

When planning the second exhibition in 2015 (Figure 13.1), we sought to push the idea of a multivocal, community-based curation further. We were more critical of language and worked to avoid terminology that perpetuated hierarchies. The 2013 exhibition subtitle utilized the phrase "giving voice," which now we see as problematic. This continued the stereotype of refugees as weak and voiceless, in need of a Western platform to speak, instead of recognizing that their voices existed before the exhibition. With the 2015 exhibition, we were aware of the power in words, and with this in mind, we avoided terms such as *giving* or *other*.

While in the 2013 exhibition we worked to include object labels written by participants, larger texts were written from a single perspective. In order to include more voices, the 2015 exhibition featured labels written by individuals involved in founding of the partner organization. To include the voices of participant artists more completely, weekly written reflections were planned during the educational program so artists could reflect on broad themes informing the exhibition. Thus, when developing the introductory texts, we pulled from various sources to shift curatorial language to one that reflected multiple viewpoints. These written statements were a conversation about resilience. The artists, collaborators, and edu-curators noted that to be resilient, one must act, create, persist, and transform. Additionally, the inclusion of interactives encouraged visitor participation and incited community-wide dialogue, pushing the idea of multivocality further (Figure 13.2). *Mapping Q*, like *Museum as Sanctuary*, collaborates with a local community organization in ways that emphasize voices that are often omitted from art museum narratives.

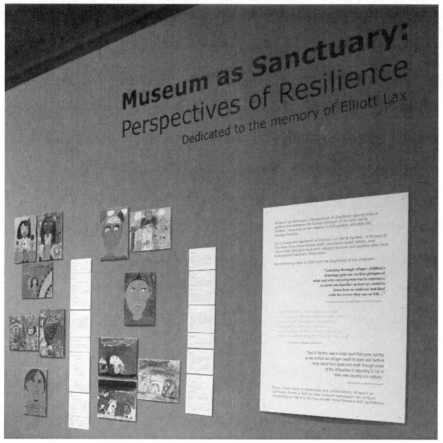

Figure 13.1.　Installation shot with introductory text from the 2015 exhibition of *Museum as Sanctuary*, which includes reflections from multiple individuals. *Source:* Used with permission of author.

Mapping Q

At the University of Arizona Museum of Art (UAMA), we have partnered with ALLY, a program of the Southern Arizona AIDS Foundation (SAAF). ALLY focuses on reducing suicide rates amongst LGBTQ youth (13–23 years old). Together, UAMA and SAAF developed a program that aims to reduce LGBTQ youth suicide and incite critical dialogue through museum-based activities, art making, and exhibitions.

Mapping Q is grounded in the belief that museums should use more democratic practices to become sites that resist prejudice.[8] Through the process of analyzing the museum's arrangement and display practices, we make connections to how our bodies are staged through a heteronormative lens. This

Figure 13.2. Installation shot and wall label from the 2015 *Museum as Sanctuary* exhibition, which includes a participant written poem and invitation to visitors to add their perspectives. *Source:* Used with permission of author.

program explores the relationship between human rights and the politics of aesthetics at play in traditional museums.[9] This community-based exhibition calls attention to how cultural institutions can "articulate the boundaries for who is accepted and under what circumstances, forming discourses of power that circumscribe socially acceptable ways of being."[10]

In our first exhibition in 2014, tombstone labels with artists' names, media, and title were all that described each work, and the introduction was written in isolation by the edu-curator. Reflecting on this first exhibition, I realized that this curatorial practice was neither democratic nor collaborative, as it excluded the voices of my collaborator and the participating youth artists. By naming, or in this context writing, on behalf of "others," I was continuing to practice hierarchical curation.[11]

When exhibition language is used to name, define, and label queer bodies, our curatorial practice perpetuates heteronormative hegemonies, sustaining hierarchies of identities.[12] Worse, when speaking for another, we risk presenting underrepresented minorities as objects for a voyeuristic audience. Freire warned, "to alienate human beings from their own decision making is to change them into objects."[13] In an effort to avoid this, youth now select and curate their

artwork. Labels written by the youth artists created descriptions that are first person. Participating youth have become producers of meaning, rather than subjects of display. My role as edu-curator is one of collaborator, working *with* the community to create diverse meanings through relationships built on trust.

Figure 13.3. Interactive map from the 2015 *Mapping Q* exhibition, where visitors created a symbol for themselves to be added to the map of the museum. *Source:* Used with permission of author.

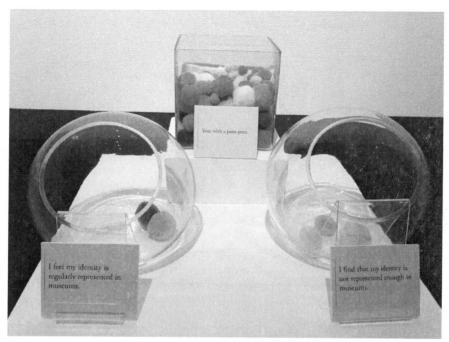

Figure 13.4. Interactive from the 2014 *Mapping Q exhibition*, where visitors voted, using colored pompoms, to show whether or not their identities were represented in museums. *Source:* Used with permission of author.

The curating process for community-based exhibitions cannot stop with the objects and wall labels; it must intentionally reflect on how visitors engage with objects and support ways to directly participate with the issues and themes of the exhibition. In more recent exhibitions, we include gallery interactives that ask visitors to reflect on their identities within the art museums; these have included participatory (Figures 13.3 and 13.4).

While the youth in *Mapping Q* critically examine the heteronormativity that occurs in the curation and collection practices of museums, we also aim to provide direct experiences with the curatorial process. One example of this has been the implementation of a label-writing workshop where participants are shown different styles of object labels, including those written from the perspective of artists, youth, and curators. During the workshop, youth develop labels by reading drafts to each other and offering immediate peer feedback. This model is a result of lessons learned from the edu-curatorial process of *Museum as Sanctuary*, which has included a multisession label-writing workshop. The one-day intensive used *Museum as Sanctuary* curriculum as the starting point to create opportunities for *Mapping Q* youth

to become more embedded in the process of writing to and for visitors. Additionally, it is one example of how UAMA and TMA have collaborated to refine community-based curatorial practices. As a result of this type of dialogue we realize that *Mapping Q* and *Museum as Sanctuary* engage in similar practices. These parallels have caused us to work more closely together, allowing us to become more critical and reflective of our practices. For example, the 2016 exhibition of *Mapping Q* was the result of collaborative edu-curatorial practice between UAMA and TMA, and was simultaneously displayed at both institutions.

COLLABORATOR AND CURATOR REFLECTIONS

In the following sections, our collaborators and colleagues share their perspectives, highlighting the ambiguous world of community-based exhibitions. They speak to the idea of how these exhibitions differ greatly from other curatorial endeavors and are distinct from traditional community practice outside of museums.

Mapping Q: Partner Perspective

Sarah is a suicide-prevention specialist at SAAF and has worked with *Mapping Q* since 2014. She observed:

> The museum atmosphere is a distinct atmosphere from what we offer at SAAF, where community spaces are small and personal compared to the museum's that are larger and more formal feeling. Offering those spaces to our youth, it validates their right to be in each of those spaces, regardless of age, race, sexual identity, or gender identity.
>
> Working with the museums has broadened my perspective of how, when, and where curriculum can be delivered. The youth that attend the *Mapping Q* program retain suicide-prevention material observably better than those who have only taken it in the classroom setting. Youth participants involved in *Mapping Q* have expressed during the exhibition that they have never experienced anything like it. Their work, and by proxy their identities, become validated. Many of the youth involved are creative individuals, and seeing others value their creative expressions legitimizes their voices in the museum's space.
>
> The exhibition process is very different from our organization's other projects. Many of the projects we do have a public-service-announcement feel to them. Frequently, the "voice" in those projects is assumed to be coming from program staff whereas in *Mapping Q* it is different since the artists' queerness is implicit. It makes the museum feel like a safe space from the start, allowing their experiences to be celebrated.

Developing work for an exhibition has opened my eyes to the powerful role that art plays in activism. Art has an active history in every movement; every turning point that humanity has made was influenced in some way through painting, poetry, song, or the like. It has been a pleasure to continue the tradition with queer youth voices.

Museum as Sanctuary: Partner Perspective

Marge, the program coordinator of Owl & Panther, a program of the Hopi Foundation, has collaborated with *Museum as Sanctuary* since 2010. She commented:

> This multi-year collaboration allowed us to serve two aspects of our mission: providing quality expressive arts programing and educating the community about refugees in order to foster acceptance.
>
> Developing artwork helped participants engage in longer-term projects that offered a reward—a place of honor on the walls of the museum. Participants reported "feeling good," "happy," "grateful," and "thankful" when they created the work. They felt excited to see their art and collaborative poems that responded to work of other artists displayed. One volunteer noted that they "initially didn't comprehend what having art on view would mean, but once they did, they were interested to know how and why artworks from others got into the museum too."
>
> *Museum as Sanctuary* helped participants integrate into their new home by interjecting their voices into the community. "It felt good because people heard my words and saw my art," said a middle-school participant. It celebrates their accomplishment and validates their growing confidence, helping to build self-worth and self-appreciation. A teen participant from Ethiopia said he felt "proud and awesome. Very happy about it. The first time I had art on display I was nervously happy. After that I was chill." One elementary school participant from the Democratic Republic of Congo said, "It made me happy because everyone saw my heart."
>
> For most of the community, it's easy not to engage with refugees. *Museum as Sanctuary* humanized this hidden group, offering the public an idea of who they are and how they are, indeed, part of the community. Another volunteer expressed that *Museum as Sanctuary* "validates them as artists when their artistic expression is taken seriously and the community meets them as artists." One of the founders of our program stated, "Older students feel they've made a mark on this new place. Some have more of a sense of belonging and better understand the value of public validations of their work." An adult from Iraq was a featured artist in the second show. Her professor at a local community college found out about her work and showcased it on her college's website. She stands taller and appears more relaxed in great part because of the long-term art making and how *Museum as Sanctuary* honored who she is in her new home.

Mapping Q: Curator Perspective

Olivia is the curator of exhibitions and education at the UAMA. She stated:

> Often an exhibition begins with the objects—they already are in existence, and the curator simply needs to choose a particular angle with which to examine and display them with regards to other objects. There are, of course, many situations where the concept is formed first, and objects are then selected to illustrate that particular concept.

> *Mapping Q* is a different approach in that it somewhat works in reverse. As in traditional exhibitions, the concept is already there. However, it is an open-ended concept that poses a question and asks others to find the answers. Rather than a single curator creating the concept, conducting the research, and formulating the answers, *Mapping Q* creates the template and facilitation but allows the participants to make and literally illustrate the findings. The malleability of the process takes the participants' voices into consideration. Rather than the educational experience being created as an add-on to the exhibition, the exhibition is the result of the educational experience, and, as such, the objects come last.
>
> Traditional curatorial practice has held that curators and educators work separately. The curator creates an exhibit and then the educator develops interpretive methods and programs for the public. *Mapping Q* turns the concept on its head in that the exhibition begins with the educational program, which then informs the exhibition. *Mapping Q* also differs from other educational programs in that it involves an unlikely community partner, which is outside the traditional box of other arts institutions. Museums often partner with one another, or with other like-minded institutions that have collections and a public education focus, such as libraries and zoos. However, *Mapping Q* has expanded the concept to include another type of community-centered institution. As *Mapping Q* has demonstrated, the partner organization's mission is in many ways aligned with that of many museums. Each institution has benefited from the partnership and has been inspired by one another's expertise.

Museum as Sanctuary: Curator Perspective

Christine is the Glasser curator of art of the American West at the TMA. She reflected:

> In the broadest sense, exhibitions are a means of storytelling that require more than the mere display of objects, but to employ several learning methods for understanding these items. Challenges in curating exhibitions include the creation of experiences that makes the visitor feel they are *part* of the story, rather than being *told* the story. Upon reflection of personal practice in planning dozens of exhibitions, it occurs to me that interpretives for all ages and backgrounds

are essential for the content to come across clearly and thoughtfully. The overarching goal is to reach individuals and assist them in finding a sense of place, relevancy, ownership, and community.

Museums are safe spaces for learning, creativity, and dialogue. Exhibitions act as conduits for open discussion. In exhibition planning, curators and education staff work together in developing new ways of visitor engagement that are outside the norm. Recently, the education and curatorial staff experimented with a multi-perspective learning tool in three different exhibitions at the Tucson Museum of Art, which utilized the descriptive text of object labels. A standard implement frequently used in museums across the world to identify and explain objects, this low-tech interactive was transformed into a non-traditional format. Not only did these labels outline the typical information about the objects on display, such as artist, title, medium, etc., but they also incorporated new voices—those of everyday people.

The *Museum as Sanctuary* participants participated in writing collaborative labels in two Western art exhibitions. The results were poetic and insightful. Building upon its achievements, in a larger exhibition this practice was expanded upon, and additional local organizations were asked to write an assortment of individual and group labels. The labels offered a counterpoint to works that depicted scenes that touched upon issues of race, gender, and violence. These likely would not have been so fully addressed without the additions of these aptly named "community voice" labels.

In the future, more multi-voice labels are planned for exhibitions as well as grander partnerships with education and curatorial staff. The label-writing projects have strengthened relationships between the museum and other cultural organizations across the region. Further, the labels have added representation of these communities and their perspectives inside the museum walls, making them active participants in the exhibition experience. When museums work with the communities they serve, better, exciting exhibitions and programs can be generated.

LESSONS LEARNED: AN UN-MODEL

These examples of community-based exhibitions illustrate a hybrid conceptualization of the edu-curatorial practice: one that calls upon an educator's skills in collaborating with partners and individuals in ways that do not privilege singular and dominant narratives, where we are rethinking our roles within educational exchanges to create a space for individuals to become producers of knowledge, where exhibitions are being planned through a constellation of perspectives, and the objects displayed are created as a product of dialogue and collaboration.

This type of work is complicated, ambiguous, nonlinear, open-ended, and constantly changing. When creating community-based exhibitions, we urge

individuals to be intentional and to employ language of reciprocity. Thus, we are *suggesting*, rather than providing, a firm template for "how to: community-based exhibitions," an un-model where these collaborative practices are built on relationships. They are not static: they evolve and grow. This un-model is imperfect and messy. It is built on interpersonal relationships, and that takes time and patience. However, there are some overarching similarities between *Mapping Q* and *Museum as Sanctuary*. First, both programs are designed with gallery-based learning and art-making opportunities and take place in art museums. Second, curriculum is not only museum-driven but also works to incorporate our partner organizations' mission, objectives, learning goals, and daily "housekeeping" needs within each session. At their cores, *Museum as Sanctuary* and *Mapping Q* shift museum narratives from linear, heteronormative, and monocultural representations to multivocal dialogic exchanges.

NOTES

1 Freire, Paulo. *Pedagogy of the Oppressed.* New York: Bloomsbury Academic, 2009; Minh-ha, Trinh T. *Elsewhere, Within Here: Immigration, Refugeeism and the Boundary Event.* London: Routledge, 2011.

2 Minh-ha, *Elsewhere, Within Here*, 65, 70.

3 Freire, *Pedagogy of the Oppressed*, 88.

4 Ibid.

5 Ibid.

6 Minh-ha, *Elsewhere, Within Here*, 70.

7 Adichie, Chimamanda. "Chimamanda Ngozi Adichie: The Danger of the Single Story." *TED* video. Posted October 2009. https://www.ted.com/talks/chimamanda_adichie_the_danger_of_a_single_story?language=en.

8 Lindauer, Margaret A. "Critical Museum Pedagogy and Exhibition Development: A Conceptual First Step." In *Museum Revolutions: How Museums Change and Are Changed*, edited by Simon J. Knell and Suzanne MacLeod, 315–329. New York: Routledge, 2007.

9 Musiol, Hanna. "Museums of Human Bodies," *College Literature* 40, no. 3 (2013): 156–175.

10 Chappell, Sharon. "Young People Talk Back: Community Arts as a Public Pedagogy of Social Justice." In *Handbook of Public Pedagogy: Education and Learning beyond Schooling*, edited by Jennifer A. Sandlin, Brian D. Schultz, and Jake Burdick, 318–326. New York: Routledge, 2010.

11 Freire, *Pedagogy of the Oppressed*, 89.

12 Levin, Amy K. "Unpacking Gender: Creating Complex Models for Gender Inclusivity in Museums." In *Museums, Equality, and Social Justice*, edited by Richard Sandell and Eithne Nightingale, 45–58. Abingdon, Oxon: Routledge, 2012.

13 Freire, *Pedagogy of the Oppressed*, 85.

BIBLIOGRAPHY

Adichie, Chimamanda. "Chimamanda Ngozi Adichie: The Danger of the Single Story." Filmed July 2009. *TED* video, 18:49. Posted October 2009. https://www. ted.com/talks/chimamanda_adichie_the_danger_of_a_single_story?language=en.

Chappell, Sharon. "Young People Talk Back: Community Arts as a Public Pedagogy of Social Justice." In *Handbook of Public Pedagogy: Education and Learning beyond Schooling*, edited by Jennifer A. Sandlin, Brian D. Schultz, and Jake Burdick, 318–326. New York: Routledge, 2010.

Freire, Paulo. *Pedagogy of the Oppressed.* New York: Bloomsbury Academic, 2009.

Levin, Amy K. "Unpacking Gender: Creating Complex Models for Gender Inclusivity in Museums." In *Museums, Equality, and Social Justice*, edited by Richard Sandell and Eithne Nightingale, 45–58. Abingdon, Oxon, United Kingdom: Routledge, 2012.

Lindauer, Margaret A. "Critical Museum Pedagogy and Exhibition Development: A Conceptual First Step." In *Museum Revolutions: How Museums Change and Are Changed*, edited by Simon J. Knell and Suzanne MacLeod, 315–329. New York: Routledge, 2007.

Minh-ha, Trinh T. *Elsewhere, Within Here: Immigration, Refugeeism and the Boundary Event.* London: Routledge, 2011.

Musiol, Hanna. "Museums of Human Bodies," *College Literature* 40, no. 3 (2013): 156–175.

Chapter 14

For the Use of Art

Astrid Cats

Whether through self-organized groups, individual initiatives, or the rise of user-generated content, people are developing new methods and social forms to deal with issues that were once the domain of the state. Feeling dissatisfied with social inequity or a failing healthcare system or simply unhappy with the way people treat one other in public life, people are coming to action with the intent to make a change. In these social undertakings, art and culture play a predominant role as instruments in service of a social cause. Cuban artist and scholar Tania Bruguera refers to these artistic practices as "Arte Útil," which translates into English as "useful art"—art as a tool or device. Arte Útil proposes a reconsideration of the value of art, contrasting the monetary evaluation of autonomous art against the value of use. In this type of art, art is not an intrinsic end in itself, but it is used in service of something else. Arte Útil as a movement seems to be regaining relevance.[1]

In a changing political, economic, social, and technological landscape, an increasing number of artists use the means and freedom of art to transform society and challenge the status quo. This exciting new paradigm for art served as the inspiration for the exhibition *Museum of Arte Útil* in the Van Abbemuseum, Eindhoven, the Netherlands (July 12, 2013–March 30, 2014). The exhibition presented examples of Arte Útil praxis from around the world to show how artists' interferences in social issues are not isolated incidents but part of a global movement shaping our contemporary world.

At the same time, the concept of "useful art" breaks with our tradition of appreciating the political independence, or autonomy, of art. Moreover, the concept invites us to reconsider museum praxis. The museum's tasks of collecting, preserving, and presenting heritage are inadequate for dealing with

art that has not representation as its end, but social transformation. Arte Útil practices ask for a museum to reconfigure from a space of spectatorship to a space of usership. The *Museum of Arte Útil* incited the museum to experiment with a new museum model: if art can be a tool, can the museum become a toolkit? And how can community members be emancipated from spectators to become activators? How does one become a user of art?

In retrospect, we regard the exhibition as a catalyst in the museum's pursuit to function as a public institution that is relevant for the community it serves.[2] We experienced that Arte Útil disseminates parallel new roles for art, the art museum, and the art audience. By revisiting the *Museum of Arte Útil* in this chapter, we aim to deepen our understanding of this tripartite relationship among art, the museum, and the public. Moreover, we want to make explicit parallels between our experiences with the exhibition and current and future practices in the Van Abbemuseum.

ART AS A TOOL, MUSEUM AS A TOOLKIT?

The installation of the *Museum of Arte Útil* was a pivotal, yet not an isolated, event in the history of the Van Abbemuseum. The museum has been running at the forefront of developments in contemporary art since its foundation in 1936 and has gained a reputation for its experimental and political presentation of art both nationally and abroad. Under the direction of Charles Esche since 2004, the museum has been seeking to frame art as a realm analogous to social and political systems. Together with collegiate museums in Europe, the Van Abbemuseum initiated a program to redefine the use of art and art museums in the twenty-first century.[3]

When Esche invited Cuban artist Tania Bruguera to have an exhibition at the museum in 2012, she proposed to install a museum of useful art. Initially, not all museum staff supported the idea to present art for utilitarian means. Some curators hesitated to threaten the ineffability of artistic autonomy and feared that such ideas could lead to an unintended bifurcation of art that is either useful or useless. At the same time, the curatorial team was critical of the treatment of autonomy as a safe haven for art—as a shield against social currents and criticism—that had caused a regression of art from politics, society, and, ultimately, life. Coinciding with the global financial crisis and sector-wide budget cuts, there was a need to reassess the value of art, not in terms of monetary value but in terms of its relevance.

These considerations finally motivated the Van Abbemuseum to install Bruguera's exhibition. The concept Arte Útil allowed us to disregard

traditional notions of what art and the art museum were supposed to be doing for centuries. There was no aim to displace the autonomy of art but rather to turn our attention to an alternative understanding of art: that of artists putting their artistic intelligence to use for a social cause. With the exhibition, the museum acknowledged these practices as art and tasked itself with presenting and facilitating the use of art in a public setting. Above all, the *Museum of Arte Útil* was an opportunity to investigate a potential new role for art, the art museum, and the public of art, an iteration of a museum that willingly dissociates itself from assumptions of what a museum is in order to speculate on what the museum might be.

INSTALLING THE "USEUM"

As the practice of Arte Útil had been little explored, Tania Bruguera and the museum's art curators had to invent a way of collecting and categorizing a vast number of representative Arte Útil projects from across the globe. Two art researchers were appointed to archive, research, and theorize these practices.[4] At the same time, curators wondered how they could include art practices that are intended to take place in "the real world" and to be activated for a social purpose, in a disinterested museum gallery. The team agreed that the only possible way to truly present Arte Útil in the museum would be to incorporate actual praxis of art-in-use in the museum. In other words, a presentation of useful art implied for the museum to become a social power plant for the use of art: not a *muse*um, but a *use*um.

The twofold ambition to both archive and activate Arte Útil entailed a radical transformation of the white-cube, modernist museum. A circular wooden structure literally broke through the museum walls, creating rooms for workshops, discussions, meetings, and even a shop that each paralleled documented Arte Útil projects (Figure 14.1). The physical alterations were perhaps the easiest. More important was that these spaces had to be activated by a public of users. To that end, visitors were invited to make use: to join, debate, transform, or alter projects to their needs. Possibilities included controversial books from Loompanics Unlimited,[5] (Figure 14.2) a light therapy room with ultramarine light to foster communication and social interaction, and even an honest shop where visitors could sell their crafted goods for a fair price.[6] In addition, the museum organized public events and activities around Arte Útil projects. Free entrance for users and extended opening hours on Thursday evenings allowed citizens to use the museum after office hours. And, most adventurous perhaps, people could freely use any of the rooms to initiate activities of their own interest.

05
Room of Controversies

04
A-Legal

03
The Room of Propaganda,
Legitimation and Belief

02
Institutional Repurpose

01
Use it Yourself

07
Space Hijack

06
Archive Room

08
Open Access

09
Legislative Change

10
Reforming Capital

Figure 14.1. *Museum of Arte Útil*: a social power plant. *Source:* **ConstructLab.**

As the attention the *Museum of Arte Útil* directed toward art usership, public programming and active participation of audiences came in focus. In previous exhibitions, the Van Abbemuseum had already experimented with visitor-centered and co-created exhibitions. In these exhibitions, however, the visitor had been confined to participation in projects initiated by the museum, implicating a preset role for the participant. An example was the Viewing Depot in the exhibition *Plug In* (2006–2009)[7] that enabled visitors to select artworks from the depot to be exhibited in the museum. Although visitors were granted a certain ability to affect or alter an exhibition, their activities and influence remained limited by a fixed structure provided by museum staff.

In the *Museum of Arte Útil*, we noticed that after some time visitors started using the museum in ways we had not anticipated. While curators and mediators put great time and effort in organizing debates and public programs, visitors independently organized yoga classes, craft workshops, and amateur theatre shows. City council members scheduled business meetings in the light therapy room, and students from Design Academy Eindhoven used the museum with its neutral atmosphere and attentive audiences as a laboratory to test their social designs on passersby. More than half of the events and activities that took place in the *Museum of Arte Útil* were initiated by audience members.[8] And, if we are frank, the hands-on workshops and activities that they organized were at times better appreciated than the activities planned by museum staff. The enthusiastic initiators often brought in their own crowds or involved passersby, thus creating new flows of people into the museum. We realized that usership is not reached by allowing visitors to participate in planned activities but by creating an environment in which one has the freedom and responsibility to do what is personally useful. Use is malleable,[9] and perhaps the best usage of the museum is imagined by its using public.

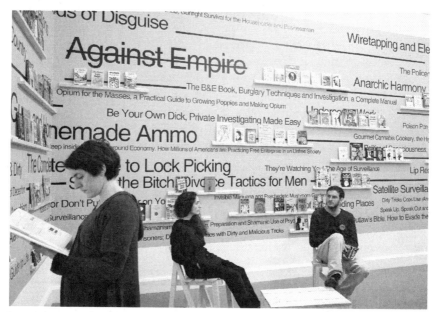

Figure 14.2. Visitors use books from Loompanics Unlimited to gain unconventional knowledge. *Source:* Peter Cox.

CHALLENGES AND OBSERVATIONS

The public's free-choice use of the museum inevitably affected the museum's methods and meanings. The attention of curators shifted from the theoretical question, *how can the museum be used,* to a more concrete and personal question, *what can the museum do for you?* This changing perspective was both refreshing and cumbersome. According to some of the staff members, the public's freedom to use the museum led to the instigation of projects of unclear relevance for the museum. For some projects, the subordination of art to a social purpose—what Arte Útil implied—perhaps went so far as to not include any art at all. While the museum continued to search for relevant social partners to use the museum, concerns grew about the use for the museum.[10]

Furthermore, the exhibition laid bare the challenges for the museum's existing operational structures to perform as a space of use. Despite their personal commitment, museum staff struggled to constantly program and host activities in the museum, oftentimes spontaneous or improvised, especially during weekends and evening hours. In addition, the curator's willful involvement in public programming conflicted with the traditional division of tasks between educators and curators. Educators, who had developed thought-through strategies for audience engagement over the course of years, were caught off guard by the unprompted initiatives by curators. Instead of collaborating and benefiting from one other's strengths, curators

and educators felt impeded to consult one other, to ask for help, and to inter-
fere with one other's initiatives. Inevitably, this lack of communication and
collaboration at times led to confusion and even annoyance. The exhibition
and associated public program laid bare that the museum still grapples with
lines of authority during collaborative efforts and that the inherent hierar-
chical distinction between curatorial and educational staff is still sensed
perhaps.

Nonetheless, as challenging as the experimental exhibition was to the
museum, the *Museum of Arte Útil* was even more demanding for its visitors.
We noticed that many had difficulties understanding the *Museum of Arte Útil*
and coming to grips with their newly acquired role as user. While they appre-
ciated social projects from their traditional perspective as spectator, they
would ask us, *where is the art?* The concept of artistic intelligence that is put
to use was alien to many visitors. Our request for them to be users required
them to dissociate from their prior expectations of their museum visit. On
the other hand, people who came to the museum with the intention to join
in an activity as "spect-actors" appeared to instinctively comprehend the
unorthodox principle of Arte Útil. L'Internationale colleague Alystair Hud-
son[11] regarded the success of the honest shop, workshops, and DIY projects
as an indication that people want to *do* something.[12] As museum curators and
mediators, we must not forget that we have had months to familiarize our-
selves with the concept of usership, while most visitors have less than a day.
A public reframing of artistic value, as proposed by the museum, requires
patience and efforts from the museum to foster public activity, rather than
theorizing and discussions.

FROM USERS TO CONSTITUENTS

These experiences from the exhibition reinvigorated ideas about the role
of the museum and its relationship with audience members. Staff members
proposed to think of audience groups, partner organizations, and other stake-
holders as *constituents*. The term, which is political with intent, signifies
an interdependent relationship between the museum and its constituent: the
constituent needs the museum to serve his or her interests, while the museum
seeks democratic legitimization from its constituents in return. The con-
stituent operates as an agent with a personal agenda, as does the museum.
However, in the course of their collaboration, they operate from a principle,
shared interest.

Bearing in mind the challenges we encountered during the *Museum of Arte
Útil*—the tension between the public's autonomy, the museum's search for
relevance, the difficulties to host and manage activities continually, and the

inability of audience members to comprehend the use of art—the concept of constituents provides an alternative manner of effectuating use. The constituent is invited to use the museum—for example, its collection, its expertise, or its spaces—in dialogue with the museum. In return, the constituent contributes to the museum by bringing new knowledge to the museum and engendering new audiences.

This is best illustrated with an example. The current collaboration between the museum and visitors with visual or hearing impairments is based on this notion of constituents. In 2014, the museum launched a three-year program to increase its accessibility and to become more inclusive of diverse audiences. Unlike most accessibility programs, the Special Guests program has been designed not *for* but *with* the communities from the start. Through intense conversation and experimentation, the museum and target audience jointly investigated how people with sensory impairments could meaningfully experience art (Figure 14.3). This collaborative way of working has led to startling insights for all participants, not the least for the museum itself. We have discovered new features of our works of art (their smell or feel), as well as of our museum (the sound of a space, the presence of a detail in a relief). While a new audience can experience art, the Van Abbemuseum can disperse our newly gained knowledge back to hearing and seeing audiences, enriching their experiences as well.

Another important constituent for the Van Abbemuseum is the Young Art Crowd, a group of young art lovers that emerged from the associated Friends of the Van Abbemuseum. The Young Art Crowd operates autonomously yet in collaboration with the museum and Friends, initiating art activities that appeal to students and youngsters, such as portfolio nights for young art talents, dinner parties, and behind-the-scenes tours in museum storage.

Despite these productive examples, some of the relationships between the museum and constituents have thus far not led to tangible results. Oftentimes, they require long-term investment from both parties who must thoroughly investigate their individual interests and their common ground, as well as build mutual trust. An example is the collaboration with The Umbrella, a network of young social designers.[13] Since they met with curators in the *Museum of Arte Útil*, the museum has been supporting their project to map and connect social design and art projects and community projects in the city. At this point, it is unclear where the collaboration might lead or whether there will be tangible results for the museum at all. Nonetheless, the museum is committed to investing in the collaboration, willing to explore what may happen next. The Van Abbemuseum thus seeks to expand its use for a diverse public of spect-actors as much as it pursues collaborations that contribute to its own objectives as a public art organization.

Figure 14.3.　Blind visitors help seeing visitors to explore a sculpture through touch.
Source: Marcel de Buck.

THE FUTURE USER

Two years after the installation and activation of the *Museum of Arte Útil* in the Van Abbemuseum, we notice the impact it continues to have as a catalyst for the museum's way of engaging with art and its audiences. Its unorthodox presentation as a social power plant gave room to experiment, to spontaneous activation, and to the construction of new relationships and ideas of the museum's potential. Despite its practical and theoretical shortcomings, it proved that the vision of the art museum as platform for social innovation is viable. If the use of art is to reflect on society and to imagine, propose, and activate new ideas for life, the art museum can be a space for the presentation and cross-fertilization of these ideas.

As much as we are imagining a museum of the future, we are imagining the audience of the future. Staff envision the museum as a space where people come to learn about artistic practices and to be inspired and empowered to put their own artistic intelligence to use. The *Museum of Arte Útil* demonstrated that, despite current challenges, visitors want to access and activate the museum's resources for all sorts of social use. The Van Abbemuseum appropriates its public as constituents to ensure that their public projects are both manageable and contribute to the objectives of the art museum. We invite colleagues and constituents, locally and globally, to reconsider what the museum might offer for you and to jointly put art to use.

NOTES

1 Bruguera, Tania. "Reflectiones sobre el Arte Útil" [Reflections on Arte Útil]. In *Lecturas para un Espectador Inquieto* [Readings for an apprehensive reader], edited by Yayo Aznar and Pablo Martinez, 194–197. Madrid: CA2M Centro de Arte Dos de Mayo, 2012.

2 I am using the pronoun "we" in reflection of my close collaboration with the curators and educators of the Van Abbemuseum over the exhibition *Museum of Arte Útil*. The insights presented in this chapter originated in conversations with museum staff that took place over the course of the two years after the exhibition had taken place.

3 L'Internationale is a confederation of six modern and contemporary art institutions: Moderna Galerija, Ljubljana; Museo Nacional Centro de Arte Reina Sofía, Madrid; Museu d'Art Contemporani de Barcelona, Barcelona; Museum van Hedendaagse Kunst Antwerpen, Antwerp; SALT, Istanbul and Ankara; and Van Abbemuseum, Eindhoven. L'Internationale works with complementary partners such as Grizedale Arts, Coniston, United Kingdom; Liverpool John Moores University, Liverpool; Stiftung Universität Hildesheim, Hildesheim; and University College Ghent School of Arts, Ghent, along with associate organizations from the academic and artistic fields. The confederation takes its name from the workers' anthem

'L'Internationale,' which calls for an equitable and democratic society with reference to the historical labor movement.

4 "Arte Útil," accessed June 27, 2016, http://www.arte-util.org/.

5 Loompanics Unlimited was a US book seller and publisher specializing in non-fiction on generally unconventional or controversial topics.

6 "Museum of Arte Útil," accessed June 20, 2016, http://museumarteutil.net/about/.

7 "Viewing Depot," accessed June 15, 2016, http://www.vanabbemuseum.nl/view ingdepot/.

8 "Calender of Events," accessed June 1, 2016, http://museumarteutil.net/calendar/.

9 Aikens, Nick, Thomas Lange, Jorinde Seijdel, and Steven ten Thije. *What's the Use?* Amsterdam: Valiz, 2016, 10.

10 Wright, Stephen. *Towards a Lexicon of Usership.* The Hague: Deltahage, 2013, 13.

11 "Director," accessed June 15, 2016, http://www.visitmima.com/about/team/director/.

12 Steven ten Thije, interview with author, March 25, 2016.

13 "The Umbrella," accessed June 2, 2016, http://theumbrella.nl/.

BIBLIOGRAPHY

Aikens, Nick, Thomas Lange, Jorinde Seijdel, and Steven ten Thije. *What's the Use?* Amsterdam: Valiz, 2016.

Bruguera, Tania. "Reflectiones sobre el Arte Útil." [Reflections on Arte Útil]. In *Lecturas para un Espectador Inquieto* [Readings for an apprehensive reader], edited by Yayo Aznar and Pablo Martinez, 194–197. Madrid: CA2M Centro de Arte Dos de Mayo, 2012.

Cats, Astrid. *Evaluation Report of the Museum of Arte Útil.* Eindhoven: Van Abbemuseum, 2014.

Wright, Stephen. *Towards a Lexicon of Usership.* The Hague: Deltahage, 2013.

Chapter 15

Philosophical Inquiry

A Tool for Decision Making in Participatory Curation

Trish Scott, Ayisha de Lanerolle,
Karen Eslea, and individual participants

> Socrates: For this feeling of wonder shows that you are a philosopher, since wonder is the only beginning of philosophy.[1]

At Turner Contemporary we have been embedding a process called philosophical inquiry (PI) into the ways in which we engage audiences with our work.[2] This multiauthored chapter introduces PI, discusses its history with Turner Contemporary, and explores how we are using it to inform the curation of two ambitious exhibitions led by members of the community.

One of the inevitable challenges of co-curating exhibitions as a large group of people is finding democratic, productive, and creative ways of structuring discussions and making collective decisions. Within these projects, PI is emerging as a key tool for undertaking collaborative thinking, decision-making, and evaluation.

In the spirit of co-curation, we held a PI with project participants as the basis of this chapter to demonstrate and reflect on the relationship of PI to collective discussion and decision making in community curation. The inquiry also brought to light thoughts about success and value within both projects.

The text that follows presents and reflects on the PI held on March 15, 2016. Shifting between live thinking and more considered reflection, it is an experimental attempt to convey something of the interactivity and spontaneity that characterizes group curation, which is something inevitably experiential and dialogical.

Karen: Ten years before Turner Contemporary opened in Margate in 2011, Victoria Pomery, the gallery's director, and I arrived in the town, faced with the wonderful but daunting challenge of developing a new organization and creating an audience for the arts in Margate.

Over the following years, a program of commissioning artists, showing artworks in the local area, and working closely with our community enabled us to test approaches and learn a huge amount. Armed with this experience, we embraced the rare opportunity of being able to create a new model of an art organization that challenges conventions and connects art and audiences in new ways, demonstrating the deep relevance of art to society and everyday life.

Aware that many of our visitors would never have visited a gallery in their lives, we began to work with practical philosopher Ayisha de Lanerolle in 2011 to initiate rich discussions around artists' work and ideas with members of our community. Working with Ayisha we developed a philosophical structure for discussions that supports creative questioning and thinking and importantly is not reliant upon prior knowledge. Since this point, whether we are training teenagers to be gallery guides, working with primary school children to regenerate their own town, training our staff, or developing interpretation, this methodology is now integral to our work.

Trish: Ayisha, can you tell us what philosophical inquiry is, and where it originates from?

Ayisha: Philosophical inquiry is a process whereby we aim to gain insight into questions of knowledge, truth, reason, reality, meaning, mind, and value by questioning our fundamental assumptions about the world. Peter Worley describes what he qualifies as "candidate" necessary conditions of the process as the four Rs: responding, reflecting, reasoning and re-evaluating.[3]

To develop a philosophical approach we have been drawing on my training, an MPhil in Dr. Catherine McCall's Community of Philosophical Inquiry (CoPI), and some staff have been trained in Level 1 of SAPERE's Philosophy for Children (P4C).[4] We use everyday language together with the structure of philosophical argument, introducing principles of inquiry into conversation as well as holding more orchestrated group dialogues. More recently we have been experimenting with thinking processes that include physical movement that aims to energize the group and make visible relationships between different standpoints.

Historian Bettany Hughes suggests that the roots of what we know as the ancient Greek tradition of philosophical inquiry may lie further back in the ancient Egyptian concept of hospitality.[5] Hughes suggests that in extending conventional hospitality from welcoming strangers over your threshold to share your food and drink, to entertaining the ideas that the visitors brought with them, the ancient Greeks were creating a safe space in which both host and guests could explore new and sometimes challenging ideas. The image of Socrates in the market place and in people's homes engaging directly and animatedly with everyone from slaves to prostitutes, politicians, and the youth of Athens conveys a sense of the potential this innovation held for both peacemaking and peacekeeping.

Trish: So why bring this to an art gallery?

Ayisha: Like the ancient marketplace, a contemporary public art gallery attracts people from all walks of life. So it seems like the perfect place for inviting everyone into the conversation about what makes us human: providing a hospitable, safe space to develop a reciprocal relationship of giving and receiving between ourselves and the artworks, the gallery and its visitors, as well as between one stranger and another.

I first learned about practical philosophy in a public gallery context when philosopher and curator Eulalia Bosch gave a talk at a conference on practical philosophy organized by the European Philosophical Inquiry Centre (EPIC) in Glasgow 1996.[6] At that time, Bosch was director of education at Barcelona's Museum of Contemporary Art, and she spoke about her work encouraging young people to engage in philosophical thinking around artworks or "mysterious creatures" that we can build our own relationships with.[7] I was thinking of this some years later when Turner Contemporary was preparing to open its doors, and I contacted Karen Eslea, head of learning and visitor experience, with the proposal to devise ways of bringing philosophical inquiry to the gallery.

Karen: In collaboration with Ayisha, we've now started to integrate philosophical inquiry into the curatorial process, working with community members to incorporate their knowledge and insights into the exhibition-making process.

Ayisha: Philosophical inquiry requires both agreement and disagreement, and when it is not constrained by needing to reach a consensus, it gives groups a sense of the ongoing nature of philosophical inquiry. The curating process invites dialogue, but it also has a specific goal of producing an event and an exhibition, so I am interested to see the experimentation that is taking place around participatory decision-making processes.

Karen: We have two major projects currently under way that demonstrate how this is happening: the Studio Group Commission's *The Three Graces* by Kashif Nadim Chaudry and *A Journey with the Waste Land* being led by a newly formed Research Group.

Studio Group are a group of twenty local artists and makers who initially worked together to realize a work with Brazilian artist Maria Nepomuceno. They did this so successfully that we invited them to commission a major work by another artist of their own choice. Through a process of collaboration and learning, working with program curator Fiona Parry, they have now commissioned the artist Kashif Nadim Chaudry (who uses elaborate textile techniques to create sculptures and installations that explore themes of identity, religion, and cultural heritage) to create a new work for our Sunley Gallery. This will open in November 2016.

A Journey with the Waste Land involves forty local researchers working with Professor Mike Tooby (who proposed the idea), research curator Trish Scott, the wider gallery team, and other experts to co-develop a major exhibition in 2018. The exhibition will explore the connections between T. S. Eliot's renowned poem, "The Waste Land" (partly written in Margate) and the visual arts.

The practice of philosophical inquiry and the associated activities that have evolved at the gallery as a result of this approach are integral to the ways in which both groups are working. They are used to generate ideas, raise concerns, question assumptions, and (in contrast to our earlier use of the practice) inform decision making.

For example, a philosophical activity with over sixty people in the shelter where T. S. Eliot wrote part of *The Waste Land* enabled one participant to question the group's assumption that Eliot would have been looking out to sea when he wrote the poem. Instead, she proposed that he may have been sheltering from the wind, on the landside of the shelter, watching the trams and people walking by. This generated a question about what the effect of looking over the bay, at such a wide expanse of space, would have been on someone recovering from a nervous breakdown. This, in turn, prompted research, which revealed that Eliot made sketches when he was sitting in the shelter. If we can find these drawings, we may be able to understand a little more about his experience in Margate and share this with visitors to the exhibition.

In contrast, following extensive research and studio visits, the Studio Group needed to agree which artist they were going to commission. Using a simple philosophical activity with marked-out sections on the floor (each representing the shortlisted artists), the group mapped their thoughts against the aims of the commission. They were able to explore if their personal preferences for the artist were influencing their decision making and whether their choice of artist reflected the overall aims of the project. Through discussing five shortlisted artists in this way, the group came to a decision about working with Kashif Nadim Chaudry.

Ayisha: I think that the power of philosophical dialogue lies in explicitly freeing up space to explore and follow through ideas. If we set up a space that invites us to embrace philosophical uncertainty, our assumptions about the world are more likely to be revealed, and a genuine dialogue can open up where participants feel freer to experiment with live thinking and new ideas.

Trish: On that note, let's turn to what happened on March 15.

We started the session with an exercise to explore Studio Group and Research Group members' opinions on group decision making (using an agree-disagree continuum with a line down the middle of the room). Statements were read out, such as "decision making is about going with the majority." Participants then responded by moving around the space in accordance to how they felt. A debate followed, during which participants adjusted their physical positions as they modified their thinking to take account of arguments made by others.

After doing some thinking, literally on our feet, we moved into a philosophical dialogue (seated in a circle) to explore some of these ideas in a more open-ended way (Figure 15.1). In this setting, ideas take center stage so that agreement/disagreement is made with the arguments rather than the individuals,

Figure 15.1. Structured thinking exercise. *Source:* ©Jason Pay, 2016.

Figure 15.2. Facilitated philosophical inquiry. *Source:* ©Jason Pay, 2016.

encouraging participants to "take an idea for a walk" even if it is not their personally held opinion (Figure 15.2).

Participants were invited to suggest a question that could form a starting point for discussion, based on something that had come up for them in the earlier exercise that they found puzzling. Ayisha, who was facilitating the inquiry, selected Sharon's question, "How are we going to measure success?"

This is an extract from the start of the PI:

Ayisha: Sharon, "how are we going to measure success?" If you could give us a short description of what you were thinking when you asked this question. . . .

Sharon: Measuring success could be by visitor numbers or maybe by press coverage because often a critique can make or break something.

Mandy: I agree, but I also think that success could be the model we're using being appreciated by other people or organizations.

Alan: For me, the initial success will be that on the day that our exhibition is supposed to open, it actually opens, and the artwork is finished. Everything else feels like an analytical exercise once that target has been achieved.

Elspeth: I disagree because I actually think that if nothing is made but we have a process and know that something has happened, that would be a success. We want the process to be something that other people will want to use. But we have to embrace the idea that sometimes nothing can come of a process. If you force a process to a conclusion, no matter what, then you might be leading to something that is watered down. Sometimes making a decision not to do something is as valid as doing something.

Laura: My initial reaction to Elspeth was "that's quite a brave statement to make," because I was siding more with Alan. But then I suddenly thought it could be really exciting to have a differentiated art exhibition where you had finished and unfinished works and maybe a space for ideas and future works to come, also staging the social model for how we're making these decisions.

Melody: I think part of the success will be the inclusion of the public. That's what galleries and museums need to be doing: reaching out to people and including them in decisions.

Fiona: I think success would be showing that curating with a group of people can create an even richer type of exhibition than a handful of curators in a gallery. You'd assume that an expert curator on T. S. Eliot might be the best person to create an exhibition, but why should one voice be more interesting than something that's able to hold lots of voices?

Ayisha: Can you just say a bit more about holding lots of voices, what do you mean by that?

Fiona: Some things shouldn't have to be unified. The exhibition shouldn't have to have one single message. An exhibition about The Waste Land has the potential to have conflict within it: different opinions within the form of the exhibition.

Mandy: I agree with Fiona and Melody. We need to remember that the public will be viewing the work. But we're members of the public who are curating and commissioning the work. Putting us, the public, in control should make for a better experience for the public who visit.

Elspeth: I agree, but I also disagree that we represent the public as a whole. We already have an interest in art. If we're talking about engaging a cross section of the public, we ought to try and have a cross section of the public involved in the curating, which we don't.

Alan: I disagree. I think we are a pretty good cross section of the general public who just happen to have an interest in art. But, then again, it's an art gallery. You wouldn't expect anything else. There are very few art professionals or professional artists within the group.

Sharon: From not knowing each other, we're now all working together. That, in itself, has value. So I agree with Elspeth. Even if we don't produce anything to put in that space, that in itself is a success.

Ayisha: Can I ask if anyone here disagrees strongly with the idea of not having anything in the space at the end?

Fiona: I disagree because I think we would not be upholding our responsibility to be creating something for a wider audience. That is ultimately our responsibility.

Sara: I agree. Our responsibility is to the public and how we reflect what we think is successful to them. If we invite the people we're representing from disparate sectors of the community, and they come in, and they don't feel the achievements and excitement we've generated, I think we will have failed.

Trish: For me, it's about how the process and outcome mesh together. They're inseparable. I can think of lots of socially engaged art projects that are all about process. I think what makes us distinct is having a process that will lead to a high-quality outcome. So maybe success is about having equal emphasis on both. And maybe it's about finding a way for the process to lead to an outcome that can incorporate difference and conflict.

Franca: I strongly agree with comments about responsibility because I think it's one of the parameters we can use to evaluate success. I think art should affect people and bring change. But we also have a mission to prove that co-curatorship works. To me, success will be a great exhibition that was designed through co-curation.

Fiona: Maybe success depends upon us becoming very sophisticated decision makers in a way that's not necessary when you've got three people around the

table. As a group of twenty people, how can we take ownership over our decision making? How can we manipulate the PI process or ourselves as a group to not end up with a watered down consensus but actually do something really innovative?

Melody: Alicia, I just wondered what you were thinking about.

Alicia: My interest, if you like, is more at the philosophical level, and so far I haven't felt there's room for my thoughts. My question would be, "how do you determine, in art, what is success and what is failure?" It surely depends on the historical time. Some painters died penniless because nobody gave a damn about what they were doing, and one hundred years later their work sells for millions of pounds. It's almost impossible to determine the success of an exhibition at the moment it occurs. It's something that happens in space and time, but it changes over time. Success is very difficult to evaluate. There are private galleries that make a fortune showing things that are very controversial, which, even if you paid me, I wouldn't go to see. Apparently they're very successful. Just not to me.

Fiona: I agree with Alicia that it's very difficult to judge the value of art, but it happens anyway. So perhaps success will be questioning or upturning the assumed value system within art galleries.

Ayisha: Can you give us an example of what might serve that purpose?

Fiona: An exhibition where there are people making work in a gallery. Maybe having the works that weren't accepted by the whole group, the works that are questioned, in their own room. . . .

Laura: Before Turner Contemporary, I remember an art exhibition on the High Street where you could go round and choose which artworks you felt spoke to you, and these went in a display case that changed from week to week. This marked an interaction, and indicated success in terms of what the audience appreciated in a very direct way.

Alan: If we go back to whether success is the finished product or relates to the people that have pulled it together, I've changed my opinion. I'm now agreeing with Elspeth about the process. I think it's going to be valuable to the gallery and to the people who are looking at it that these exhibitions have been curated and put on by non-professionals (with professional assistance).

Elspeth: I agree. We want to empower people to feel able to come into the space and feel confident about saying, "I like this, but I don't like that."

Sara: Maybe it's really interesting for the audience to share our questioning. It might be a really exciting outcome to create spaces where they can experience what we collectively have been going through.

Mandy: Yes, I agree, and I think one thing that I'm really realizing about this whole process is that people are going to look at the work in different ways, quantify success in different ways, and that's great.

Trish: Perhaps in relation to consensus or non-consensus, in terms of what constitutes success or in terms of how we make decisions, maybe we just need consensus for there to be dissent and difference? It's not about all agreeing the same thing but agreeing to disagree and making a space for that difference within the space of the exhibition.

Trish : In looking over the transcript of the philosophical inquiry, what had, at the time, felt like an intense and revealing process seemed somewhat circuitous and flat. Why was reading a transcript of a philosophical inquiry so different from participating in one? Would it be of interest to a secondary audience? Why were we all so committed to PI as being the key to operating in a sophisticated manner (or the key to avoiding decision by committee)?

Ayisha: Perhaps because this space is also surprisingly physical. Participants need to be seated in a circle so that they can all see and hear each other; they can envisage the ideas in the center and are free to view them from different angles. The comments on a page don't necessarily convey a sense of this experience.

Trish: To think about the difference between live thinking and considered reflection, we exchanged comments about the lasting impact of the PI.

Alicia: Through PI you are forced to really listen to the other person and not just wait for the opportunity to push your pet theory or favorite subject. At our discussion on the 15th of March, Mandy persuaded me to take the opposite view to my initial reaction: true "consent given after dialogue."

I generally have strong opinions about art, and find it difficult to enter into a dialogue with others for fear of confrontation. What philosophical inquiry creates is a physical space (you vote with your feet!) and later, the opportunity to substantiate your decision. True democracy in action!

Melody: I found it surprising what was brought to light, through quite startlingly opposing viewpoints, in a fairly structured debate.

I gained from having to think in a more abstract conceptual way about the nature of philosophy and why it matters to have this as part of the conversation. I have taken some positives from the inquiry such as trying to grasp the bigger picture of a given subject rather than getting bogged down by the detail or any irrelevant issues that inevitably surround an event such as this.

Mandy: The PI process helps us to see things openly from differing angles and helps us to consider things we may not have considered on our own.

PI builds confidence and helps people to be honest about how they are feeling. In just playing with ideas, the pressure is taken off.

Elspeth: I think that its value as a tool for critical thinking increases with a personal understanding of how the process works and what you expect to achieve. Although I have experienced using philosophical inquiry now on a number of occasions, in two different projects, I am only now starting to understand the process and how it can be useful to me in clarifying my thinking in order to reach a decision.

Sara: Philosophical inquiry allows you to refine your opinion so that you are ultimately more clear thinking. In enabling you to state ideas that might not be your own, it is a license to be provocative and articulate an unfamiliar viewpoint, which is liberating and also enables one to see things from different perspectives.

You can't drift away from the inquiry but remain immersed in it.

The discussion on March 15th was group based, which gave an impetus to the thinking: my current thoughts are influenced by the session, and my viewpoint expanded, but I no longer have a group to test notions with.

Trish: If we bring this back to the specific: I can identify a number of outcomes we might directly attribute to this PI. Measures of success that came up in conversation have been fed into how we're evaluating the project.

One group member, from entertaining ideas such as there being no artwork in the space or the exhibition containing unfinished works, was inspired to formally propose (outside the space of the PI) an idea back to the bigger group—the poem appearing in vinyl on the floors throughout the gallery. Playful thinking within the PI is inspiring bold and playful ideas outside of these liminal moments. It's helping the group to take risks to be different.

Finally, from being focused on themes and artworks in our general meetings, this PI marked the start of more spatialized thinking about the exhibition and how it might be physically structured to reflect a balance of voices. Since March 15th a sub-group has been established for A Journey with "The Waste Land" to start capturing and mapping experimental ideas for how content could be ordered that allows for synergies and dissonance and for this discursive element to be a feature of the exhibition itself.

Ayisha: Reading through the transcript and the reflections, I do think that these show key elements of the philosophizing process in operation. In their reflections, most participants identify a way of working that encourages them to listen, think again, agree and disagree freely, and to think beyond their own opinions with the possibility of re-evaluating their position. One of the participants described trying out a new position in the moment to see how it felt and recognized this as a new source of curiosity; another commented on the benefit of ongoing practice and mentioned conducting philosophical inquiries with herself.

A cycle of dialogue and decision making is allowing one process to feed the other, creating space to entertain ideas and grow the capacity to agree to disagree. These long-term curating projects are enabling continuity of group practice, and it appears to me that a philosophical community of inquiry is forming.

As we explore the impact of philosophizing in a visual art environment, I feel particularly excited to see ways in which the gallery can integrate more marginal voices, such as using the process of Deep Democracy, where in response to a majority vote the minority is consulted on what they might need in order to give their consent.[8]

NOTES

1 Plato. *Theaetetus* (155d). Plato in Twelve Volumes, Vol. 12 translated by Harold N. Fowler. Cambridge, MA: Harvard University Press; London: William Heinemann Ltd., 1921. Accessed June 20, 2016. http://www.perseus.tufts.edu/hopper/text?doc=plat.+theaet.+155d.

2 Since opening, Turner Contemporary has become one of the most successful galleries in the United Kingdom. We are leading the social and economic regeneration of Margate and have injected over £50 million into the local economy. See www.turnercontemporary.org.

3 Worley, Peter. *What Is Philosophy?* The Philosophy Foundation. Accessed June 20, 2016. http://www.philosophy-foundation.org/what-is-philosophy.

4 Community of Philosophical Inquiry (CoPI) in Scottish schools is explored in Cassidy, Claire, and Donald Christie. "Community of Philosophical Inquiry: Citizenship in Scottish Classrooms," *Childhood and Philosophy* 10, no. 9 (2014): 33–54. See also https://www.youtube.com/watch?v=Z3-fanPax4o. SAPERE stands for Society for the Advancement of Philosophical Enquiry and Reflection in Education.

5 Hughes, Bettany. "On Hospitality" from BBC Radio series *The Ideas That Make Us*, first aired September 2014, http://bbc.in/1aAmbpb.

6 1996 EPIC International & SOPHIA meeting, Glasgow (EPIC stands for European Philosophical Inquiry Centre, https://epic-international.org/; SOPHIA stands for European Foundation for the Advancement of Doing Philosophy with Children, http://www.sophianetwork.eu/).

7 Bosch, Eulalia. *The Pleasure of Beholding—The Visitor's Museum*. Barcelona: ACTAR, 1998.

8 The Lewis Method of Deep Democracy is available at http://www.deep-democracy.net/. Accessed June 20, 2016.

BIBLIOGRAPHY

Bosch, Eulalia. *The Pleasure of Beholding—The Visitor's Museum*. Barcelona: ACTAR, 1998.

Cassidy, Claire, and Donald Christie. "Community of Philosophical Inquiry: Citizenship in Scottish Classrooms," *Childhood and Philosophy* 10, no. 9 (2014): 33–54.

Hughes, Bettany. "On Hospitality" from BBC Radio series *The Ideas That Make Us*, first aired September 2014, http://bbc.in/1aAmbpb.

The Lewis Method of Deep Democracy is available at http://www.deep-democracy.net/. Accessed June 20, 2016.

Plato. *Theaetetus* (155d). Plato in Twelve Volumes, Vol. 12 translated by Harold N. Fowler. Cambridge, MA: Harvard University Press; London: William Heinemann Ltd., 1921. Accessed June 20, 2016. http://www.perseus.tufts.edu/hopper/text?doc=plat.+theaet.+155d.

Worley, Peter. *What Is Philosophy?* The Philosophy Foundation. Accessed June 20, 2016. http://www.philosophy-foundation.org/what-is-philosophy.

Chapter 16

Teaching Visitor-Centered Exhibitions

A Duoethnography of Two Team Members

Ann Rowson Love and John Jay Boda

In this chapter, we examine the process of teaching curatorial collaboration as a part of graduate professional preparation. To shape and share our story, we used the method of duoethnography to explore the nature of collaboration—both within the power system of teacher and student relationships and team-based, co-curatorial relationships—during exhibition development. Duoethnography is an emerging methodology first articulated by Norris and Sawyer.[1] Duoethnography is inherently dialogic, allowing the researchers to examine identity and "lived curriculum," what the articulators refer to as currere, or self-investigation.[2] Thus, the researchers are firmly ensconced in the story. This form of qualitative research is narrative and ontologically post-poststructuralist or develops out of "an interrogation of contingent spaces as text in order not only to interrogate meaning within that space (as in post-structuralism) but also to evoke, interrupt, and create new uncertain spaces."[3]

Sawyer and Norris asserted that lived experience produces *internal scripts*, both cultural and historical, that we all carry within us. Duoethnography encourages an exploration of these underlying scripts. We took the opportunity to explore this notion by generating an actual script that provides a frame for our research. Jay, who has an MFA in screenwriting, suggested using a screen-writing form called a beat sheet[4] as a way to guide our conversations, which is the basis for what follows. As qualitative researchers, we know the research should guide the form rather than the form guiding the research. However, metaphorically and literally the beats helped us think through the collaborative process—ours together and reflecting upon the exhibition teamwork—including the messy experiences and the triumphal ones. Duoethnography is not explicitly presented in the formal research paper structure. Pertinent literature is part of the conversation as is the method. The result is a script crafted from our conversations written in the spirit of a screenplay.

VEXING AND REWARDING MUSEUM RELATIONSHIPS

Logline:[5] A professor and her doctoral student reflect on their shared experience during a visitor-centered exhibitions class and reckon with contentious museum relationships and what it means to collaborate.

ACT 1

Opening Image: A snapshot setting the story's tone, sometimes conveying its theme.

FADE IN:
INT. DINING ROOM—DAY
On a midsummer afternoon in Tallahassee, Florida, DR. ANN ROW-SON LOVE, an assistant professor at Florida State University, talks with JAY BODA, a doctoral student. Ann's the coordinator of Jay's program, Museum Education and Visitor-Centered Exhibitions (MEX). She's just finished teaching Jay's class in visitor-centered exhibitions, and they're reflecting on their class experiences. They chat at Ann's dining room table. They record their conversation's audio with Ann's computer. The date is July 5, 2016.

> *Jay:* I'm glad you liked my suggestion to frame and guide our conversation with a beat sheet.
>
> *Ann:* Why don't you start with a short explanation of what that is.
>
> *Jay:* Sure. Beat sheets are used by writers for outlining stories, usually movies and plays.
>
> *Ann:* And that's your background.
>
> *Jay:* Right. I went to film school for screenwriting. So, when we talked about how we might frame our duoethnography, I suggested using a beat sheet to guide our recorded conversation—as an outline of sorts. It sketches out the major moments of a story. Looking over my semester journal, I thought our class experience had a comparable story arc to most films. We had a foundational set up, a catalyst that got the class working towards a goal, obstacles to overcome, and a climax resolving into lessons learned. That's a movie. So, I thought, why not use a beat sheet to frame our discussion?

Setup: The normal world showing what's missing from the protagonist's life and the lesson to be learned.

Ann: At the very end of the semester I reposted a quote from Daily Dose on our class Facebook page about collaboration, "Collaboration is not about gluing together existing egos, it's about the ideas that never existed until after everyone entered the room." Remember that?

Jay: I do! That was a big light bulb moment for me because it was something that was also said early in the class (chuckles) . . .

Ann: I know! I actually posted that on the board during our first month of class. And I think it really resonated with you right at the end when you reflected on the semester.

Jay: It did. One of your earliest readings was in McKenna-Cress and Kamien's book.[6] The first chapter is all about collaboration. It was all about bringing in a range of voices and creating something that couldn't be created unless everyone's in the room. But, at the beginning of the semester, I guess I wasn't ready to hear it, or I wasn't ready to sew it into my soul.

Ann: That's a cool expression.

Jay: I first heard it in film school. It's about making something second nature. I bristle at the word collaboration. I've had one or two poor experiences in college with group type experiences.

Ann: I think we all have (laughs).

Jay: The funny thing is, I was ready to work with a team. I knew we were going to be doing a collaborative exhibition. I guess I had to go through a journey to understand what collaboration really is.

Ann: Every time I work with an exhibition team there is a time when I'm ready to collaborate and also time when I'm still kind of struggling with how collaboration works. That's one of the reasons I like McKenna-Cress and Kamien's book because it talks about collaboration from the point of advocacy, you know?

Jay: Right.

Ann: Our class was called visitor-centered exhibitions so from the start I hoped students knew we were advocating for the audience. There's advocacy for or by staff members or stakeholders in the museum. And then there's the museum itself as an institution. So you're trying to tackle all these important aspects and negotiate your own participation. . . .

Jay: Right.

Ann: . . . and that's difficult. It's challenging and it takes time working together more than once, probably, to get it into a seamless work together.

Jay: One of my journal notes written early on was how teams within college settings can be artificial because you work with whoever signed up for the class (laughs). But, I guess that echoes work environments— like in an office or museum—because you don't always get to pick your coworkers.

Ann: Right, and especially with museums that are just getting started using a collaborative curatorial process. If your museum has worked in a more traditional manner, where curating is more of a lone creative activity, then moves into having more voices around that creative process, it's a very different experience. Would you like to explain the set-up of the class?

Jay: Sure. Right from the start, you introduced several core ideas we would eventually use to develop the exhibition. We focused on interpretive planning, for example.[7] We also did some activities where you laid out exhibition materials like pamphlets and catalogs and had us classify them according to how useful we thought they were. The activities got us thinking about exhibitions, but also gave us a glimpse into how our classmates thought and communicated within the group.

Ann: Early on, we did a lot with team building in different ways to build that comfort level. One thing you do need to have in a team is not only comfort to talk with each other, especially with challenging moments that might come up later, but you also have to establish trust. Trust is a big issue. This might be the start of our next beat, but it strikes me that part of our set-up should include introducing our protagonist. I think you're our protagonist, Jay.

Jay: Or it could be both of us. We both learned some lessons along the way (chuckles).

Catalyst: The moment that sets the story into motion causing a call to adventure for the protagonist.

Ann: So then one day, something happens. . . . (chuckles). After a few weeks of activities, I announced the artist whose artwork would be featured in our class exhibition, Gina Phillips, an artist I've worked with before who's based in New Orleans. I liked the idea of students getting to work with a living artist and her gallery—two artworld perspectives.

Jay: It was a big day in class. I was relieved we didn't have to start from absolute scratch.

Ann: I usually choose the starting point for a team, so that we're not starting with the world of possibilities. From there, before object selection, I try to guide students to thinking about big ideas, or enduring ideas.

Jay: Yes. That was a big challenge for us. Choosing our exhibition's big idea. We didn't commit for a long time (Figure 16.1).

Ann: True, even though you had your ideas stated very early in the semester.

Uprooting & Rerouting: Exploring the Themes

Origins
Memories of home and the people we grew up with play powerful roles in our lives. Phillips is often inspired by her roots, which she embeds through thick layers of fabric, thread, and paint in many of her art pieces.

Journeys
Life has many twists and turns taking us down routes both planned and unexpected. Phillips experienced several significant transitions in her life, including a move to New Orleans for graduate school and rebuilding her home and studio after Hurricane Katrina.

Identity
The places we've lived and the experiences we've had impact our identity, but so do the people we've met along the way. Phillips beckons new beginnings and opportunities created by our surroundings and the people in our lives.

Figure 16.1. Exhibition wall panel with themes.

Debate: The protagonist weighs options about which way to go, questions their abilities.

Jay: At this point, everyone started doing independent research about Gina then shared what we learned with the group. You also had us start defining our roles. Right?

Ann: Yes, in my own research, I've studied the various roles we take on as we co-curate on teams.[8] In my observation of teams, each member questions or wants to better understand what her or his role will be on the team. In our class, we had ten student co-curators! That's a big group!

Five team members were from the art history department, and five were students from art education in the MEX program. All of the early class activities were geared toward mixing up the two program cohorts so you would all feel comfortable working together. The artist research allowed everyone to start with something you already knew how to do—work alone, getting a feel for the topic.

Then we thought about curatorial roles within exhibition development such as roles related to content, interpretation, collections management, community engagement, fundraising, and so forth. With such a large group, I wondered if maybe individuals would feel more comfortable picking a role to advocate for during collaborative work.

Jay: I thought that worked well. Especially for smaller museums. It makes sense to have people play to their strengths.

Ann: There are challenges, too. Looking back, I now know that a couple students weren't really sure what role, or roles, made sense for them since they had yet to intern or work in a museum setting.

Jay: Maybe it would have been better to introduce role selection earlier in the class.

Ann: Maybe so. On the other hand, each exhibition has its own unique aspects that may require unexpected kinds of roles. Do we all do everything, which could be problematic with a large group, or do we encourage defining a focus for each team member? In a museum setting, that might be easily solved based on your position in the organization. In the end, we generated our own list of roles based on what the group felt would be needed for this exhibition.

Jay: My role was focused on story, ensuring the exhibition told a relatable story that resonated with visitors. I remember thinking my role would finish early in the process. Then what would I do later?

Ann: In a way your role was facilitative. How could it disappear if all the pieces don't come together until the end of the process?

Jay: Right. I learned that somebody needed to reiterate how various elements connected to the exhibition's story. If someone veered into a new direction, I was there.

Ann: This is where things got a little dicey, right?

Break into Two: The protagonist accepts their challenge and embarks into a new world.

Jay: While defining our roles, one of the art history students, someone who I think wanted a more traditional curatorial role, was curious about

what my role really meant. I think she thought storyteller encroached on her role.

Ann: Everyone on the team was a co-curator so that student's role was focused more on research and the scholarly contribution to the exhibition—the most traditional curator focus.

Jay: At one point, she suggested that I become the group's note taker.

Ann: I don't remember that!

Jay: I do. Distinctly.

Ann: Yes, of course you do!

Jay: That was my first brush with a traditional curatorial mindset.

Ann: And it was happening in a graduate class! I think that mirrors what other authors in this book discuss about traditional, or lone creative, curatorial roles. A curator may think, "Hey, that's my job!" But, you also need someone helping the group articulate an exhibition's story working collaboratively. Not every team would call it a storyteller role. That was unique to how we defined roles in our group.

Jay: We definitely blurred the lines between traditional museum roles.

Ann: That's the nature of collaboration. In art museums, we are moving away from working individually to working collaboratively to include different voices on the team, and each voice needs to be part of the story and process.

Jay: Absolutely!

ACT 2

The Promise of the Premise: The fun part, the protagonist explores and encounters interesting characters and obstacles.

INT. DINING ROOM—DAY (LATER)

Ann and Jay take a short break. Refilled with drinks and a snack, they reconvene at the dining room table. A couple of CLICKS of a MOUSE. Ann continues recording their conversation with her computer.

Jay: So, we're getting the exhibition on its legs, or at least the planning part of it. Did you want to continue our discussion about our big ideas of the exhibition, the themes?

Ann: Sure. I introduce big ideas the same way I do in art education curriculum development.[9] What are the understandings we would like for visitors to take away? How do we articulate those understandings as outcomes? How do we make strong connections to the human condition through our story? As the figure above suggests, the group articulated the big ideas early in the semester, but it took a longer time to commit.

Jay: When we were deciding on objectives, a lot of debate surrounded word choice and meanings. The storyline focused on our themes—origins, journey, and identity. We got hung up on what those words mean. I think the art history and museum education students had different perspectives.

Ann: And maybe it was somewhat focused on the roles everyone chose for themselves. It's probably not surprising that most of the art history students felt more comfortable in research collection activities whereas museum education students moved more toward interpretation, story, design, and evaluation. Did that set up a natural divide or conflict?

Jay: Perhaps, but as we started focusing on our big ideas during object selection, we had one particular team member whose research didn't seem to connect to the story—to put it mildly.

Ann: Yes, there was some palpable frustration.

Midpoint: A reflective moment, sometimes an interlude that demonstrates the lesson the protagonist must learn.

Ann: So, it's interesting to see how things start moving towards a turning point. There was a field trip to an art museum. Describe that experience for you.

Jay: I felt the field trip reinforced much of what I saw in our class regarding the culture clash between museum education and lone creative curators. Our exhibition tours were led by curators. They were knowledgeable, they had obviously done a lot of research. But they didn't allow for much discussion or offer other ways for the visitor to interpret or engage with the art. To me, that was our class experience, too. Some of the art history students were fairly singular in their vision of the exhibition.

Ann: Yes, and we can say students were encouraged to visit multiple museums. There's a continuum of what you would expect to see in visitor-centered exhibitions and some that you don't.

Jay: And our meet-and-greet lunch with the museum's staff was another example of disconnect.

Ann: It was a big group of staff members.

Jay: What stuck out to me was about representation. Our museum education program reinforces a philosophy about a museum's staff reflecting the community it serves, to represent and hopefully broaden its audience. I didn't necessarily see the community represented in the museum's staff.

Ann: We see that across the board in museum work. There's a push for diversity, but it's not at the level it should be.

Jay: That field trip was so good. We read about ideals museums should strive for, but when you see the reality, you begin to understand how difficult it can be to make it happen.

Ann: And remember, every museum is at a point on the continuum. In class, we introduced case studies and how different museums approach these things in different ways and the range of inclusiveness.

Bad Guys Close In: The protagonist's adventure becomes more perilous as obstacles become more difficult to overcome.

Ann: So, let's get back to our exhibition. Let's talk about object selection. Initially everyone had a chance to pick some things they couldn't live without. It's a kind of owning, like when we use the Anderson and Milbrandt critical analysis model, when you let everyone have their initial reaction.[10]

Jay: It was a big moment of the semester. After everyone picked their object, our lone creative co-curator (laughs) explained we had chosen objects created before Hurricane Katrina and after Katrina—important since the artist's work changed when her home and studio were destroyed. This team member favored the idea of having only post-Katrina objects for aesthetic reasons. I thought our theme of journey and transition and the artist's personal story lent itself to before-and-after-Katrina objects. The class discussed it and eventually agreed about doing post-Katrina objects, but we had a healthy debate over that issue.

Ann: Perhaps this was a more positive moment of the team's collaboration?

Jay: (chuckles) Yes, but I can't help but think of McKenna-Cress and Kamien's chapter on collaboration. They offered warning signs to watch out for, and they started to happen: lack of trust, lack of commitment, inattention to results, complaining, lack of compromise. Compromising. . . .[11]

Ann: And consensus. Instead of really duking it out, just giving in to end debate. All of the work we did ahead of time to build team camaraderie kind of broke down at this point in class.

Jay: I think some of it was from stress. At this point, we hadn't made final decisions about our exhibition's title, the objectives, even the themes. Most of the complaining was from that. Thankfully, about two or three weeks before the end of the semester, our team's project manager really put hands on the process. That helped us a lot.

Ann: Yeah, and that's an act of bravery to step forward like that and have the group say, we need that.

Jay: I've had that experience in my prior career in the Air Force. I think I need to learn to foster that in others.

Ann: Well, you're thinking like a teacher. It's hard. It would be very easy for me to whack the table and tell everyone what we're doing, but it's harder to let the group figure that out, to find their way through that.

All Is Lost: The protagonist's lowest point as hard-fought gains disappear, hopelessness sets in.

Jay: We were making progress, decisions were being made. But then, in almost a last gasp of desperation, our lone creative co-curator questioned the entire exhibition, especially the story, and proposed a new way to go. As a screenwriter, I felt like this was an "all-is-lost" moment. We were finalizing outcomes, and the lone creator went to the whiteboard to write out a new idea. When I tried to steer it back to the team's agreed-upon story, the team member said, "I don't get it." There were only a couple of weeks left in the semester. I was stunned. I tried to explain the story again. The co-curator still didn't get it. I threw my hands up, leaned back, and asked for someone else to explain. I don't know if you remember that moment. . . .

Ann: Yes.

Jay: It was a very frustrating moment because, damn, we were agreed, we were done with story. We had to move on.

Ann: Yes. I certainly remember seeing that, and it was a question of should I intervene or let the group. . . . Should I be the one chopping off the discussion or see what happens. And maybe it wasn't the right choice, I don't want people feeling that frustrated with the process.

Jay: I think a benefit of the experience was to have this collaborative, friction-filled moment. It was an important moment for me. To dilute or diffuse it could have taken away some of the learning experience. I realized the other person was fighting for something of value, too. I didn't see it at the time, but I do now. We learned from Mckenna-Cress and Kamien's lessons. We didn't settle for consensus.

Ann: I also think this is the classic situation in the curatorial—educational collaboration. In the team process, as you're both negotiating how

to move this forward, be open to these new ideas and respect what they are, but stay true to what's been decided and discussed and is furthering the outcomes that you have already planned for the exhibition itself. If it's going off-target in a new direction, if it's valuable or not, you need to ask, what was the reason behind it?

Break into Three: Newfound inspiration reinvigorates the protagonist to begin again and complete the quest.

Ann: In your post-semester reflection, you wrote "Ann saves the day." I'm really curious about that; I don't remember saving any days. Did I cut someone off at some point?

Jay: Oh, that was about the moment mentioned earlier, about the lone creative not understanding the story. Others in class contributed their perspectives. I think many felt unsatisfying compromises had been made. But, by the end of that class, you were able to reframe our comments showing us how we were mostly in agreement. It's like what you said earlier, that our beginning ideas were our final ideas. We left that class thinking we got what we wanted. You saved the day (chuckles).

Ann: And that sets us up for Act 3.

ACT 3

Finale: Using everything they learned, the protagonist overcomes the final obstacle and completes the journey.
INT. GALLERY, WILLIAM JOHNSTON BUILDING—DAY
A month has passed. The exhibition is up. *Rerooting & Rerouting: Origins, Journeys, Identity.* Ann and Jay sit at a large round table in the gallery surrounded by Gina Phillip's artwork. As before, they record their conversation with Ann's laptop. The date is August 23, 2016.

Jay: So, we have hung the exhibition.

Ann: Did you want to reflect about your perceptions of the process of installation?

Jay: (chuckles) It went a lot better than I thought it would. Gina (the artist) came to do the installation, and she didn't have any airs about her at all.
 The three or four of us there for the install showed her our exhibition plan and gallery layout. She saw we had arranged some of the temporary walls at a diagonal. Gina wasn't very keen on that idea. She wanted a more open feeling to the gallery. That's when we, as co-curators, collaborated with the artist during installation (Figure 16.2).

We told Gina the exhibition's narrative was about origins, journeys, and identity. In essence, transitions in life. Gina treated the gallery's one long wall as a big canvas and combined pieces together to create a larger story.

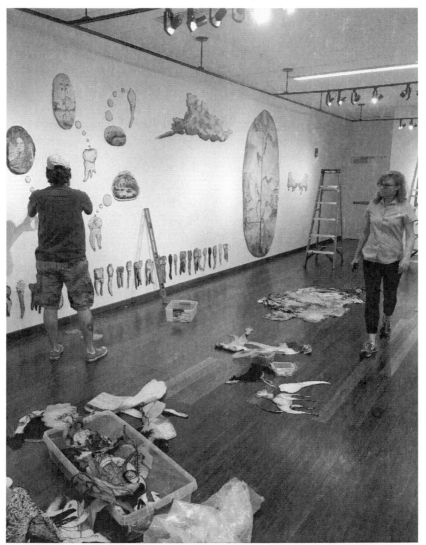

Figure 16.2. Installation of Gina Phillips's narrative wall for the visitor-centered exhibition, *Uprooting & Rerouting: Origins, Journeys, Identity,* William Johnston Gallery, Florida State University. *Source:* Art courtesy of Jonathan Ferrara Gallery, New Orleans. ©Ann Rowson Love.

Ann: Sort of like creating one larger installation.

Jay: Right. It was a very organic process. And while she was hanging her work, we were able to talk to her and ask questions and gather more of the stories that went with her art.

Ann: And ultimately, it didn't end up that far off from what the team planned in your exhibition design—which was the last piece that came out of the class. And we were able to do some interesting things with the double-sided pieces so you get to see even more of Gina's work through the gallery's glass walls (Figure 16.3).

Figure 16.3. Final installation of Gina Phillips's art for the visitor-centered exhibition, *Uprooting & Rerouting: Origins, Journeys, Identity.* **Source: Art courtesy of Jonathan Ferrara Gallery, New Orleans. ©Ann Rowson Love.**

Jay: Right. That came out of us experiencing the art for the first time in person.

Overall, I liked how we had our plan, but it was more like a guiding star. Like you said, the essence of everything we did in class is intact in the exhibition, and Gina added her voice becoming another collaborator. It was a wonderful experience.

Finale: The hero returns with new eyes having been transformed by hard fought lessons, ready to teach others.

Ann: So, now that you've been through the installation, through the entire process, what are your takeaways? How do you think this will impact your future and how you'll approach your future profession?

Jay: Hmm. . . . I don't think what we accomplished as a group could have been done as a lone creator or one person's vision. I can't point to anything in the gallery and say that was one person's idea. It looks like one person's vision, but it isn't.

And like I mentioned before, my entire definition of collaboration changed. It was practically a four-letter word to me, a class project I had to "get through." I think seeing our exhibition shattered my paradigm. Not to say there wasn't friction or bumps along the way. There was, but what we created really was worth the effort, and I learned a lot from the experience.

Ann: And your approach for your future profession?

Jay: I have no doubt I'll experience frustration if I go into a museum that doesn't embrace visitor-centered approaches or multiple voices during interpretive planning. But, I think that's what our program is really about. We're learning about edu-curation practices. It's a journey about transition and changing identities. Those of us in museum education and visitor-centered exhibitions are the seeds that will go out into the field and share these kinds of lessons. I see it as part of my job to foster more collaborative practices within museums and with our visitors, too. It wasn't completely painless, but I think we created an exhibition that's quite special.

Final Image: A last look at the protagonist's transformation.

Ann: Any final thoughts about visitor-centered exhibitions?

Jay: We concentrated on who our visitor was going to be. In our case, Florida State students. We thought about the timing of the exhibition, the first month of the fall semester. Our visitors will be going through pivotal and sometimes difficult transitions in their lives. We wanted to mirror that journey with Gina's art and her life story. Ultimately, we wanted visitors to connect and relate to Gina's art in a meaningful way (Figure 16.4).

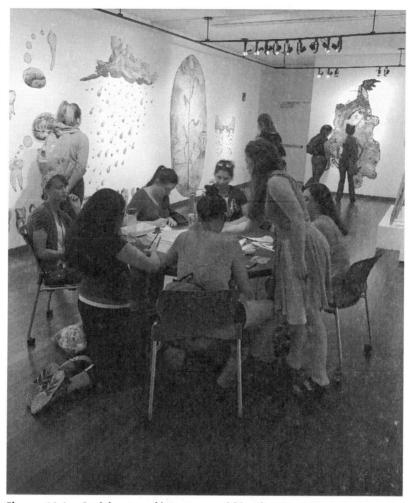

Figure 16.4. Social art making space within the *Uprooting & Rerouting: Origins, Journeys, Identity* visitor-centered exhibition. *Source:* Art courtesy of Jonathan Ferrara Gallery, New Orleans. ©Ann Rowson Love.

Visitors experienced Gina's story, her art. How she left what was comfortable, adapted, and made it through better than before. They'll see her story and see themselves. Gina's experience is a universal human experience. That's what we were tapping into (Figure 16.5).

Fade to Black.

Figure 16.5. Gina Phillips's artist gallery talk in the William Johnston Gallery.
Source: Art courtesy of Jonathan Ferrara Gallery, New Orleans. ©Ann Rowson
Love.

THE END

REFLECTIONS ON THE EXPERIENCE OF AN ARTS-BASED DUOETHNOGRAPHY

Our duoethnography became an arts-based research project as it evolved
into screenplay in form and presentation. This form opened up through our
creative art making, while at the same time grounding the dialogic process.
Looking back through our resulting story, we find a few takeaways that we
will continue to explore and use within our own professional practices as edu-
curators, teachers, and researchers, including the need for:

• Teaching collaborative curation as a part of art history programs: If we
 want to change the paradigm of the traditional model of the lone creative
 as curator, we need to start with preprofessional curators during graduate
 school. This may mean inserting collaborative opportunities in art history

courses or adding visitor-centered coursework to graduate requirements, or ideally, both.

• Finding your team's own language and role development: Each collaborative curatorial team will have its own group identity and underlying internal scripts. Allow role definitions and functions to evolve organically out of the group conversation.

• Facilitative wait time: Facilitators of collaborative curatorial teams are more than project managers. There are no quick fixes or easy answers to avoid conflict, but there is wait time. It can be painful, but essential, to build trust in each other to overcome conflict and move to resolution in order to build strong exhibition narratives.

One of the enticing components of duoethnographic research is that the researchers share their story, but readers bring their stories to the work as well.[12] You may relate to our experiences and you may generate your own takeaways. We look forward to continuing this dialogue with you in the future.

NOTES

1 Norris, Joe, and Richard D. Sawyer. "Toward a Dialogic Methodology." In *Duoethnography: Dialogic Methods for Social, Health, and Educational Research*, edited by Joe Norris, Richard D. Sawyer, and Darren Lund, 9–39. Walnut Creek, CA: Left Coast Press, 2012.

2 Norris and Sawyer, "Toward a Dialogic Methodology," 12. The authors use Pinar's notion of *currere*, which "views a person's life as curriculum." Through conversation, duoethnographers interpret the past, present, and possibilities for future.

3 Sawyer, Richard D., and Joe Norris. "Why Duoethnography: Thoughts on Dialogues." In *Duoethnography: Dialogic Methods for Social, Health, and Educational Research*, edited by Joe Norris, Richard D. Sawyer, and Darren Lund, 289–305. Walnut Creek, CA: Left Coast Press, 2012.

4 Snyder, Blake. *Save the Cat: The Last Book on Screenwriting You'll Ever Need.* Studio City, CA: Michael Weiss Productions, 2005. Beat sheets can take many forms. We use Snyder's beats to guide the conversation.

5 McKee, Robert. *Story: Substance, Structure, Style, and the Principles of Screenwriting.* New York: Harper Collins, 2007. A logline is a one-sentence summary of a screenplay.

6 McKenna-Cress, Polly, and Janet Kamien. *Creating Exhibitions: Collaboration in the Planning, Development, and Design of Innovative Experiences.* Hoboken, NJ: Wiley, 2013.

7 Wells, Marcella, Barbara Butler, and Judith Koke. *Interpretive Planning for Museums: Integrating Visitor Perspectives in Decision-Making.* New York: Routledge, 2013.

8 Love, Ann R. *Inclusive Curatorial Practices: Facilitating Team Exhibition Planning in the Art Museum Using Evaluative Inquiry for Learning in Organizations.* PhD diss., Florida State University, 2013. ProQuest (3596578).

9 Wiggins, Grant, and Jay McTighe. *Understanding by Design.* Alexandria, VA: Association for Supervision and Curriculum Development, 2013.

10 Anderson, Tom, and Melody Milbrandt. *Art for Life: Authentic Instruction in Art.* New York: McGraw Hill, 2004.

11 McKenna-Cress and Kamien, *Creating Exhibitions.*

12 Norris and Sawyer, "Toward a Dialogic Methodology."

BIBLIOGRAPHY

Anderson, Tom, and Melody Milbrandt. *Art for Life: Authentic Instruction in Art.* New York: McGraw Hill, 2004.

Love, Ann R. "Inclusive Curatorial Practices: Facilitating Team Exhibition Planning in the Art Museum Using Evaluative Inquiry for Learning in Organizations." PhD diss., Florida State University, 2013. ProQuest (3596578).

McKenna-Cress, Polly, and Janet Kamien. *Creating Exhibitions: Collaboration in the Planning, Development, and Design of Innovative Experiences.* Hoboken, NJ: Wiley, 2013.

McKee, Robert. *Story: Substance, Structure, Style, and the Principles of Screenwriting.* New York: Harper Collins, 2007.

Norris, Joe, and Richard D. Sawyer. "Toward a Dialogic Methodology." In *Duoethnography: Dialogic Methods for Social, Health, and Educational Research*, edited by Joe Norris, Richard D. Sawyer, and Darren Lund, 9–39. Walnut Creek, CA: Left Coast Press, 2012.

Sawyer, Richard D., and Joe Norris. "Why Duoethnography: Thoughts on Dialogues." In *Duoethnography: Dialogic Methods for Social, Health, and Educational Research*, edited by Joe Norris, Richard D. Sawyer, and Darren Lund, 289–305. Walnut Creek, CA: Left Coast Press, 2012.

Snyder, Blake. *Save the Cat: The Last Book on Screenwriting You'll Ever Need.* Studio City, CA: Michael Weiss Productions, 2005.

Wells, Marcella, Barbara Butler, and Judith Koke. *Interpretive Planning for Museums: Integrating Visitor Perspectives in Decision-Making.* New York: Routledge, 2013.

Wiggins, Grant, and Jay McTighe. *Understanding by Design.* Alexandria, VA: Association for Supervision and Curriculum Development, 2013.

Part V

SUSTAINING ENGAGED ORGANIZATIONAL LEARNING

Chapter 17

Complementary

Reflections on Curator–Educator Teamwork at the Denver Art Museum

Stefania Van Dyke

For more than fifteen years, I have worked as a museum educator, but recently I have become unsure of my precise role in exhibition development. I asked my museum's director, a former curator: how would he describe what someone in my position does? The question prompted him to start by thinking about a curator's role—part of curating is putting together a checklist, but part is also "storytelling, making objects talk, and hopefully, sing."[1] He acknowledged that educators on exhibition teams are, in fact, doing exactly that.

Where does curation end and education begin? We generally understand our respective roles; Lisa C. Roberts wrote in 1994, "On the surface it has appeared so straightforward: curators are responsible for an exhibit's content, designers are responsible for its look, and educators are responsible for the visitors."[2] But Roberts also highlighted the complexities within those not-so-clear-cut roles, and indeed the educator's job is actually multifaceted: audience advocacy, evaluation, learning theory, communication, interpretation, and subject matter. Within each of those areas, there are even more nuanced layers.

Not surprisingly, there has been a lot of confusion among curators, educators, and designers as to what, *really*, the others do. Juliette Fritsch realized that many noneducation staff use the words "learning," "interpretation," and "education" interchangeably. After further prodding, Fritsch found that there were indeed significant distinctions between the terms. In fact, "education" tended to have a pejorative connotation among some interviewed—it implied children's workshops, events, and "blah blah blah."[3] And "interpretation" proved the most elusive term of the three—curators and others were not able to articulate a clear definition.

Fritsch's study raised important questions about the perception of interpretation, especially on cross-departmental exhibition teams:

> For these team members, learning is a fundamental part of not only . . . visitor experience, . . . but also part of their individual construction of their own life experience in relation to museums, professional or personal. These team members can form interpretive communities both in terms of their individual professional contribution to the project but also to the project team as an interpretive community in its own right.[4]

What if team members' roles are further blurred? What if an educator takes on responsibilities that have traditionally been in the curatorial realm? What if stepping into others' shoes could add significant value to the collaborative exhibition development model?

In this chapter, I'll discuss types of curator–educator teamwork we've been exploring at the Denver Art Museum (DAM), including educator-led installations in which curators served as consultants. By participating in this type of project, as well as the more common model with a curatorial lead, I have realized that periodically taking on each other's roles—or at least having candid conversations about them—helps cultivate collegial empathy and leads to richer interpretive solutions and positive visitor experiences.

REFINING OUR APPROACH TO EXHIBITION EXPERIENCES

Educators have been on exhibition teams for several years at the DAM, but I will focus on how our roles have expanded and how our approach to exhibition development has changed in the past few years. Many of us in the museum education field have long been trying to break exhibitions out of the traditional knowledge transmission model into one that's more dynamic and immersive, and Leslie Bedford provides real examples with supporting research and learning theory.[5] Her book *The Art of Museum Exhibitions: How Story and Imagination Create Aesthetic Experiences* helped me think about how to get visitors' imaginations churning, their creative juices flowing, and their personal connections poignantly or surprisingly revealed.

I was fortunate to get an advance copy of the manuscript in 2013. It came at a time many of my departmental colleagues were ready for a collective shift. Decades ago, the DAM's then-head of education, Patterson Williams, created the position of master teacher to identify educators who were on the same level in the institutional hierarchy as the curator with whom she or he was paired. Master teachers, who were knowledgeable about subject matter as well as visitor engagement, were responsible for how content would be communicated to museum audiences in the most meaningful way possible.

The DAM master teachers' conversation a few years ago about *The Art of Museum Exhibitions*[6] was one catalyst in questioning our job title. Hadn't we become even more deeply involved in exhibition development and the interpretive implications that fall within that realm? We believed that "master teacher" implied only "education" in an outdated, even negative sense. We suggested changing our title to "interpretive specialist," signifying our focus on crafting stories and interpreting art works in ways that take into consideration the *whole* of visitor experience.

We began to move away from developing exhibition "interpretive plans," which had been limited in scope, and focused only on the text and other so-called interpretive materials.[7] We started to develop more holistic "experience plans": living documents that are rich with visuals, focused on sensorial aspects of experience and feelings we hope to evoke, and are reflective of team discussions. Whereas few members of exhibition teams seemed to look at the text-heavy, minutely detailed interpretive plans, experience plans have become our go-to working documents throughout the exhibition development process.

My departmental colleagues and I started thinking about museum experiences in a new way—a former interpretive specialist coined the term *positive expectation violations*,[8] referring to exhibition elements that offer an unexpected perspective but are grounded in something relatable. For us, that meant interpretive interventions like installing scents based on the paintings of Monet. By pushing the interpretive status quo in our team meetings, we could help trigger creative ideas in our teammates for offering moments of surprise and connection in exhibitions.

While interpretive specialists were reconsidering the nature and possibilities of interpretation at the DAM, the museum administration was developing an institutional vision to coincide with a renovation of our historic North building by the year 2021. The staff had a mandate to go big, with an explicit focus on visitor experience. Vision 2021 positioned us to become a "beloved anchor in Denver's cultural and creative ecosystem, a national beacon for the ingenuity and boldness of our community, and a place that welcomes everyone."[9]

In *Magnetic: The Art and Science of Engagement*, Anne Bergeron and Beth Tuttle wrote about how "magnetic" museums work from the inside out, getting internal stakeholders on board with shared values and vision and then radiating out to engage visitors and the larger community.[10] Just after Vision 2021 launched, we moved to a new office building, which was designed specifically for openness and collaboration. It was a spatial manifestation of the museum's vision statement, and it was not a smooth adjustment for some staff. In our leadership's view, shared spaces went hand in hand with shared values, and eventually, we lost some staff members who were struggling with the new direction.

The museum's vision statement emphasized creativity—exposing artists' processes, inspiring visitors' creativity, and connecting all of us with the shared human capacity for innovation, experimentation, and artistry. An eighteen-month study we conducted, which concluded around the same time as the launch of Vision 2021 and our office move, revealed that creativity was a fulsome lens through which to experience artwork. One visitor reported, "What I love about the Denver Art Museum is they're not saying the art is up here, it's unapproachable and untouchable. It's accessible to everyone and you can be a part of it."[11]

Other principles the report outlined for enhancing creativity centered around providing variety and variation, featuring the unexpected, creating opportunities for participation in safe environments, accentuating elemental qualities of human expression and new ways of thinking, and promoting risk-taking. These ideas now help guide the questions the interpretive specialists ask throughout the exhibition development process.

CURATOR–EDUCATOR TEAMWORK

Our 2016–2017 exhibition, *Star Wars and the Power of Costume*, was originally organized as a completed traveling exhibition. As such, no internal curator was assigned. Rather, Melora McDermott-Lewis, chief learning and engagement officer, and I would lead the charge, though I consulted with Florence Müller, our curator of textile art and fashion, on issues of display and accuracy along the way. Although there was a checklist of costumes and an organization to the exhibition, we wanted to give our audiences what they'd come to expect—insight into creative process, a variety of voices, and delightful surprises. On a recent visitor panel we heard: "I expect this museum to show me something different when I come. . . . 'Oh, this is sort of a shock; good.' I don't want to come and have things be predictable."[12]

As we worked through the *Star Wars* exhibition process, I found myself falling into the same trap I find curators often fall into: trying to say too much, trying to squeeze in too many concepts, too much stuff. There was a moment during planning in which I realized what was happening, and taking on another teammate's role allowed me to cultivate empathy for the challenges they face. Part of this is also realizing how difficult it is to marry the curatorial and interpretive perspectives when one individual is tasked with providing both.

As educators, we are trained to look out for the visitor; empathy is already in our toolbox. Perhaps we just need to point it in multiple directions: not only toward the visitor but also toward our co-workers. The power of shared experiences, feelings, interests, and values could ultimately connect us more

deeply to each other and to our visitors. I realized that other principles guiding my interpretive philosophy for visitors could also be applied to my internal relationships.

Principle 1: Celebrating Multiple Perspectives

Museum audiences are composed of different people with different responses to art, motivations, expectations, backgrounds, perspectives, and learning styles. We strive to offer visitors choices in our exhibition experiences, and to cater to a diversity of needs. Exhibition teams offer that same diversity of individuals, on a micro scale. One reason exhibition teams exist is that each member contributes something unique; ideally the team works together to create a great experience for visitors. But it is sometimes tricky to respect those different staff perspectives when your own seems so important and may be at risk of taking a backseat.

My first project at the DAM was to conceptualize, populate, and install the Nancy Lake Benson Thread Studio, a dense, process-driven exploratory space attached to our Textile Art gallery (Figure 17.1). I had little scholarly or exhibition experience with textiles at the time, so consultation with our then-curator of textile art, Alice Zrebiec, was crucial. Thread Studio was also part of a suite of installations associated with her collection area, so of course she had a stake in it. Alice patiently reviewed my proposals for the installation. She fact-checked, shared her honest opinions, and put me in touch with local artists and enthusiasts—I ended up involving more than 150 community members in the project.

Alice made clear to me throughout the process that this was *my* project, and I'm sure that's partly because she wanted me to feel ownership. But I got the sense that it was also because she would have approached it very differently. As an experienced scholar and curator, her focus might have been more historical, orderly, and comprehensive. As an interested nonscholar, my focus was on creativity and process. I liked the idea of simultaneously piquing visitors' nostalgia with familiar things like antique tools and patterns, while showing pieces that expanded preconceived notions of what textiles can be and how they might help us look at other works of art in new ways.

In the end, we were all pleased with the result and how the relatively crowded, colorful Thread Studio and the clean, beautiful textile gallery complemented each other (Figure 17.2). In fact, visitors commented on the pairing: "Having that juxtaposition of the interactive part of the gallery and then examples of work that's been done through the centuries gives you a better appreciation."[13]

Another visitor, remarking on the relaxed, living room atmosphere of Thread Studio, said, "Creativity comes when you're comfortable."[14] This has become a mantra for me, and I would argue that it extends beyond the

Figure 17.1. Nancy Lake Benson Thread Studio, detail. *Source:* Christine Jackson, ©Denver Art Museum, 2015.

Figure 17.2. Textile Art Gallery and entrance to Thread Studio. *Source:* Christine Jackson, ©Denver Art Museum, 2013.

public spaces of the museum into the creative hubs within our offices—in the work of exhibition development teams. When we're comfortable with our colleagues and respect our unique perspectives, we're freer to let ideas loose without fear of judgment.

Principle 2: Celebrating Personal Passions

According to museum evaluator Randi Korn, "Passion is tied to internal commitment and builds a sense of responsibility among individuals—essential ingredients for good programs."[15] This is also essential for good exhibition experiences and good working relationships. If you can get at the foundation of why a colleague is so passionate about a subject, it can be infectious and perhaps will help get visitors excited, too.

DAM curator Timothy J. Standring spent the last several decades studying Giovanni Benedetto Castiglione, a little known, but masterful, draftsman of the Italian Baroque. The time had finally come, in 2015, for the exhibition that would be the culmination of all that scholarly work. It fell to me to keep us on track to make this material interesting and, in fact, meaningful to our primary audience (who are, like core visitors to most art museums, educated but not trained art historians).

In *Castiglione: Lost Genius—Masterworks on Paper from the Royal Collection*, we attempted to implement findings from our recent audience research by revealing the artist's creative process and elements of his life that helped break down walls between today's museum-goers and an artist who lived more than 400 years ago. But what really stood out to me as indicative of successful cross-departmental teamwork was an area of the exhibition that dove into the *curatorial* process.

Even Timothy wasn't under any illusion that people would be rushing to see *Castiglione*. But I wanted, once we got them through the doors, to offer perhaps a new way of thinking about this type of art. Talking with Timothy about this artist was point of connection between us, as I had focused my art historical study on Italian Renaissance art. During one casual conversation, he recounted how he and his counterpart at the Royal Collection, where these art works have been hiding for the last 250 years, sifted through hundreds of works on paper to determine which were by the master and which were by talented followers. He mentioned that he and his co-curator didn't always agree. An idea struck me. Could we let visitors in on the connoisseurship process? Could we leave it open for visitors to decide for themselves whether a given work was by Castiglione? We developed an interpretive element we called "Connoisseurs' Debate," which highlighted details that helped sway the two curators one way or another (Figure 17.3).

Figure 17.3. "Connoisseurs' Debate" interpretive area in *Castiglione: Lost Genius—Masterworks on Paper from the Royal Collection*. **Source:** Christine Jackson, ©Denver Art Museum, 2015.

Timothy and my mutual interest and comfort level enabled us to lift the curtain on something many curators may not have wanted to reveal publicly. It was a small, simple part of the exhibition, but an important one that opened up a new layer of meaning. One day in the gallery, a staff photographer stopped me in front of the work featured in "Connoisseurs' Debate" and laid out her arguments, by pointing out specific details, for why she believed that piece was *not* by Castiglione.

There is much talk in museum education circles about nurturing visitors' intrinsic motivation, the drive to act or learn solely because of personal interest and enjoyment.[16] There is something to be said, too, for acknowledging and celebrating the personal passions that drive us as professionals, as we were able to do by publicly highlighting Timothy's long-standing devotion to—and questions about—Castiglione.

Principle 3: Encouraging Self-Awareness and Self-Discovery

With just fourteen paintings, *Matisse and Friends: Selected Masterworks from the National Gallery of Art* (2014–2015) offered visitors permission to slow down and interact with art in a comfortable, intimate environment. The museum's director, Christoph Heinrich, served as curator. He believes that in any given museum experience, visitors can have memorable interactions with only a handful of artworks. By limiting the *Matisse* checklist, his idea was to "cut out all the fluff."

Christoph then stepped back and ceded creative oversight to interpretive specialist Danielle St. Peter, along with the designer and project manager, to create the appropriate ambience and conditions for a meditative, intimate visitor experience. The team was inspired by Henri Matisse's quote: "What I want is an art of equilibrium, of purity and tranquility, free from unsettling or disturbing subjects, so that all those who work with their brains . . . will look on it as something soothing, a kind of cerebral sedative as relaxing in its way as a comfortable armchair."[17]

The team filled the gallery with comfortable seating (Matisse's "armchair"), positioned for relaxed and prolonged viewing, warm colors, and homey accoutrements like rugs and a metal birdcage like one Matisse kept in his studio. Most visitors did exactly what the exhibition team hoped: they contemplated, meditated, and recharged (Figure 17.4).

Figure 17.4. Typical visitors at *Matisse and Friends: Selected Masterworks from the National Gallery of Art*. Source: © 2016 Artists Rights Society (ARS), New York/ ADAGP, Paris. Photograph by Christine Jackson ©Denver Art Museum, 2014.

Visitors wrote poetry and intimate reflections in the in-gallery journals: "Holiday, vibrant, proud. Bright as a Sunday afternoon, the man stands without losing his balance as he watches this, committing it to memory. It is a fine day. Exciting. I don't want this to end."

How exhibition teams communicate and articulate goals and intentions relates significantly to this interpretive principle of self-awareness. In discussing the core capabilities that foster collective leadership—and, related, effective team collaboration—business strategists Peter Senge, Hal Hamilton, and John Kania noted:

> Reflection means thinking about our thinking, holding up a mirror to see the taken-for-granted assumptions we carry into any conversation and appreciating how our mental models may limit us. Deep, shared reflection is a critical step in enabling groups of organizations and individuals to actually "hear" a point of view different from their own, and to appreciate emotionally as well as cognitively each other's reality. This is an essential doorway for building trust where distrust had prevailed and for fostering collective creativity.[18]

Matisse and Friends taught me to sit back, sink into a metaphorical chair, and contemplate my place in the world of exhibitions. How can I be most effective on these teams? It's only when we really stop to think about our own roles and those of others that we can garner respect and trust.

Principle 4: Finding Relevance

We know from years of research and experience that visitors are overwhelmingly responsive to museum experiences that help them forge personally meaningful connections with the artworks and their makers.[19] By providing tools that give objects a human dimension—for example, through stories and contextual materials—exhibition teams can facilitate visitor meaning making and sustained learning.

Wyeth: Andrew and Jamie in the Studio (2015–2016) explored the converging and diverging styles of a father and son artist pair through an "artistic conversation." The pull of creativity as a unifying human tendency helped guide us toward artworks that revealed the Wyeths' respective creative processes and toward content that emphasized the emotional realness of the artists as people.

The notion of "place," particularly Pennsylvania and Maine—the Wyeths' long-standing home states—was central to them and their work, yet those places are relatively far removed from our core audience in Denver. So we strove to immerse our visitors in the Wyeths' places as much as possible through graphics, photography, color choices, additional objects and

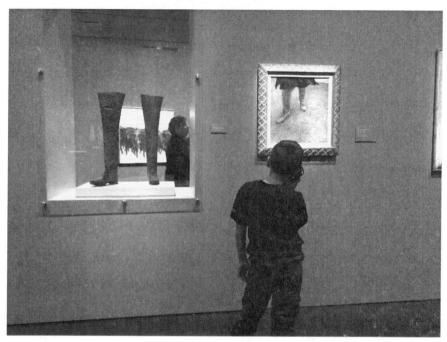

Figure 17.5. A young visitor listening to audio tour stop at Andrew Wyeth's painting *Trodden Weed*, and the artist's boots, in *Wyeth: Andrew and Jamie in the Studio*. *Source:* © 2016 Andrew Wyeth/Artists Rights Society (ARS), New York. Photograph by Stefania Van Dyke, 2016.

ephemera, evocative language, prominently featuring the artists' own voices, and the works themselves (Figure 17.5). We wanted the space to serve as more than a setting for the art works; we also wanted it to be imbued with the sensibilities of the artists.

Bedford wrote that "the potential for meaningful experience . . . lies not in the so-called universal, but in the specific, the concrete, the particular detail that can, in some circumstances, become the inspiration for what might be called the universality of emotional response."[20]

By highlighting the specificity of the Wyeths' subject matter and intimate emotional connections to it, we were able to hit on ideas deeply relatable to most visitors. For Andrew Wyeth, it was *that specific* hill on which he studied every blade of grass, on which he marched in his beloved worn boots, within which he could feel his deceased father's chest rise. We may not know that hill, but we all know the types of grief, love, and memories that the artist associated with that piece of home.

It's the same with our interdepartmental teammates. Why do I (or why *should* I) care about this exhibition? Why should my coworkers? Timothy was

the curator on this project, and, again, he excitedly guided me and other team members toward the artists and their passions. It went deeper than art history. We traveled to the East Coast at the outset of planning to tour the Wyeths' homes and studios, pore over their artworks, and spend time with Jamie Wyeth and his family. We experienced visceral emotions while walking in the artists' footsteps, seeing the peeling wallpaper in their subjects' homes, feeling the harshness of the Maine landscape. I appreciated Andrew and Jamie's work before that trip, but afterward, I truly understood the humanness of it, and of them. Through firsthand experience, I found relevance that, in turn, ignited a sincere desire to facilitate the same feelings for our Denver audience.

CONCLUSION

These things—celebrating multiple perspectives, personal passions, self-awareness, and relevance—all lead back to the notion of empathy. If museum educators don't have opportunities to play a curatorial role, to experience for themselves the challenges curators face and the delights that feed their passions, I'd suggest having more informal conversations with exhibition teammates in order to understand where each other is coming from. In turn, educators should be vocal about their own passions and drives, authentically sharing in the reasons we do this work. Through understanding, we become better collaborative partners and thus more impactful visitor advocates.

The DAM's director, Christoph Heinrich, told me that, to him, the most successful exhibitions are those like *Wyeth*, in which he can't tell which team member is responsible for what. There is power in the holistic vision of the individual team members' contributions that ultimately come together in a cohesive, harmonious way. Our roles may be well defined on the surface, but if we apply what we know so well about visitors and museum practice to our internal collaborative efforts, the lines can—and should—get a little blurry.

NOTES

1 Conversation with Christoph Heinrich, April 21, 2016.
2 Roberts, Lisa C. "Educators on Exhibit Teams: A New Role, A New Era," *Journal of Museum Education* 19, no. 3 (1994): 6.
3 Fritsch, Juliette. "Education Is a Department Isn't It?: Perceptions of Education, Learning and Interpretation in Exhibition Development." In *Museum Gallery Interpretation and Material Culture*, edited by Juliette Fritsch, 234–248 (esp. 239). New York & London: Routledge, Taylor & Francis Group, 2011.
4 Ibid., 247.

5 Bedford, Leslie. *The Art of Museum Exhibitions: How Story and Imagination Create Aesthetic Experiences*. Walnut Creek, CA: Left Coast Press, Inc., 2014.

6 Ibid.

7 The fact that we changed our title to *include* the word *interpretive* and the plans to *eliminate* it confirms Fritsch's findings about the muddiness surrounding the term. To us, "interpretive" held different signification in our titles than it did in the plans.

8 Lindsey Housel, former interpretive specialist, architecture, design, and graphics.

9 Denver Art Museum, Vision 2021, 2014.

10 Bergeron, Anne, and Beth Tuttle. "Magnetism and the Art of Engagement." *Museum* (September/October 2013). Accessed April 30, 2016. http://onlinedigeditions.com/article/Magnetism+And+The+Art+Of+Engagement/1481144/0/article.html.

11 Denver Art Museum and Institute of Museum & Library Services. *Tapping into Creativity & Becoming Part of Something Bigger*, 2014. http://denverartmuseum.org/about/research-reports, 43.

12 DAM visitor panel associated with the exhibition *Arrangements*, 2015.

13 Denver Art Museum and Institute of Museum & Library Services, *Tapping into Creativity*, 54.

14 Ibid., 58.

15 Korn, Randi. "The Case for Holistic Intentionality," *Curator* 50, no. 2 (2007): 255–262 (esp. 257).

16 Csikszentmihalyi, Mihaly, and Kim Hermanson. "Intrinsic Motivation in Museums: Why Does One Want to Learn?" In *Public Institutions for Personal Learning: Establishing a Research Agenda*, edited by John H. Falk and Lynn D. Dierking, 65–67. Washington, DC: American Association of Museums, 1995.

17 Matisse, Henri. "Notes of a Painter, in *La Grande Review*, 52 (December 25, 1908): 731–745.

18 Senge, Peter, Hal Hamilton, and John Kania. "The Dawn of System Leadership." *Stanford Social Innovation Review*, 2015. https://ssir.org/articles/entry/the_dawn_of_system_leadership, 28.

19 See, for example, Roberts, "Educators on Exhibit Teams."

20 Bedford, *Art of Museum Exhibitions*, 100.

BIBLIOGRAPHY

Bedford, Leslie. *The Art of Museum Exhibitions: How Story and Imagination Create Aesthetic Experiences*. Walnut Creek, CA: Left Coast Press, Inc., 2014.

Bergeron, Anne, and Beth Tuttle. "Magnetism and the Art of Engagement." *Museum* (September/October 2013). http://onlinedigeditions.com/article/Magnetism+And+The+Art+Of+Engagement/1481144/0/article.html.

Csikszentmihalyi, Mihaly, and Kim Hermanson. "Intrinsic Motivation in Museums: Why Does One Want to Learn?" In *Public Institutions for Personal Learning:*

Establishing a Research Agenda, edited by John H. Falk and Lynn D. Dierking, 65–67. Washington, DC: American Association of Museums, 1995.

Denver Art Museum and Institute of Museum & Library Services. *Tapping into Creativity & Becoming Part of Something Bigger*, 2014. http://denverartmuseum.org/about/research-reports.

Falk, John H. *Identity and the Museum Visitor Experience*. Walnut Creek, CA: Left Coast Press, Inc., 2009.

Fritsch, Juliette. "Education Is a Department Isn't It?: Perceptions of Education, Learning and Interpretation in Exhibition Development." In *Museum Gallery Interpretation and Material Culture*, edited by Juliette Fritsch, 234–248. New York and London: Routledge, Taylor & Francis Group, 2011.

Korn, Randi. "The Case for Holistic Intentionality," *Curator* 50, no. 2 (2007): 255–262.

Roberts, Lisa C. "Educators on Exhibit Teams: A New Role, A New Era," *Journal of Museum Education* 19, no. 3 (1994): 6–9.

Senge, Peter, Hal Hamilton, and John Kania. "The Dawn of System Leadership." *Stanford Social Innovation Review*, 2015. https://ssir.org/articles/entry/the_dawn_of_system_leadership.

Chapter 18

Building a Workplace That Supports Educator–Curator Collaboration

Jennifer Wild Czajkowski
and Salvador Salort-Pons

The Detroit Institute of Arts (DIA) has been experimenting with progressive models of educator–curator collaboration in the development of exhibitions and gallery projects since 1997.[1] Certain processes, job descriptions, and resource allocations have changed during this ongoing effort, modifying the workplace culture. This chapter highlights areas of institutional growth in pursuit of this foundational shift, as explicated by a former curator—now director—and a former educator—now vice president for learning and interpretation. These long-term DIA colleagues offer a curatorial championing of the interpretive planner's value and a broader context for their own institution's change.

SETTING THE STAGE: SALVADOR SALORT-PONS ON UNDERSTANDING THE INTERPRETIVE PLANNER'S CONTRIBUTION

Prior to being appointed director of the DIA, I was the museum's curator of European Painting, starting in 2008. Since then working at the DIA has tremendously enriched the way I think about and understand curatorial practice. The key to this experience has been close collaboration with the DIA's education department—one of the most progressive in the country. What follows is part of the story of this fruitful experience.

During the time I attended university in Spain (1988–1993) and Italy (2000–2002), no programs existed that trained students to become curators. In fact, no programs related to any jobs in the museum profession at all were available. To become a museum curator, the route was to first study geography and history with a specialization in art history and later obtain a

PhD. Essentially this was the career path of a scholar who aimed to work at a university teaching and conducting research as a professor. Museums, in my country and in continental Europe, generally hired scholars with no previous museum training to work as curators. Therefore, my training as a curator was the same training an academic would have received to become a university professor.

During the early period of my career, I generally viewed exhibitions as highlighting an artist or a period in art history. The main goal for the former was to clarify the life and work of an artist from a scientific standpoint. This would mean to review, for instance, the entire corpus of his or her work, adding new works of art, disputing attributions, or reattributing new works. One of the goals of this exercise was to provide a sequence in which the artist made the works of art. New archival research to discover fresh information about the artist's life and family as well as other personal connections received considerable attention. In an exhibition of this kind, curators focused on the artistic context in which the artist lived, his or her artistic sources of inspiration, the masters he or she had lived with and influenced, and any piece of information (historical or artistic) that had a noticeable impact on the art on view.

As a result of the nature of exhibitions, labels were purely devoted to discussing scholarly problems based on connoisseurship, archival research, and technical analysis. They were reflective of the content provided in the catalogue and were conceived as incentive for further exploration. Often the labels were extensive and would have to blend with wall color as they were not meant to call attention or distract the viewer from art contemplation.

The curator conceived the checklist of the exhibition, attempting to illuminate the areas of his or her research presented in the show. As a matter of fact, curators generally believed that the only good reason to move a work of art from one museum to another was to learn more about that specific object or others related to it.

The installation of the exhibition was historically driven to illustrate the evolution of the artist. Each gallery was installed following art historical criteria, and the arrangement of the paintings played a specific role in the presentation of the scholarly information and research. The curator was solely responsible for the layout of the works. He or she considered the arrangement both from an art historical and an aesthetic perspective. The gallery needed to look balanced and beautiful, and this was done in a very efficient fashion, sometimes with the help of an architect or exhibition designer.

Many times I thought that curating an exhibition was like putting together or organizing the parts of a scholarly article. My audience was my peers, and curating a show was an extraordinary opportunity to clarify a theory or prove a hypothesis. The actual exhibition was better than writing an article because I had the original works of art. My goal was to advance science, to advance

the knowledge of art history, and to give new insights about the past. I was not familiar with the DIA's significantly different approach to exhibitions when I joined the museum in 2008. In 2009, the then-DIA-director proposed that I organize a show about art fakes employing primarily the DIA collection. As with all DIA exhibitions at that time, the idea was discussed and approved by the cross-divisional strategic interpretive team. This was to be an in-house exhibition with the possibility of including a few loaned objects. We titled the show *Fakes, Forgeries and Mysteries,* and it included works of art from most of the curatorial departments at the DIA, which is an encyclopedic museum.

Working with curators from different DIA departments, I assembled an object checklist that I shared with Madeleine Parthum, the interpretive specialist[2] assigned to the exhibition team. After several discussions about the checklist and objects, Parthum and I began working on a big idea—the overarching concept that would give direction to the exhibition.[3] An important component of a good big idea is that it must have a consequence that will be meaningful to a general audience. All the galleries and themes in the exhibition needed to support that big idea. The next step was to define the visitor outcomes. In other words, we needed to describe the things we hoped visitors would see, feel, and do after seeing the exhibition. Understanding the visitor outcomes was the key to my understanding of the DIA exhibition process. In general terms, curators think about the art object (provenance, stylistic qualities, relation to other similar works, etc.), while educators think about the visitors and how they are going to perceive and interact with the object. More importantly, they think of how the object can be meaningful to a visitor from any background.

Once Parthum and I established the big idea and the visitor outcomes, I provided written information for each object in the exhibition.[4] This information included about five to ten points describing the most relevant data for each work. After reviewing all the documents, Parthum proposed object groupings, a first draft of a gallery layout, and an interpretative plan that included a number of group labels, extended labels, gallery panels, videos, and other activities, including an audio tour.[5] I was encouraged by Parthum's proposed layout and object groupings, and we agreed to it very quickly after small adjustments. I came away feeling confidence in the process we were following. Generally a curator establishes the layout of the gallery, but Parthum's proposal, after our discussions of the checklist, was compelling and fresh. While it was fundamentally grounded in the art historical information I provided to her, anyone with any background could understand and be engaged with the story it presented.

We then began the process of label writing. Starting from the written information I had provided, Parthum prepared the first drafts. I reviewed them and

sent her my own adjustments. Later we sat down for a series of meetings in front of a large monitor and made all the changes together. DIA label guidelines at the time suggested a maximum of fifty words for an object label, and much of the negotiation focused on making the text more concise, choosing the most efficient words, and making smart choices when selecting the data we wanted to present. It was important to keep in mind that the content of the label needed to refer to the big idea to trigger the visitor outcomes we had defined. As a curator who traditionally had been in charge of writing labels, this exercise helped me understand the philosophy behind the ways we wanted to connect art with our visitors. When writing labels, I focused on the object, while Parthum focused on the visitors; this combined approach made the label content more powerful and positively promoted both of our objectives.

Once we completed the labels, we enlisted the help of the DIA's evaluation team and tested about 20 percent of them with visitors in the galleries. The evaluators prepared a report that we used to understand if our labels were sending the message we wanted. I was interested in the feedback from our visitors to help us adjust the labels with fresh information: the visitor perspective! In one case, we decided to remove an object from the exhibition. Based on the visitor feedback, we reworked the text at least twice, but we were unable to align its content with the visitor outcomes and the big idea. As a curator, I understood it was better to give up one object and remove it from the exhibition if it was not going to serve the purpose of our story. After this experience, I realized that doing research and discovering new aspects of an art object was important, but we also needed to transmit this new information in a meaningful way to a general audience.

By going through the exhibition process for *Fakes, Forgeries and Mysteries*, I learned a new way of thinking about art, thinking about visitors, and sharing ideas. The exhibition was solid in scholarly terms and engaged our visitors, according to visitor exit surveys. Looking back, I can say that this experience raised my professional level. While I continue to have my scholarly interest and connoisseurship skills intact, I have gained new knowledge in preparing exhibitions and looking at objects. I am certainly a more skilled curator and have expanded my horizons when I think about art and how it is presented in a museum setting. Furthermore, I now understand that art can be a platform to trigger dialogue and that the history an object carries can be transformed into text that connects to issues of contemporary interest. If, for instance, we can make the message of an "old master" current to our own time, the object becomes alive and relevant, gaining new stature and appeal. This idea can be paralleled to the idea of how a curator is transformed when working with the interpreter and vice versa. The curatorial information gains new light when it is seen through the eyes of the interpreter, and curators

look at objects in new ways when they consider them with the mind-set of an interpreter. In a true collaborative environment, curators feel their work is realized through the interpreter's approach, and interpreters find an inspiring springboard, a wealth of engaging ideas, in the necessary curatorial expertise.

THE CHANGING WORKPLACE: JENNIFER WILD CZAJKOWSKI ON THE BROADER CONTEXT

Salort-Pons's transition from a curator predominantly focused on academic priorities to one who works in a collaborative partnership with an interpretive specialist happened in a rich context. The interpretive planner who influenced him had worked at the museum several years, was a member of highly functioning interpretive team, and was primed to work on her first exhibition as the lead educator. The project was unconventional because it included objects from a variety of DIA collections and took on the nontraditional issue of fakes and forgeries. Salort-Pons, new to the DIA, approached the project with an open mind, intellectually curious about what the interpretive planner knew. It was a fitting landscape for experimentation, and both professionals embraced the opportunity. Their work, however, fits into the much larger context of a changing workplace.

Creating a Professional Identity for Interpretation

Since 1997, the DIA's department of education has changed from a department dominated by art historians to a division of learning and interpretation where staff members hold advanced degrees in education, critical theory, museum studies, liberal studies, and arts administration. The diversity of backgrounds is intentional and enhances the interdisciplinary characteristic of interpretive work that seeks to connect art to an array of human experiences. Though they are responsible for background reading on their exhibition subjects, DIA interpretive specialists and planners rely on their curatorial colleagues for art history and connoisseurship. Through their specific academic training and rigorous study of aesthetic development, learning theory, and visitor behavior, DIA interpretive planners bring expertise to the work of exhibition development that did not exist in art museums twenty years ago.

Interpretive expertise can be defined as a continually deepening knowledge of museum visitor behavior and the ways people learn,[6] supported by a practice of critical thinking necessary to interrogate ideas and implement creative solutions that make art accessible and engaging to all, while paying particular attention to those who traditionally have not felt included in such experiences. To do this work well, DIA interpretive planners need constant

and regular communication with the people they seek to engage. This often comes in the form of evaluations and visitor studies informed by planners' aspirations and conducted by the DIA's department of evaluation. Increasingly, it comes from direct contact with community advisors, who provide expertise in lived experience, and academic advisors from areas outside of art history. The work of the interpretive staff is certainly distinct from the art historical expertise and connoisseurship that a curator brings to exhibition development, as Salort-Pons described earlier in this chapter.

Since 2013, a group of art museum educators has met on the day before each American Alliance of Museums annual meeting to discuss the growing professionalization of the interpretive planner position.[7] The group shares ideas, connects practice to theory, and discusses professional standards. Each year the meeting group has grown larger, with additional museums sending representatives who continue to explore this burgeoning profession.

Leading with Interpretive Expertise

The presence of those with interpretive expertise in the upper levels of the traditional museum hierarchy has increased and is helping to shape the DIA. In 2012, the DIA's head of education position was raised from the executive director to the vice president level in recognition of the central role the division plays in fulfillment of the museum's mission.[8] The year before, a director-level position was created to lead the new department of interpretation within the division of learning and interpretation.[9] The director of interpretive engagement chairs the steering committee for permanent collection galleries and sits on the exhibitions strategies committee. While the vice president uses her expertise to inform the museum's overall artistic program and strategic plan, the director of interpretive engagement looks across all interpretive projects, guiding the museum in a holistic plan for autonomous visitor engagement in art galleries. She determines processes for engaging communities and individuals in the interpretation of exhibitions and galleries and has made significant innovations in the way the DIA works with audience consultants.[10] She also provides training in big idea development, outcomes-based planning, and use of visitor studies for cross-departmental exhibition teams, which is building capacity for progressive practice across the museum. The close relationship between these two education leaders and the DIA's co-chief curators is a strategic priority for the museum.

Quantifying Interpretive Work

Strong exhibition work requires time for generous dialogue between interpretive planners and curators, research and evaluation, creative thinking, and

experimentation. At the DIA, it has been difficult to agree upon how much time this work requires. Making matters more complicated, staff turnover and a lack of full agreement on processes and responsibilities have made managing schedules difficult. While leadership has wanted every exhibition and permanent collection gallery project to benefit from a full interpretive effort, it has not been possible.

In early 2016, the DIA's new director asked the leader of interpretation to identify what it would take to streamline certain aspects of the DIA interpretive planning process. A few months earlier, after urging from both educators and curators, the exhibitions department had been expanded to take on the substantial project management work that the interpretive planners had been doing since the 2002–2007 reinstallation. That decision was paying off, giving interpretive planners more time to focus on their areas of expertise. Upon the director of interpretive engagement's recommendation, funds were identified to create a new database for managing interpretive projects, so that planners would have the long-needed software for managing their work more efficiently. Based on the expected time savings, the lengths of the different phases in the interpretive process were slightly compressed for future projects, and planner capacity was marginally increased.

After studying the fluctuating staffing and processes for exhibition work over the last several years, the director of interpretive engagement detailed and standardized the interpretive process by phases. She reviewed staff time records in order to calculate pacing and the number and scale of projects one person could reasonably work on simultaneously. With better software tools and project management support from the exhibitions department, the director of interpretive engagement was able to shift assignments from two interpretive planners per major exhibition to one. After adding time reserved for professional development, publication and presentations, pop-up projects, vacation and illness, she reviewed the future exhibition and project schedule again and made a strong case that the museum still needed an additional planner to give all projects on the five-year calendar a meaningful interpretive plan.

Seeing the work streamlined, clearly defined, and visibly documented, museum leadership approved an additional interpretive planner position. The department currently includes five interpretive planners, a part-time administrative assistant, and a director. A digital experience designer in the division supports their work as well. The museum has standardized the amount of time each planner has to spend on a project—and when that time fits on the calendar. All parties know this timing well in advance and can plan their schedules accordingly. For the museum to meet this goal of providing interpretive plans for all exhibitions and gallery projects, it will be important for the number and scale of projects to remain consistent and staffing to remain stable.

Supporting Relationships between Educators and Curators

Curators and museum educators often come from very different academic, workplace, and social cultures. Professional success in their fields may look different, and they can feel distinct kinds of pressures as they seek fulfilling and successful careers. It is widely recognized that understanding what motivates people, why they might feel pressure to make a particular decision, or how they communicate when stressed can give team members the information they need to move through difficult moments and thrive in the work. Museums need to facilitate such understandings between educators and curators in order to be successful at the collaborative exhibition model. When the museum staff moved back into the DIA's renovated building in 2007, a strategic decision was made to place curators and educators in adjacent office areas surrounding the library. This makes for frequent, casual interactions throughout the day and a growing understanding of how people in different departments work. To further support informal interaction, educators and curators recently initiated quarterly coffee breaks, which include a conversation starter activity. Museum leadership designates funds for curators, interpretive planners, and other exhibitions staff to travel together when working on exhibitions; sharing meals and visiting exhibitions together is providing new opportunities to foster relaxed conversations about personal interests, academic training, and work experiences. A much-valued additional support is a series of mandatory professional development sessions on effective workplace communication.

Redefining Relationships with Other Museum Departments

The commitment to an educator–curator collaboration model for exhibition development has had a significant impact on many departments at the DIA. The museum's exhibitions department has experienced more change than most. Previously a department of one focused on exhibition contracts, budgets, and the multiyear schedule; the department has expanded and now leads project management and design for each exhibition and gallery reinstallation. Two new exhibition assistants have taken over much of the project management work previously done by the interpretive staff. This has freed the interpretive planners to focus on what they do best. Designers have adjusted as well. The DIA process has shifted from one where the curator and designer worked together first, with an interpretive specialist joining later, to a model where the interpretive planner and curator first determine big ideas and outcomes, then invite the designer to bring their interpretive plan to life.

Collections management staff have also made room for the collaboration between interpretive staff and curators. DIA interpretive planners have been

joining curators on the floor during art installation since the 2007 reinstallation. Their presence makes it possible for the team to work out any floor plan discrepancies that become apparent during installation, while making sure the relationship between works of art and interpretation addresses visitor needs. Whether works of art and interpretive materials are fully laid out ahead of time for review or whether the installation happens piecemeal, the installation crew is now accustomed to having the curator and the interpretive planner on the floor giving direction based on the interpretive plan. Changes to the permanent collection galleries require similar collaboration. Each year, the director of collections management, the chief curators, and the director of interpretive engagement work together to create a list of gallery improvements for the annual budget. Together they agree on priorities and present the plan to executive leadership for approval.

Personnel in the marketing and public relations departments have had to adjust their processes and communications as well. In the past, the curator and the director were the media spokespersons for a new exhibition or gallery installation at the DIA. They also reviewed exhibition media releases. In recent years, it has become common for the interpretive planner to speak with the media as often as the curator. The director of public relations now has the curator and the planner review and comment on exhibition-related press releases. By beginning a tradition of introducing the interpretive planner and inviting her to speak at media events, former DIA director Graham Beal drew public and internal museum attention to the interpretive team's behind-the-scenes contributions, demonstrating the depth of experience and planning that goes into the museum's presentation of art.

Likewise, DIA development professionals increasingly rely on interpretive planners as they do with curators. Interpretive planners have made substantial contributions to successful grant proposals, playing a major role in writing the exhibition walk-throughs required for some federal grants. Seeing museum patrons' interest in the ways interpretive planners facilitate meaningful connections between works of art and visitors, development staff are increasingly calling on planners to assist with donor cultivation alongside their curatorial colleagues.

LOOKING FORWARD

Art historians becoming better curators, museum educators becoming better interpretive planners, and an organization becoming more relevant to all: this is what the DIA is trying to achieve in its ongoing experiment with collaborative exhibition development. Continuing supported communication between educators and curators about expertise, roles, and responsibilities is critical.

Interpretive planners, bringing a new expertise to the table, must be articulate and steadfast about the value they bring to the institution. From their areas of expertise, curators need to actively support the interpretive work that can amplify what they know, making it relevant and engaging for a larger public. Importantly, museum leadership must take a critical look at long-held ways of doing business and allocating resources across the organization and commit to boldly, creatively, and optimistically transforming their institutions.

NOTES

1 In 1997, the DIA created an associate educator position within the department of education to focus on interpretation by applying knowledge of aesthetic development, constructivist learning theory, and visitor studies to exhibitions and permanent collection galleries.

2 As interpretive expertise has developed at the DIA, job titles have changed. The first educators focusing on interpretation were informally called interpretive educators. The title interpretive specialist was created in 2010. In 2013, interpretive specialists who had achieved a higher degree of expertise were promoted with the title interpretive planner. Nonetheless, it remains common to use the term *educator* when referring to professional staff in the division of learning and interpretation.

3 For more information about the big idea, see Serrell, Beverly. *Exhibit Labels.* Lanham, MD: Rowman & Littlefield, 2015.

4 Because *Fakes, Forgeries and Mysteries* covered many areas of the DIA collection, I worked with each curatorial department independently. We looked at the selected objects together and through discussions based on connoisseurship, art historical documentation, and technical analysis, we selected the information that could be used in exhibition development.

5 In most DIA exhibition development processes, the curator and interpretive planner refine these details in multiple sessions together, with the planner leading inquiry and discussion.

6 The DIA division of learning and interpretation defines learning broadly to encompass personal growth.

7 For a synopsis of the interpretive group's first meeting, see Koke, Judith, Jennifer Czajkowski, Julia Forbes, and Heather Nielsen. "Interpreting the Future of Art Museums." January 21, 2014. Blog entry. Center for the Future of Museums. http://futureofmuseums.blogspot.com/2014/01/interpreting-future-of-art-museums.html

8 Jennifer Wild Czajkowski has been the DIA's vice president of learning and interpretation since 2013 and head of the division since 2010.

9 Swarupa Anila has been the DIA's director of interpretive engagement since 2011 and head of the department since 2010. Key leadership positions in the DIA division of learning and interpretation include the directors of interpretive engagement, education programs, public programs, and studio. All report to the vice president of learning and interpretation, a member of the museum's executive leadership team.

10 Anila, Swarupa. "Visitors Enter Here: Interpretive Planning with Audiences." In *Interpreting the Art Museum: A Collection of Essays and Case Studies*, edited by Graeme Farnell, 17–39. Boston, MA: Museums Etc, 2015.

BIBLIOGRAPHY

Anila, Swarupa. "Visitors Enter Here: Interpretive Planning with Audiences." In *Interpreting the Art Museum: A Collection of Essays and Case Studies*, edited by Graeme Farnell, 17–39. Boston, MA: Museums Etc, 2015.
Serrell, Beverly. *Exhibit Labels.* Lanham, MD: Rowman & Littlefield, 2015.

Chapter 19

Visitor-Centered Exhibition Design

Theory into Practice

Elizabeth K. Eder, Andrew Pekarik,
and Zeynep Simavi

The Freer Gallery of Art and Arthur M. Sackler Gallery (Freer | Sackler) of the Smithsonian Institution in Washington, DC, are currently engaged in an experiment that has the potential to change the exhibition-making process and to improve the experience of museum visitors. The experiment is based on a theory of experience preference, known as IPOP, created at the Smithsonian Institution in 2009 and 2010 by an exhibition developer (Barbara Mogel), a visitor researcher (Andrew Pekarik), and a university professor (James B. Schreiber). The theory developed from surveys, observations, and interviews conducted in Smithsonian museums over many years. It identifies four key dimensions of experience: *Idea* (conceptual, abstract thinking), *People* (emotional connections), *Object* (visual language and how things are made and used), and *Physical* experiences (somatic sensations). The model maintains that individuals are naturally drawn to these four dimensions of experience to different degrees (Figure 19.1).

Initially this idea of experience preference helped the individuals who create museum exhibitions (known here as exhibition makers) examine their own preferences, and it encouraged staff in general to appreciate how their own preferences influence the decisions they make on behalf of visitors. The benefit of this approach has been documented in *Curator: The Museum Journal.*[1]

To refine and test the IPOP concept, a survey instrument was constructed that asks respondents about their degree of self-identification with various types of leisure activities. The survey responses provide IPOP scores that indicate the degree to which individuals are drawn to the four dimensions, compared to others in the database. About 1,000 staff members have taken the long form of the survey questionnaire. More than 20,000 visitors at sixteen museums in the United States and Canada have answered shorter versions of

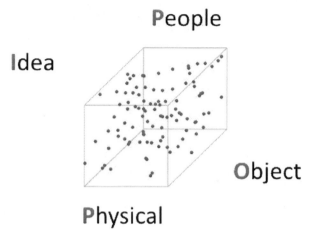

People

Idea

Object

Physical

Figure 19.1. Different degrees of attraction to these four dimensions of experience.
Source: Courtesy of Andrew Pekarik.

the questionnaire. This information has been collected in a database so that scores can be compared. Results from these studies have provided empirical evidence that supports the theory's claim of experience preferences influencing what attracts visitors' attention and how they respond to various elements in an exhibition.[2]

Since the Freer | Sackler identified enhanced visitor engagement as one of the primary goals of its strategic plan in 2015, the IPOP theory was introduced to the entire museum staff and a core group of individuals volunteered to serve as "IPOP Champions." This chapter summarizes IPOP theory, relates its origins at the Freer | Sackler, and introduces the toolkit of methods that have developed around it.

Although single elements of the toolkit had been applied at other Smithsonian museums, the Freer | Sackler offered the first opportunity to apply the toolkit consistently and extensively to change approaches to serving visitors. This experiment is still in its early stages. In the future, we will be prepared to report on the results of this initiative.

IPOP THEORY

According to IPOP theory, at least four major dimensions of experience exist: the conceptual (idea), emotional/narrative (people), aesthetic/pragmatic (object), and the somatic (physical). These four IPOP dimensions describe unconscious preferences for certain ways of engaging with the world. While these dimensions are not the same as skills, individuals who have honed their preferences over time may be particularly adept in these arenas.

1. **Help us to understand your interests. For each of the following items, please indicate the degree to which that activity describes you.**
I like to...

I like to...	Not me at all	A little me	Me	Very much me
...bring people together	○	○	○	○
...construct things	○	○	○	○
...divide things into categories	○	○	○	○
...go camping	○	○	○	○
...help others in person	○	○	○	○
...identify patterns	○	○	○	○

I like to...	Not me at all	A little me	Me	Very much me
...jog/run for fun	○	○	○	○
...know how things are made	○	○	○	○
...learn philosophy	○	○	○	○
...play competitive sports	○	○	○	○
...shop	○	○	○	○
...spend my leisure time with other people	○	○	○	○

Further, the theory holds that individuals are attracted unconsciously to these four dimensions to different degrees. Approximately 17 percent of individuals surveyed are drawn fairly equally to two dimensions, 3 percent equally to three dimensions, and one in a thousand shows no preference.[3] Patterns of these differences are most evident in leisure activities and habits because individuals choose them with relative freedom. The current IPOP scoring instrument uses levels of self-identification with various such activities to measure strength of preference in the four dimensions.

Individuals are most likely drawn to experiences that are the most readily noticed and engaged. For example, an individual strongly drawn to the idea dimension may be more inclined to read texts, while a person with a people preference may be more drawn to images of people. As a result, these preferences influence what people do and how they respond. Thus, IPOP differs from many other personality systems in that experience preferences have some predictive value.

Of course, everyone has had meaningful experiences in all four of the IPOP dimensions, and preference is not the only factor that influences what people do and enjoy. Much behavior is determined by conditioning in how to find satisfaction in a particular kind of environment, whether it is an art museum, a science center, or a zoo. That conditioning might be the result of accident,

training in how to appreciate a painting or familiarity with scientific principles, or childhood memories of and experiences in such places.

Museums in the United States once focused nearly exclusively on object experiences. In the past decade, many museums have been opening themselves to an even broader range of visitor experiences and services. The now-standard practice of including shops and cafes or restaurants in the museum setting has enhanced opportunities for object and physical experiences in the same way that docents, texts, mobile apps, and lecture programs have made idea experiences more available. Today, many museums strive to create a broader range of people experiences through social engagement, live demonstrations, after-hour parties, and meet-the-artist programs. In this sense, the recognition of experience diversity in museums is not a new development, but a more self-conscious and deliberate understanding and application of experience preference theory can help museum staff enhance efforts to welcome diverse audiences and to better shape the visitor experiences.

The principles of IPOP were combined with various exhibition-making processes to create a set of specific methods known as the IPOP Exhibition Development Toolkit. In the application of these methods, exhibition developers grew aware of their own experience preferences and those of others on the team. They became more conscious of how their perspectives are reflected in the ways they approach the work of the team, identify their individual intentions, and frame their internalized expectations for visitors.

From this perspective, it is ideal when the collective preferences of IPOP team members cover all four dimensions, because together they directly provide four distinct perspectives. By working in a team with others who have different perspectives and preferences from one another, standards for beauty, truth, interest, quality, pleasure, and importance cannot automatically be the privilege of one team member. At the same time, it cannot be assumed that such standards are shared by more than a small number of museum visitors. Therefore, a balance of IPOP dimensions is best in both team composition and exhibition development.

IPOP AT THE FREER | SACKLER

This section reviews the organizational context for the use of IPOP at the Freer | Sackler, the development of an internal IPOP Champions team, the IPOP Toolkit, and its use. It also includes tips on how to form a team, the type of training provided to team members, and examples of the use of specific tools for concept development, title creation and testing, and content card sorts.

Organizational Context—Serving Visitors

When Julian Raby, Dame Jillian Sackler director of the Arthur M. Sackler Gallery and Freer Gallery of Art, first became aware of the IPOP theory, he discussed it with Andrew Pekarik, who had conducted several exhibition evaluation studies through a central Smithsonian office. IPOP was in an early stage of development when the Freer | Sackler staff was first introduced to it in 2012 and 2013.

Its potential to play a role in the Freer | Sackler, however, increased substantially when the museums set forth a new strategic plan for 2015–2017. Raby wrote in the plan's introduction, "Our museums' Strategic Plan for fiscal years 2015–17 focuses on our visitors. . . . To achieve this, we need to appreciate the wide diversity of our current visitors and to acknowledge whom we are not reaching."[4] The plan focuses on Freer | Sackler visitors in two of its three strategic goals: enhance the visitor experience and diversify our audiences.

The IPOP Champions Team

Not long after the strategic plan was adopted, Pekarik was asked to suggest an approach for improving awareness of the importance of the museum visitor experience. He proposed forming an IPOP Champions team, and interested staff members were asked to volunteer. Five individuals came forward: the head of the design department, the head of education, an editor, a curator, and a specialist in scholarly programs. Later a second curator joined. Each team member completed the long-form IPOP survey and learned that together they formed the ideal IPOP team with preferences in all four dimensions.

From June 2014 to September 2015, the Freer | Sackler team was trained in IPOP theory, open-ended interviewing, and the toolkit methods in a series of monthly meetings. With the cooperation of curators both inside and outside the team, the IPOP Champions used some of the methods on actual exhibitions that were under development as part of their training.

This Champions team was critical to the increased use of the IPOP toolkit within the museum. Formed with the approval and support of the director and chief curator but outside any departmental structure, the team had the initiative, influence, and skills necessary to promote the use of IPOP and the toolkit in ways and at times that were appropriate and useful. The team continues to serve as a resource, inspiration, and guide for all things IPOP at the Freer | Sackler.

As other staff members have come to appreciate the value of these methods, they have steadily applied the IPOP concepts to other projects, such as testing exhibition titles for marketing purposes. The IPOP Champions support the efforts of those who are curating exhibitions by introducing them to

the toolkit methods and by teaching and modeling their proper use. Indeed, their commitment to IPOP has helped to reassure staff that these approaches are interesting, useful, and worth pursuing. The benefit and power of having an IPOP team that exists outside departmental structures has become apparent to various exhibition teams. Not only does the IPOP Champions team serve as an example for other working groups that are formed for specific exhibitions, but it is also a valuable resource in the techniques of the IPOP toolkit and a way to keep IPOP theory alive and useful in the museum.

Using the Toolkit

The key to incorporating IPOP principles in the museum is the IPOP Exhibition Development Toolkit. The IPOP Champions team is an essential resource for providing initial training in using the toolkit and in helping to resolve problems that might arise. A team that is developing an exhibition can easily learn the methods and adapt them to their own uses.

The process of learning the methods requires limited, short periods of effort over a few weeks or months. Team members typically meet for one or two hours every other week. In between these sessions individuals or smaller groups prepare or revise materials.

Key elements in the toolkit (Figure 19.2) should now be followed in this sequence:

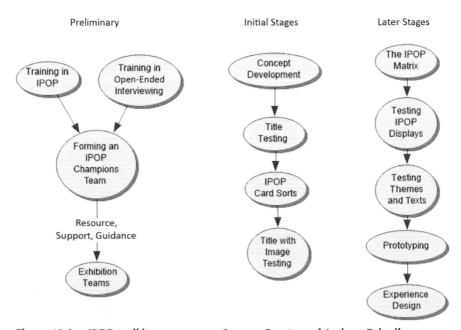

Figure 19.2. IPOP toolkit process map. *Source:* **Courtesy of Andrew Pekarik.**

1. Forming an IPOP team
2. Training: understanding IPOP and learning to conduct open-ended interviews with visitors
3. Concept development
4. Title creation and testing
5. Content card sorts
6. The IPOP matrix
7. Testing four-experience displays
8. Testing section themes and text
9. Prototyping
10. Experience design

The first five of these are introduced in this chapter. Additional information can be found on the website of the Smithsonian Office of Policy and Analysis at https://www.si.edu/opanda/IPOP.

Forming an IPOP Exhibition Team

The core members responsible for creating an IPOP exhibition should include the lead curator or content specialist and at least one person with a preference in each of the four IPOP dimensions. This could require adding someone to the team whose functional expertise may be less crucial to the exhibition at that stage. Through this range of fundamental perspectives, the team is better equipped to serve the diversity of visitors and to resist the tendency to feel that visitors "are like me" in their values and views. Of course, this diversity demands a decision-making process that allows each team member to have a voice that is heard and respected.

Training

Two skills—understanding IPOP and being able to interview visitors "without questions"—are key to the effective implementation of the toolkit methods. The core concepts behind IPOP are easy to grasp, but they are also easy to misconstrue. The terminology of Idea, People, Object, and Physical can be misleading. More accurate but less memorable terms for the four dimensions are *conceptual*, *emotional/narrative*, *aesthetic/pragmatic*, and *somatic*. Moreover, the theory is new, and research on the relationship between experience preferences and both behavior and response is still ongoing. As this research develops, and as more teams work with the toolkit, understanding and appreciation will deepen and shift.

Learning how to conduct open-ended interviews is important because of the all-too-common notion that visitor interviews serve to obtain answers to questions. The focus of the toolkit method, however, is on listening, not

asking, and on allowing the interviewee to reveal distinctive ways of seeing and interpreting the world with as little influence from the interviewer as possible. IPOP interviews specifically endeavor to get unmediated perspectives from visitors.[5]

Concept Development

Concept development ideally takes place early in a project during regularly scheduled meetings, usually held every other week. In the first half of the one- to two-hour meeting, the team divides into pairs, with one person being the interviewer and the other serving as the notetaker. The pairs scatter throughout the museum or to other relevant locations and show visitors a simple description of the exhibition, along with a few photographs of potential objects or gallery configurations where appropriate. Statements can vary widely in format—sometimes they are a single paragraph, a page in length, or just a list of bullet points. The form and exact content of the concept statement is not critical in the beginning. Its role is to represent what the exhibition team intends to present and to evoke a response in museum visitors who read it. Interviewees are invited to offer input into planning a new exhibition, and, if they agree, they are handed the statement and selected images. The notetaker records responses as visitors are interviewed using an open-ended interview strategy.

When the pairs reassemble, the notetakers report on responses that they perceive as unusual, unexpected, new, or surprising. The team might also be looking for confirmation that the exhibition and its concepts are heading in the right direction. All of this information is discussed, and appropriate next steps are considered. In the early stages of the exhibition development process, team members might decide to alter the direction and focus of the project as a result, or they might decide to forge ahead. If a direction is already definite, one common response is to rethink and rewrite the statement shown to visitors since the initial wording might not adequately represent what the team wishes to communicate. IPOP preferences among some visitors are often evident in their reactions to the materials, and this can help to clarify the meaning of the four dimensions in the minds of team members. Whether visitor reactions inspire major rethinking or minor changes in wording, they can introduce the unexpected and arouse new ways of conceiving the task at hand.

It usually takes at least three rounds of concept development to arrive at a statement or direction that works well both for the team and for visitors. The statement can then serve multiple purposes: as part of public relations materials, as an announcement about the exhibition on the museum's website, as wording in fund-raising materials, or later as an introductory statement in the exhibition itself.

Title Creation and Testing

An exhibition title signals what visitors can expect to see and experience when they go to a museum. It immediately connects with potential visitors or discourages them from attending. Sometimes a title incites no reaction at all. The ideal title should have "drawing power" across all IPOP dimensions. The first step in devising such a title is to have a clear idea of what the exhibition will offer visitors. Presumably that was defined during the concept development process. The challenge then is to find the words that succinctly express the content of the exhibition and meet visitor expectations.

The method here begins with team discussions of potential titles, followed by the same sort of paired interviews that were used in concept development. This time visitors are asked to respond to potential titles. After an initial investigation of responses, the interviewer describes the exhibition as presented in the concept statement and then asks visitors which part of the description most attracted their attention. They are then asked what they would call the exhibition if they were inventing a title. In this way, possible new titles are proposed and explored.

After the pool of acceptable titles is narrowed down to four possibilities, a survey form is created for each one. Museum visitors are shown only one title per survey and are asked how interested they would be in seeing that exhibition if it were on view now. This brief survey also asks age, gender, previous visit history, and eight IPOP questions. The results reveal not only which title has the greatest draw but also whether it is strong or weak in particular IPOP dimensions.

At another session in the galleries, the process is repeated with the selected title along with images of potential exhibition objects. Previous surveys have shown that the wrong choice of image can destroy visitor interest in an exhibition, even if the title has proven to be attractive. Decisions to attend an exhibition or not, similar to decisions over whether or not to buy a product, originate in the unconscious, and they can be difficult for individuals to recognize and articulate.

Content Card Sorts

At this point in the process, exhibition developers engage with visitors to refine the key exhibition elements in all four IPOP dimensions. They create a deck of forty-eight cards with twelve cards for each dimension, that is, the top twelve ideas, the top twelve people or stories, the top twelve objects, and the top twelve ideas for physical (somatic) experiences.

Museum visitors select the cards that most appeal to them and then arrange them in groups however they want. They identify the groups by assigning names or titles, and then they fill out a brief survey that includes basic

demographic information and a few IPOP questions. The results are analyzed to see which cards are most effective, whether differences by demographic characteristics or IPOP are discernible, which cards are grouped together, and which words visitors use in their descriptions.

Based on these results, the team can then decide whether cards should be changed, removed, or added for a second round of surveys. Was a key idea not chosen because it was poorly phrased? Was an important story not picked because the descriptive text missed the point? Are there seemingly radical ideas for content that the team would like to try out? Through this process, exhibition development team members, working in conjunction with curators, can refine the core content and consider it from many angles to ensure it is being used to best effect.

TOOLKIT IN PERSPECTIVE

Three activities in the IPOP Exhibition Development Toolkit are well-established visitor research methods: interviews with visitors, surveys, and card sorts. Card sorts have been used as a front-end evaluation method in exhibition development[6] and even in occupational therapy settings. For example, the "Activity Card Sort (ACS) is an interview-based, client-centered tool that measures the activity engagement of older adults aged sixty-five years and above. The tool consists of photos that clients are asked to sort into categories to reflect their previous and current level of engagement."[7]

Key differences between these traditional methods and the IPOP toolkit are:

- a specific theoretical framework (IPOP theory);
- the organizational context in which these activities are undertaken (commitment to enhanced visitor experience across the four IPOP dimensions);
- internal change agents (the IPOP Champions team) that can support exhibition developers; and
- the use of this approach to affect a culture change in the institution toward a more visitor-centered approach (if needed).

The first-stage methods—forming and training an IPOP Champions team—focus on the transfer of ideas and skills into the heart of the museum. At the Freer | Sackler, this meant the transfer went from the evaluation experts to the IPOP Champions team and then to other museum staff who are involved in developing, interpreting, programming, funding, and marketing exhibitions. This team is the single most important element in making IPOP part of the institutional culture. Without its support, IPOP might be just another passing fad, and its potential would be difficult to realize.

The second-stage methods—concept development, title testing, and content card sorts—are designed around the principle of experience preference diversity among visitors. In each approach, whether qualitative or quantitative, visitor input is considered against the backdrop of the IPOP theory. Two critical features are evident in all of these activities: they involve the exhibition team members as data collectors as much as possible, and they provide opportunities to gain perspective, which will enhance creativity. They are not "instructions" or "directions" that those developing and curating the exhibition are obliged to follow, but rather tools that can be employed.

EXHIBITION TEAMS AS DATA COLLECTORS

In traditional background studies and formative evaluations, interviews and surveys are frequently used in museums to help plan exhibitions. Such public engagement with visitors is primarily the job of audience specialists, visitor researchers, evaluators, and internal or external consultants. In these scenarios, exhibition developers typically raise questions and ask the specialists to find the answers. This can insert distance between the exhibition developers and museum visitors. When exhibition team members agree with study findings, then the activity itself can be seen as having had relatively little value. When the same individuals do not agree with the findings, that distance might make it relatively easy to ignore or dismiss conclusions, reports, and recommendations. They usually justify this resistance by criticizing the method, sample size, or other aspects of the process. This resistance often does not occur when exhibition team members themselves meet and listen to visitors. Arguments fade, and the work of the team moves more smoothly when the evidence of visitor response is personally experienced.

THE TOOLKIT AND CREATIVITY

When team members who are creating exhibitions participate in concept development and other activities in the toolkit, they see firsthand the reaction of visitors to their ideas and texts. Not only do they experience how to engage visitors through close listening but they are also present to witness responses. Team members quickly encounter museum visitors whose unprompted perspectives might differ from their own range of ideas, and their prior assumptions about the public are seriously challenged.

During the second half of a concept development meeting, notetakers report on visitor comments that were unexpected, strange, intriguing, or even reassuring. These responses offer an opportunity for creative

thinking. Not all visitor comments call for an immediate reaction, but they often do raise new possibilities and introduce questions. Is that something we should consider? How would we address that perspective, if we choose to do so?

In the long process of developing and curating exhibitions, teams frequently reach a stage where fresh ideas are hard to find. All thoughts and perspectives have been put forward and discussed, resolved, or dropped. Unanticipated input from visitors can rouse the team to reinvigorated rounds of creative thinking. As a result, team meetings are more likely to be exciting and innovative when conducted as part of the IPOP toolkit.

NEXT

This experiment of implementing the IPOP Exhibition Development Toolkit is being conducted at the Freer | Sackler in an environment with regular, rigorous visitor testing. Its success will be evaluated not just in the way staff members feel about their work but also in the overall experience ratings provided by museum visitors. The entire point of the process is to improve the quality of visitor experience at the Freer | Sackler. Since this requires a rethinking of past museum practices, the full implementation of the model has been gradual and steady. Over the course of the next few years, the efficacy of the process will be tested, both in the development of permanent collection galleries and special exhibitions. Further reports will follow.

NOTES

1 Leger, Jean-Francois. "Shaping a Richer Visitors' Experience: The IPO Interpretive Approach in a Canadian Museum," *Curator* 57, no. 1 (2014): 29–44; Pekarik, Andrew J., and Barbara Mogel. "Ideas, Objects, or People? A Smithsonian Exhibition Team Views Visitors Anew," *Curator* 53, no. 4 (2010): 465–482.

2 Beghetto, Ronald. "The Exhibit as Planned Versus the Exhibit as Experienced," *Curator* 57, no. 1 (2014): 1–4; Schreiber, James B., and Andrew J. Pekarik. "Technical Note: Using Latent Class Analysis Versus K-Means or Hierarchical Clustering to Understand Museum Visitors," *Curator* 57, no. 1 (2014): 45–60; Schreiber, James B., Andrew J. Pekarik, Nadine Hanemann, Zahava D. Doering, and Ah-Jin Lee. "Understanding Visitor Behavior and Engagement," *Journal of Educational Research* 106, no. 6 (2013): 462–468.

3 IPOP scores are standardized z-scores with a mean of 0 and a standard deviation of 1. They reflect each person's responses to questions in each IPOP dimension with respect to the average responses of all visitors in the dataset. The current dataset has

more than 20,000 cases. An individual is considered equally drawn to multiple preferences when one or more scores are within 0.2 standard deviations of the highest score.

4 *2015–17 Strategic Plan, Freer Gallery of Art and Arthur M. Sackler Gallery*, unpaginated.

5 Patton, Michael Quinn. *Qualitative Research and Evaluation Methods*. Thousand Oaks, CA: Sage Publications, 2002. This type of interview—where the interviewees are free to respond in whatever ways they choose, and the interviewer focuses on close listening and requests for clarification—has many different names, including open-ended interviewing, unstructured interviewing, and ethnographic interviewing. Probably the best label for it is informal conversational interviewing.

6 Ades, Susan, and Sarah Townes Hufford. "Front-End Evaluation in Art Museums: Is It Effective?" http://www.informalscience.org/sites/default/files/VSA-a0a4i1-a_5730.pdf; Stockdale, Meghan, and Elizabeth Bolander. "Mastering the Art and Science of Formative Evaluation in Art Museums." http://mw2015.museumsandtheweb.com/paper/mastering-the-art-and-science-of-formative-evaluation-in-art-museums/.

7 Gustafsson, Louise, Desleigh de Jonge, Yvonne Lai, Jessica Muuse, Nicola Naude, and Melanie Hoyle. "Development of an Activity Card Sort for Australian Adults Aged 18–64 Years," *Australian Occupational Therapy Journal* 61, no. 6 (2014): 403–414.

BIBLIOGRAPHY

Ades, Susan, and Sarah Townes Hufford. "Front-End Evaluation in Art Museums: Is It Effective?" http://www.informalscience.org/sites/default/files/VSA-a0a4i1-a_5730.pdf.

Beghetto, Ronald. "The Exhibit as Planned versus the Exhibit as Experienced," *Curator* 57, no. 1 (2014): 1–4.

Gustafsson, Louise, Desleigh de Jonge, Yvonne Lai, Jessica Muuse, Nicola Naude, and Melanie Hoyle. "Development of an Activity Card Sort for Australian Adults Aged 18–64 Years," *Australian Occupational Therapy Journal* 61, no. 6 (2014): 403–414.

Leger, Jean-Francois. "Shaping a Richer Visitors' Experience: The IPO Interpretive Approach in a Canadian Museum, *Curator* 57, no. 1 (2014): 29–44.

Patton, Michael Quinn. *Qualitative Research & Evaluation Methods*. Thousand Oaks, CA: Sage Publications, 2002.

Pekarik, Andrew J., and Barbara Mogel. "Ideas, Objects, or People? A Smithsonian Exhibition Team Views Visitors Anew," *Curator* 53, no. 4 (2010): 465–482.

Pekarik, Andrew J., James B. Schreiber, Nadine Hanemann, Kelly Richmond, and Barbara Mogel. "IPOP: A Theory of Experience Preference," *Curator* 57, no. 1 (2014): 5–27.

Schreiber, James B., and Andrew J. Pekarik. "Technical Note: Using Latent Class Analysis versus K-Means or Hierarchical Clustering to Understand Museum Visitors," *Curator* 57, no. 1 (2014): 45–60.

Schreiber, James B., Andrew J. Pekarik, Nadine Hanemann, Zahava D. Doering, and Ah-Jin Lee. "Understanding Visitor Behavior and Engagement," *Journal of Educational Research* 106, no. 6 (2013): 462–468.

Stockdale, Meghan, and Elizabeth Bolander. "Mastering the Art and Science of Formative Evaluation in Art Museums." http://mw2015.museumsandtheweb.com/paper/mastering-the-art-and-science-of-formative-evaluation-in-art-museums/.

Index

experimentation, 38, 102, 110, 127, 144, 189, 195, 228, 243, 245

facilitation, 15, 71, 74, 89, 136, 178
Falk, John H., 4, 7, 14
Feldman, Kaywin, 94
feminist systems theory, 15; adapted feminist systems theory, 17; collaborative, 16; feminist systems thinking planning guide, 18. *See also* ecofeminism
focus groups. *See* evaluation
Freire, Paulo, 155–57, 169–70, 173
From Periphery to Center: Art Museum Education in the 21st Century, 4

gallery activity, 94, 104–5
gender, 15–16, 111, 156, 176, 179, 259
general audience/public, 5–7, 24, 31, 50, 92, 199, 241–42

hegemony, 92, 173
Hein, George E., 4, 7, 127–28
heritage, 28, 132, 183, 195
heteronormativity, 169, 172–73, 175
hierarchies, 14, 19, 24, 75, 156, 169, 171, 173, 226, 244; decentralization, 170; traditional, 50. *See also* feminist systems theory
higher education, 5, 38, 90. *See also* training
hooks, bell, 157
Hooper-Greenhill, Eilean, 7, 33, 127
human rights, 154, 173

identity, 15, 19, 33, 37, 129–32, 169, 171, 173, 205, 212; professional, 243; sexual and gender, 176; team, 79; themes of, 195
IMLS. *See* Institute of Museum and Library Services
immersive experiences, 33–34, 61, 226
implications: collaborative work, 32; of decisions, 14; interpretive, 227; traditional museum models, 161; uniting curatorial and education functions, 35
inclusive and pluralistic perspectives, 16–18, 72, 149, 213. *See also* perspectives
informal conversations, 32, 148, 236
injustice, 154, 158
innovation, 74, 88, 191, 194, 228, 244

Institute of Museum and Library Services, 58–59
interactive experience model, 14. *See also* museum experience model
interdepartmental teams. *See* teams
interdisciplinary work, 38
interpretation: approaches, 65; collaborative, 170; community-based, 170; elements, 65, 231; evaluation, 58; experience, 60–61, 65–66; expertise, 243–44; interpreters, 242–43, 227–28, 233, 243, 246; interventions, 227; language, 170; materials, 170; methods and programs, 58, 89, 178; perspectives, 15, 228; philosophy, 229; strategies, 51, 89, 91, 93, 101, 116, 122
interpretive planning: concept of, 28; planners, 49, 52, 239, 243–47; plans, 7, 88, 227, 245–47; process, 14, 68, 88, 245; teams, 58–59
intrinsic motivation, 232
IPOP (Ideas, People, Objects, Physical): champions, 252, 254–56, 260; dimensions of experience, 251–53; exhibition, 254, 256–57, 260, 262; Exhibition Development Toolkit, 254, 256, 260, 262; experience preference theory, 251–54, 257, 261

justice, 18, 153–55, 157, 161

Kai-Kee, Elliot, 94
Kamien, Janet, 28, 38, 207, 213–14
knowledge bearers, 15, 17, 79
Knowles, Malcolm S., 128, 131
Koke, Judith, 14, 47, 117
Korn, Randi, 74, 231

labels: collaborative, 179; student-written, 115–16, 119, 122–23; writing, 242
leadership, 17, 51, 72, 245–46; collective leadership, 234
learning, 7, 33, 65, 89, 91, 128, 131; co-learning, 72–73; collaboration, 195; critical, 154–55; free-choice, 154; interactive, 156–57; visitor-centered, 27
learning theory, 225–26, 243
lessons learned, 108, 112, 136, 175, 179, 206
LGBTQ, 169, 172

About the Editors and Authors

Christian Adame is assistant education director at Phoenix Art Museum. He has worked in museums for thirteen years, holding various positions at the California State Archives; the California Museum of Women, History, and the Arts; and the Crocker Art Museum in Sacramento. He has received awards and fellowships from the American Alliance of Museums, the Balboa Park Cultural Partnership, the Teaching Institute in Museum Education, and the Getty Leadership Institute's NextGen Executive Education Program. He earned his BA in art history in 2005 from the University of California, Davis.

Kathryn E. Blake is director of the Juniata College Museum of Art in Huntingdon, Pennsylvania. Prior to her current appointment, she worked for twenty-four years in the Education Department of Phoenix Art Museum, where she served as the Gerry Grout education director from 2007 to 2015. In 2013 she was awarded a sabbatical fellowship by the Virginia G. Piper Charitable Trust to study the meaning of audience engagement. Blake holds a BA in art history from Wellesley College and an MA in art history from Boston University.

John Jay Boda is a doctoral student studying museum education and visitor-centered exhibitions at Florida State University. A former docent at the Salvador Dalí Museum (St. Petersburg, Florida), his research interests include docents, storytelling, and fostering social justice through museum education. He holds an MFA in screenwriting, and *Frankenstein's Light*, the thesis film he wrote, won the Directors Guild of America award for Best Student Filmmaker.

Astrid Cats is an independent researcher and educator in museums and theaters based in the Netherlands.

Dany Chan serves as assistant curator for exhibition projects at the Asian Art Museum of San Francisco. She received a BA in East Asian studies (Chinese) from Colby College and holds an MA in the history of Chinese art and architecture from Brown University. Prior to her current appointment, she served as curatorial assistant and assistant curator in the museum's Chinese Art Department.

Deborah Clearwaters has her dream job as director of education and interpretation at the Asian Art Museum of San Francisco, where she has worked in education for nineteen years. She has a master's degree in Japanese art history from the University of Maryland. She is coauthor of the Asian's first children's book called *Adventures in Asian Art: An Afternoon at the Museum*, forthcoming in early 2017.

Jennifer Wild Czajkowski is vice president for learning and audience engagement at the Detroit Institute of Arts (DIA), her hometown museum. She is a member of the DIA's strategic leadership team with responsibility for the areas of interpretation and education, studio, and public programs. From 2002 to 2007, Czajkowski was the lead interpretive educator on the DIA's comprehensive reinstallation project. Since the DIA's successful 2012 campaign for public tax support, Czajkowski has reoriented museum programs to address the DIA's community partnership commitments while building on the division's history of learner-centered practices.

Ayisha de Lanerolle is a practical philosopher based in London. In 2008 she set up the Conversation Agency. The core of her work is facilitating dialogue where ideas, not individuals, are the focus, and participants work together to reexamine familiar concepts, testing out, trying on, and developing new ideas and arguments in collaboration with others.

Elizabeth K. Eder has been head of education at the Smithsonian's Freer Gallery of Art and Arthur M. Sackler Gallery since 2013. She has responsibility for the overall planning, direction, and management of education programs and activities for docents and volunteers, K–12 learning, digital outreach, audience research and evaluation, and visitor experience. From 2005 to 2013, Eder served as assistant chair, National Education Partnerships at the Smithsonian American Art Museum, where she developed strategic partnerships, educational products, and educator services across the United States. She has also worked as director of professional education at the American Alliance of Museums, head of school and teacher programs at the Walters Art Museum in Baltimore, and education lecturer at the National Gallery of Art. She holds a master's in museum education from George Washington

University and a doctorate in history of education from the University of Maryland College Park. Eder has taught social foundations of education at the University of Maryland College Park and Millersville University in Pennsylvania and is currently on the faculty of the Johns Hopkins University master's program in museum studies.

Carla Ellard is the curator and photography archivist at the Wittliff Collections, Alkek Library at Texas State University, where she has worked since 2000. She has curated many exhibitions at the Wittliff and has served as juror for regional and campus art exhibitions.

Karen Eslea is head of learning and visitor experience at Turner Contemporary. Since 2001, Karen has worked closely with the director to develop Turner Contemporary's vision, audience, and gallery building, which opened in Margate in 2011. Karen has established the gallery's learning program and has pioneered both the use of philosophical inquiry to explore artworks and community-led curation at Turner Contemporary. With over twenty-five years' experience of working in gallery education, Karen was awarded a Marsh Award for Excellence in Gallery Education in 2011.

Chelsea Farrar is curator of community engagement at the University of Arizona Museum of Art. Before working in museums she taught art, technical theater, and advanced placement art history at a high school in Tucson, Arizona. Her research focus is on arts integration for museum-based curriculums, social justice issues, and community-based programs and exhibitions. Her work with community engagement through the arts has included several award-winning community-based programs and exhibitions involving LGBTQ youth, military families, and adults with disabilities.

Hannah Heller is a doctoral student in the art and art education program at Teachers College. She has an MA in museum education from Tufts University and has taught and worked on research and evaluation projects in several cultural institutions, including the Museum of Fine Arts, Boston; Lincoln Center for the Performing Arts, Inc.; Whitney Museum of American Art; El Museo del Barrio; and the Museum of Arts and Design. Her research interests include developing skills around empathy and orientations toward social justice through close looking at art; she believes art can play an active and healing role, especially when addressing difficult topics such as race in a group setting.

Brian Hogarth is director of the leadership in museum education program at Bank Street College in New York. He has taught classes in educational

theories, object-based learning, exhibition design for educators, and various survey courses in Asian art. Prior to Bank Street, he directed education and programming departments at several major museums across the United States and Canada for over two decades. His background also includes work in performing arts management.

Stephanie Fox Knappe is the Samuel Sosland curator of American Art at the Nelson-Atkins Museum of Art. She holds a doctoral degree in art history from the University of Kansas where she taught several courses. Knappe has contributed to the exhibition catalogues *Tales from the Easel: America Narrative Painting from Southeastern Museums, circa 1800–1950* (University of Georgia Press, 2004); *Aaron Douglas: African American Modernist* (Yale University Press, 2007); *Romancing the West: Alfred Jacob Miller in the Bank of America Collection* (Nelson-Atkins Museum of Art, 2010); and *Go West! Art of the American Frontier from the Buffalo Bill Center of the West* (High Museum of Art, 2013). She was the curator for *Frida Kahlo, Diego Rivera and Masterpieces of Modern Mexico from the Jacques and Natasha Gelman Collection* and was a venue curator for the Nelson-Atkins's presentation of *Shared Legacy: Folk Art in America*, *Rising Up: Hale Woodruff's Murals at Talladega College*, and *American Epics: Thomas Hart Benton and Hollywood*. She recently participated as a summer scholar in the National Endowment for the Humanities Summer Institute on the topic of the Visual Culture of the Civil War and Its Aftermath.

Judith Koke is the Richard and Elizabeth Currie chief, public programming and learning, at the Art Gallery of Ontario in Toronto, Canada. Her career is rooted in over a decade of audience research; hence the imperative to incorporate visitor and community input into creating meaningful participation and learning runs deeply. She has published extensively and is a coauthor of *Interpretive Planning for Museums: Integrating Visitor Perspectives in Decision Making*.

Ann Rowson Love is the coordinating faculty member for the museum education and visitor-centered exhibitions program in the Department of Art Education at Florida State University. She is also faculty liaison to The Ringling. Prior to her current position, she was the director and associate professor of the graduate museum studies program at Western Illinois University-Quad Cities based at the Figge Art Museum in Davenport, Iowa. Ann has been a museum educator, curator, and administrator for over 25 years. She presents and publishes widely on curatorial collaboration, visitor studies, and art museum interpretation.

Matthew McLendon, is curator of modern and contemporary art at the John and Mable Ringling Museum of Art. He has been responsible for the final design, construction, and opening of *Joseph's Coat*, the Skyspace by James Turrell, as well as major projects with Sanford Biggers, Toni Dove, R. Luke DuBois, Trenton Doyle Hancock, Sofia Maldonado, and Jill Sigman, among others. He has a PhD from the Courtauld Institute of Art and has taught graduate and upper-level undergraduate seminars on contemporary art and theory at Florida State University and New College of Florida, the State Honors College.

Monica O. Montgomery is an international speaker, museum director, and cultural consultant, curating media and museums to be in service to society. She leads collectives like Museum Hue in building cultural equity and diverse representation through social justice and arts. She is the founding director of Museum of Impact, the world's first mobile social justice museum, inspiring action at the intersections of art, activism, self, and society.

Marianna Pegno is associate curator of education at the Tucson Museum of Art and a doctoral candidate in art history and education at the University of Arizona. For over ten years, she has worked in various capacities to transform the museum into an interactive, community-centered space. As an educator, she has developed tours for the visually impaired, multivisit programs for refugee families, programming for K–12 students, visitor-generated labels, and community-based exhibitions.

Andrew Pekarik is currently senior museum research fellow at the Freer and Sackler Galleries of the Smithsonian Institution. He retired in 2016 from the Smithsonian Institution's Office of Policy and Analysis, where he was senior research analyst. He spent twenty-two years designing and conducting studies of Smithsonian museums, exhibitions, and programs and participating in exhibition planning teams. Prior to joining the Smithsonian, he worked as a curator, author, museum administrator, and exhibition organizer.

Rosie Riordan has been the head of school and educator services at the Nelson-Atkins Museum of Art for five years. She has her BFA in painting from Kansas State University and her MS in curriculum and instruction from Avila University. She taught K–12 in the public school system for over twenty-five years. She served as elementary division director on the National Art Education Association board and as president of the Kansas Art Education Association. She has received many awards, including Western Region Art Educator of the Year.

Keri Ryan is the associate director, interpretation and visitor research, at the Art Gallery of Ontario. Keri brings insights to the AGO's planning tables from over fifteen years of experience as a museum educator, evaluator, and interpretive planner. Prior to joining the AGO ten years ago, she worked on cultural projects worldwide with Lord Cultural Resources with a focus on building exhibitions with communities.

Salvador Salort-Pons was appointed director, president, and CEO of the Detroit Institute of Arts (DIA) in October 2015. He joined the DIA's curatorial division in 2008 as assistant curator of European paintings and served as head of the European art department beginning in 2011, adding the role of executive director of collection strategies and information in 2013. He also served as the Elizabeth and Allan Shelden curator of European paintings at the DIA and played a key role in the museum's strategic planning process. Prior to coming to Detroit, he held positions in Dallas, Madrid, and Rome.

Trish Scott, research curator at Turner Contemporary, joined the gallery in 2015. With a background in social anthropology and fine art and a PhD focusing on authorship and agency at the intersection of social encounters, Trish is currently working with forty members of the local community to co-curate Turner Contemporary's first major exhibition of 2018.

Zeynep Simavi is a program specialist at the Department of Public and Scholarly Engagement. She is responsible for the scholarly programs and publications at the Freer and Sackler Galleries. She coordinates the fellows program and scholarly events and is the managing editor of the journal *Ars Orientalis*. She has a BA in English literature from Bogazici University (Istanbul), an MS in media and cultural studies from the Middle East Technical University (Ankara), and an MA in art and museum studies from Georgetown University, and is currently a PhD candidate in art history at the Istanbul Technical University.

Jerry N. Smith is the Hazel and William Hough chief curator and interim director at the Museum of Fine Arts, St. Petersburg, Florida. Smith previously served as curator of American and European Art to 1950 and Art of the American West at Phoenix Art Museum, where he oversaw thirty-eight exhibitions during an eleven-year span. Smith holds bachelor's and master's degrees from Arizona State University and a PhD from the University of Kansas, all in art history.

Maureen Thomas-Zaremba is curator of education at the John and Mable Ringling Museum of Art. She oversees educational programming at The

Ringling for the Museum of Art; the Circus Museum; Ca' d'Zan, the Ringling's historic mansion; as well as the Bayshore Gardens and special exhibitions. Educational programming includes community outreach, K–12 tours, youth and family programs, professional development opportunities, public programs, lifelong learning, symposia, and management and training of the 150-member docent corps.

Stefania Van Dyke is interpretive specialist, Textile Art and Special Projects at the Denver Art Museum. Previously, she was museum studies and practice editor at Left Coast Press, Inc., deputy director for learning at Vizcaya Museum & Gardens in Miami, and has worked in the education departments at the Brooklyn Museum and the Morgan Library and Museum. She has an MA in art history and an MS Ed. in museum education.

Kathy Vargas is an artist/photographer and associate professor at the University of the Incarnate Word in San Antonio, Texas. She has had exhibits at Sala Uno in Rome, Galeria Juan Martin in Mexico City, Centro Cultural Recoleta in Buenos Aires, and the McNay Art Museum in San Antonio, Texas. Her work is in the collections of the Smithsonian American Art Museum and the Toledo Art Museum, among others, and her papers are housed at the Smithsonian's Archives of American Art.

Alicia Viera is an interpretive planner in the Learning and Audience Engagement Division at the Detroit Institute of Arts and a doctoral candidate in art education/arts administration at Florida State University. She was previously arts administrator with the City of San Antonio's Department for Culture & Creative Development and director of cultural programs at the Texas A&M University—San Antonio's Educational & Cultural Arts Center. Viera has published and presented at regional, national, and international conferences placing an emphasis on her research interests that include supported interpretation, visitor-centered and bilingual exhibitions, multiculturalism and inclusiveness in art museums, and visitor studies.

Pat Villeneuve is professor and director of arts administration in the Department of Art Education, Florida State University, where she has developed graduate programs in museum education and visitor-centered exhibitions. Pat is editor of the book *From Periphery to Center: Art Museum Education in the 21st Century* and recipient of the National Art Education Association National Museum Educator of the Year award in 2009. She has published and presented extensively nationally and internationally and has developed supported interpretation, a model for visitor-centered exhibitions.

Maia Werner-Avidon is the manager of research and evaluation at the Asian Art Museum of San Francisco. She has a master's degree in museum studies from John F. Kennedy University. Prior to joining the museum, she worked as a research specialist at the Lawrence Hall of Science in Berkeley, California, for eight years.

DATE DUE

MAY 1 0 2017

PRINTED IN U.S.A.